The Ascendance

The Ascendance of Harley Quinn

Essays on DC's Enigmatic Villain

Edited by SHELLEY E. BARBA
and JOY M. PERRIN

McFarland & Company, Inc., Publishers
Jefferson, North Carolina

Library of Congress Cataloguing-in-Publication Data

Names: Barba, Shelley E., 1982– editor. | Perrin, Joy M., 1981– editor.
Title: The ascendance of Harley Quinn : essays on DC's enigmatic villain /
 edited by Shelley E. Barba and Joy M. Perrin.
Description: Jefferson, North Carolina : McFarland & Company, Inc.,
 Publishers, 2017. | Includes bibliographical references and index.
Identifiers: LCCN 2017031150 | ISBN 9781476665238 (softcover :
 acid free paper) ∞
Subjects: LCSH: Harley Quinn (Fictitious character) | Comic books, strips,
 etc.—History and criticism. | Graphic novels—History and criticism. |
 Women in literature. | Villains in literature.
Classification: LCC PN6728.H367 A83 2017 | DDC 741.5/9—dc23
LC record available at https://lccn.loc.gov/2017031150

ISBN (print) 978-1-4766-6523-8
ISBN (ebook) 978-1-4766-2999-5

British Library cataloguing data are available

Front cover image © 2017 canbedone/iStock

Printed in the United States of America

McFarland & Company, Inc., Publishers
 Box 611, Jefferson, North Carolina 28640
 www.mcfarlandpub.com

We would like to dedicate this work to all of Harley Quinn's fans. Without them, this book would have not been possible.

Acknowledgments

We would like to thank Ian Barba and John Perrin for looking through the whole manuscript. We would also like to thank Heidi Winkler for dealing with the lot of us during this process.

Contents

Introduction

With the incredibly long history of Batman and associated comics, it is unusual for something new to come along and grab a new generation's attention, and yet, that is exactly what happened in 1992 when young fans were introduced to Harley Quinn, a strange and eccentric female sidekick to the already popular villain, the Joker. Harley was introduced almost by accident as the creators of *Batman: The Animated Series* were looking for a female villain to pop out of a cake during one of the Joker's elaborate heists. Harley's addition to the official comic book canon in 1993 marked an unusual instance in which a character introduced in an animated series for children influenced the comic books. Harley has since captured the hearts and imaginations of fans of all ages and regions of the world, appearing in multiple TV shows, movies, video games, and DC merchandise. This book aims to shine a brighter light on the character of Harley Quinn and reveal her as a complex figure in her own right.

Harley has maintained a strong following as one of the most popular characters for women (and men) to cosplay at conventions (cons), Halloween activities, and other costume parties. On the television show *Arrow*, a brief appearance off-screen by Harley raised a lot of interest. As the list of villains was released for the 2015 movie *Suicide Squad*, the most anticipated and most recognizable character was, of course, Harley Quinn. With the film's release, she was the break out character, earning Margot Robbie a two-picture deal to continue portraying her. In 2014, Jesse Schedeen wrote a piece titled "Between the Panels: Why Is Harley Quinn So Popular?" in which he tried to explain the character's appeal. Schedeen cited Harley's entertaining humor and hyper-violence without consequences. Schedeen also pointed out that Harley gives fans everything that the Joker cannot: she is personable, funny, and occasionally a good person. Harley's struggle over her obsession with the Joker and her complex moral code creates a unique character that is capable of gory violence but also acts of extreme kindness. She develops close relationships with both villains and heroes alike and saves little girls and

animals from abuse. However, in her duality, she also facilitates the most horrific of the Joker's crimes. What makes Harley so lovable? Maybe it is this mix of dark and light, effervescence and rage, debilitating obsession and intelligence.

Since Harley's introduction in 1992, she has maintained a steady fan base as viewers of the cartoon series have followed the character through the comic books, live action plays, video games, and now movies. Those interested in a deeper understanding of Harley's bubbly and sometimes malicious character will delight in reading these selected essays on a diverse array of topics such as gender representation, psychology, literature analysis, and pop culture studies. While there are other books that touch on Harley as a sidekick to the Joker, or that talk briefly about her possible mental illness, this five-part book focuses more on the broad spectrum of aspects of Harley Quinn and various iterations of the character.

Part One consists of essays that establish the character, covering her history, background, and context of the character in the overall scheme of popular comic book characters. Part Two specifically focuses on Harley's relationship with the Joker and the implications for how victimhood is perceived in the media, how the relationship could be explained through hybristophilia, and how Harley can be seen as a hero to those who have survived abusive relationships.

Part Three focuses on Harley's relationships with others: her bisexual coding through subtext, issues of agency and how she relates to other characters, and how the character relates to freak discourse. Part Four covers her representations through *Batman: The Animated Series*, how the character visually evolves over time and medium, her representation in video games, and the instability of Harley's persona through volatile agency. Part Five focuses on philosophic theory of the Harley Quinn character: as a representation of the ritual jester in regards to the social order, how she is used as a proxy character for the readers, and the concept of evil in the *Harley Quinn* comic series.

The book concludes with an appendix containing a mediography of the comic books, television shows, web content, video games, and movies that are most significant to the development of the character. This mediography is provided to help readers find other content related to Harley Quinn. For now, we hope you enjoy this collection that covers the past twenty years of this engaging and personable character.

"It is to laugh"
The History of Harley Quinn

EMILEE OWENS

Brains, brawn, beauty—Bruce Wayne is not the only DC Comics character to have encompassed all three of these traits. Doctor of psychology, gymnast, femme fatale, as well as professional lunatic, Harley Quinn has undoubtedly become the epitome of strong female characters with a quirky twist, proving herself to be an enduring icon within the DC Universe. In the relatively short time that she has been in existence, she has had a drastic effect on pop culture, making her mark through multiple forms of media and accumulating a vast, vibrant history, developing all the while over the course of twenty-four years. Her time and importance within the Batman franchise was anticipated to be short-lived, but she surpassed all that was expected of her, inevitably becoming one of the most influential, well-known DC comic book characters, matching if not surpassing the popularity of her beloved Joker.

When most think of the Batman franchise, they hardly think of soap operas, unless they think of the drama surrounding most of the more recent plots, though it was a soap opera that directly inspired the creation of the Clown Princess of Crime. Creator of Harley Quinn, Paul Dini, was writing freelance scripts for what was, at the time, the upcoming Warner Brothers cartoon *Batman: The Animated Series*. He had decided upon giving the Joker a couple of henchmen and was drawn to the idea of making one of them a woman. It was during the process of writing an episode when he had watched an episode of the soap opera *Days of Our Lives* in support of his friend, actress Arleen Sorkin. In the series, Sorkin played the sprightly Calliope Jones. With a vivacious personality, high pitched voice, and an overbearing presence, it's surprising that inspiration hadn't struck Dini sooner. It wasn't until he had seen a skit during an episode that involved a daydream where Calliope rushes

3

into a throne room on roller skates to entertain a very uninterested royal family while dressed as a court jester. With a notable two-tone pattern on her costume as well as ruffled wrist cuffs to aid her goofy mannerisms, Dini had come to the realization of what he wanted the Joker's new female sidekick to look like. After a few revisions (or rather, an entire redesign) done by artist and co-creator, Bruce Timm, Harley had officially come to be. The casting choice, however, was much simpler than creating the character design. For Dini, it was a simple decision—the woman who inspired the character. Sorkin gave her an accent that came naturally to her, the thick accent of a Brooklynite, and portrayed her with all of the cheer she could muster, reminiscent of Calliope (Reisman; Dini, Smorning Show #20).

1992

On September 11, 1992, Dini introduced Harley Quinn in the *Batman: The Animated Series* episode "Joker's Favor." She was as bright and jubilant as a harlequin is expected to be, adorning a wide smile coated in black lipstick. Created to be nothing more than a one-time accomplice for the Joker, some of her first lines merely introducing "the caliph of clowns, the mogul of mountebanks" himself, it struck Dini as well as DC by surprise when she immediately won the hearts of viewers, pressing Dini to further develop her character and for Warner Brothers to allow her more screen time in future episodes (Dini, Randomski, "Joker's Favor"). Harley had then earned many appearances in the animated series, some of which revolved entirely around her like "Harlequinade" and "Harley's Holiday" which highlighted her wacky personality and antics and gave her a life of her own outside of her devotion to the Joker, and "Harley & Ivy" which introduced a friendship with the enchanting villain Poison Ivy that has endured the test of time, only to flourish into a canonical relationship in 2015 (Dini, Randomski, "Harlequinade," "Harley's Holiday"; Dini, "Harley & Ivy").

1993

In September of the year following her first appearance in *Batman: The Animated Series,* she appeared in her first ever comic in a spinoff of the series—*The Batman Adventures #12,* written by Kelley Puckett. In the comic she and Poison Ivy team up to crash a costume party that Barbara Gordon, Batgirl, is attending, while appropriately dressed as her crime fighting alter ego (Puckett). Being such a key part of Harley's history and being an incredibly rare collectible item as it's not only difficult to find, but difficult to come

across a copy in *good condition*, near-mint condition copies can cost well over $500, as displayed by Midtown Comics' website and listings on Amazon (Planet Comic, Midtown Comics, Amazon).

1994

With Harley's already-booming popularity amongst fans, it was only a matter of time before Dini had eventually written an origin for her in a single issue comic titled "Mad Love." She was introduced as Dr. Harleen Quinzel, a new psychiatrist at Arkham Asylum planning to write a "tell-all book" on her findings of the criminally insane that are kept there. She takes on the challenge of treating the Joker, extensively preparing to treat him for months, only to fall victim to his manipulation, falling in love with him. She feels as if he truly trusts her, confided in her, and that he is no more than "a tortured soul crying out for love and acceptance," constantly antagonized by Batman (Dini, "Mad Love and Other Stories" 37). After the Joker escapes from the asylum and, of course, loses in a scuffle with Batman, he's returned battered and bruised. This is Harley's breaking point, then leaving to find herself an appropriate costume and take on her new identity. She reintroduces herself to the Joker as his "new and improved Harley Quinn" and helps him break out of asylum once again, then taking on the role of his henchwoman and, unbeknownst to her, nothing more than his hired help, the two of them then becoming the ultimate dysfunctional duo (28–42). It gave depth to her character, placing a meaning behind her madness—a story that most could sympathize with, and even empathize with, as she admits her life is off-track, "Face it, Harl. This stinks. You're a certified nutzo wanted in two dozen states and hopelessly in love with a murderous, psychopathic clown. At what point did my life go Looney Tunes?" ("Mad Love" 1994).

The comic further proved Harley's popularity not only with fans, but with San Diego Comic Con's judging committee, as well, as it won an Eisner Award for "best single story" in 1994, then being adapted into an episode of *The New Batman Adventures* under the same title—one of the most well-known episodes of the series amongst Batman fans to this day (Comic-Con). This story is still the most highly accepted origin of her villain-hood.

1999

By 1999, Dini saw an opportunity to draw away from the DC Animated Universe, which opened the door to a whole new level of Harley Quinn— she was no longer confined by the bounds of a cartoon directed toward a

demographic of children, welcoming older audiences to embrace her new misadventures and an endless amount of possibilities for other writers. While making appearances in prior comics, such as *Batman #570*—her second comic appearance as well as her first appearance in a mainstream title—her true introduction to the main comics canon was in October 1999 in the comic, aptly titled, *Batman: Harley Quinn*, written by Paul Dini (Total Comics Mayhem). This was the catalyst for a flood of comic book appearances. Not long after *Batman: Harley Quinn's* release, other authors were quick to build on the foundation that Dini had laid out for the franchise.

2000

In December 2000, Karl Kesel created the comics series under the same name. The first volume of *Harley Quinn* comics ran over the course of four years with 38 issues, and atop the very first issue read the line—"At last! In her own monthly comic!"—as if reading the minds of the fans themselves as they excitedly purchased it at their local comic shops. Reminiscent of Harley's adventures in *Batman: The Animated Series*, the series revolved solely around Harley, not unlike the preceding graphic novel by Dini. It followed her on many remarkable adventures, including team-ups with other existing Batman villains as well as crossovers with other DC characters such as Superman and one of his many villains, Bizarro (Kesel, "All Aboard the Roller Coaster of Love!," "Going Out with a Bang!"; Lieberman, A.J.).

2009

Her adventures with other Batman characters continued throughout her history, as displayed in 2009 when DC launched the series *Gotham City Sirens*, initially written by Dini before being written by Peter Calloway, which followed the team-up of three of Batman's voluptuous villainesses—Harley Quinn, Poison Ivy, and Catwoman. After a scrape with the villain Hush in *Heart of Hush* and then with Batman's second Robin-turned-antihero, Jason Todd, in *Batman: Battle for the Cowl*, Catwoman was left weak. After being saved by Poison Ivy, she's taken back to her present hideout where she is staying with Harley who's currently separated from the Joker. They join together as a team in order to protect one another, doing their very best to do right by themselves and try their hardest (though usually failing) to stay out of trouble (Dini, "Gotham City Sirens" 1–10). The series in its entirety gave insight to how Harley can be a great asset to a team, how loyal she can be to those other than the Joker, and how she really can do the right thing, even

if it's in her own bizarre way. *Gotham City Sirens #7* gave more depth to Harley's character as she goes home to her birthplace of Brooklyn, NY, to celebrate Christmas with her family. Readers got a glimpse of her home life as they were introduced to her mother, deadbeat brother and his two children, and father who is currently serving time in prison, having a long history of swindling women out of their fortunes. It gave a sense of realism to Harley's life and a bit of insight as to why she has decided to take her own path, as unconventional as it may be (Dini, "Holiday Story" 10–18).

Dini's work in writing Harley stretched beyond that of comics and television in 2009, when he worked with video game company Rocksteady Studios to write the first of what became a popular trilogy—*Batman: Arkham Asylum*—introducing Harley Quinn to the world of video games. Many of those who played the trilogy were already fans of the Batman franchise and familiar with her character, simultaneously amused and appalled by her new realistic look, complete with a new design—the first drastic change in costume in her history. The new costume sparked some controversy amongst fans as it was much more revealing than her previous harlequin uniform and many complained about the blatant sexualization of her character. Though perhaps looking more like an excuse, the design seemed to be justified—that in order to fit the game's dark, gritty atmosphere, she was given a more adult-oriented design, Dini himself describing it as "a little harder edged because the game seemed to demand that. She does have her impish side to her, but it's really dark, for the game" in an interview with *GameSpot* (Dini, Batman: Arkham Asylum Q&A: Writer Paul Dini on Arkham, Batman, and More).

"Well hiya, B-Man. Harley Quinn here! How do you like my new uniform? Pretty hot, huh?" (*Batman: Arkham Asylum* 2009). Initially voiced by none other than Arleen Sorkin to appropriately complement Mark Hamill's casting as the Joker, despite the outfit change, the combination of her voice and Dini's writing in this Animated Series-based game gave fans of the show a refreshing sense of nostalgia. In an interview with *The Telegraph*, Dini explained, "…we were going for so many iconic aspects of Batman to put in the game, so why not include a few voices that are iconic to those characters; I can't imagine Harley Quinn sounding like anyone other than Arleen Sorkin…" (Dini, Batman: Arkham Asylum Interview with Paul Dini). Though after the release of *Batman: Arkham Asylum*, Sorkin retired from voicing Harley, and was replaced by actress Tara Strong, well-known for her work in children's cartoons. Despite losing the familiarity and coinciding nostalgia of Sorkin's portrayal of Harley, fans were not deterred by the re-casting. If anything, fans' love for her character in the game franchise only *grew* after the first game's release. It brought about a new wave of recognition as video games are in high demand and extremely popular.

2011

Rocksteady had taken note of Harley's popularity as she played a larger role in the second installment, earning her first DLC that took place after the main events of the game, ominously titled "Harley Quinn's Revenge." While players did not get the chance to play as Harley herself, but instead as Tim Drake (the third Robin) on a mission to rescue Batman, it was about time that she gained the recognition she deserved within the gaming franchise. Shown as powerful, relentless, and capable of taking over the Joker's legion of goons, she could only grow more powerful on both the fictional and non-fictional fronts.

By the time of the final installment of the Arkham trilogy, *Batman: Arkham Knight*, in June 2015, Harley had already become somewhat of a household name amongst comic fans and video game fans alike. She was one of the most anticipated characters in the game and companies took advantage of this, going on a Harley Quinn marketing spree. Being given her own DLC once again, but this time giving players the opportunity to play *as* her, those who pre-ordered the game through GameStop would have access to it for free, as well as her face being displayed in multiple storefronts well before the game's release. The amount of Harley Quinn merchandise for the final game nearly outweighed the amount of Batman merchandise when he was, naturally, the main protagonist of the game.

Though as far as comics were concerned, the momentum of DC's well-written stories about Harley had seemed to come to a screeching halt in 2011 with the New 52 reboot. DC planned to release 52 new series to replace all of the comics that they had discontinued, introducing new plots, new origins, and new character designs. Harley was introduced to the New 52 via the fourth volume of the *Suicide Squad* comics that November, to many fans' dismay. With a drastic outfit change, far from her usual longstanding two tone jester uniform which had been replaced with two tone *hair*, and completely white skin resembling the Joker's, fans were both shocked and outraged. Shown on the cover with a nonsensical as well as impractical corset and shorts, the controversy over her sexualization and a clear example of male gaze[1] had returned. While Harley had always been an alluring character, the costume change immediately acted like a deterrent for the reboot. Though the fan base did not falter; people found themselves having to adjust to this new design, but stuck around despite the superficial problems they had with the series. They also found themselves having to adjust to Harley's new characterization. Some elements of her character had remained, such as her clever-but-dark humor and, of course, her love of the Joker, but she was more menacing—pushed to the edge by the thought of the Joker's presumed death in the series.

With the reboot also came her new origin in *Suicide Squad #7*—the conclusion to "The Hunt for Harley Quinn" arc that lasted two issues. Similar to Dini's origin in "Mad Love," Harley was a psychiatrist working at Arkham Asylum, but writer Adam Glass paid particular attention to the pressures that she faced while working there, making her like a ticking time bomb under the Joker's influence. Unlike her pre-boot counterpart, the struggles she had faced while working at the asylum pressed her to become resentful of her career, looking for a sense of freedom within the confines of it, with the Joker encouraging her to set herself free as a means to help himself. Once again she assists him in escaping from the asylum, but it's at this part of the story where Glass altered the most defining point in Harley's life. Rather than Harley choosing to take on the role of Joker's sidekick on her own, Joker brings her to the site of his *own* origin, ACE Chemicals, and pushes her into a vat of chemicals to replicate his own "birth," as he put it, against her will. Accounting for the dual colored hair and white skin, Harley emerges wilder, crazier, and the ideal mad sidekick (Glass 4–6, 12–15). "This is a *special* place for me. It's where I was born. What happened here … *fixed* me. And it can fix you, too" (The Joker, *Suicide Squad #7* [2011]).

Glass' origin stirred up some issues amongst the fan base as there were those who were displeased with its quality, claiming that it had taken away a fundamental part of her character by altering the fact that she made the decision to become a villain herself at the mercy of manipulation. The idea was that it snubbed the basis of Harley's relationship with the Joker, but Glass had a different take on her character. In an interview with Comic Book Resources, Glass said, "I wanted her to become her own person and to become her own person, she has to step away from the very thing that I think these fans love, which is she's attached to the Joker's hip. My Harley, the New 52 Harley, she loves the Joker. She's very dedicated to him, but if Mr. J's not around, and he's not around right now, she's out in the world. She's got to survive and she's going to do what she has to do to survive" (Glass, CBR TV 2012: Adam Glass on "Suicide Squad," Harley Quinn & Angry Fans). Though, origin aside, she had proven herself to be a worthy adversary amongst the other members of Task Force X²—fierce, clever, and lively as ever.

2013

Harley's existence in the New 52 reboot was off to a rough start, but the issues with her costume design and origin were nothing compared to backlash of a disastrous promotion for the upcoming second volume of *Harley Quinn* comics in 2013. DC held an art contest with the idea that aspiring comic artists could make their breakthrough in the comics industry if they won

with the opportunity to work on a future issue. The theme of the contest was to draw Harley in a series of situations where she was attempting to commit suicide. Artists were encouraged to draw four panels, each with a particular suicide method—one where she's standing atop a building with the hopes of being struck by lightning, one of her covered in raw chicken in an alligator pond, one where she's willingly sitting in the mouth of a whale, and the last of her being naked in a bathtub as a variety of electronic appliances dangle above her (The Outhouse). The concept of the last panel drove people wild with protest, some even going as far as saying they would never purchase any DC merchandise again as they wouldn't support a company that would sexualize something such as suicide. Organizations such as the American Foundation for Suicide Prevention, the American Psychiatric Association, and National Alliance on Mental Illness also made a statement group on the topic, stating "we are disappointed that DC Comics has decided to host a contest looking for artists to develop ways to depict suicide attempts by one of its main villains…" The contest was not only morbid, but ill-timed as it was announced the week before National Suicide Prevention Week, on September 5, 2013. Jimmy Palmiotti, script writer of the scenario as well as one of the authors of the *Harley Quinn* (2013) comics themselves, posted about the debacle on his Facebook page. In the post he stated, "That the tryout Harley Quinn page went out without an overall description of tone and dialogue is all my fault. I should have put it clearly in the description that it was supposed to be a dream sequence with [co-writer] Amanda and I talking to Harley and giving her a hard time…. I hope all the people thinking the worst of us can now understand that insulting or making fun of any kind was never our intention. I also hope that they can all stop blaming DC Comics for this since it was my screw up." A DC representative later released a statement to Huffington Post, stating that "DC Entertainment sincerely apologizes to anyone who may have found the page synopsis offensive and for not clearly providing the entire context of the scene within the full scope of the story" (Sieczkowski).

After the discourse surrounding the contest had died down, DC went ahead and published the first issue of *Harley Quinn* (2013) in November 2013. Written by husband and wife Jimmy Palmiotti and Amanda Conner, and illustrated by *seventeen* different artists, *Harley Quinn #0* was an interesting reintroduction to the monthly series with a New 52 twist. The comic constantly breaks the fourth wall, the plot being Harley fantasizing about what it would be like to have her own comic book series and the authors themselves suggesting different artists and themes to her. Each page was illustrated by a different artist, and some paid homage to Harley's past, such as Bruce Timm illustrating one of the pages. It had a lighthearted and cartoonish vibe, cracking jokes about the illustrators and authors themselves as well as the situations

that Harley was put in on each page (Conner, Palmiotti, "Picky Sicky"). The following comics took on a similar tone, following Harley on a series of adventures that were usually appropriately gruesome, but also cheerful and comical—a witty balance that complemented her character well. With a likable upbeat plot, despite the initial troubles and threats to boycott, fans reacted well to the comics as they became one of DC's better-selling comics series, as reported by Diamond Comic Distributors (Miller).

Conner and Palmiotti had also given Harley a couple of new traits, such as her intense love of animals (as displayed in issue #1 when she steals a dog from an ungrateful owner or when she sets free many *more* animals in the next), and a more typically insane personality, building off of Glass' work with Suicide Squad, by giving her a "pet" beaver named Bernie that she hallucinates talking to her (Conner, Palmiotti, "Hot in the City"; "Helter Shelter" 9–10). Most notably, the comics are renowned for Harley's confirmed canonical relationship with Poison Ivy. It was immediately hinted to in *Harley Quinn #2* when Ivy plants a kiss on Harley's cheek as she sleeps and again multiple times throughout the series, but it wasn't until June 12, 2015, that DC confirmed their relationship via a tweet. During a Twitter Q&A titled under the hashtag "Harley Quinn Chat," someone asked for a confirmation of their relationship. DC replied with "Yes, they are girlfriends without the jealousy of monogamy" (Conner, Palmiotti, "Helter Shelter" 17; DC Comics). This is further confirmed in *Harley Quinn #25* when a sexual relationship between the two villains is alluded to (Conner, Palmiotti, "Twenny-Five Big Ones" 6). While many may deny the polyamorous relationship that was made not only blatantly clear but also confirmed, many others embraced this relationship and were happy to see Harley moving away from the Joker's grip, developing as a character after a twenty-three year struggle with being hopelessly devoted to the Joker and finally earning a relationship filled with support, trust, and the genuine love that she deserves.

2014

The New 52's influence on Harley Quinn's portrayal did not stop with comics, but carried over into what was most-likely a lifelong dream of most of her fans. In October 2014, Warner Brothers announced ten DC film titles that they planned to release between 2016 and 2020, one of which was *Suicide Squad*, directed by David Ayer (McMillan). In December of that year the cast was announced, Australian actress Margot Robbie, most well-known for her role in *The Wolf of Wall Street,* was cast as Harley Quinn, and Jared Leto was set to play her menacing "Mistah J." Out of the other characters and well-known A-list actors like Will Smith being cast in the film as well, most of the

excitement surrounding the film was due to Harley's existence alone (Kroll). Most fans could probably look back and remember the era following Christopher Nolan's film *The Dark Knight* and how they wished that they had a Harley Quinn to complement Heath Ledger's Oscar-winning Joker performance, and now after six years, they were finally getting at least *part* of what they had hoped for—the chance to finally see her in live action. As set photos leaked onto the web, it was no surprise that her outfit stirred up controversy. With a shirt reading "Daddy's Lil' Monster" and a jacket with "Property of Joker" written on it, feminists were undoubtedly disappointed. She took on an edgier look to suit the film's no-doubt edgy theme, reminiscent of her design in the *Suicide Squad* comics with her small shorts and pale skin. Though both of her creators, Paul Dini and Bruce Timm, were not offended by the costume design. In an interview with *Polygon*, when asked about what it's like to see the characters he's created being interpreted in live action films, Timm said "I just today ... saw the first image of Harley Quinn from the Suicide Squad movie, and I thought 'Woah. She looks actually pretty cute!' I was actually kind of worried ... but nah, she's not too bad" (Timm). A lot more initially optimistic, Dini told the *Shanlian on Batman* podcast "It's a rougher, more street look. I think it works fine" and went on to praise Margot Robbie, noting his approval of the casting choice for the film. "I think Margot is very nice, she's a very wonderful actress, certainly very attractive and very talented.... I'm very excited to see that interpretation of Harley" (Dini, Harley Quinn Co-Creator Paul Dini Loves Margot Robbie's Suicide Squad Look).

2015

Warner Brothers' first *Suicide Squad* trailer, released in January 2016, further proved the edginess of the film and showed Margot's portrayal of Harley in action—seemingly as quirky and crazy as one would expect her to be after her dip in toxic chemicals. Harley and the Joker's newfound love of tattoos was used as a fun marketing technique, creating the concept of Harley's Tattoo Parlor. In August 2015, director David Ayer tweeted two pictures—one of Margot, in full costume giving somebody a tattoo, and another of a piece of paper with "Harley Quinn's Tattoo Parlor" written on it, with the misspelling of "parler" crossed out. It was unconfirmed whether or not this was all in good fun amongst the cast and crew or pertinent to the film itself, but it was later used to market it. In March 2016 at film, interactive media, and music convention South by Southwest, or SXSW, in Austin, Texas, Harley's Tattoo Parlor became a reality. Attendees were able to purchase both temporary and permanent tattoos modeled after professional designs created to promote the film, each representing a member of Task Force X (Lawler).

With all of the emphasis on her character, she was undoubtedly the most highly anticipated character in the film.

Not long after the *Suicide Squad* announcements, DC had another announcement to make—they would be partnering with toy company Mattel to create their first ever line of action figures for girls. In an April 2015 official press release, DC stated that famous female characters, superheroes and super villains alike, would be part of a line of toys "that helps build character and confidence, and empowers girls to discover their true potential." Harley was one of many female characters to be included in the toy line, amongst Wonder Woman, Batgirl, Poison Ivy, and more. Warner Brothers Animation also developed a series of online shorts to accompany the toy line for girls to have the chance to interact with the characters and learn more about their adventures together (DC Comics). Geared for ages 6–12, Harley's zany antics were brought back to a level suitable for children. She, along with all other characters, were aged down to teenagers, making Harley more relatable than ever before amongst young girls. "DC Super Hero Girls represents the embodiment of our long-term strategy to harness the power of our diverse female characters. I am so pleased that we are able to offer relatable and strong role models in a unique way, just for girls" (Diane Nelson, President of DC Entertainment, Official Press Release, 2015).

Her relatable, fun-loving, playful personality is surely entertaining, but these qualities as well as her perseverance were for once being emphasized for girls to look up to. After twenty-three years, Harley had become a role model. She could stand as a reminder to young girls that they can be a bit unorthodox but still be loved, misunderstood but intelligent; that they hold the power to brighten room with a joke or a smile, and harness enough strength and courage to be their own hero.

Her influence does not end with young girls, as the virtues that her character demonstrates transcend all age groups. There is no doubt that part of why she has affected pop culture and the Batman franchise as she has is due to her resiliency. She has proven that she is a force to be reckoned with, whether that be within the stories that she is written in or within the franchise as a whole. She has become the embodiment of so many things other than just being the Joker's sidekick—loyal, ambitious, and comical; a role model, a feminist icon. Growing along with her fan base, not only in age or size, but also in depth. With all the complexities and characteristics that make her so memorable, her future within the franchise looks as bright as her smile.

NOTES

1. Term coined by feminist film critic Laura Mulvey to describe the derogatory ways that media can cater to a male audience.

2. The alternate name of the Suicide Squad.

WORKS CITED

"Batman Adventures #12 - Midtown Comics." *Midtown Comics.* Midtown Comics, n.d. Web. 03 Feb. 2016.

Batman: Arkham Asylum. Rocksteady Studios. Eidos Interactive, Warner Bros. Interactive Entertainment, Square Enix, Time Warner, 2009. PlayStation 3, Xbox 360.

"Batman: Arkham Asylum Q&A: Writer Paul Dini on Arkham, Batman, and More." *GameSpot.* GameSpot, 21 Apr. 2009. Web. 02 Feb. 2016.

Batman: Arkham City. Rocksteady Studios. Warner Bros. Interactive Entertainment, 2011. PlayStation 3, Xbox 360.

Batman: Arkham Knight. Rocksteady Studios. Warner Bros. Interactive Entertainment, 2015. PlayStation 4, Xbox One.

Brucculieri, Julia. "Margot Robbie's Harley Quinn Plays Tattoo Artist in New 'Suicide Squad' Set Photo." *Huffington Post.* The Huffington Post, 19 Aug. 2015. Web. 12 Mar. 2016.

Carlton, Bronwyn (w). Deodato, Mike (p). Roach, David (i). "The Code: Part 1: Breakin' the Law." *Batman.* v1. #570. (Oct. 1999), Warner Brothers. [DC Comics].

Comic Book Resources. "CBR TV 2012: Adam Glass on 'Suicide Squad,' Harley Quinn & Angry Fans." Online video clip. *YouTube.* YouTube, 7 May 2012. Web. 4 Feb. 2016.

Conner, Amanda, and Jimmy Palmiotti (w). Conner, Amanda, Becky Cloonan, Tony S. Daniel, et al. (p). Conner, Amanda, and Becky Cloonan, Sandu Florea, et al. (i). "Picky Sicky." *Harley Quinn.* v2. #0. (Jan. 2014), Warner Brothers. DC Comics.

_____. Hardin, Chad (p) (i). "Hot in the City." *Harley Quinn.* v2. #1. (Feb. 2014), Warner Brothers. DC Comics.

_____. Hardin, Chad (p) (i). "Twenny-Five Big One$." *Harley Quinn.* v2. #25. (Apr. 2016), Warner Brothers. DC Comics.

_____. Hardin, Chad, and Stéphane Roux (p) (i). "Helter Shelter." *Harley Quinn.* v2. #2. (Mar. 2014), Warner Brothers. DC Comics.

Cowen, Nick. "Batman: Arkham Asylum Interview with Paul Dini." *The Telegraph.* Telegraph Media Group, 02 Sept. 2009. Web. 02 Feb. 2016.

DC Comics. DC Entertainment. "WB and DC Entertainment in Partnership with Mattel Launch 'DC Super Hero Girls.'" *DC Comics,* 22 Apr. 2015. Web. 07 Mar. 2016.

DC Comics (DC Comics). "Yes, They Are Girlfriends Without the Jealousy of Monogamy." 12 Jun. 2015, 4:32PM. Tweet.

"DC Releases Script for Harley Quinn Contest, Internet Outraged." *The Outhousers.* The Outhouse, 6 Sept. 2013. 02 Aug. 2016.

"DC Super Hero Girls." *YouTube.* YouTube. n.d. Web. 07 Mar. 2016

Dini, Paul (w). Lopez, David (p). Lopez, Alvaro (i). "Holiday Story." *Gotham City Sirens.* v1. #7. (Feb. 2010), Warner Brothers. DC Comics.

Dini, Paul (w). Yvel Guichet (p), Aaron Sowd (i). *Batman: Harley Quinn.* Warner Brothers. DC Comics, 1999.

Dini, Paul, and Bruce Timm (w). Timm, Bruce, Glen Murakami (p). Timm, Bruce (i). "Batman: Mad Love." *Batman: Mad Love and Other Stories.* vol. 1. Ed. Scott Peterson. NY: DC Comics, 2005.

Dini, Paul, and Scott Lobdell (w). March, Guillem (p). March, Guillem (i). *Gotham City Sirens.* v1. #1. (Jun. 2009), Warner Brothers. DC Comics.

Glass, Adam (w). Henry, Clayton, Ig Guara (p). Hanna, Scott (i). "The Origin of Harley Quinn." *Suicide Squad.* v2. #7. (May 2012), Warner Brothers. DC Comics.

"Harlequinade." *Batman: The Animated Series Volume Three.* Dir. Kevin Altieri. Writ. Paul Dini and Eric Randomski. Warner Brothers, 2005. DVD.

"Harley & Ivy." *Batman: The Animated Series Volume Two.* Dir. Boyd Kirkland. Writ. Paul Dini. Warner Brothers, 2005. DVD.

"Harley's Holiday." *Batman: The Animated Series Volume Three.* Dir. Kevin Altieri. Writ. Paul Dini and Eric Randomski. Warner Brothers, 2005. DVD.

Hughes, Mark. "'Batman' Writer Paul Dini Reveals His Reaction to 'Suicide Squad'" *Forbes.* Forbes Magazine, 04 Sept. 2015. Web. 06 Mar. 2016.

Jayson, Jay. "Harley Quinn Co-Creator Paul Dini Loves Margot Robbie's Suicide Squad Look." Comicbook.com. n.p. 08 Sept. 2015. Web. 06 Mar. 2016.

"Joker's Favor." *Batman: The Animated Series Volume Three*. Dir. Boyd Kirkland. Writ. Paul Dini and Eric Randomski. Warner Brothers, 2005. DVD.

Kesel, Karl (w). Dodson, Terry (p). Dodson, Rachel (i). "All Aboard the Roller Coaster of Love!" *Harley Quinn*. v1. #1. (Dec. 2000), Warner Brothers. DC Comics.

_____. "Going Out with a Bang!" *Harley Quinn*. v1. #19. (Jun. 2002), Warner Brothers. DC Comics.

"Key Comic #11: Batman Adventures #12." *Planet Comic*. PlanetComic.com, 13 Aug. 2015. Web. 03 Feb. 2016.

Kroll, Justin. "Suicide Squad Cast Revealed: Jared Leto to Play the Joker, Will Smith Is Deadshot." *Variety*. Variety Media, 2 Dec. 2014. Web. 06 Mar. 2016.

Lawler, Kelly. "You Can Get a 'Suicide Squad' Tattoo at SXSW." *USA Today*. USA, 10 Mar. 2016. Web. 12 Mar. 2016.

Lieberman, A.J. (w). Adlard, Charlie (p) (i). "Cuckoo for Incarceration." *Harley Quinn*. v1. #38. (Jan. 2004), Warner Brothers. DC Comics.

McMillan, Graeme. "Warner Bros. Announces 10 DC Movies, 3 Lego Movies and 3 'Harry Potter' Spinoffs." *The Hollywood Reporter*. n.p. 15 Oct. 2014. Web. 06 Mar. 2016.

Miller, John Jackson. "Comichron: A Resource for Comics Research." *Comichron: A Resource for Comics Research*. The Comic Chronicles. n.d. Web. 02 Aug. 2016.

"1990s." *Comic-Con International: San Diego*. San Diego Comic Convention, n.d. Web. 02 Feb. 2016

Polo, Susana. "Harley Quinn Co-Creator Bruce Timm Thinks Suicide Squad's Harley Is Pretty Cute." *Polygon*. Vox Media. 04 May 2015. Web. 06 Mar. 2016.

Puckett, Kelley (w). Parobeck, Mike (p). Burchett, Rick (i). "Batgirl: Day One." *The Batman Adventures*. v1. #12. (Sept. 1993), Warner Brothers. DC Comics.

Riesman, Abraham. "The Hidden Story of Harley Quinn and How She Became the Superhero World's Most Successful Woman." *Vulture*. New York Media, 17 Feb. 2015. Web. 01 Feb. 2016

"2nd Appearance Comics to Invest In." *Total Comic Mayhem*. Blogger, 12 Dec. 2014. Web. 02 Aug. 2016.

Sieczkowski, Cavan. "DC Comics Holds Harley Quinn Drawing Contest with Suicide Scenarios." *The Huffington Post*. The Huffington Post, 12 Sept. 2013. Web. 5 Mar. 2016.

Smith, Kevin. "Smorning Show #20." Interview. Audio blog post. *Smodcast*. Squarespace, 21 Oct. 2011. Web. 16 Dec. 2015.

Harlequin Romance
The Power of Parody and Subversion

Cia Jackson

Hmph. Romance. Who needs it?—Harley Quinn, *Harley Quinn Volume 1: Hot in the City* (2014)

Since her inception as a background character in Paul Dini and Bruce Timm's *Batman: The Animated Series* (1992–95), Harley Quinn has been depicted in the DC comic book universe as the ultimate romantic heroine. Stories featuring the character over the past two decades have focused upon her never-ending quest to prove her love to the Joker. The character's name is a play on the word harlequin, creating a convincing link between the comic book character and the harlequin figure of sixteenth century Italian theatre, *commedia dell'arte*. Her costume and make-up, with their vibrant colors and diamond motifs, create a visual connection with the jester figure's appearance. This play on harlequin also establishes a connection with the popular, mass-produced romance novels of the same name, the Harlequin romance. By linking Harley with the Harlequin romance, both the character and her titled comic come to be associated with the values, conventions, and tropes found within these novels. This in turn enables writers and readers to explore complex themes such as gender, sexuality, and female agency—all of which are central to the portrayal of Harley's character. This connection is further strengthened when the character's role within the DC Universe is taken into account. Indeed, romance can be seen at the core of the character's identity, created by Dini and Timm in order to serve as the Joker's paramour. Harley's introduction and origin story in the DC Universe was that of a love story; one which has resonated to such an extent that it has been played out by numerous writers and artists over a wide range of comic books over the past two decades. Although the confines of this essay prevent a detailed analysis

16

of all media in which Harley Quinn has appeared and will focus specifically upon comic books, it is worth noting that the character's relationship with the Joker has also been portrayed in live-action films and video games, as well as serving as the subject for fan-fiction stories. The character's appearance may be that of a harlequin jester; however, Harley is the epitome of the romantic heroine both in name, nature, and narratives featuring the character consumed by writers' portrayal of her quest for love.

Harlequin Romance Defined

This section will define what constitutes a Harlequin romance before outlining key critical engagement with the novels to date. The term Harlequin romance refers to mass-published romance novels of the same name, originally produced by Harlequin Enterprises. The company initially produced a wide range of books on a variety of subjects and genres; however, they became synonymous with the romance genre following a contract in which the company gained the rights to publish British Mills & Boon romances in North America in 1957. The company eventually bought Mills & Boon in 1971 and continues to publish new romance novels on a monthly basis under the imprint name of Harlequin Mills & Boon. At this point, it should be noted that as with DC and its highly varied superhero comic books, Harlequin is not a genre in and of itself, but a brand, publishing the works produced by a wide range of authors. As critic Stephanie Harzewksi states in her seminal study, *Chick Lit and Postfeminism* (Harzewksi, 2011), it can be viewed as one of many manifestations and producers of romance literature (Harzewksi, 41). At present, Harlequin advertises its novels as falling under different subcategories (including but not limited to Fantasy, Mystery, Wholesome, and Erotica), all of which are ultimately centered around providing readers with "uplifting escapes featuring real, relatable women and strong, deeply desirable men" (Harlequin Romance, 2000–2014). The novels serving as a means with which women can escape from their daily routines and vicariously experience a relationship has long been a source of contention amongst readers and critics. The merits behind these works are subject to debate since the end of the twentieth century. Although Janice A. Radway suggested in her extensive study into romantic fiction, *Reading the Romance* (Radway, 1984), that this feature could be viewed as a reactionary mode, allowing female readers to simultaneously escape and explore the boundaries of a patriarchal society through their identification with the heroine (Radway, 75), other critics are more skeptical. Ann Barr Snitow argued in her article, "Mass Market Romance: Pornography for Women is Different" (Barr Snitow, 1994), that this feature of the novels enabled the promotion of regressive gender stereotypes. According

to Barr Snitow, although the use of the female point of view assists in enabling readers to identify with the heroine, it also causes the novels to be "permeated by phallic worship" (Barr Snitow, 192), placing greater emphasis upon the hero and fulfilling his needs, than those of the heroine. Certainly, the hero is described in great detail, ranging from his physical appearance, to his desires and career, all of which are presented as extremely attractive to the reader while the heroine is bland and barely described in comparison (Barr Snitow, 195). This is a view supported by Tania Modleski, who expands upon Barr Snitow's arguments in "The Disappearing Act: A Study of Harlequin Romances" (1990), writing that in identifying with the heroine, readers are encouraged to "undergo a complex process of self-subversion ... and ... participate in and actively desire female self-betrayal" (Modleski, 435), changing herself in order to prove that she is worthy of the hero. Both critics also address the issue of violence within their respective studies, arguing that male brutality and violence towards women is presented to the reader as a sign of the hero's love for the heroine, gradually normalizing male aggression towards women.

More recent criticism is equally scathing, supporting the views expressed by Barr Snitow and Modleski. Stephanie Harzewski argues that although the novels claim to respond to the needs of an everywoman, the heroines are frequently portrayed as girls; thus, they are inexperienced and must defer to the worldlier and experienced older hero (Harzewski, 9). Noting Radway's proposal that the romance novels have a reactionary quality, Harzewski suggests that the novels reveal society's fundamental discomfort with female agency and adulthood. Harzewski's comments echo the concerns of recent engagement with the portrayal of women in comic books. Critics including Trina Robbins (1997) and Jacqueline Danziger-Russell (2013) have discussed the portrayal of female comic book characters at length, noting the frequency with which the characters are presented as girls as opposed to women; depicted as the young, attractive, and weaker appendages of male characters on whom narratives are centered. It can be no coincidence that Harley Quinn was created and first appeared in the reactionary medium of comic books during the period in which Harlequin romances were at the height of their popularity amongst readers and gaining greater attention and derision from both the public and academics. Or, indeed, that the development of the character occurred as more recent waves of feminism gained more momentum.

Romantic Beginnings: Mad Love and Secret Origins

As the constraints of this paper do not allow for extensive analysis, the first half of this section will focus on Dini and Timm's *The Batman Adventures*

Mad Love: The Deluxe Edition ([1994] 2015) comic book, arguing that the writer and artist's portrayal of Harley in this tragicomic love story reflects and parodies the values found within the Harlequin romance. Attention will then turn to Amanda Conner and Jimmy Palmiotti's recent retelling of Harley's origin story in *Secret Origins #4: Harley Quinn* (2014), discussing their portrayal of Harley in light of Harlequin romance conventions and Dini and Timm's version of Harley in *Mad Love*.

Dini and Timm's *Mad Love* (1994) tells the origin story of Harley Quinn, revealing her transformation from Doctor Harleen Quinzel into the Joker's "hench-wench" and introduces the character into DC's comic book canon. The story is told primarily through the use of Harley's voice and internal monologue, and charts the character's relationship with the Joker from their first meeting in Arkham Asylum to her most recent attempts to secure the Joker's affections. Dini and Timm use Harley and the Joker in order to parody the romance genre, creating a tragicomic love story.

Dini reflects upon the creation of *Mad Love* in the foreword to the recently reissued deluxe edition, stating that the narrative and his portrayal of Harley can certainly be perceived as an unconventional love story. Dini writes that *Mad Love* is "about what happens when someone loves recklessly, obsessively, and for too long," and is both a cautionary tale and a universal one. The portrayal of the comic's narrative through Harley's hopes, desires, and heartbreaks are something to which all readers will eventually come to experience and relate. Dini describes the comic as a "funhouse mirror" allowing the readers to see distorted reflections of themselves in Harley and vicariously experience the narrative through her. This particular element of Dini's commentary creates an explicit link between the comic Harley Quinn, and the romance genre. This is in terms of their subject matter's direct concern with themes of love and romance, but also through his assertion that readers are able to utilize *Mad Love* and Harley's character as a means with which to experience the narrative. Thus, suggesting that in this instance, Harley is playing the role of the Harlequin heroine and her presence within the narrative is a crucial enabling factor for the readers' identification with Harley and the vicarious adoption of her role within the panels.

Bruce Timm's unused original back cover for *Mad Love* is included within the deluxe edition of the comic, and can be viewed as an overt parody of a Harlequin romance, drawing further parallels between Harley and the mass-produced romances. In this image, Timm portrays Harley smiling and dabbing at her eyes with a handkerchief as she reads a novel entitled *Love's Wacky Fury*. The novel, and Timm's portrayal of Harley's tearful response to it in particular, can be viewed as lightly mocking romance novels and their readers. However, in portraying Harley and her novel in this manner, Timm's illustration also draws attention to criticism leveled towards Harlequin

romances and women in comic books through the repetition and depiction of their core values. Although Harley is depicted as reading the faux novel, Timm also presents her on the cover of *Love's Wacky Fury*, involved in a passionate embrace with the Joker. The presence of Harley both as the reader and object of the romance parody draws upon both predictability of romance plots (published by Harlequin and other publishing houses) which conclude with the hero and heroine's embrace, encased within identikit pastel covers. Furthermore, the image also highlights the romance novel's function as a fantasy aid or distorted mirror, allowing the reader to identify with and take the place of the heroine, vicariously experiencing the romance through the act of identification (Radway, 113). In this instance, Timm has presented Harley as utilizing this ability and indulging in the act of escapism, imagining herself and the Joker as the heroine and hero of the faux novel in question. The primary purpose of this image is to amuse, to mock Harley for both her unfailing adoration of the Joker and her stereotypically feminine and trivial reading pursuits. However, there is also a tragic element. In using the novel as a means of escape and fantasy, readers are reminded of the hopelessness of the character's situation: the character is canonically repeatedly rejected by the Joker, thus she is seeking emotional fulfillment via fantasy, and therefore this evokes our pity. Although this back cover image produced by Timm was ultimately unused, its inclusion within the deluxe reissued edition of *Mad Love* is certainly significant, suggesting that Dini and Timm's creation and subsequent portrayals of Harley and her relationship with the Joker were, in part, influenced by the Harlequin romance novel. Certainly, this image does imply a demonstrable connection between the Harlequin brand and the heroine, particularly when the comic's narrative and Dini's foreword are also taken into consideration.

Clear links between the Harley Quinn and Harlequin romance can also be seen through the comic's storyline. While there are instances in which Batman and Alfred's voices are present within the narrative, Dini uses Harley's voice throughout, tracing the course of her relationship with the Joker through her internal monologue and occasional dialogue. By only presenting Harley's voice and point of view, the reader is invited to identify with her and vicariously experience the character's tumultuous relationship. The comic's combined text-image state emphasizes this, the images providing the reader with a mirror and further encouraging them to imagine themselves as Harley and share in her experiences. This is further enabled when Harley's appearance over the course of the comic is considered. As noted by Ann Barr Snitow, the heroine of a Harlequin romance often has a limited or "bland" appearance (Barr Snitow, 195), rendering her a blank canvas for reader identification. Dini and Timm present Harley at the beginning of her relationship with the Joker as possessing an unassuming appearance; Timm depicts Harley clad in

a dull skirt and shirt with a lab coat, her hair pinned back and face free of any make-up. There is little to separate Harley from other Arkham staff, all of whom are depicted wearing similar clothing in a muted color palette. Dini also portrays Harley as sharing the Harlequin heroine's youth and inexperience, utilizing Harley's dialogue exchanges with other characters in order to highlight this. Dini frames Harley's interactions with the Joker and foreshadows the villain's actions with the warnings of Harley's superior, Joan Leland.

Dini presents Leland as openly stating that the inmates would "just as soon kill you as look at you," and later reiterating this when Harley remembers Leland's warning that the Joker "was an animal, plain and simple. A fiend who enjoyed twisting the minds of those stupid enough to trust him." By drawing attention to Harley's inexperience in this manner, Dini further enables the reader's identification with her while also planting the suggestion that the character's falling in love with a dangerous criminal is excusable. As an intern, Harley lacks the requisite experience to appropriately work with and counsel the Arkham inmates. This coupled with her ambition and youthful naiveté are what facilitate the Joker's seduction. Though this portrayal of Harley is humanizing, appealing to the reader's sense of sympathy and empathy, it also perpetuates the regressive gender politics critics associate with Harlequin romances discussed by Barr Snitow and Modleski in the 1990s. Certainly, more recent criticism of Harlequin romances and the wider romance genre has expanded upon their assertions, focusing upon the frequency with which writers present heroines as being of a low or medium status. In "Man Change Thyself: Hero versus Heroine in Harlequin Romance Novels" (Fisher & Cox, 2010), Fisher and Cox argue that the heroine's career prospects and ambitions are as ordinary and unthreatening as her appearance, particularly when compared to the hero, who is often portrayed as an older, more experienced and attractive figure at the top of his career path (Fisher & Cox, 311). By presenting heroines in this manner, writers suggest that a woman's greatest success is not found in her career, but in her ability to secure a partner. Dini's portrayal of Harley certainly perpetuates this, particularly when earlier panels present the character as cheating and manipulating her grades at university. The implication is that Harley cannot achieve wealth and success through hard work; she is only able to do so through more nefarious means. Although not necessarily a desirable hero, it is certainly undeniable that the Joker has been somewhat successful in his villainous career path; he may be imprisoned, but he is without question Batman's greatest foe and the most notorious criminal in Gotham. Harley is an intern who did not truly earn her intellectual recognition. Furthermore, though Dini presents Harley as possessing ambitions such as writing an exclusive book about Arkham, he also then presents the character as punished for these ambitions, falling in love with a psychotic criminal, losing her career, and becoming a

wanted criminal herself. Dini and Timm further reinforce this later within the comic through a splash page in which they portray Harley imagining a future of domesticity with the Joker.

Timm depicts Harley baking and struggling to control two rowdy children, miniature copies of Harley and the Joker, while the Joker relaxes with a newspaper. The image is an entertaining and chaotic vision of Harley's desires; desires which have dramatically changed from chasing individual fame and fortune to providing for the Joker and his children. Perhaps more worryingly, Dini portrays Harley as continuing to chase this dream throughout the rest of the narrative despite the Joker's cruelty towards her. If Harlequin romances encourage readers to aim no higher than a husband, Dini and Timm's Harley Quinn origin story actively dissuades readers from this, their portrayal of Harley's trajectory through the comic serving as a warning tale. However, this subversion of the Harlequin values also simultaneously reinforces them; Harley's ambitions are seen as the direct cause of her downfall. Thus, the implication is that in following their goals and desires, female readers will also set their own demise into action.

A further way in which Dini and Timm incorporate the dynamic and associated gender politics between the romantic hero and heroine is through their portrayal of Harley and the Joker's interactions, particularly during the characters' first meeting by subtly shifting the focus of the panels in these scenes. As Harley's infatuation with the Joker grows, her sense of self and control within the narrative begins to fade. The Joker's presence within these panels increases and many focus entirely upon his face and dialogue while Harley gradually disappears. Dini and Timm present this sequence of panels as Harley remembering her first meetings with the Joker. Her absence from the panels creates the sense that the readers are sharing the character's memory and thus reliving the events through her eyes.

However, the removal of the character's image and voice, combined with the keen focus upon the Joker's appearance and speech suggest a decline of Harley's sense of importance and the strength of her own identity within her own narrative and memories. Her interests and goals fade into the background, and instead, the Joker's face and voice dominate, creating a sense of hierarchy in which he is of greater importance to Harley than her own experiences or desires. This is further emphasized by the content of the Joker's dialogue; although Dini presents the villain as talking to Harley and briefly mentioning her in conversation, it is redirected and framed through the Joker's opinions and experiences. Thus, her name is of significance and interest *to him*, she may listen *to his* secrets, and so on. When Dini and Timm present the Joker playing at being Harley's psychiatrist, it is still the Joker's voice the audience hears. Moreover, it is his voice diagnosing Harley and informing both Harley and the reader how and why the heroine feels as she does. This

draws another parallel between the comic book and the Harlequin romance in which the heroine's sense of self and identity is sacrificed as the hero becomes the sole focus of both the heroine's attention and that of the narrative. Again, this reinforces the concept that a woman's greatest and only success can be her lover.

Secret Origins

By combining the tropes and conventions associated with the Harlequin romance with the comic book form, Dini and Timm successfully incorporate Harley Quinn into the DC universe and comic book canon while establishing a character and love story which continues to resonate with fans two decades later. The comic book's distorted mirror-like form certainly aids in readers' identification with the character; however, this also aids in the perpetuation and reinforcement of gender inequality also found within Harlequin romances, both at the time and those published today. In vicariously experiencing Harley's transformation and violent relationship with the Joker, readers are encouraged to internalize patriarchal values in which women are seen as the appendages of successful male characters. In spite of this, Dini and Timm's portrayal of Harley continues to inspire writers and artists, and in 2013, Amanda Conner and Jimmy Palmiotti gained creative control over the Harley Quinn character and the New 52 *Harley Quinn* comic (2013–). At the time of writing, Conner and Palmiotti's *Harley Quinn* is one of DC's most successful comics, regularly appearing at the top of bestseller lists. Though the comic and character share a number of similarities with Dini and Timm's original portrayal of Harley, Conner and Palmiotti have made a number of changes throughout their series, in particular, working to distance Harley from the Joker. Moreover, they have also retold Harley's origin story, adapting Dini and Timm's original tale. Although the story shares a number of similarities, Conner and Palmiotti make subtle changes to the narrative, which can be viewed as subverting *Mad Love* and the Harlequin conventions it parodies, but also empowering Harley in the process. This section will now examine Conner, Palmiotti and Roux's portrayal of Harley in *Secret Origins #4: Harley Quinn*, comparing their presentation of Harley with that of Dini and Timm, and the conventions associated with romantic heroines.

Conner and Palmiotti begin by first addressing the existence of multiple adaptations of the character's origins through Harley's opening dialogue to the comic, stating, "How did I become the wonderful person you see before you? A coupl'a ways, but the funny thing is, each time I tell the story, it's a bit different. That happens, y'know. As time goes on, the details change." By explicitly drawing the readers' attention to the frequency with which Harley's

background has been explored and expanded upon by other writers, Conner and Palmiotti are able to establish Harley as an unreliable narrator. This suggests that any inconsistencies or changes to her story have been made by the character herself, reinforcing the character's canonically accepted whimsical and unpredictable nature. Moreover, this does not entirely negate any previous writers' work with the character, instead allowing the reader the opportunity to seemingly accept and discount any details they see fit, in the same manner in which they present Harley as perhaps changing information herself whenever she "tell[s] the story." Furthermore, by introducing the story through Roux's opening splash page, in which Harley is depicted facing and directly addressing the reader and an unseen audience, Conner and Palmiotti are able to present Harley as an autonomous character in control of both her history and the extent to which details around it are revealed. This is a stark contrast to Dini and Timm's portrayal of character and background in *Mad Love*, in which they explicitly portray Harley's origins and transformation as part of a cautionary love story and parody of the Harlequin romance. Conner and Palmiotti establish *Secret Origins #4: Harley Quinn* as an entirely female narrative, providing the character with a voice and removing her from the shadows of the Joker, thus empowering her. By establishing Harley's voice as pivotal to the telling of the narrative, Conner and Palmiotti restore agency and ownership of the story to Harley. It is not a cautionary tale, nor is it concerned with only exploring the effects the Joker's influence has upon her. The comic is instead entirely focused upon exploring female experience through the authority of a female voice.

Conner and Palmiotti's wider focus on Harley's life before her meeting with the Joker also contrasts with the Harlequin romance convention of providing heroines with a limited backstory or history, if any. The opening panel of the comic and Harley's dialogue directly acknowledge an entire series of events which led to the character's transformation as opposed to simply meeting the Joker, and the panels which follow depict Harley at various points during her life, ranging from childhood to early adulthood and beginning her career as a psychiatrist. These panels focus entirely on Harley, and by including them, Conner and Palmiotti are able to further remove attention and emphasis from the Joker. Indeed, the Joker features in surprisingly few panels throughout the comic, contrasting with both the Harlequin romance convention of increasingly placing emphasis upon the hero and also Dini and Timm's original representation of the two characters. Similarly, though these panels only provide snapshots of the character's life, Conner and Palmiotti provide a great amount of detail through the use of Harley's internal monologue in order to narrate the events, providing readers with information which was not disclosed by previous writers in their versions of Harley's origins. Harley is presented as reminiscing about her "standard childhood" in

which "my brothers did their thing as Mom fussed and Dad finagled." The presence of these details within Harley's narrative provides a further contrast with the Harlequin romance heroine, both generally expanding upon Harley's background, but also providing her with the family and emotional ties which are otherwise absent from the life of the Harlequin romance heroine, as noted by critics such as Barr Snitow (Barr Snitow, 196) and Fisher and Cox (Fisher and Cox, 311). This grounds Harley, adding further normalizing elements to character and narrative to which readers may then relate.

Conner and Palmiotti are also quick to establish Harley as a highly intelligent and successful individual early within *Secret Origins #4: Harley Quinn*. Roux's panels depicting Harley's childhood emphasize her youth and her advanced intelligence, juxtaposing images of the character with her hair split into bunches and sucking on lollipops while she reads advanced criminology textbooks, such as *Studying the Criminal Mind*. This is then further emphasized by the presence of the character's younger siblings in the backgrounds of the panels, presented by Roux as chasing one another and behaving in a more stereotypically childish fashion, reinforcing Harley's difference while also presenting her as possessing abilities well beyond her age. Conner and Palmiotti later reinforce this when discussing the character's studies and early career, presenting Harley as ambitious and focused upon her work. They write that Harley "received a bunch a' scholarships …and dived head first into my work. I graduated at the top of my class and quickly found work at a prominent hospital." This information is delivered through Harley's internal monologue, in panels in which Roux presents the character at work as a psychiatrist, dressed in conservative clothing while interacting with her patients. This portrayal contrasts with that of Dini and Timm, both further suggesting and reinforcing earlier scenes in which Conner, Palmiotti, and Roux present Harley as extremely intelligent and hard-working as well as keen to do her job to the best of her abilities. Indeed, in one panel, readers see her addressing a patient, stating that, "I can't help you if you don't speak to me." Conner and Palmiotti also continue to draw attention to Harley's personal and career ambitions through her internal monologue. Harley's patients are viewed by others as "broken an' unfixable," and thus Harley is presented as viewing this as "a big, fat challenge" and keen to return to the subject of her university thesis: studying the criminal mind. In the panels that follow, Harley is seated at a desk covered in open patients' files and making notes. The idea that Harley sees the patients as a "challenge" and her preoccupation with studying "the criminal mind" could negate any views that the character is engaging in her chosen career due to a desire to care for others, suggesting that she instead works from a desire of intellectual stimulation. This preoccupation with studying the patients in order to satisfy her own curiosity again highlights the character's aspirations and further contrasts with the Harlequin heroine,

whose only goals are connected to falling in love and subsequently securing the hero's affections.

This also contrasts to Dini and Timm's portrayal of Harley in *Mad Love*, in which they present her as simply using her femininity to seduce others into giving her good grades and positions of power. Conner, Palmiotti and Roux's portrayal of Harley's childhood and early career is an empowering one, frequently emphasizing that the character achieved her goals through the determined application of her intelligence, as opposed to manipulating a series of regressive patriarchal stereotypes.

Another important distinction to make is that where Dini and Timm present the Joker and his seduction of Harley as responsible for the character's transformation, Conner and Palmiotti do not. In the panels depicting Harley's plot and eventual infiltration of the Arkham Asylum's patient population, she is not having any form of interaction with the Joker or prior knowledge as to his presence as a patient. Her physical transformation begins before meeting him and is motivated by a desire to fit in with the prisoners rather than wanting to sexually appeal to the villain. By removing any suggestion of the characters having any direct contact, Conner and Palmiotti are able to present Harley with a greater level of individual autonomy than Dini and Timm in *Mad Love*. Readers see Harley in Roux's panels and learn through Conner and Palmiotti's use of Harley's internal monologue that Harley forms her plans alone. The character's decisions are entirely her own and are not tainted by the influence of, or the character's attraction to, the Joker. Nor are they motivated by a desire to prove her love for him; it is not until after Harley has dyed her hair and entered the Arkham populace that Conner, Palmiotti, and Roux finally introduce the Joker to the comic's panels. Where Dini and Timm afforded countless panels and pages to the Joker's seduction of Harley, here the Joker only features in three and only ever utters two words. Harley's voice dominates the events throughout, the narrative focusing upon her thoughts and feelings, again contrasting with Dini and Timm's portrayal of the Joker's seduction. Conner and Palmiotti provide Harley with a degree of control and agency when recounting the scenes depicted, but their use of language to describe the Joker's influence reveals an imbalance of power between the two characters. They present Harley as viewing the Joker as "calculating an' insightful … brilliant an' dangerous an' unpredictable" and "this man had a power over me. The way he spoke ta me, as if he knew me my whole life…. Just the kinda guy my mother warned me about…. I gave myself up ta him"; her praise of the villain simultaneously highlights his unsuitability as a romantic partner. Similarly, when Harley's descriptions of the Joker are considered alongside Roux's portrayal of the Joker, readers further see a parallel between the characters and the inequality between a Harlequin hero and heroine. While Conner and Palmiotti's descriptions of the Joker suggest that

he is certainly more experienced and worldly than Harley, Roux reinforces this by depicting the Joker as having extremely sharp and lined features, creating the impression that he is significantly older and able to manipulate the young, ambitious Harley. Certainly, it could be suggested that the villain manipulates Harley into abandoning her career and becoming his sidekick, perpetuating the concept of a heroine transforming and sacrificing herself in order to successfully "achieve" a partner. However, Conner and Palmiotti instead subvert this trope through their continuation of Harley's internal monologue. While Dini and Timm's portrayal of Harley presents the character as vulnerable, feminine, and submissive, Conner and Palmiotti restore further autonomy to Harley, presenting her as identifying that by modifying her behavior, she is able to manipulate the Joker's behavior towards her. She is presented as aware that she has the ability to become "Someone who could be anything they wanted. The sex kitten, the seductress, the innocent, the aggressor, the antagonist, the victim, the ditz…. He really loved the ditz, so I played along" (Conner, Palmiotti & Roux). The use of the phrase "I played along" alters the balance of power between the characters, suggesting that although it may seem that the Joker is more experienced and powerful, it is merely because Harley has allowed it and is instead perhaps humoring him. This interpretation is supported by Kate Roddy, who suggests in "Masochist or machiavel? Reading Harley Quinn in canon and fanon" (Roddy, 2011) that early comic book portrayals of Harley Quinn can be read as part of a BDSM narrative in which the character is presented by writers as enjoying behaving in a submissive manner towards the Joker. The idea that Harley is simply "playing along" with the Joker's desires and behavior can be viewed as further evidence of this. Rather than sacrificing herself in order to appeal to male sexual desires, Harley is empowered, presented as taking control of her sexuality and using it in order to manipulate the Joker and fulfill her own desires.

Both *Mad Love* and *Secret Origins: Harley Quinn* end with the Joker's rejection of Harley. However, where Dini and Timm present the possibility of the character's reconciliation, Conner and Palmiotti present Harley as freed and empowered by the situation, suddenly aware and taking advantage of the fact that she "could choose fer myself who I wanted ta be…. I worried less about my soul mate and found myself in the process." Harley may have lost both her career and lover, but Conner and Palmiotti present the character as all the more successful and happy as a result; her journey is one of self-discovery and acceptance. Rather than undergoing the self-sacrifice faced by romantic heroines in order to eventually prove their love to the hero, Harley is portrayed as both rejected by and rejecting the romantic quest society offers, and the comic ends on an uplifting tone. Harley is free to act as she chooses, her identity her own and a world of possibility before her. While readers could certainly identify with the version of Harley created by Dini

and Timm, Conner and Palmiotti's Harley is a more progressive heroine, and their presentation of the character reflects a change in society and comic book culture as feminism increasingly calls for equality and the improved representation of women. Certainly, in vicariously sharing in Harley's experiences, female readers may be liberated from patriarchal stereotypes, finding self-acceptance and greater agency over their careers and sexuality.

Conclusion

At time of writing, there has been little study into Conner and Palmiotti's work, and a greater examination of their *Harley Quinn* series would certainly prove fruitful. Conner and Palmiotti have continued to develop Harley's character throughout their work, subverting the values and conventions of Harlequin romances in the process. More recent issues have focused upon Harley's sexuality and agency, establishing the character's sexual relationship with Poison Ivy as canonically accepted, as well as presenting her as rejecting heteronormative fantasies of marriage and children in the 2015 *Harley Quinn: Valentine's Day Special #1*. Other themes have also been explored within the issues, including more positive and diverse representation of female characters, creating greater distance between their work and other writers' interpretations of Harley while also providing a more relevant reflection of changing attitudes in current society. Dini and Timm were inspired by Harlequin romances and used Harley in order to parody and reflect the patriarchal society the novels presented at the time. Nearly two decades later, Conner and Palmiotti's Harley has been utterly transformed, providing readers with a subversive and empowering heroine.

WORKS CITED

Barr Snitow, Ann. "Mass Market Romance: Pornography for Women Is Different." *Radical History Review* 20 (1979): 141–161.

Conner, Amanda, and Jimmy Palmiotti (w). Chad Hardin (p) (i). "Hot in the City." *Harley Quinn*. v2. #1. (2014), Warner Brothers. DC Comics.

_____. Stéphane Roux (a). "Secret Origins." *Harley Quinn: Power Outage*. v2. (2015), Warner Brothers: DC Comics.

Dini, Paul, and Bruce Timm (w). Bruce Timm (p) (i). "Mad Love: The Deluxe Edition." *The Batman Adventures*. (2015), Warner Brothers. DC Comics.

Eagleton, Mary, editor. *Feminist Literary Theory: A Reader*. 2nd ed., Blackwell, 1996.

Fisher, Mary, and Anthony Cox. "Man Change Thyself: Hero Versus Heroine in Harlequin Romance Novels." *Journal of Social, Evolutionary and Cultural Psychology* 4.4 (2010): 305–316.

Harlequin Romance. *Harlequin Romance*. Retrieved October 25, 2015, from www.harlequin.com.

Harzewksi, Stephanie. *Chick Lit and Postfeminism*. University of Virginia Press, 2010.

Modleski, Tania. *Loving with a Vengeance: Mass-Produced Fantasies for Women*. 2nd ed., Routledge, 2008.

Radway, Janice. *Reading the Romance: Women, Patriarchy, and Popular Literature.* University of North Carolina Press, 1984.

Roddy, Kate. "Masochist or Machiavel? Reading Harley Quinn in Canon and Fanon." *Transformative Works and Cultures* 8 (2011).

She Laughs by Night
Mad Love, the New 52 and Noir

GREGORY BRAY

In her article, "The Exact Moment 'Suicide Squad' Fails Harley Quinn Is in the New Trailer," Donna Dickens bemoans Harley Quinn's contemporary treatment in DC Comics' New 52, and in the *Suicide Squad* film (Dickens). The basis of her critique stems from Harley's change of attitude, attire, and origin from her earlier appearances in the animated series and comics. Dickens makes note of Andrew Riesman's article, "The Hidden Story of Harley Quinn and How She Became the Superhero World's Most Successful Woman," which gives a critical overview of Harley Quinn that also, at times, evaluates Quinn's overall appearance in the *Arkham* games and *Suicide Squad* comics. *Ask Chris's* Chris Simms further asserts that New52 Harley Quinn has not only turned into a "manic pixie dream girl" fantasy but has also transformed into a villainess without redemption. "If Harley's aiding and abetting the Joker because she's obsessively in love with him, then she's a tragic and sympathetic figure. If she's deciding on her own to commit acts of mass murder and terrorism, that's a fundamental change that removes that sympathy" (Simms *The Trouble*).

Though some critics and columnists have found Quinn's evolution problematic, her transformation from the obsessed henchwoman, to standing on her own as a dangerous villainess is not without precedent. The development of Harley Quinn from her early beginnings in the animated series through her contemporary treatment in *Suicide Squad* mirrors a cinematic character type trajectory—the femme fatale.

Femme fatale has become an umbrella category for strong female characters, usually villainesses, in post–World War II crime dramas through recent films that pay homage to the noir tradition (neo-noir). Rather than a gun moll or hench-woman, such as Marie (Ida Lupino) in *High Sierra* (Walsh)

the fatale relies on her individual strength and resilience. In her article *Women in Film Noir,* Janey Place locates three female archetypes in the cinematic convention, but focuses almost exclusively on two: the spider woman and the nurturing woman (Place). A fourth unexplored category in her work is the spirited thrill-seeking fatale, who wreaks havoc on her surroundings. This type is generally part of a pairing such as Bart and Annie in *Gun Crazy* (1950), and later Mickey and Mallory in *Natural Born Killers* (1994). Nearly all iterations of Harley Quinn fit within this tradition.

This essay addresses Harley Quinn's developing physiognomies, and demonstrates how she maintains her agency, by rooting her character and her world of story as a thrill-seeking fatale. It begins with a brief overview of Gotham as a noir city, and then establishes how character types are cultivated from this landscape. From there, it situates Harley Quinn in the femme fatale paradigm through *Mad Love* (Dini and Timm), and later in the New 52, while connecting the shifts in her character with contemporary neo-noir films.

The Naked Gotham City

Considerable material has been written on film noir, from scholars and critics deliberating its definition (Borde and Chaumenton), to its subcategories (Schrader), to long-term historical study (Muller), to character studies (Place) as well as women and gender studies (Johnston). Other scholars and popular culture historians have examined the connections between *film noir* and detective fiction, as well as popular comics (Vaz; Coogan).

As a cinematic style, but not quite a genre, film noir peaked during the cultural uncertainty of post–World War II. Customarily implied masculinity collided with the actuality of men exhibiting posttraumatic stress disorder or returning home with varying levels of damage. These injuries (psychological, physical) generated a feeling that men were returning home impotent—underlined by the image of Walter Neff on crutches during the opening of Billy Wilder's *Double Indemnity* (Johnston). Men of that era could not properly address their wounds, and women found a historically unusual level of cultural agency through the workforce. The post-war era saw the same women return to the home, while the men, now impaired, attempted to reclaim their place as father and provider. This level of uncertainty manifested in stories where, as Roger Ebert has suggested, "there are no more heroes," only a great deal of paranoia and fear in a dystopian setting (Ebert *Batman Returns*). In other words, film noir reflected the American psyche at that time.

In *Tales of the Dark Knight: The First 50 Years*, Mark Cotta Vas writes,

"The Batman mythos has been steeped in (*noir*) traditions from the very beginning" (46). The comics from the late 1930s through 40s, and then in the 1970s through current issues give the reader a world with danger around every corner—showcasing rich, dark aesthetic tones, paranoid characters, and a code that will ensure the protagonist will never find happiness. As Vaz states, "this *noir* menace is the glue that holds the whole of the Batman oeuvre together" (46).

When Batman first hit the newsstands in 1939, the hard-boiled writings of James M. Cain, Dashiell Hammett, and Raymond Chandler had penetrated the American reader's consciousness through popular books, novellas, and in fiction magazines. Detectives such as Sam Spade, Phillip Marlowe, and Mike Hammer began their vicarious fight *against* the metropolis. As a character of place, the city was a cesspool of hyperbolic and metaphorical characters, where *good* people were devoured or destroyed. Tim Burton's *Batman* (1989), which borrows heavily from the earlier comics including *The Case of the Chemical Syndicate* (1939), is a *noir* superhero film (Finger & Kane).[1] Early in *Batman,* mob enforcer Jack Napier tells Alicia, "Decent people shouldn't live here. They'd be happier someplace else." In later cinematic returns to the streets of Gotham, such as *Batman Returns,* and Chris Nolan's *The Dark Knight Trilogy,* the city, itself, "turns eagle scouts into crazed clowns, and happy homemakers into Catwomen" (Burton *Batman Returns*). Gotham City birthed hyperbolic archetypes, such as Edward Nygma (Riddler) and Victor Fries (Mr. Freeze). *Batman: The Animated Series* continued the deco noir style witnessed in Burton's films on the small screen. Harley Quinn is the very yield of this noir city.

Kiss Me Puddin'

Harley Quinn is not the first woman to be dazzled by Joker's smile in a noir setting. In Burton's *Batman,* Alicia, played by Jerry Hall, is a *moll* for kingpin Boss Carl Grissom. When the Joker bumps off Carl, Alicia joins Joker's side but gets abused and disfigured. "Now like me, she is a living work of art," Joker tells a terrified Vicki Vale, as Alicia removes her harlequin mask to reveal her acid-scarred face. When the Joker later divulges, "Alicia threw herself out the window," there is a more than a subtle hint that the Joker has murdered her—or at the very least, drove her to destruction. Joker then laughs and smashes Alicia's damaged harlequin mask with his fist (Burton *Batman*).

Despite the harlequin motif, what differentiates Harley Quinn from Alicia is her impetus for being near the Joker—it is Harley's unfathomable ardent adoration, and for the thrill that the Joker promises in the mean streets of Gotham City. The Joker also manipulates Quinn's sympathies. These moti-

vations directly connect Harley Quinn to the thrill-seeking fatale in noir cinema.

Joker Crazy

Conspicuously garbed in her costume, the femme fatale waits in the getaway car while her lover, off-screen, holds up a bank. She witnesses a beat cop walk around the corner, clearly oblivious to the criminal activity beside him, and she springs into action. She hops out of the car, and he straightaway eyes her outfit—an unusual garb designed for a carnival act. "Nice get up," he tells her. "I like it," she says, attempting to avoid eye contact. "Good lookin' gun, too," he adds, removing the weapon from her hip holster. For a moment she looks dazed but attempts to regain composure. "Thanks," is all she can manager. The cop indicates the gun—a shiny six-shooter. "It's English ain't it?" "That's right," she says as he holsters it for her. A moment later, she tells the police officer that his is nice too, and she reaches for it—he holds back, and gently reminds her that she is not allowed to touch his weapon. He killed someone with it last year. This information gives her pause. An alarm goes off. A man, who is clad in the same themed costume as his lady, runs out of the bank. She knocks out the cop, and the carnival-clad couple makes a daring escape, screeching away from the bank.

Though this scene could easily describe a caper pulled off by Harley Quinn and her Mr. J., this moment is from the 1950 noir thriller *Gun Crazy*. Directed by Joseph Lewis, *Gun Crazy* tells the story of an ill-fated obsession between Annie Laurie Starr (Peggy Cummings) and Bart Tate (John Dall) as they tear off on a series of Bonnie and Clyde–inspired heists. They meet at a carnival sideshow, where Bart instantly falls under her spell. She is an expert markswoman, clad in dangerously tight black pants, flashing a daring gleam in her eye. A marksman himself, he sees shades of his own forte in her, and as he is revealed to be "dumb about women," falls for her—passionately, desperately, obsessively. In this example Harley can be likened to Annie at times and Bart at other times, as the more dominant obsession is reversed. In *Gun Crazy*, Bart fascinates over Annie, though it is not clear if she could possibly love anyone or anything outside of her own thrill of wrongdoing.

There is an evident association between the film *Gun Crazy* and the story *Mad Love* (Dini Timm), which reveals Harley Quinn's origin. For both pairings (Bart and Annie, the Joker and Harley), any semblance of a "normal" relationship is impossible. Marriage is impossible. Their desires cannot be enacted in public with "all the social niceties, so the coupling only has one path—destruction (Harvey 31). It is "niceties" that Harley craves. In Sylvia Harvey's essay *Women's Place: The Absent Family in Film Noir,* she argues,

"that it is ... (the) representation of the institution of the family, which in so many films serves as the mechanism whereby desire is fulfilled ... that in the film noir front serves as the vehicle for the expression of frustration" (22).

While Harvey argues that this desire is deeply entrenched in the "value generating nexus of the family," (22) in the case of Harley Quinn, the fantasy is askew. In *Mad Love,* Harley reveals her idealized life. At one point in the comic book, we see a thought balloon drifting from a dejected Harley Quinn (Dini and Timm).

Wearing harlequin makeup, her trademark jester hat and little else aside from an intimate slip, Harley endeavors a little romance with her puddin'. "Rev up your Harley," she encourages him; he rejects her then tosses her from his room, so he may focus on a scheme to destroy Batman. Harley sits with her two hyenas, as they behave like doting lap dogs, and then, in her imaginary panel, pictures a traditional life with the Joker. At first glance it reads as a hyper-realized heteronormative family, with the Joker holding a father-knows-best pipe, wearing black-rimmed reading glasses, and Harley as subservient mother and homemaker, pulling a cookie sheet from a hot oven, in an overtly patriarchal household. Two children (one boy and one girl) complete the nuclear family. The text and *mise en scène*, however, gives away Harley's expectations—the two children bear striking resemblance to their parents, right down to character costumes and parch white faces. Little Joker Boy is attempting to poison Little Harley Girl using a squirting lapel flower. There are knives, sticks of dynamite, and a handsaw on the floor. Sister is holding an axe. Batman's head is mountain on the wall, as a hunter's trophy. A toy Batmobile burns, Barbie is beheaded, and a stuffed animal lay in ruins.

This family life is not possible while the Joker's fixation resides elsewhere—on Batman. As established throughout the annals of the DCU, the Joker's *raison d'être* is having the last laugh on The Dark Knight, and very little else. Most variations of the Joker stories include language that locates this fixation front and center. As the Joker's focus is on Batman, and only Batman, Harley, it seems, is left aside. Harley comes to the conclusion that she must get rid of Batman, and the Joker will be hers. This is a violent conclusion, and will also be the first time in her character's history that Harley truly strikes out on her own, while partnered with the Joker.

A number of noir films speak to action undertaken in the name of passion—however misguided or malignant. For the femme fatale, the affection may either be requited and yet not enough, as witnessed in *Leave Her to Heaven* (20th Century Fox 1945); or unrequited as in *Raw Deal* (1948 Eagle-Lion). In the former, Ellen Berent (Gene Tierney) pulls Richard Harland (Cornel Wilde) into her web. Richard resembles Ellen's long deceased father—she lost him in a tragic event she has not put behind her. Richard takes Ellen to his getaway in Maine. There, she fires the groundskeeper (to have Richard

all to herself) and in, arguably, the "most notorious—and memorable—scene" in the film, drowns Richard's crippled brother (Muller 91). Later, when she learns she is pregnant, she stages an accident to lose her unborn child. She will share Richard with no one. Though she has won Richard's affections, it is not enough and it will never be enough. Every element around Richard is an obstacle, one that Ellen feels compelled to violently resolve, just as Harley desires to get rid of Batman. The issue for both Ellen and Harley is that the obstacles are not for either of them to resolve—in Ellen's case, the obstacles are imaginary; in Harley's case, the obstacle (Batman) is the Joker's conundrum to resolve.

In the comic *Mad Love*, Harley channels Ellen Berent when she kidnaps Batman, with an aim to end him once and for all (Dini and Timm). With the caped crusader done in, her dream of a *normal* life can finally come to fruition. She even employs a scheme the Joker had designed but then rejected. The trap was simple—lower Batman into a tank of piranhas as a late night meal. The Clown Prince of Crime dropped this idea as piranhas' mouths are shaped in a permanent frown. Harley reasons if Batman is lowered in upside down, Batman will experience death by smiling fish.

Harley ensnares an unsuspecting Dark Knight, ties him up, and dangles him upside down over the large fish tank. When Batman wakes, all he can do is laugh at Harley's predicament. He tells her the Joker never has, and never will, love her. Batman reveals to Harley that the Joker's intimate stories he has shared with her have all been fabricated. The deceptive backstory is in keeping with the Joker in comics from stories outside of *The Batman Adventures* such as *The Killing Joke*, where he admits his backstory tends to be "multiple choice" (Moore and Bolland). This motif is also brought to the silver screen, as the Joker taunts his would be victims "Do you want to know how I got these scars?" before sharing a presumably fabricated story about his background (Nolan 2008).

The Joker has lied to and manipulated Harley Quinn into aiding him with deceptive stories about his unfortunate upbringing, designed, in part, to mirror Harley's own difficult childhood. Harley, pushing away tears, cries out "You're *Wrong!* My puddin' DOES love me! He DOES!" (Dini and Timm). She calls the Joker to her at once to witness Batman's end, and to set the Joker straight. When he arrives, she explains to the Joker that his plan to end Batman works, if Batman is suspended upside down. The Joker grows furious that she would intervene, crying out "If you have to explain a joke, there is no joke!" It seems clear, in this moment, that Batman was correct and that the Joker will never appreciate Harley. This rejection, despite her sincere yet imprudent gestures, suggests another woman in noir, Pat Cameron in *Raw Deal*.

Harley's Raw Deal

In the beginning of Anthony Mann's *Raw Deal* (1948), Pat Cameron (Clair Trevor) springs her lover, gangland hit man Joe Sullivan (Dennis O'Keefe) out of the slammer. Joe then pursues big boss Rick (Raymond Burr), who set Joe up in order to save his own skin. While Pat works to convince Joe to give up on his mission, a rival for his affections steps into the frame—good girl Ann Martin (Marsha Hunt).

Raw Deal (1948) showcases characteristics that directly influence *Mad Love*. The first is the aesthetic influence—visionary cinematographer Jon Alton fearlessly employed negative space to a heightened degree. He photographed the film with stark contrasts and minimal light. Indeed, there is very little "gray space" in his films—they are truly black and white. In *Mad Love*, and much of the animated series and *The Batman Adventures* comics, Bruce Timm (along with assistants Glen Murakami and colorist Rick Taylor) give the sense of single light sources in the Joker's lair, and little light outside of what is needed to illuminate the characters and key objects from page to page. As Sylvia Harvey indicates, "it is at the additional and perhaps more important level *of mise en scene* … that the physical environment of the lovers … is presented as threatening, disturbing, fragmented" (25).

There is an elegant minimalism present in the artwork, equally present in Alton's composition. A second influence is the use of the voiceover. While voiceovers (i.e., the inner thoughts of a character spoken in the *voice of God* convention) were not new to detective and noir thrillers, *Raw Deal* is an early example of a female protagonist's thoughts as the vehicle. She pines for Joe, just as Harley (first in unspoken blocks of text on the page, and later voiced over in the animated adaptation) reconciles with her past through a non-diegetic interior monologue.

The unfamiliar use of the female voiceover caused some to misinterpret the movie. In his book *The Crime Films of Anthony Mann*, Max Alverez notes, "Edward Small and the Eagle-Lion publicists were convinced that the film … was not only a love story but, to quote the press book, "a WOMAN'S PICTURE." Pat Cameron is the storyteller, her softly spoken words of desperation … ideally suited to such brawny melodrama"(119).

When *Raw Deal* begins, her solemn voice over commences. "This is the day. This is the day, the last time I have to drive up to these gates. These iron bars that keep the man I love locked away from me. Tonight he breaks out of these walls. It's all set," as her car approaches the prison (1948). In the animated series adaptation, Harley's voiceover appears as she breaks a bruised and battered Joker out of Arkham, and they speed away in her sedan. "It seemed like we would live happily ever after" (1999).

Just as Pam breaks Joe out of prison when the film begins, Harley Quinn

frees the Joker from Arkham Asylum at the beginning of their adventures. These efforts do not pay off for either Pat or Harley. At the close of *Raw Deal*, Pat watches Joe, a man who has never, nor will ever, return Pat's affections expire on the sidewalk, cradled by another woman. Pat will assuredly go to jail for helping Joe escape from prison. At the end of *Gun Crazy*, Annie and Bart are trapped, ensnared in rolling fog as the authorities approach. Both wind up shot to death. At the conclusion of *Leave Her to Heaven*, Ellen drinks poison to frame Richard, who faces prison toward the film's end. As *Mad Love* comes to a close, Joker throws Harley Quinn through a nearby window—a fate remarkably similar to Alicia's in Burton's film. She falls a few stories. It is unclear if the Joker calculated her survival one way or another. Harley interrupted the Joker's game with Batman, and for that, she had to pay. He frees Batman, apologizes for the inconvenience, they do battle, and Joker faces yet another trouncing.

There is no happy ending for Harley and the Joker in this story. As Harvey states, "in film noir it is not only at the level and narrative resolution that lovers are not permitted to live happily ever after." Chris Simms also asserts, "it's not just that the Joker doesn't love Harley back, it's that he doesn't even see her as anything that could possibly be desired…. And to make things worse, it's not just that he doesn't return her love, it's that he *uses it*" (Simms 2013).

At the close of the *Mad Love* comic, a heavily bruised and bandaged Harley Quinn recovers in her cell at Arkham, cradling an arm in a sling, wearing a neck brace. An Arkham doctor, outside of her cell, asks, "How did it feel to be so dependent on a man that you give up everything for him and gain nothing in return?' With a somber expression, Harley turns her head and says "it felt like…" and then it catches her eye—a single get-well rose signed "Feel Better Soon. J." She finishes her sentence with a radiant look of hope renewed.

Though her relationship, however defined, with the Joker costs Harley Quinn her career, her position in society, and causes her severe mental and emotional injury, she remains optimistic that the Joker will come around. For the thrill-seeking femme fatale, the pursuit serves as a metaphor—Harley's reward was the possibility of a *normal* life with the Joker, while the risk was living outside of the law. Lost in Harley's subjugation is her sense of self. What would it take for Harley Quinn to walk away from the Joker?

Harley's Conflict

The New 52 comics, while channeling the tradition of the noir Gotham City, are in closer alignment with neo-noir. In his book *Neo-noir: The New*

Film Noir Style from Psycho to Collateral, Ronald Schwartz defines this subset as new noir, with an aesthetic that is "harsh and reflective of forty years of the Cold War, nuclear unrest, fiscal uncertainties, and the sexual revolution. (xi)." Neo-noir utilizes the stylistic conventions of its predecessor, but further dislocates previously established archetypes into both a feminist and postmodern framework. The New 52 Harley Quinn is rendered in the neo-noir fatale tradition. She is independent, combats against those who have victimized her, and exhibits a mischievous sexual fluidity not unpacked in her previous appearances.

A distinct difference between this version of Harley and the previously established character in the animated series is her origin. Elements of it are intact—she is a psychiatrist from Arkham Asylum, the Joker was a patient—however, in this version the Joker's physical abuse toward Harley starts from the very beginning. He *creates* Harley by dropping her into a similar chemical that resulted in his appearance, and the story indirectly suggests, his lunacy (Glass, Henry, and Barrows 2012).

This, in part, accounts for Simms's and Dickens's concerns. Dickens asserts, "Harley's transformative origin was unveiled, explaining her bleached white skin and two-tone hair. It was a severe departure from her first origin, and a far inferior one due to one factor: it removed Harley's agency. In other words, it took her choices out of her hands and put them in the Joker's" (2015). Dickens suggests that Harley both in the recent comics and in the film *Suicide Squad* is one who has been emptied of her previously established context, is no longer her own character, but the Joker's byproduct. This critique is a fairly large misunderstanding, as there are many iterations of the wronged-woman in noir cinema. As Jamaluddin Aziz notes, "in classic noir films like *Beyond a Reasonable Doubt, Sleep, My Love,* and *Conflict,* the wronged women are the victims of the men they love" (128).

In *Projecting Trauma: The Femme Fatale in Weimar and Hollywood Film Noir,* Barbara Hales asserts that writers and directors "projected their anxieties onto the character of the femme fatale" (225). Hanna Loo, in considering neo-noir fatales pushes back against this assertion, "it is in this way that contemporary neo-noir femmes fatales may be seen as subversions or even rebels of the definitions that confined their predecessors" (66). She continues that as they are "no longer bound by the same historical context" these characters can demonstrate greater fluidity in their "identities in neo-noir films." She then establishes a neo-noir fatale can "both rebel and be victim to the confinements of the original femmes fatales" (Loo 66). While Harley's transformed origin establishes Harley as the Joker's victim, and in the same gesture provides a path for regaining her agency when she finally delivers the Joker his comeuppance.

Act of Violence

The Joker lay on the floor of his cell. He is bleeding from his mouth; his face swollen shut and purpled. Harley Quinn kneels on his body with her arm pulled back, her hand curled into a fist. She tells him, "I'm not yer toy anymore, Unnerstand? You DID mean somethin' to me *one time*, but *that* time is *over*.... Now, do yerself a FAVOR and fer ONCE in yer miserable life say NUTHIN'. No Chattin. No Chortlin'. Just lie there and BLEED" (Conner and Palmiotti, Hardin 2016).

In Harley's earlier adventures, Poison Ivy, or at times Batman, steps in when Harley's in danger—Batman rescues her during the animated episode *World's Finest* (Dini, Timm *Finest*). In the New 52, Harley asserts herself. Unlike the majority of noir thrillers of yesteryear, in neo-noir thrillers the femme fatale is able to take matters into her own hands and succeed. Aziz goes further in her examination, stating, "This means, on one hand, an underlying ideological motive of the noir genre is to negate female subjectivity or agency ... the neo-noir genre, on the other hand, uses the strategy of appropriation to the foreground a wronged woman's subjectivity, allowing her to take revenge for herself" (Aziz 129).

In films ranging from *Blue Steel* to *Bound*, the neo-noir woman can seek out her own "vindication" (129). While the Joker and Harley have had their battles over the years, pre and post–New 52, there is a sense of finality in this last exchange. Harley as a neo-noir fatale is further exemplified by Harley's sexuality.

Leave Her to Ivy

The femme fatale, Violet (Jennifer Tilly), lay on the bed, spent. The lighting is suggestive—it's dark, there are deep shadows, as she pulls herself, slightly, up to address her lover. Her lover, Corky (Gina Gershon) stands with a button shirt partially open. She is wearing little else. She grabs a beer from a mini-refrigerator, and kicks the door closed. Violet smiles as Corky sits beside her and says, "I needed that." The lovers are entwined in a neo-noir world. In the film, *Bound* (1996), Violet plans to take a great deal of money from Cesar, a money launderer for the Mob, who is also dating and abusing her. Violet wants out of this violent lifestyle and calls in their plumber, a beautiful woman named Corky, to aid her. She seduces Corky, and they enact their plan. There are several lesbian sex scenes in the film, scenes that would not have made it past the censors post–World War II.

In previous noir films, lesbianism (which is about as close to bisexuality or fluidity in sexuality as those films approached) was represented by tough-talking masculine women—devoid of any feminine traits, and, furthermore,

de-sexualized. In Orson Welles' *Touch of Evil*, Mercedes McCambridge plays a bike gang leader, who, along with her cohort, restrain and abuse Susie Vargas (Janet Leigh). In *The Matter of Images: Essays on Representation*, Richard Dy puts forth that in postwar films, lesbians "have been negative sexual categories, at best viewed pathologically, at worst as moral degeneracy" (21). Though not explicitly stated, the iconography of the de-sexed female serving in a masculine role was in keeping with societal impressions of female homosexuality. The image of lesbianism and female bisexuality is far more investigated in contemporary neo-noir thrillers such as *Mulholland Drive* (2001), *Basic Instinct* (1992), and *Bound*.

Though there are hints that Poison Ivy and Harley Quinn may have been intimate during *Batman: The Animated Series* as well as various comics, it is not confirmed until the New 52. During the second issue of *Harley Quinn*, Harley, excited by the prospect of sharing an apartment with Poison Ivy, asks "But first do you want to meet my beaver?" (Conner and Palmiotti 2014). Ivy's excitement leaps off the page, though it turns out to be nothing more than a well-executed pun.

In a later comic, evoking a scene from the *Bound*, Harley changes her clothing in their bedroom while Ivy sits on the bed. Nude from the waist up, Harley embraces Ivy. Harley is free from the Joker and is looking to move on. Ivy tells her, "I just don't trust anyone else." Harley retorts, "Y'Mean You Love me? Awww.... I got Goosebumps! Wanna feel 'em?" Ivy playfully kicks Harley's rear end, "We both know where *that* leads and you don't have *time* for that" (Conner and Palmiotti 2016). Though the reader can certainly absorb the subtext, DC comics later confirmed their pairing. Donna Dickens references a series of DC Comics' posts on Twitter, "In a series of tweets, Harley officially became bisexual, perhaps even pansexual" (Dickens 2016).

However Harley Quinn came to be in the New 52, she is a fully realized character—in control of her own sexuality, her own choices, and her own agency. Neo-noir presents femme fatales as fully dimensioned characters beyond the dangerous sexuality presented on screen. This Harley Quinn is not a mask—she is not an object the Joker can smash on Vicki Vale's mantel piece while chuckling over her demise. This Harley Quinn will not be thrown through a window, only to survive and still consider the Joker above all else. This Harley Quinn is more than a moll, a byproduct, or a gimmick. She is a smart, capable, dangerous, sexy woman who stands on her own.

The Third Harley

Harley Quinn saunters down the street, in glittering boy shorts, hair tied in tails, holding a baseball bat. Her shirt posits *Daddy's Little Monster*,

in saccharine pink lettering. Smacking her gum loudly, miming shotgun blasts with her baseball bat, she is alluring and undeniably confident. *This* Harley Quinn is from the *Suicide Squad* film (2016) and clearly is adapted from the more recent comics. She has transitioned in the stories from the wronged thrill-seeking henchwoman, to an icon of neo-noir feminism. In his *Vulture* article on Harley Quinn, Andrew Riesman quotes Tara Strand, "Feminism is about showing women as fully fleshed out human beings, and that's what Harley is. She doesn't make choices that are smart or good for a woman, but she gets to make those choices" (2016).

Adaptation theorists, such as Julie Sanders, and affect theorists such as Erin Hurly and Sara Warner have opened new terrain in discussing how stories are told and retold, and that the audience's nostalgia is in play when viewing adapted works (Sanders, Hurly &Warner). In this case, not only is Harley Quinn being adapted from a previous iteration, noir itself is also being reimagined for a new audience, while having a foothold in the familiar. Though Harley's origin, costumes, and some behaviors may change, her agency is still very much her own.

NOTE

1. This issue was also the first appearance of Batman. Finger, Bill (w) and Kane, Bob (p) (i) "The Case of the Chemical Syndicate." *Detective Comics*. #27, at 2 (DC Comics May 1939), reprinted in *Batman Archives*. vl. #7 (Dale Crain ed., DC Comics 1990).

WORKS CITED

Aziz, Jamaluddin Bin. *Transgressing Women: Investigating Space and the Body in Contemporary Noir Crime Thrillers*. Diss. University of Lancaster, 2005.
Basic Instinct. Dir. Paul Verhoven. Perf. Michael Douglas, Sharon Stone. Paramount, 1992. DVD.
Batman. Dir. Tim Burton. Perf. Jack Nicholson, Michael Keaton, Kim Basinger. Warner Home Video, 1989. DVD
Batman Returns. Dir. Tim Burton. Per. Michael Keaton, Danny DeVito, Michelle Pfeiffer. Warner Home Video, 1992. DVD.
Borde, Raymond, and Etienne Chaumeton. "Towards a Definition of Film Noir." *Film Noir Reader* (1996): 17–25.
Bound. Dir. Wachowski Brothers. Perf. Gina Gershon, Jennifer Tilly. Olive Studios, 1996. DVD.
Conner, Amanda, and Jimmy Palmiotti (w). Hardin, Chad, and Stéphane Roux (p) (i). "Can't Fight City Hall… or Can You?" *Harley Quinn*. v2. #24. (Jan. 2016), Warner Brothers. DC Comics.
_____. "Helter Shelter." *Harley Quinn*. v2. #2. (Mar. 2014), Warner Brothers. DC Comics.
Coogan, Peter. *Superhero: The Secret Origin of a Genre*. MonkeyBrain, 2006.
The Dark Knight. Dir. Christopher Nolan. Perf. Christian Bale, Heath Ledger, and Maggie Gyllenhaal. Warner Home Video, 2008. DVD.
Dickens, Donna. "The Exact Moment 'Suicide Squad' Fails Harley Quinn Is in the New Trailer." *Hitfix*. January 2016. Web. 20 January 2016.
Dini, Paul, and Bruce Timm (w). Timm, Bruce, and Glen Murakami (p). Timm, Bruce (i). "Batman: Mad Love." *Batman: Mad Love and Other Stories* vl. Ed. Scott Peterson. NY: DC Comics, 2005.

Double Indemnity. Dir. Billy Wilder. Perf. Fred MacMurray, Barbara Stanwyck. Universal Studios Home Entertainment, 1944. DVD

Ebert, Roger. "Batman Returns." *Roger Ebert*. June 1992. 21 January 2016.

Finger, Bill (w). Kane, Bob (p) (i). "The Case of the Chemical Syndicate." *Detective Comics* #27, at 2 (DC Comics May 1939), reprinted in *Batman Archives*. vl. #7 (Dale Crain ed., DC Comics 1990).

Glass, Adam (w). Henry, Clayton (p). Barros, Ig Guarra (i). "The Hunt for Harley Quinn," *Suicide Squad*. v2. #7 (May 2012), Warner Brothers. DC Comics.

Gun Crazy. Dir. Joseph Lewis. Perf. John Doll, Peggy Cummins. Warner Brothers Home Video, 1950. DVD.

Hales, Barbara. "Projecting Trauma: The Femme Fatale in Weimar and Hollywood Film Noir." *Women in German Yearbook: Feminist Studies in German Literature & Culture* 23.1 (2008): 224–243.

Harvey, Sylvia. "Woman's Place: The Absent Families of Film Noir." *Women in Film Noir*, edited by E. Ann Kaplan, London: British Film Institute (1978): 22–34.

Hurley, Erin, and Sara Warner. "Special Section": Affect/Performance/Politics."" *Journal of Dramatic Theory and Criticism* 1.2 (2012): 99–107.

Johnston, Claire. "Double Indemnity." *Women in Film Noir* (1980): 100–111

Leave Her to Heaven. Dir. John M. Stah. Perf. Gene Tierney, Cornel Wilde. 20th Century Fox, 1945. DVD.

Loo, Hannah. "Agatha: The Subversion and Reflection of the 1940's Femmes Fatales in the Neo-Noir Film Minority Report." 2012. Web. 28 January 2016.

The Maltese Falcon. Dir. John Huston. Perf. Humphrey Bogart, Marty Astor. Warner Home Video, 1941. DVD.

Moore, Alan (w). Bolland, Brian (p). *Batman: The Killing Joke*. (2008), Warner Brothers. DC comics.

Mulholland Drive. Dir. David Lynch. Perf. Naomi Watts, Laura Harring, Justin Theroux. Universal Studios Home Entertainment, 2001. DVD.

Muller, Eddie. *Dark City: The Lost World of Film Noir*. Macmillan, 1998.

Natural Born Killers: The Director's Cut. Dir. Oliver Stone. Perf. Woody Harrelson, Juliette Lewis, Tom Sizemore, Warner Home Video, 1993. DVD.

Out of the Past. Dir. Jacques Tourneur. Perf. Robert Mitchum, Jane Greer. Turner Home Entertainment, 1947. DVD.

Place, Janey. "Women in Film Noir." *Women in Film Noir*, edited by E. Ann Kaplan, London: British Film Institute (1989): 47.

Raw Deal. Dir. Anthony Mann. Perf. Dennis O'Keefe, Claire Trevor, Marsha Hunt. Eagle-Lion Studios, 1948. DVD.

Riesman, Abraham. "The Hidden Story of Harley Quinn and How She Became the Superhero World's Most Successful Woman." *Vulture*. February 2015. Web. 23 January 2016.

Sanders, Julie. *Adaptation and Appropriation*. Routledge, 2015.

Schrader, Paul. "Notes on Film Noir." *Film Comment* 8.1 (1972): 8–13.

Schwartz, Ronald. *Neo-Noir: The New Film Noir Style from Psycho to Collateral*. Scarecrow Press, 2005.

Sims, Chris. "Ask Chris 173: The Trouble with the Joker's Girlfriend Harley Quinn." *Ask Chris*. Dec. 2013. Web. 10 January 2016.

Suicide Squad. Dir. David Ayer. Perf. Margot Robbie, Ben Affleck, and Will Smith. Warner Brothers, 2016. Film.

Vaz, Mark Cotta. *Tales of the Dark Knight: Batman's First Fifty Years, 1939–1989*. Ballantine Books, 1989.

The Clock Is Ticking

Brandon Benge

Harley Quinn is a popular character in the world of comic books, for the moment. As has happened with so many of her four color forbearers, that fact will change in the near future. Even if nothing significant about the character changes, or she is completely revamped as part of some ill-advised attempt to tap a new audience, Harley's grip on the market will loosen. If the same writers and artists continue to produce the same type of stories they churned out in the past, Harley will lose her hold on the readers. If new creative groups take her in directions that no one has ever taken her before, Harley's popularity will fade. In the comic book industry, downturn is inevitable.

This fact should not be news to any comic book or popular culture fan. Comics, like most forms of entertainment, are very cyclical in nature. Trends and fads come and go on a regular basis. In an industry where superheroes, westerns, romances, science fiction, fantasy, horror, humor, war stories, and autobiographical comics have all managed to dominate the market at one time or another, the story of a psychotic, violent abuse victim trying to find her place in the world seems unlikely to hold position at the top of the industry. Harley's rise and fall is simply one part of the never ending cycle of ups and downs in the history of comic books.

Even Legends Stumble

Although comic books and newspaper comic strips had been around for years, the industry changed dramatically when *Action Comics* #1 was published in 1938. That issue saw the debut of Superman. The character was an instant success and has continued to star in *Action Comics* almost a thousand issues later. Roughly a year after his debut, Superman even got his own self-titled book. That was a feat almost unheard of at the time as publishers tended

to stick to the anthology format, featuring a variety of characters and stories in each issue. Superman's success signaled the beginning of how comic books could cross over into other media. The character was spun off in his own newspaper strip, radio program, movie serials, cartoon, and television series, all within years of his first appearance in *Action Comics*. Since that time, Superman has starred in additional cartoons, television shows, video games, movies, and comic books. *Action Comics* and *Superman* are still published to this day. Over the years, Superman has teamed with a number of other heroes, including Wonder Woman and Batman, to star in a number of comics, television shows, and movies, making him one of the most recognized fictional characters the around the world.

Despite the early success of Superman, it didn't take long for a new hero to challenge his popularity. In 1940's *Whiz Comics #2*, Captain Marvel was introduced to the world. In a short amount of time, the World's Mightiest Mortal was one of the top selling super heroes in the 1940s, managing to outpace Superman. Captain Marvel even beat Superman to the silver screen with the release of *Adventures of Captain Marvel*, a film serial release by Republic Pictures in 1941 ("Adventures of Captain Marvel"). Despite stealing a great deal of Superman's thunder, in 1953, Fawcett Comics stopped publishing Captain Marvel comics due at least in part to a lawsuit filed by DC Comics claiming infringement on their Superman character ("National"). Captain Marvel, now billed as Shazam, still exists to this day somewhat ironically published by DC Comics. Like so many victims of the comic book cycle, Shazam's current popularity falls well short of the character that he routinely outsold in his early days.

Superman has continued to experience a number of ups and downs in popularity since his early struggles against the likes of Captain Marvel. Events like the 1978 film *Superman*, 1980's *Superman II*, and the 1986 comic book series *The Man of Steel* all generated a great deal of renewed interest in Superman. However, that interest always managed to dim a short time later (see 1987's *Superman IV: The Quest for Peace*) ("Superman IV"). Even 2013's *Man of Steel*, while a financial success, ("Man of Steel") could only generate mixed reviews. This prompted producers to push back a direct sequel to the film, instead following up with 2016's *Batman v Superman: Dawn of Justice*. Hoping to make up for Superman's somewhat weak solo performance, Batman, Wonder Woman, The Flash, Aquaman, and Cyborg were all worked into the new movie, laying the foundation for a larger shared universe of DC theatrical releases. While not a monetary flop, ("Batman v. Superman") the movie can only be generously said to have opened to mixed reviews. The failures of the movie cannot be entirely blamed on the current theatrical version of Superman, but being involved in two lackluster movies in a row does nothing to reinvigorate the popularity of the Man of Tomorrow.

Illustrating some of the ups and downs of Superman, arguably the most well-known comic book character ever created, proves that same cycle can and will happen to any comic book character eventually, even Harley Quinn. Harley does not have an almost eighty-year history or the near-universal name recognition of Superman to fall back on, so it is not inconceivable that a downturn for Harley Quinn could be more severe and harder to recover from than a character of Superman's stature.

Month to Month, Year to Year

The comic book market is always changing, and the sales charts reflect that fact. On an almost monthly basis, and especially on a year-to-year basis, the top sellers are always playing a game of musical chairs. Usually what drives top selling titles is an event. Whether the event in question is a major cross-over that brings together a company's big name characters in one epic story, the first appearance of a new character, the reintroduction of an old character that has been away or "dead" for a while, or the launch (or re-launch) of a new title; something novel has to be happening to drive up sales. Typically, an average issue of an ongoing title, no matter how popular the title, is not going to top the charts. Something significant, like the death of at least a semi-important character, is going to have to take place for a non-event book to take the top spot. Buzz can begin building for these events months before they even occur, sometimes even earlier than the typical two months between the solicitation for an issue and its actual release. Over the last several years it has not been unusual for a book to generate buzz after it has been released. Internet chatter can build demand for a book that seemingly had no heat before its release.

Spawn debuted in *Spawn* #1 in 1992. Todd McFarlane, the creator, writer, and artist on Spawn, had already made a name for himself at Marvel Comics working on various titles, culminating with his work on *The Amazing Spider-Man* and *Spider-Man*. When McFarlane and a group of his fellow creators left Marvel to start their own company, Image Comics, they got a lot of attention in the industry. *Spawn* was one of the first titles Image released. The character, and the book, were an immediate success with the first issue selling approximately 1.7 million copies (Parker). In 1992, two issues of the book managed to claim spots in the top ten best-selling issues for the year (Miller 1992). The following year, several issues of *Spawn* managed to crack the top twenty, but none made it to the top ten (Miller 1993). In 1994, *Spawn* took four spots in the top ten and shared another one because of *Spawn Batman* (Miller 1994). *Spawn* continued to hold spots in the top ten for 1995 (Miller 1995) and 1996 (Miller 1996), falling back into the top twenty for 1997 (Miller

1997) through 1999. In the year 2000, the biggest selling issues of *Spawn* came in at number fifty-one (Miller 2000). The next year saw *Spawn* fall out of the top 100 issues sold for the year. Despite 2015's number 250 and *Spawn Resurrection*, which brought original Spawn Al Simmons back to the starring role, *Spawn* has yet to crack the top 100 again, only managing to sell 60,000 and 32,000 copies respectively (Miller 2015).

Granted, straight sales of 1.7 million are an anomaly in today's market that Harley Quinn cannot be reasonably expected to match. Typically, the only way single issues sell close to a million copies these days is to be included in a Loot Crate box or some other gimmick that boosts numbers well beyond what brick-and-mortar comic shops typically can sell. Despite lesser sales numbers industry-wide compared to the 1990s, Harley titles only occasionally crack the top ten in a month. Given the inevitable slide all titles eventually suffer in a few short years, we will see Harley Quinn books fall out of the top twenty and even the top one hundred.

Not Quite an Original

One of the attributes that helps a comic book character stand out and grab the attention of the reader is a sense of uniqueness. Originality in origin, appearance, abilities, or other traits, in some form or fashion, is what separates lasting characters from the fads. Harley Quinn is hardly an original character. Sadly, in the manner of so many female comic book characters before her, Harley at her core is little more than a female derivative of a male progenitor, in this case the Joker. Unfortunately, few female comic book characters come into being from whole cloth with a background and history all their own like Wonder Woman. Instead, characters such as Supergirl, Hawkgirl, and Mary Marvel are usually created as offshoots of a male character in an attempt to feign diversity while hoping to attract more female readers to what has been a predominately male-dominated medium. In the earlier comics, these female characters are little more than damsels in distress. Despite frequently having powers and abilities on par with their male costars, it is the female characters that more often need saving. They only occasionally get the chance to turn the tables and rescue the men. Harley's origin is hardly better than a character in a 1940s pulp novel: an intelligent, educated woman falling victim to the whim of a killer madman all in the name of love.

Despite rough beginnings, the only thing stopping these female doppelgangers from being fully developed, independent, and interesting characters is the creative team put in charge of them. Barbara Gordon is an excellent example of this notion. Barbara's Batgirl was not even the first Batgirl to appear in the pages of a Batman comic. The original Batgirl, Betty Kane, was

basically a miniature version of Kathy Kane, the original Batwoman. The original Batwoman and Batgirl added diversity to the world of Batman and Robin but not a lot of substance. Barbara's Batgirl managed to undo some of the female stereotypes that plagued Batwoman's existence. Barbara was created to attract female readers as a crime fighter all her own, not just as a love interest for Batman or Robin, as in the cases of the original Batwoman and Batgirl. Barbara does not carry a purse with gadgets disguised as lipsticks and makeup compacts like her predecessors. This Batgirl had a utility belt just like Batman and Robin. She was the head of the Gotham City Public Library and became a member of the U.S. House of Representatives. She was even able to save Batman and Robin on occasion instead of always having to be the one rescued.

The Barbara Gordon Batgirl was an instant success on television and in the comics. In addition to back-up stories in *Detective Comics* and a starring role in *Batman Family*, Batgirl had numerous guest appearances across the DC Universe for close to twenty years. Eventually, Batgirl's popularity had diminished enough that 1988's *Batgirl Special* #1 was to be the end of the character (Randall). Later that year, Barbara Gordon appeared in Alan Moore's *Batman: The Killing Joke*. In the story, she is little more than a plot device, shot and crippled by the Joker in an attempt to mentally break Commissioner Gordon (Moore). Unfortunately, using a female character in such a manner is hardly a rare occurrence especially in the comic book world. It was not until 1999 that Gail Simone coined the term "Women in Refrigerators" as shorthand for just such incidents (Simone). The term refers specifically to the events of *Green Lantern vol. 3* #54, when Alexandra DeWitt, girlfriend of then Green Lantern Kyle Raiyner, is killed and stuffed into a refrigerator to send him a message (Marz). The Barbara Gordon character could have been relegated to being just another female character on that list, victimized solely to further a storyline about male characters. However, shortly after *Batman: The Killing Joke*, Kim Yale and John Ostrander gave Barbara Gordon a new persona, Oracle, in the pages of *Suicide Squad* (Ostrander). No longer able to fight crime as Batgirl, Barbara focused on becoming an information specialist, using her gifted mind and information gathering skills to become the eyes and ears of the superhero community in the DC Universe. In addition to being the go-to source of information for Batman and the Justice League, she even went on to lead her own team of predominately female heroes, the Birds of Prey. Barbara's evolution took her well beyond her somewhat limited origins.

Despite having an origin shackled to a pre-existing male character, there is no reason that Harley Quinn cannot be an intriguing, distinctive entity. In the right hands, Harley could evolve just as in the case of Barbara Gordon. The problem is the temptation to return Harley to her roots is always there.

No matter how much distance is put between them, references to Harley's relationship with the Joker always seem to surface. Too many of her stories tend to devolve into her trying to win back his affection or to punish him for past misdeeds. Any growth the character manages is almost always undone. Until a creative team can come along that will break Harley from this cycle, she will always be just inside the Joker's shadow.

Once a Sidekick, Always a Sidekick

In her earliest appearances, Harley Quinn fit into the sidekick role alongside the Joker. In her case, starting out as a villain, the term *goon* might be more appropriate. Hype man would also apply, as her initial purpose was as a flamboyant character there to draw the attention of the heroes or run interference while the Joker worked his schemes. Her slightly more garish costume and second-in-command status set her apart from the other nameless henchmen. Regardless of her statues as a deluxe goon, Harley was still expected to mix it up when it came time to fight, just like her counterparts.

Arguably, Robin is the most famous sidekick in the history of any medium. He has had a huge following since his debut in 1940, giving the young readers of *Detective Comics* and *Batman* a character they could relate to better than a millionaire playboy fighting crime by night. Dick Grayson evolved over the years, even growing out of the role of Robin to become Nightwing, all the while holding on to his popularity. Despite the love of the fans, a comic book of his own, and appearances in other media, Dick Grayson has never managed to eclipse the popularity of Batman. In 1989, Tim Drake was introduced to the Batman universe. He eventually became Robin, filling the role left vacant by Dick Grayson and Jason Todd (introduced in 1983 and killed by fan vote in 1988) (Easton). In 1993, after starring in three miniseries of his own, the Tim Drake Robin got his own ongoing comic, lasting 183 regular issues over almost sixteen years. Although popular enough to manage a healthy run, the title never consistently outsold the *Batman* title. Later incarnations of Robin continue to flourish, as both characters and comic titles, but with the same sales results. The sidekick inevitably will always come in second place.

In the case of Harley Quinn, it is difficult to compare sales numbers of her title to that of the Joker's, since he hasn't had his own title since the short lived series that ran between 1975 and 1976. However, the last major Batman storyline that involved the Joker, *Endgame*, started in *Batman, vol.* 2 #35 (December 2014) (Snyder). That issue was the biggest seller for the month with an estimate of just over 113,000 issues sold (Miller December 2014). That same month, *Harley Quinn, vol.* 2 #13 ranked number eleven with sales esti-

mated at just over 68,000 issues. As the industry stands today, 68,000 issues sold in a month is nothing to scoff at, but it is still a far cry from 113,000. The sales trend between the two books continued through April 2015, except for the month of March when there was no issue of *Batman* published. Despite strong numbers, Harley, like so many sidekicks before her, could not outperform her forbearer, the Joker.

Cut from the Same Cloth

As the character has developed over the years, a typical Harley Quinn story usually involves a mix of violence and dark humor which are trademarks of the character. While the situations may be unique, the formula is not. That same mix has been used repeatedly over the years for a number of characters to varying degrees of success. Typically, that success has a limited shelf life. Harley is just one of the latest characters to be written onto that bandwagon.

In 1983, DC Comics introduced a character named Lobo in the pages of *Omega Men*. Sharing more than a similar complexion with Harley Quinn, Lobo evolved into a very similar character. In the beginning, he was a rather unremarkable bounty hunter/gun-for-hire in outer space. Lobo appeared in a number of issues of *Omega Men*, but had little impact on the industry. It was not until 1990 that he came into his own. As a parody of other over the top violent characters in comics, an added element of humor elevated the hyper-violent Lobo to one of the most popular comics characters of the 1990s. Despite numerous solo comic book series, guest starring on *Superman: The Animated Series,* and having his own video game developed, that popularity quickly waned. Since the height of his popularity, Lobo has made multiple guest appearances around the DC Universe. In October 2014, he was once again given his own solo title. The debut issue reached number sixty-six for the month, with sales of roughly 39,000 copies (Miller October 2014). The series, which saw a major revamp to the once popular character in an attempt to regain some faded glory, ended after just thirteen regular issues.

Wolverine, a character with a violent temper and a sarcastic sense of humor, gained a quick following after his debut in 1974. By 1975, he was part of the revamped X-Men lineup introduced in *Giant-Size X-Men* #1. Through the 1980s and 1990s, Wolverine starred in a number of his own series as well as guest spots and storylines in a number of other Marvel titles. He was even a part of *X-Men, vol. 2* #1 from 1991, entered into *The Guinness World Records Book* in 2010 as the highest selling single comic book ("SDCC"). Despite his success, Wolverine's sales numbers fluctuated over the years. His last solo title debuted in February 2014, reaching the number three spot for the month with sales of almost 89,000 copies (Miller February 2014). The last two issues

of that series, issues #11 & #12, both came out in August 2014, occupying the 29th and 26th spots, respectively (Miller August 2014). The issues sold around 50,000 each. The end of that series led to the four issue limited series *Death of Wolverine* in September 2014. The first issue held the number one slot for the month with sales of almost 262,000 copies (Miller September 2015). In October 2014, the series wrapped up with issue #4 selling over 165,000 copies, almost 100,000 fewer copies less than the first issue from just the previous month (Miller October 2014). As of this writing, Wolverine, in his typical form, has yet to reappear in the comics medium.

Currently, the only comic book character that could arguably put a mix of dark humor and violence to better use than Harley Quinn is Deadpool. Initially, the character of Deadpool was not used in a humorous way. He was just an assassin, setting the baseline of the violent aspect of his character still in use today. It was not until he got his own ongoing series in 1997 that more humorous elements really took root, evolving the character into what he is today. While Deadpool has internal voices that he and he alone talks to, in the current Harley Quinn series, she has discussions with a stuffed beaver that only she can hear. Both characters are more aware of the fact that they exist in a comic book reality, often breaking the forth wall and talking directly to the reader. Coincidentally, both characters primarily wear costumes of red and black. While Deadpool is currently riding a huge wave of popularity fueled by comic book and movie appearances, like Harley, it will only be a matter of time before that wave breaks.

A Lack of Notable Events

Harley Quinn was introduced into the mainstream DC Universe in the 1999 event, *No Man's Land*. Other than finally incorporating her into the larger Batman world, her role in that story is rather insignificant. Since that integration, she is a part of several notable Batman events (*Hush, Death of the Family*) and appears in several different titles, either as a regular character or a guest star (*Gotham City Sirens, Countdown, Birds of Prey, Suicide Squad, New Suicide Squad*). However, she has yet to be the pivotal character that those events or series revolve around. *Gotham City Sirens* gives her a lot of face time because she is one of the book's three main characters. When Harley is not being used as backup to whatever story Catwoman or Poison Ivy are involved in or as comic relief, she is usually wrapped up in plotlines that had something to do with the Joker. When starring in her own series, Harley has limited interaction with characters outside her supporting cast. Her appearances in *Suicide Squad* and *New Suicide Squad*, while taking place in the DC Universe at large, so far steer clear of the core elements of that world. *Harley's*

Little Black Book, launched in 2016, finally gives her a chance to interact with characters from outside her usual sphere such as Wonder Woman, Green Lantern, and Zatanna. These stories are generally little more than slapstick, making it almost impossible that she will have a major impact on the greater DC Universe. That lack of impact makes it harder for Harley to become an enduring character. Notoriety is one of the qualities that keeps a character at the forefront of the industry.

Unlike his once and future sidekick, the Joker has had a major impact in the history of Batman and the DC Universe at large. The Joker is one of Batman's oldest foes, having been introduced roughly a year after Batman himself. Since that time, he has been an ever-present figure in Batman's life and responsible, or at least present, for some of the most significant events in Batman's history.

One of the most memorable and far reaching of these events was the murder of Jason Todd, the second Robin. The character of Jason Todd was never as popular as his predecessor, Dick Grayson. Introduced in *Batman* #357, just a few years later, he was killed in *Batman* #428 (Starlin). In *A Death in the Family,* Jason is trying to track down his birth mother. After finding her, it is revealed that she is being blackmailed by the Joker. In an attempt to cover up her crimes, she hands Jason, as Robin, over to the Joker. After beating Jason with a crowbar, the Joker leaves him and his mother to die in an explosion. This event, and the fallout of the eventual resurrection of Jason Todd, still have a major impact on every character in the Batman universe.

Another pivotal event the Joker is involved in is the crippling of Barbara Gordon. Crippling a character that had been a part of the Batman universe for twenty years was a big deal, but the fallout proved to be more important. As Oracle, the computer and information specialist for Batman and other heroes, she had a hand in many events over the next twenty years of DC history. The impact of this story is only lessened by that fact that DC chose to rewrite a large portion of Barbara's history for The New 52 re-launch. While still shot by the Joker, she is only briefly disabled. She recovers and resumes her role as Batgirl, making little more than a pit stop as Oracle.

During 2015's *Endgame,* the Joker returned for only his second significant story in The New 52. The story starts with Batman being attacked by the Justice League, all victims of Joker gas. The Joker reveals that he knows Batman's true identity, cuts off Alfred's hand, and infects most of Gotham with a deadly plague. The story culminates with a fight between the Joker and Batman that effectively kills them both, at least temporarily.

Even when he is not the driving force of a storyline, the Joker plays at least some part in a number of other significant Batman events over the years. It is the Joker and Scarecrow that kidnap the mayor during *Knightfall.* During *No Man's Land,* he kills Commissioner Gordon's second wife, Sarah Essen.

For a time, the Joker even manages to steal Mister Mxyzptlk's power and uses it to recreate the universe in his own way (*Emperor Joker*). The Joker was one of a long list of villains set in Batman's way during the *Hush* story, and he killed Alexander Luthor during *Infinite Crisis*. The Black Glove tried to recruit him during *R.I.P.*, and it is heavily implied that he knows Batman's true identity in the buildup for *The Return of Bruce Wayne*. Until Harley can be the catalyst of or be involved in at least a few significant events like these, she will remain little more than a novelty character.

Gone but Not Forgotten

Someday in the not-so-distant future, Harley Quinn will not be starring in multiple titles. Her self-titled series will eventually be canceled as well, just as it was once before. Her number of guest appearances in other comics will dwindle. She will pop up on a lot less ancillary merchandise than she currently does. No one will pay to see her on the big screen. Instead of seeing her everywhere, fans will have to actively seek out Harley-themed material. It will be dark times for the truly devoted.

Using history as a guide, it is safe to conclude that while her presence will certainly be diminished in the not-so-distant future, Harley Quinn will never completely disappear. While she will still be around, it might become harder to recognize her. Just as the numerous characters before her slid off their pedestal of popular culture dominance, future artists will inevitably have Harley go through some changes in order to try to regain some semblance of her former glory. Whatever changes will be made in the desperate attempt to boost sales again be they costume, super powers, age, race, religion, birthplace, sexual orientation, gender, hair color, or even shoe size will probably be short-lived when they do not pan out. The truly devoted Harley fans will grumble and moan as they continue to buy a product they do not truly enjoy, all the while longing for the good old days. However, if fans can hold on long enough, someday they just might get a project that takes Harley Quinn back to her roots. Whatever it was about Harley Quinn that drew them to her in the first place will return, and just like that, the halcyon days will be back. Just like before, the clock will be ticking away as the cycle starts anew.

Works Cited

Adventures of Captain Marvel. Dir. John English and William Witney. Perf. Tom Tyler and Frank Coghlan, Jr. Republic Pictures, 1941. Film.
"Batman V Superman: Dawn of Justice (2016)." *Box Office Mojo*. IMDb.com, 25 Mar. 2016. Web. 27 July 2016. http://www.boxofficemojo.com/movies/?id=superman2015.htm
Easton, Brian K. "DC FLASHBACK: The Life and Death and Life of Jason Todd." *Comic*

Book Resources. Comic Book Resources, 11 June 2007. Web. 27 July 2016. http://www. comicbookresources.com/?page=article&id=10464

"Man of Steel (2013)—Daily Box Office Results." *Box Office Mojo.* IMDb.com, 14 June 2013. Web. 27 July 2016. http://www.boxofficemojo.com/movies/?page=daily&id=superman 2012.htm

[Marz, Ron (w). Aucoin, Derec, Darryl Banks, and Steve Carr (p). Tanghal, Romeo (i).] "Forced Entry." *Green Lantern* #54 (Aug. 1994), [DC Comics].

Miller, John Jackson. "Comic Book Sales Figures for August 2014." *Comichron.* John Jackson Miller, 15 Aug. 2014. Web. 27 July 2016. http://www.comichron.com/monthlycomics sales/2014/2014–08.html

_____. "Comic Book Sales Figures for December 2014." *Comichron.* John Jackson Miller, 15 Dec. 2014. Web. 27 July 2016. http://www.comichron.com/monthlycomicssales/2014/ 2014-12.html

_____. "Comic Book Sales Figures for February 2014." *Comichron.* John Jackson Miller, 10 Feb. 2014. Web. 27 July 2016. http://www.comichron.com/monthlycomicssales/2014/ 2014-02.html

_____. "Comic Book Sales Figures for October 2014." *Comichron.* John Jackson Miller, 15 Oct. 2014. Web. 27 July 2016. http://www.comichron.com/monthlycomicssales/2014/ 2014-10.html

_____. "Comic Book Sales Figures for September 2015." *Comichron.* John Jackson Miller, 12 Sept. 2014. Web. 27 July 2016. http://www.comichron.com/monthlycomicssales/2015/ 2015-09.html

_____. "Comic Book Sales for 1992." *Comichron.* John Jackson Miller, n.d. Web. 27 July 2016. http://www.comichron.com/monthlycomicssales/1992.html

_____. "Comic Book Sales for 1993." *Comichron.* John Jackson Miller, n.d. Web. 27 July 2016. http://www.comichron.com/monthlycomicssales/1993.html

_____. "Comic Book Sales for 1994." *Comichron.* John Jackson Miller, n.d. Web. 27 July 2016. http://www.comichron.com/monthlycomicssales/1994.html

_____. "Comic Book Sales for 1995." *Comichron.* John Jackson Miller, n.d. Web. 27 July 2016. http://www.comichron.com/monthlycomicssales/1995.html

_____. "Comic Book Sales for 1996." *Comichron.* John Jackson Miller, n.d. Web. 27 July 2016. http://www.comichron.com/monthlycomicssales/1996.html

_____. "Comic Book Sales for 1997." *Comichron.* John Jackson Miller, n.d. Web. 27 July 2016. http://www.comichron.com/monthlycomicssales/1997.html

_____. "Comic Book Sales for 2000." *Comichron.* John Jackson Miller, n.d. Web. 27 July 2016. http://www.comichron.com/monthlycomicssales/2000.html.

_____. "Comic Book Sales for 2015." *Comichron.* John Jackson Miller, 9 Feb. 2015. Web. 27 July 2016. http://www.comichron.com/monthlycomicssales/2015.html

Moore, Alan (w). Bolland, Brian (p) (i). *Batman: The Killing Joke.* (March 1988), DC Comics.

National Comics Publications V. Fawcett Publications. 93 F. Supp. 349 (S.D.N.Y. 1950). 10 Apr. 1950. *Court Listener.* Free Law Project, 12 Oct. 2010. Web. 27 July 2016. https://www. courtlistener.com/opinion/1971798/national-comics-publications-v-fawcett-publica tion/

Ostrander, John (w). Yale, Kim (w). McDonnell, Luke (p). Kesel, Karl (i). "Weird War Tales." *Suicide Squad.* vl. #23 (Jan. 1989), Warner Brothers. DC Comics.

Parker, John R. "*Spawn* 20 Years Later: Looking Back at the Quintessential '90s Comic Book." *Comics Alliance.* Screencrush Network, 2 Feb. 2002. Web. 27 July 2016. http://comicsal liance.com/spawn-compendium-20-years-todd-mcfarlane/

Randall, Barbara J. (w). Kitson, Barry (p). Patterson, Bruce D. (i). "The Last Batgirl Story." *Batgirl Special* #1 (1988), Warner Brothers. DC Comics.

"SDCC 2010: Marvel Breaks into Guinness." *Marvel.* Marvel, 22 July 2010. Web. 27 July 2016. http://marvel.com/news/comics/13386/sdcc_2010_marvel_breaks_into_guinness

Simone, Gail. "Wir—The List." *Women in Refrigerators.* Gail Simone, Mar. 1999. Web. 27 July 2016. http://lby3.com/wir/women.html

Snyder, Scott (w). Capullo, Gre (p). Miki, Danny (i). "Endgame, Part One." *Batman,* vol. 2 #35 (Dec. 2014), DC Comics.

Starlin, Jim (w). Aparo, Jim (p). DeCarlo, Mike (i). "A Death in the Family, Book Three." *Batman* #428 (Winter 1988), DC Comics.

"Superman IV: The Quest for Peace (1987)." *Box Office Mojo*. IMDb.com, 11 Apr. 2004. Web. 27 July 2016. http://www.boxofficemojo.com/movies/?id=superman4.htm

"That just proves he wants me back"

Pure Victimhood, Agency and Intimate Partner Violence in Comic Book Narratives

K. Scarlett Harrington *and* Jennifer A. Guthrie

This essay[1] investigates how Harley Quinn's relationship with the Joker in *Gotham City Sirens* disseminates discourses of victimhood, agency, and intimate partner violence (IPV) to readers. Like women in the real world, women in comics have not been given the recognition they deserve and are often only created as auxiliary characters to their male counterparts. Madrid argues that when compared to male superheroes, female superheroes' strengths and agility have been overshadowed by plotlines concerning romance (vi). Miczo argues that "superheroines fail to reach their potential when they are placed in situations that make salient negative female stereotypes (e.g., that females are fragile, hysterical, and catty)" (171). Stabile explains that being a heroine implies less agency than that of a hero because comics that focus on the visual aspect of the protagonist depict men as having bodies that are strong, unbreakable, and able to prevail against any evil, whereas female bodies are represented as breakable and easily obtainable as an object of desire (89). In essence, heroes have more agency because the male anatomy is perceived to be stronger than that of a heroine. However, being depicted as having less agency than their male counterparts, the physical strength and extraordinary abilities of these women bestow them with an *a priori* notion of agency where they are expected to have the self-determination and physical ability to protect themselves and others.

55

Some characters, like Harley Quinn, fluctuate between villain and hero. Notwithstanding such fluidity, the *a priori* expectation of her agency leads readers towards a preferred interpretation of her relationship with the Joker. Harley and the Joker's volatile relationship is not unknown; in fact, it is celebrated. Hot Topic's "Mad Love" sale and countless comic-con couple cosplayers demonstrate that few fans recognize Harley's abuse as illegitimate and her as a victim. Scholars like Loseke and Picart note that society often views issues like IPV in terms of survivors who achieve agency by leaving their partners and "pure victims" who are abused "at no fault of their own" that lack the agency to leave (Picart 97). Even though agency implies empowerment, agency also validates that an individual's abuse was significant enough to warrant separation.

Though researchers have determined that agency is important for survivors of IPV, scholars nonetheless grapple with how agency should be conceptualized (Mahoney; Schneider). For example, if agency is defined as the ability to make choices and have "free will" (Dunn and Powell-Williams 980), social conceptualizations of agency tend to thus imply that only women who leave violent relationships have agency. However, recent scholarship has illuminated how it is problematic to "dichotomize victimization and agency" because survivors can be both victim *and* agent even when they do not leave an abusive relationship (Dunn and Powell-Williams 979). Having limited perceptions of what it means to be a victim can deny or undermine survivors' agency or capacity to have agency. Although scholars continue to problematize implications of agency, few scholars have sought to understand the meanings of victimhood assigned to women who are physically capable of defending themselves. Harley Quinn in *Gotham City Sirens* offers an alternative meaning for agency and victimhood in which readers are encouraged to assess the nuances of the ways characters are not/able to enact agency. Overall, the chapter argues that Harley's prowess and actions in the narrative leave her unable to be defined as part of the agent/pure victim dichotomy. Being defined outside of the dichotomy designates Harley to a status of "non-victimhood" wherein she is not viewed as a victim of IPV, and her abuse is considered insignificant, and therefore, not serious. Campbell argues that a critical rhetorical analysis "examines rhetorical acts in order to describe processes of influence and explain how they occur" (14). Using Campbell's definition of a critical analysis, this evaluation seeks to understand the processes of influence in *Gotham City Sirens* and explain how these processes occur. Because comic books use narratives to disseminate their message, this project adopts Walter Fisher's narrative paradigm for understanding the rhetorical potential of a super heroine's narrative. Specifically, the authors assert that Fisher's ideas about narrative fidelity and good reasons are particularly significant to this research because they help explain how meanings assigned to characters are justified and persuasive.

Discourses of pure victimhood are problematic in two ways: first, they narrow the public's definition of what victimhood is, and second, by narrowing victimhood also narrows the experiences the public classifies as abusive. In what follows, the authors evaluate how Harley's action in the narrative positions her as a non-victim. Additionally, the authors investigate how meanings of non-victimhood contribute to the overall narrative's interpretation of IPV.

Literature Review

Narrative Paradigm

Danzinger-Russell notes that comic books enact cultural values and actions that make their message even more relatable, and comic books are at their most influential during catastrophic moments (37). Stabile asserts that superheroes commonly emerge in response to real world moments of crisis, anxiety, and uncertainty (87). Narratives that reflect cultural values validate a specific expectation for how an individual should address a critical situation. Despite taking place in a fictional reality, the reinforcement of social truths in comics opens up a space of deliberation Stabile refers to as "imagined here and nows" (87), in which readers can assess a particular issue and figure out ways in which they can potentially solve that issue. As comic book characters negotiate the meaning of significant social, political, and personal issues within alternate realities, readers negotiate the meaning of the same issues within the context of their own world. Though Stabile contends that these spaces of deliberation most commonly appear in times of crisis, this chapter extends her argument by noting that imagined here-and-nows are available whenever a text offers an interpretation of a social "truth." Being grounded in human experiences heightens a comic's persuasive potential because readers are able to connect the narrative to their own experiences. Such connections can be used to inform a reader's real world judgments about social truths concerning gender, race, class, and physical ability. Accordingly, stories can influence how people perceive and interpret their own and others' experiences.

Fisher asserts that the narrative paradigm extends Kenneth Burke's concept that humans are symbol-creating, using and abusing creatures that use these symbols to interpret the world around us (6). These symbols are commonly communicated through the stories humans tell, and such stories "give order to human experience and have persuasive potential" (6–7). Stories are incredibly influential on the ways human beings have carried on cultural values for centuries, and Fisher refers to narration as "a theory of symbolic

actions—words and/or deeds—that have sequence and meaning for those who live, create, or interpret them" (7). Within this paradigm, narratives are moral constructs based on reasoned meanings that resolve the issues of a public moral argument (7). The moral messages of narratives appeal to personal, cultural, and societal values by being grounded in "good reasons" that provide justification for the message presented in a narrative (7). As Fisher explains, such justification influences the possible ways a reader agrees with or disputes a text. If a reader disputes a text, it may be due to the lack of narrative probability within the text (7). Readers are aware of what "constitutes a coherent story"; if a narrative were to lack narrative probability, then it is unlikely that it would be persuasive (8). Fisher asserts that narrative fidelity occurs when a reader believes that a protagonist's or narrator's good reasons are true based on the reader's experience, and persuasion is more likely to occur if there are similarities between a protagonist's narrative and a reader's experiences (8). Therefore, when a reader believes the story "makes sense" and it relates to their own experiences, the reader is more likely to be persuaded by the narrative.

Comics as narratives are concerned with human experience. The similarities between comic books and the real world can lead readers to assess those similarities in imagined here-and-nows. Portrayals of human experiences in comics make the judgments derived from this space of deliberation particularly significant because comic books are *analogous* to the real world. Barthes argues that analogues in which text and image interact are *linguistic messages* that use certain tropes to reflect "our fundamentally *relational* understanding of reality" (Chandler 125). As analogues of reality, comic books draw on socio-cultural meanings attached to a particular real world person, event, issue, and policy. Accordingly, narratives guide readers towards a preferred reading by providing structure and coherence to something in the literal world that can be strange, unfamiliar, taboo, dangerous, etc. (Fisher 7). That which could be constituted as strange and unfamiliar fits within Fisher's idea that narratives are utilized to resolve public moral arguments. Within narratives the superficial characteristics of a particular character represent denotation in that it is a representation of an object/person in the literal world; categorizations of race, gender, ethnicity, and abilities give a character partial meaning based on socio-cultural perceptions of those categories. Connotation in narrative occurs when there is a particular socio-cultural meaning attached to the representation (Chandler 125). As such, messages in a narrative analogue "reflect major culturally variable concepts underpinning a particular world view—such as masculinity, femininity, freedom, individualism, objectivism, Englishness, and so on" (Fisher 6). When these particular world views are disseminated, they become cautionary tales that dictate and reinforce what is culturally appropriate. Chandler argues that some of these world

views are so culturally ingrained that their appearances within society often go unnoticed and/or unquestioned (145).

Narrative analogues assume that most readers have similar experiences and are aware of prominent social meanings. In doing so, narrative analogues heighten their persuasive potential because they are more likely to support what a reader knows to be true. Fisher explains that narrative fidelity involves a reader's acceptance of the preferred interpretation (7). Essentially, a narrative must justify the preferred interpretation in good reasons. These good reasons use a character's actions in the narrative to support how they should be interpreted. In order for the interpretation to be persuasive, such justification has to ring true to a reader's experiences and what they know to be *true*. Even if a reader has no first-hand experience with a particular issue and/or attitude, they can rely on prominent socio-cultural attitudes and the media to determine if a narrative's interpretation has fidelity. Narratives rely on socio-cultural conceptualizations to ground and forward the meanings assigned to characters and the overall message. The reader's experience with socio-cultural values acts as a source of information whereby they can assess the narratives' "truthfulness." Additionally, a reader's experience with knowing/challenging/reinforcing a specific socio-cultural attitude influences how they view the narrative's good reasons as pragmatic and justifiable.

Intimate Partner Violence and Pure Victimhood

Comics not only enact cultural values, they perpetuate them. Within Stabile's paradigm, the dissemination of particular socio-cultural mores within comics can influence how readers interpret those mores in real life (87). When comic narratives highlight plotlines concerning IPV, those interpretations can lead to the reinforcement of problematic myths about victims and abusers.

The United Nations defines intimate partner violence as "behavior by an intimate partner or ex-partner that causes physical, sexual or psychological harm, including physical aggression, sexual coercion, psychological abuse, and controlling behaviors" (par. 2). Robert F. Bornstein argues that IPV is larger in scale, effecting between 20 and 25 percent of the American public (595). In the year before *Gotham City Sirens* was published, IPV accounted for "14% of all homicides, with 70% of intimate partner victims being women" (Policastro & Payne 330). Although half a million women reported domestic violence in 2008, others sought help from domestic violence agencies. In their annual survey in 2009, the National Network to End Domestic Violence found that 65,321 adults and children sought help from an agency (3). Despite being able to help those individuals, agencies were understaffed and unable to help 9,280 individuals in violent situations and had to turn them away (3).

Though these numbers allude to the alarming amount of individuals who experience IPV, it does not explain the socio-cultural attitudes that hinder victims from reporting and ending their abusive relationships.

Berns asserts that IPV is an issue that has been largely framed by socio-cultural attitudes disseminated through the media (3). These mediated messages "play an important role in how the public understands social problems" by categorizing what is normal and appropriate (3). Conceptions of normal and appropriate are largely derived from myths about IPV that have been reinforced throughout generations. Similar to rape myths, IPV myths define what is to be considered appropriate (Policastro & Payne 333). The reinforcement and/or negotiation of appropriateness becomes troublesome when the "public recognizes a broad definition of domestic violence that encompasses a wide range of behaviors from verbal abuse to physical assault" (332). Due to the broad definition of IPV, members of the public make judgments on victimhood and IPV by judging the violence's "legitimacy." Loseke explains that violent actions that cause injury and possible death to a victim are categorized as "illegitimate" acts of violence because they have no justification (5). Conversely, illegitimate violence does not cause severe bodily harm and the victim is often perceived to have provoked the abuse. Loseke argues that severe physical violence is more likely to be viewed as "significant" by the general public and therefore worthy of sympathy in comparison to emotional and/or sexual abuse (6). Berns, Loseke, and Wood note that there are two overarching myths about how IPV is viewed: 1) IPV is not a common issue and should be dealt with privately; 2) victims are responsible for solving their abuse and in some instances cause it (Berns 23–24). In addition to these two myths there are also two problematic yet prevalent attitudes: (1) responsibility of the abuser can be obscured if they are thought to be mentally ill and; (2) the public focuses more on the psychological characteristic of an abusive relationship (Berns 23–24).

Public depictions of IPV perpetuate the idea of what Picart calls the "pure victim," and this representation reinforces attitudes that assign responsibility to the victim. The idea of the pure victim "promotes a stereotypic depiction of victimhood, and fails to 'get at' the nuances of what being a 'victim' entails" (Picart 98). Picart explains that pure victimhood entails "one who must be protected from 'evil' and predatory forces because she is incapable of any acts of agency to defend herself"; a pure victim is portrayed as weak, passive and without self-esteem (97). This discourse is problematic because it likens victimhood to childhood: a victim can only be free from responsibility when they are delineated as powerless and incapable of making rational decisions. Though these characteristics are not "one size fits all," this is how the media often depicts survivors who are deemed worthy of sympathy.

IPV discourses that center on agency highlight that individuals become

agents when they resolve their situation by finding the strength to overcome their abuse. In order to be considered agent, victims must resolve their situation by ending the abuse, most often by leaving their abusive partners, and such notions often frame how the public conceptualizes IPV agents (Picart 8). Contrary to attitudes about agency, an individual can only be a pure victim if they are not considered to have provoked the abuse and/or are incapable of removing themselves from the violent situation. When victims are unable to be designated as part of the dichotomy, they are delineated to a status the authors call "non-victimhood." Though IPV is largely framed publically within the pure victim/agent dichotomy, meaning is also assigned to individuals who fall outside of that division. Essentially, not fitting in the dichotomy assigns meanings of non-victimhood whereby these characters are perceived to have contributed to their abuse, stayed with the abuser, and/or provoked the abuse. When victims are viewed as provoking/wanting their abuse, the seriousness of the IPV incident is downplayed as legitimate and unproblematic violence. Discourses of pure victimhood in the twenty-first century are particularly significant because they are persistent in a time in which IPV has become recognized as a serious social ill and information about victim-blaming has been widely circulated. There is still speculation about the "purity" of a victim's abuse that can make it difficult for that victim to receive assistance and support, legal or otherwise. Because individuals rely on media representations to understand social issues they have not experienced, it is important that scholars understand how mediated interpretations of reality reinforce these attitudes.

Individuals are rarely perceived to be a victim of legitimate abuse unless they fit into the agent/pure victim dichotomy. The narrow categories that define an individual as either pure victim or agent results in a broad array of actions that can be categorized and defined as non-victimhood. When a narrative narrows the meanings of "pure victim," it also narrows the definition of IPV and such narrowing denigrates the seriousness of the issue. This narrowing is problematic because it disseminates specific notions about IPV and victims that ignores the nuances of a violent romantic relationship. When scholars and the general public ignore these nuances, we ignore potential victims of IPV who could be in need of help. In order to understand the attitudes the public may have held during the time *Gotham City Sirens* was published, the authors investigate the public's judgments about one famous IPV case from 2009.

Implications of Conceptualizing Victimization

In the months immediately preceding the release of *Gotham City Sirens* one case of IPV caused a media stir and provoked public judgment. During

the 2009 Grammy awards, rapper Chris Brown was arrested after beating his then girlfriend, Rihanna. In the wake of this incident, unauthorized police photos of Rihanna's bruised and bloodied face leaked to the media. Kristen Rodier and Michelle Meagher argue that the police photos had the opportunity to encourage women to recognize signs of violence. However, instead of raising awareness to the issue of IPV, these photos were sensationalized through reports of Brown and Rihanna's actions preceding the abuse and questioning what could have caused such brutality. Although Rodier and Meagher note that these photographs and their accompanying report had created some awareness, media stories that did not speculate about the "cause" of the violence focused on Rihanna's failure to leave Brown after his arrest. Editor-and-chief of *Hollywood Life*, Bonnie Fuller, wrote a scathing article about Rihanna's failure to leave Brown. Likening Rihanna to Tina Turner, Fuller proclaimed that Rihanna needs to ask herself "do I want to spend years of my life, like Tina, trapped in a relationship so controlling that I could lose all my self-esteem and control over my own finances?" Although Fuller vilifies Brown, she places equal responsibility on Rihanna: she assigns blame to Rihanna for not recognizing her situation and achieving agency while also making assumptions that Rihanna lacked self-esteem or believed that the violence was a onetime occurrence.

Fuller's article is only one of thousands that berate and reprimand Rihanna for her decision to continue a relationship with Brown. For the media and the public who consumed those reports, Rihanna failed to garner substantial sympathy because she did not meet the characteristics of pure victimhood. Successful, self-confident, with the available resources to leave the situation, Rihanna could not be depicted as a pure victim because she was/is not weak, powerless, and/or incapable of making rational decisions. Although some media reports advocated for IPV protection, they also reinforced notions of pure victimhood and belittled Rihanna's experience as a victim.

The tensions among pure victimhood, agency, and non-victimhood are represented in *Gotham City Sirens*. Because superheroes save innocent people from imminent doom, it can be assumed that they have the agency to enact self-determination in their own lives. The tensions between superhero and victim, agency, and non-victim in *Gotham City Sirens* are manifested in a way that undermines the seriousness of Harley's abuse.

Analysis

Within the text, *Gotham City Sirens*, Harley's actions guide the narrative towards an interpretation of how a reader should assess victimhood and IPV.

Harley's extraordinary abilities automatically give her some notion of agency whereby she has the capacity to act against her abuser. When Harley does not act in the way expected of agents, she cannot be defined as agents in their IPV situations, regardless of her super powers. The preexisting notions of agency places Harley in a double bind because her abilities automatically determine that she has the capacity to act and is therefore not a pure victim. What follows is an investigation of this tension and if it becomes enacted in the narrative text.

Harley has been and continues to be defined by her relationship with the Joker. Villains in the text like Bone Blaster, Hush, and the kidnappers refer to her as "Joker's chick," and her friends' perceptions of the abuse leads Poison Ivy, Catwoman, and Harley to attempt to resolve the problem of Harley's abusive relationship.

Harley is separated from the Joker at the beginning of the narrative. Although it can be perceived that being detached from the Joker's abuse is agential, Harley's actions suggest that their separation is a matter of force rather than independence. Early on in the text, Catwoman and Ivy express skepticism when Harley asserts that she and the Joker are over:

> CATWOMAN: Oh, please. He'll be calling for your money the second he hears about it. [...]
> HARLEY: *HAS* he called?! [Dini 10].

In these panels, readers are guided to initially interpret Harley's abuse through her friends' perceptions. If Catwoman and Ivy do not trust Harley to have agency, readers cannot assume that she has the capacity to act. The reader can assume that Harley gives little consideration to the benefits of being separated from that relationship. Instead, the narrative suggests that Harley provokes and wants the abuse.

After the Joker tries to kill Harley for going on a date with Bruce Wayne/Hush, Harley and Ivy state:

> HARLEY: I don't need Bruce Wayne, especially now that Mr. J is back.
> IVY: But he tried to **kill** you.
> HARLEY: That just **proves** he wants me back! [93].

Although almost being killed by her partner fits within the characteristics of illegitimate violence, Harley does not consider her situation to be abusive. In fact, the narrative explicitly expresses Harley's justification for the abuse. Though readers are invited to interpret Ivy's perceptions as more reasonable than Harley's, these panels are particularly concerning because they perpetuate a myth that designates violence as a measure of affection. Although Ivy attempts to reason with Harley, she insists that the Joker's action in finding and shooting at Harley was evidence of his want to continue the relationship. Ivy's attitudes are more reasonable, but Harley's perceptions and

actions concerning her relationship inform the reader of how they should assess her abusive situation. If Harley believes his abuse is a measure of affection and therefore insignificant, the reader is guided to interpret her abuse as unimportant. Harley continues to rationalize the Joker's violence as a measure of affection:

> I made him so **jealous** that he pulled out all the stops to get my attention! He hasn't used classic shtick like giant balloons and wacky henchmen in **years**! My puddin' loves me. Really. I know he gets a bad rap, but beneath the madness he's nothin' but a **puddy tat** (94).

Immediately following Harley's justification, the Joker sneaks up on the three super heroines and starts to shoot at them inside their dwelling. The Joker's action following Harley's definition is somewhat ironic; though she is justifying his actions, he is reasserting his aggressive and controlling behavior. Within the overall narrative, Harley's justification of violence is particularly significant because it completely removes her from the realm of victim. Niwako Yamawaki et al. argue that justifications for violent situations provide outsiders with negative meanings associated with not leaving the partner (3197). Additionally, Policastro and Payne contend that victims who stay in their relationships and justify their abuse are viewed as liking/wanting the abuse and/or liking the attention of the abuse (342). For Harley, her desire to continue her relationship with the Joker guides the reader to interpret her experience as insignificant and not even abusive. Essentially, the narrative text guides the reader to victim blame Harley for her abuse. Harley is not a victim because the abuse is portrayed as being her fault. Yet she is not an agent because she is not independent from the Joker's victimization. Although Harley's action set the reader to have a victim-blaming interpretation of Harley's abuse, the Joker's actions further heighten the responsibility placed on Harley.

The Joker's controlling behavior in the text is particularly distinctive because it upholds Harley's abuse as insignificant while also decreasing the responsibility placed on the Joker. The text tells us that the Joker is controlling by alluding to his past controlling actions and illustrating his current actions against Harley. When the kidnappers notice that Harley is "Joker's girl" they indulge in a little anecdote whereby one kidnapper warns the other of the Joker's vociferous behavior: "Buddy of mine was doing a stint in Arkham. He *whistled* at her [Harley] once. That night they found him hanging from a drainpipe with his lips cut off" (Dini 37). Even if a reader was not already aware of Harley and the Joker's relationship, the text often alludes to the severity and the prevalence of violence.

Utterances of Harley being "Joker's chick" insinuate that Harley is essentially *owned* by the Joker. When the kidnappers explain the Joker's actions

against another man who simply whistled at Harley, he is telling the readers that the Joker is controlling and unwilling to even allow another man to look at her. Harley considered the Joker's controlling behavior when she contemplates a prospective relationship with Bruce Wayne. On the balcony during their date, Harley attempts to dissuade herself from being romantic with her date by referencing the Joker's controlling behavior: "Aw, come on. Me and BRUCE WAYNE? I couldn't do that to the poor sap. Somehow, some way Mr. J would kill him" (81). The text tells readers that the Joker sees a newscast reporting on Harley's date with Bruce Wayne. Upon seeing Harley with Wayne, the Joker embarks on a mission to prevent the two from forming a romantic relationship. When the Joker interrupts their date, he admits his perceived betrayal: "My, My! When I saw it on TV, I just couldn't **believe** it! But here's my proof my one and only squeeze Harley Quinn making hey-hey with Bruce Wayne" (84).

Despite being shot at after this sentence, Harley attempts to rationalize with the Joker: "Puddin'! **WAIT!** Would it help if I said this is all a **big misunderstanding?**" (85).

Although Harley is attempting to deter the Joker from killing her and Bruce Wayne, he refuses to be deterred. The next panels highlight the true extent of the Joker's controlling behavior. However, such demonstration also depicts him as mentally ill and therefore not responsible for the abuse:

> I suppose I should be **big** about it. After all, what can I offer her in the long run but a life of crime and maybe a honeymoon cell for two in the **Laughing Academy**? Anyone else would be **happy** to see her moving on and forming such a promising relationship. But I'm really a small, vindictive soul beneath this smile, and nothing would give me greater pleasure than to see her **die in agony**! [86]

The Joker's scene in which he attempts to kill Harley and Bruce Wayne offers the reader a particular interpretation of the Joker. His narrative on this page seems almost self-deprecating. When he talks about his "small, vindictive soul" the reader is guided to assume that the Joker is experiencing some sense of mental illness that makes him unable to control his actions. Supporting Loseke's evaluations, the Joker's responsibility for the abuse is mitigated due to his perceived mental illness. Due to his obvious insanity, the Joker is not necessarily responsible for his abusive actions because they are a result of his insanity. Furthermore, Wood argues that such denigration of abuse is consistent with long held romance narratives that position an abuser as a misguided protector.

Wood explains that romance narratives are pervasive and are constantly being repurposed and bolstered in popular culture (242). These narratives take a once strong heroine and turn her into a character that comes under the protection of an abusive prince. It is difficult to interpret the Joker's actions

as protection; however, they do repurpose a narrative whereby Harley is weaker than the Joker and submissive to his demands. The Joker openly discusses his controlling behavior and other characters confirm it, yet Harley continues to justify his actions and continue their relationship.

It can be argued that Harley's abuse is void when the Joker is actually identified as Gaggy. However, the authors argue that this scene actually amplifies Harley's assigned responsibility. Essentially, Harley uses Gaggy's disguise as a means to justify the real Joker's affections towards her. Because Gaggy is the one who tries to kill her in the text, she dismisses the Joker's past abusive actions when she expresses her desire to continue her relationship at the end of the text. When Harley believes that Gaggy is the Joker, she does not fight back and merely dodges his fatal advances, whereas she fights back once learning that Gaggy is the real assailant. Her feelings and attitudes conveyed to Gaggy reveal that she wishes to please and continue a relationship with the real Joker. These actions indicate that Harley is willing to battle against people who she knows are not the Joker. When the text ends, the Joker's true identity becomes the focus of Harley's attention. After the three characters defeat Gaggy, Harley expresses that desire to return to the Joker. Because Gaggy disguised himself as the Joker, it was Gaggy who tried to kill her, not Mr. J.

Conclusion

There are very fine lines drawn between agent and victim, and the outlining of this narrow dichotomy ultimately leaves most individuals who experience abuse to be considered as neither victim nor agent. Interestingly, this dichotomy makes it extremely difficult for an individual to be placed in either pole, leaving most IPV experiences to be considered as legitimate and thus normal. Readers of IPV narratives are only privy to information that the narrative gives. When a narrative does not offer concrete solutions to a victim's abuse, the reader must use socio-cultural meanings associated with IPV to make sense of the character's actions and abusive situation.

For both Catwoman and Harley, their status as superheroes automatically assigns them to a position of expected agency. Their expected agency is problematic because it simultaneously relegates them to non-victimhood. When these superheroes fail to achieve agency, it is hard for them to be recognized as pure victims. Harley Quinn's narrative insinuates that Harley *wants* to be abused. Ultimately, when victims of domestic abuse are assigned to non-victimhood, they are considered part of the abusive problem.

The designation of abuse to non-victimhood negotiates and repurposes gender schemas that depict men as powerful and women as weak (Wood

241). When narratives ground a victim's abuse in non-victimhood, illegitimate violence is not enough to ground their IPV narrative in good reasons. Harley's actions in the narrative act as good reasons for the meanings assigned to her character. Those actions and meanings are then used as good reasons to justify her status as non-victim Based on physical prowess and abilities, Harley is expected to be agential yet does not resolve her situation by ending the abuse. In fact, the text guides a reader to interpret that Harley wants and is responsible for her abuse. Harley's justifications of the Joker's abuse offer readers a unique perspective of IPV: Harley is both naïve and fully aware of her abuse. She knows that the Joker has tried to kill her on multiple occasions yet she is naïve to his perceived intentions. To Harley, acts of violence indicate romance, not danger. Harley's actions justify the meaning assigned to her character that she is naïve while also grounding her status of non-victimhood in good reasons. Harley knows about her abuse, but puts herself and others at risk to continue that relationship. The actions motivated by her longing to continue her relationship act as good reasons to justify her status of non-victimhood. She is not an agent because she has not resolved her situation, but she is not a pure victim because she is considered at fault for the abuse.

In the overall message of the narrative, the meanings assigned to these characters and their abusive situations do not support IPV as a socially desirable action. Rather, this analogue disseminates an interpretation of IPV that minimizes the significance of the issue. This interpretation provides readers with a way of understanding victimhood that can be used to make real world assessments. If a reader has no first-hand experience with IPV, they could use this text to discern what is and is not considered victimization and IPV. By narrowing the definitions of agency and pure victimhood, individuals are more likely to be placed as non-victims who are not in urgent need of resolving their violent circumstances. Additionally, the narrowing of the definition of victimhood resulting from Harley's narrative opens up the possibilities for a reader to interpret the violence against her as legitimate. If a reader were to use this narrative as a framework in the real world, they could misinterpret similar actions as illegitimate IPV. In reinforcing that most individuals who experience IPV are non-victims, media portrayals of this social issue reproduce a belief that "women must be accommodating and to seek and please men; men are taught to be dominant and to regard women as inferior" (242).

Lastly, it is interesting to note that both Catwoman and Harley Quinn are experiencing violence at the hands of men disguised as their romantic partners. Both Catwoman and Harley experienced some measure of abuse in their relationships with Bruce Wayne and the Joker, but their abuse in the text is perpetrated by other men. Though the abusers in the text are disguised as Catwoman and Harley's intimate partners, they are not initially aware of this impersonation and their narratives are grounded in their relationships

with the real partner. The fact that Gaggy was an impersonator of the Joker offers this analysis an interesting understanding of meanings of victimhood: if Gaggy was an average villain in a different story arc, Harley probably would have been more likely to protect herself against Gaggy's violent actions. By disguising himself as Harley's romantic interest, Gaggy was able to assert the same authority over her as the Joker. This dynamic suggests that female superheroes are able to be agential against opponents but not necessarily romantic interests who act violently towards them. Additionally, this dynamic insinuates that female characters may not perceive an individual to be a villain if they are a romantic interest. Ultimately, Gaggy's impersonation of the Joker tells readers that female characters are less likely to respond to violence by romantic interests and enact agency in those situations. Because the reader only knows what the narrative tells them, this aspect tells readers that a female superhero can downplay their ability to be an agent if they are enacting agency in response to a romantic interest's actions. Overall, *Gotham City Sirens* provides readers with a preferred interpretation of IPV that disseminates a particular definition of intimate partner violence and victimhood. The text's interpretation is similar to prominent socio-cultural IPV myths that absolve an abuser of responsibility and places that responsibility on the victim. These myths place the burden of proof on the victim, and if they are unable to be placed within the agent/pure victim dichotomy, the victim is then assigned blame for their abuse. Additionally, this narrative upholds a prevalent sociocultural myth that supports a notion that most cases of violence between intimate partners are illegitimate and legitimate IPV is rare. When texts continue to support this notion, they continue to diminish the importance and seriousness of IPV.

Note

1. An earlier version of this chapter was made available by the University of Nevada, Las Vegas, as a 2015 thesis. The chapter has been edited to meet the requirements of this publication.

Works Cited

Barthes, Roland. *The Responsibility of Forms: Critical Essays on Music, Art, and Representation.* Berkeley: University of California Press, 1985. Print.

Berns, Nancy. *Framing the Victim: Domestic Violence Media and Social Problems.* New York: Aldine de Gruyter, 2004. Print.

Bornstein, Robert F. "The Complex Relationship Between Dependency and Domestic Violence: Converging Psychological Factors and Social Forces." *American Psychologist* 6.6 (2006): 595–606. Electronic.

Bortolussi, Marisa, and Peter Dixon. *Psychonarratology: Foundations for the Empirical Study of Literary Response.* Cambridge: Cambridge University Press, 2003. Print.

Campbell, Karlyn Kohrs. *The Rhetorical Act.* Belmont: Wadsworth Publishing Company, 1982. Print.

Catalano, Shannon. "Intimate Partner Violence 1993–2010." *U.S. Department of Justice,* November 2012, Web. February 2015. http://www.bjs.gov/content/pub/pdf/ipv9310.pdf.

Chandler, Daniel. *Semiotics: The Basics*. London: Routledge, 2002. Print.

Dazinger-Russel, Jacqueline. *Girls and Their Comics: Finding Female Voice in Comic Narrative*. Lanham: Scarecrow Press Inc., 2013. Print.

Dini, Paul (w). March, Guillem (p). Villarrubia, Jose (i). Wands, Steve (l). "Gotham City Sirens: Book One." *Gotham City Sirens*, v1 (2009) Eds. Rachel Pinnelas, Warner Brothers. DC Comics.

Dunn, Jennifer L., and Melissa Powell-Williams. "'Everybody Makes Choices': Victim Advocates and the Social Construction of Battered Women's Victimization and Agency." *Violence Against Women* 13.10 (2007): 977–1001. Electronic.

Fisher, Walter R. "Narration as a Human Communication Paradigm: The Case of Public Moral Argument." *Communication Monographs* 51.1 (1984): 1–22. Electronic.

Fuller, Bonnie. "Tina Turner to Rihanna: Leave Chris Brown Now!" *The Huffington Post*. March 23, 2009. Web. February 2014. http://www.huffingtonpost.com/bonnie-fuller/tina-turner-to-rihanna-le_b_168736.html

Madrid, Mike. *Supergirls: Fashion, Feminism, Fantasy, and the History of Comic Book Heroines*. Minneapolis: Exterminating Angels Press, 2009. Print.

Mahoney, Martha R. "Victimization or Oppression? Women's Lives, Violence, and Agency." *The Public Nature of Private Violence: The Discovery of Domestic Abuse*. Ed. Martha Fineman and Roxanne Mykitiuk. New York: Routledge, 1994. 59–92. Print.

Miczo, Nathan. "Punching Holes in the Sky: Carol Danvers and the Potential of Superheroism." *Heroines of Comic Books and Literature*. Ed. Maja Bajac-Carter, Norma Jones, and Bob Batchelor. Lanham: Rowman & Littlefield, 2014. 171–184. Print.

National Network to End Domestic Violence. "Domestic Violence Counts 2009: A 24-Hour Census of Domestic Violence Shelters and Services." *National Network to End Domestic Violence*, 2009. Web. February 2015, http://nnedv.org/downloads/Census/DVCounts2009/DVCounts09_Report_BW.pdf

Picart, Caroline Joan S. "Rhetorically Reconfiguring Victimhood and Agency: The Violence Against Women Act's Civil Rights Clause." *Rhetoric & Public Affairs* 6.1 (2003): 97–125. Electronic.

Policastro, Christina, and Brian K. Payne. "The Blameworthy Victim: Domestic Violence Myths and the Criminalization of Victimhood." *Journal of Aggression* 22.4 (2013): 239–347. Electronic.

Schneider, Elizabeth M. "Feminism and the False Dichotomy of Victimization and Agency." *NYL Sch. L. Rev.* 38 (1993): 387–399. Electronic.

Stabile, Carol A. "'Sweetheart, This Ain't Gender Studies': Sexism and Superheroes." *Communication and Critical/Cultural Studies* 6.1 (2009): 86–92. Electronic.

Wood, Julia T. "The Normalization of Violence in Heterosexual Romantic Relationships: Women's Narratives of Love and Violence." *Journal of Social and Personal Relationships* 18.2 (2001): 239–261. Electronic.

Bride of the Monster
Harley Quinn as a Case of Hybristophilia

Michał Siromski

On July 22, 2011, the Norwegian Anders Breivik left his home dressed in a police uniform and traveled to Utøya Island, where the Workers' Youth League held summer camp. Claiming he was there because of an earlier attack on Regjeringskvartalet, the government headquarter in Oslo, he walked around the island and shot vulnerable young people with a rifle. Before voluntarily surrendering to the police, he murdered sixty-nine people and seriously wounded another thirty-three ("Anders Behring Breivik: the indictment."), making it one of the most horrifying crimes of the twenty-first century. The world's media focused on Breivik's case for many days, presenting him unanimously as a hideous monster while also trying to understand the reasons for his actions. However, following the story something even more strange happened. The jailed Breivik began to receive numerous love letters from different women. They were not women who knew him previously but ones who fell in love with him *after* the terrible acts he committed on Utøya Island.[1]

Of course, Anders Breivik is not the first and the only killer to receive this kind of attention. In fact, the phenomenon of murderer's admirers or serial killer "groupies" is as old as the phenomenon of serial killers itself. From William Henry Theodore Durrant's "Sweet Pea Girl," to Ted Bundy's two hundred love letters a day on death row, female admirers have surrounded almost every famous killer. How does one explain this phenomenon? Why do some women fall in love with terrifying criminals, from whom all others run as far away as possible? It is easy to assume that these women must be abnormal, unattractive, unable to find love, sick, or immoral. However, the evidence does not confirm these assumptions. As RJ Parker stated, "Most SKGs [serial killer groupies] are attractive and well educated. Many are

already married; they are mothers, and in several cases, they even work in law enforcement or psychology" (loc. 125).

Specific examples also contradict the theory that such women are abnormal. Perhaps most remarkable is the case of Richard Ramirez who made crime history as the repulsive serial killer called the "Night Stalker." He was convicted of 60 crimes (many of them brutal murders and rapes), and despite this, he had a whole collection of women admirers while on death row. According to prison authorities, he averaged eight to ten female visitors per week. Doreen Lioy, a journalist, a publisher of children's literature, a woman with a Master's degree in literature and IQ 152 (Czerwiński), decided to marry him.

These examples mirror Harley Quinn and The Joker's relationship. This essay explores how Harley Quinn is a classic case of this unusual phenomenon through the lenses of psychology and criminology.

"Your diagnosis, Doctor J.?"[2]

In Grant Morrison's illustrated story, *The Clown at Midnight*, a narration box says that Harley loves the Joker "with a love so pure and unconditional, it has its own severe medical disorder classification in the psychiatric journals" ("The Clown at Midnight"). In fact, such disorder has already been classified: in the newest version of the American Psychiatric Association's (APA) classification of mental disorders (Morrison), in section Paraphilias, under code 302.9 (Paraphilia Not Otherwise Specified) can be found a list of some rare disorders. Among them is hybristophilia, defined as a sexual attraction to persons who have committed crimes, particularly violent crimes such as murder or rape. It is quite a rare disorder as evidenced by the fact that there is very little literature on this topic. It is also very atypical compared to other paraphilic behaviors since, according to Corey Vitello, the vast majority of hybristophilia cases affect women, while for most other sexual disorders it is exactly the opposite. The disorder is also diverse in characteristics and intensity (Parker loc. 214).

RJ Parker distinguishes two types of hybristophilia: passive and aggressive (loc. 189). Passive hybristophilia occurs when a person willingly contacts a serial killer, develops fantasies about him, and writes love or sexual letters to him. Aggressive hybristophilia is when a person is actively involved in committing crimes and does so as an expression of love.

It is necessary to point out that that although hybristophilia is a mental disorder, it does not mean that these women are mentally ill. Mental illness means having observable anomalies in behavior, emotions, or in relationships with others. Hybristophiles however fully understand the consequences of their actions, correctly perceiving reality and reacting to it.

Hybristophilia also should not be confused with the tendency of some women to bond with psychopathic men. Not every criminal is a psychopath, and not every psychopath breaks the law. Nevertheless, murderous psychopaths and creative psychopaths have a set of very similar traits, differing only in the intensity of these traits (Dutton). Likewise, women attracted to psychopaths show many of the same traits but with varying intensity as hybristophiles. Therefore, this essay discusses literature on both hybristophilia and admirers of psychopaths in describing the Harley Quinn character.

"This is just the beginning!"[3]

Before discussion of Harley Quinn, it is important to understand the Joker character. The text *Four Things You Always Wanted to Know about the Joker (But Were Too Afraid to Ask)* (Boucher) develops the concept of the Joker as a "super-psychopath."

Psychopathy is a persistent personality disorder characterized by two elements: an inability to establish deeper relationships with others and a deficit of fear (Pospiszyl). Five key personality traits of The Joker's (cruelty, high intelligence, the ability to manipulate people, lack of fear, and narcissism) are all very specific to psychopathic personality, but these traits are raised to an extreme level, thus making him a "super-psychopath."

The Joker shows a high capacity for cruelty that implies sadism. Mental and physical torture not only give him visible joy, but they are also important elements of the sense of absolute power he has over his victims. Much like Barbara Gordon's portrayal in *Batman: The Killing Joke*, the Joker's victims are forced to bear pain and humiliation without any opportunities to defend themselves. This is a very important issue, which gives some understanding to why the Joker decided to pursue a relationship with Quinn. For the Joker, it is not a question of love; it is a question of power and control. That is why the Joker so often hurts Harley Quinn; he is proving his dominance over her, treating her like a toy, with which at any moment he can do what he wants.[4]

Cruelty is also a sign of high masculinity and high levels of testosterone. According to evolutionary psychology (Parker loc. 1686), women (as female animals) have always sought out alpha males, which are aggressive, self-confident, dominant, and energetic men. Psychopathic murderers fulfill these conditions completely. For these reasons, many women cling to psychopaths, seeing them as highly masculine and attractive (Seltzer). Paradoxically, while bonding with such a man is a guarantee of safety from others, the alpha male will be able to protect his women and children; she will also be in danger from his cruelty.

The second trait of psychopathic personality, high intelligence, makes the Joker a true criminal mastermind. He is able to outsmart Batman (*Batman: The Man Who Laughs*), but also shows incredible creativity and imagination such as his famous "laughing fish" scheme in Detective *Comics Vol. 1 #475*. In fact, many non-murderous psychopaths are aggressively assertive, successful people in such areas as television, science, politics, or business. Success is also seen as a sign of masculinity, power, and control, and therefore attracts other people, including women.

High intelligence also corresponds with the ability to manipulate people. Psychopaths possess glibness and superficial charm. They are often funny, eloquent, and persuasive. Many serial killers lure their future victims not by force, but by coquetry and personal charm. Evidence suggests that psychopaths are able to read perfectly the body language and emotions of their victims (Dutton 27). They know exactly what to say and what to do in order to charm their victims. The Joker has this skill at a remarkable level with an almost magnetic charisma and is able to bring, with great ease, other criminals or even protagonists to his side. His interactions with Harleen Quinzel/Harley Quinn are the greatest examples of this kind of manipulation.

Psychopaths further suffer from emotional poverty; they cannot feel stronger emotions or higher arousal states. They are unnaturally calm and cold as if they were deprived of their nervous system (which in many cases helps to commit crimes). Many of them do not know or experience fear; they therefore need strong incentives. They are looking for extreme sensations, wanting to live intensely and to be near the center of action. In the Joker's case, his lack of fear has manifested as a total lack of self-preservation. Many stories show that he does not feel any pain, laughing even when he is beaten or shot. His behavior is not risky or reckless from his perspective, he just really does not care whether he lives or not. For him committing crimes is just a form of thrill seeking. In the same way, his relationship with Quinn exists to break the boredom.

Psychopaths are very egocentric with inflated self-esteem. They are confident, arrogant, narcissistic, and insolent. They believe that the world around them exists only to satisfy their needs. From the psychoanalytic perspective, narcissism is the most important trait of psychopathy and plays a key role in the development of this psychological disorder (Pospiszyl 43–45). It is also a key benefit of relationships for a psychopath. A partner who is fixated on him will satisfy his desires and the need to be admired. The Joker also has that need, and Quinn fulfills this role perfectly. The intensity of the Joker's narcissism is so great that it easily morphs into theatrics. The Joker seems to believe that all eyes are turned on him, and that he plays the most important role in the most important play of all time. To him, the whole world is a theater, other people are props, and Batman is either the most important audience

or the only audience.[5] Harley Quinn is ultimately a prop; a tool the Joker uses to manipulate others.

"Say hello to your new, improved ...
Harley Quinn!"[6]

With the understanding of the Joker as a super-psychopath, this essay can take a closer look at his relationship with Harley Quinn and at Harley herself. Most of the information on this topic can be found in the most famous comic book starring this pair, *Mad Love*. The comic book compares in look and style to the *Batman: The Animated Series* and was indeed executed by the creators of this series, Paul Dini and Bruce Timm.[7] The story reveals the origins of the relationship between Quinn (as Dr. Harleen Quinzel) and the Joker. The story shows the first meeting between the two, their subsequent therapy sessions, and finally Quinzel's transformation into the criminal Harley Quinn. We also see Quinn's painful present: full of violence and humiliation in her life with the Joker.

The story *Mad Love* is an excellent narrative for this discussion about the hybristophilia phenomenon and Harley Quinn as a character. In particular, an examination of why she fell in love with the Joker, how the Joker manipulated her agency, and the personality traits that made Quinzel susceptible to hybristophilia.

Katherine Ramsland, Professor of Forensic Psychology at DeSales University, gives several reasons why some women decide to have a relationship with a criminal ("Women Who Love Serial Killers"), of which three are of note for this analysis. The first is that these women see the murderer, not as a violent man, but as a wronged boy and are compelled take care of him. Harley's relationship with the Joker is a perfect example of this compulsion. In one of the crucial moments of *Mad Love*, the Joker tells Dr. Quinzel, as part of a therapy session in Arkham Asylum, his childhood memories about his alcoholic father. He details a visit to the circus, his attempts to make his father laugh, and his father's violent outburst, "...then he broke my nose. / (...) I woke up in the hospital three days later" (Dini 26–28). Quinzel's facial expressions during this scene: first the sadness, then growing laughter, and finally horror portray her growing empathy with the Joker. This is groundbreaking scene for readers, because Dr. Quinzel no longer sees the Joker as a patient, a deranged killer. Instead, from that point on he is a wounded seven-year-old boy, who she should love and heal. Indeed, Quinzel describes this view of the Joker, "In the weeks ahead, it soon became clear to me that the Joker, so often described as a raving, homicidal madman, was nothing more than à tortured soul crying out for love and accept-

ance. / A lost, injured child looking to make the world laugh at his antics" (Dini 29).

The second reason Ramsland identifies is that these women crave part of the media's attention surrounding the famous murderers ("Women Who Love Serial Killers"). With few exceptions, almost all hybristophiles are mediocre, unknown women, and the object of their desire is a media star. The women become famous in their own way, selling the rights to the book or film to share their experiences with the public. Often, however, the public's interest in the serial killer groupie passes just as quickly as interest in the murderer himself.

This motivation also can be seen in *Mad Love*. When Dr. Quinzel starts her very first day of internship at Arkham Asylum, her motivation is clear. She wants to work there because she thinks that discovery of the famous criminals' secrets will bring her fame, "You can't deny there's an element of glamour to these super-criminals" (Dini 21)—she says to Joan Leland. Leland replies, "If you're thinking about cashing in on them ... / by writing a tell-all book ... / ... think again." (21).

The third reason Ramsland identifies is women's belief that pure love can transform a murderer and make him become a good man ("Women Who Love Serial Killers"). Such a missionary approach may seem to have a pure, altruistic basis, but nothing could be further from the truth. In fact, this belief is about their sense of agency and control. If they are able to change murderers into good men, it means these women have power over these men and are able to make the extraordinary happen.

Seemingly, this motive does not appear to apply to Harley Quinn. She does not want to change the Joker, or even convince him to abandon criminal activity. She repeatedly helps him commit crimes in many of the iterations and stories. However, Harley has two dream scenes of an idyllic life with the Joker, starting a family, having children. These scenes suggest that deep down Harley dreams about a very different life with a very different Joker, and that she subconsciously seeks to change him.

"It felt like a kiss...!"[8]

Harley Quinn's love probably would not be so intense without the brilliant psychological manipulations used by the Joker.

In 2008, researchers Sandra L. Brown and Liane J. Leedom issued a book titled *Women Who Love Psychopaths. Inside the Relationships of Inevitable.* The book collects the experiences of many women and is designed as a guide to help women who are involved in relationships with psychopathic men. The authors present, among other things, manipulation techniques used by

these men. Many of these techniques can be found in the Joker's relationship with Harley Quinn.

Of particular importance is the first phase of relationship, which Brown and Leedom call the "process of luring" (51). Many women perceive the beginning of a relationship with a psychopathic man as a period of very strong, positive emotions. A psychopath is then a "charming and engaging conversationalist, agreeable, insightful, sweet, twinkling eyes, a compelling talker, funny, a great storyteller, fun to be with, delightful, exciting, companionable, loyal, enthusiastic, upbeat, fun-loving, intense, and sensitive" (Brown and Leedom 55). This same description could be used to describe the Joker in the first phase of relationship with Quinzel. Before their first meeting he gives her a rose with an alluring letter; during the meeting he tells her that her name "puts a smile on [his] face" and that she is "someone who might like to hear [his] secrets" (Dini 25). During their therapy sessions, he is always nice, charming, understanding, and witty. Of note is his body language at this stage of the story. The Joker never shows aggression, brutality, rage, and does nothing to arouse fear. This behavior from the Joker is completely different from any other part of this comic.

Psychopaths have a marked ability to manipulate people, to capture and control the emotions of others, and are able to sense what they need to say or do with perfect timing. That is why many women experience feelings of "synchronization" during this period, detailed in Brown and Leedom's work: "It felt like he was my twin," "He was so in tune to my morals and beliefs" (59). These women describe their partner agreeing with them: "We would finish each other's sentences," "we had perfect understanding of each other and he enjoyed intellectual discussions" (59). They also describe great communication: "We could talk for hours" (59).[9] Psychopaths know exactly how to make a good impression and how to make women feel appreciated and understood. *Mad Love* provides a near textbook example, when Harleen Quinzel lays down on the couch and confides in the Joker that she is in love with him. "Pretty crazy, huh?" she says. "Not at all," Joker responds. "As a dedicated, career-oriented young woman, you felt the need to abstain from all amusement and fun. It's only natural you'd be attracted to a man who could make you laugh again." Harleen responds happily, "I knew you'd understand!" (Dini 30).

One of the classic tricks of psychopathic men is the use of women's strong empathy traits to inspire compassion or maternal impulses through a true or false story about their past life and relationships. Of these stories, one of the most frequent will concern the psychopath's painful childhood or abusive parents. Brown and Leedom cite significant testimony of one of the examined woman speaking of a psychopath: "He told me about being abandoned by his mother, the death of his dad, childhood abuse and being sexually

abused. I actually cried for the little boy he had been that wanted love and care but did not get it and I held him. He was very sensitive, childlike—a quiet woundedness to him" (Brown and Leedom 57). This example clearly shows the power this empathy trick can have.

The example in Brown and Leedom is remarkably similar to Quinzel's reaction to the Joker's circus story. It is unknown whether this painful story really happened. Ultimately, it does not matter, as the Joker only needs it to be a tool of manipulation. Batman understands this and tries to show Harley. "Was it the line about the abusive father, or the one about the alcoholic mom? Of course, the runaway orphan story is particularly moving, too. He's gained a lot of sympathy with that one" (Dini 45).

In a later stage of relationship, when a psychopath is no longer able to maintain his positive image, he engages in more sophisticated, but also more brutal, manipulations. These manipulations are based in a state of constant change and are designed to confuse their partners. The psychopath can be tender and sensitive one moment, brutal and aggressive the next. The Joker often treats Quinn harshly, but often also shows her sensitivity unexpectedly. In *Mad Love*, she suffers much at the Joker's hands, but a simple rose and note in the last scene causes all the painful moments to fade into oblivion for Quinn. Moreover, it is surprising how often this scene is repeated in other comics. In *Batman—Harley Quinn* (Dini 43), Quinn is chasing the Joker to repay him for all her pain and suffering, but the Joker's terse apology of "sorry" once again revives her love. In a *Gotham City Sirens* ("Hell Hath No fury") story, Quinn breaks into Arkham Asylum to finally solve her problem by killing the Joker, but again the Joker's words, "Hello, Harley. I've missed you" and a big hug causes her to recall only positive memories and passion towards him.

It is no coincidence that the Joker so often uses the same trick; it is effective. A woman in such an abusive relationship will seek approval, despite the violence; will display a need to believe that not all is lost, that the psychopathic partner really loves her. These women look for evidence of love and overestimate each sign as proof of this love. They convince themselves that all the suffering was not in vain, that it all makes sense, because these small displays will suffice. Psychopathic men know this and can keep a woman in this condition for years. That is why it is so hard for these women to leave a psychopathic man.

Harley Quinn has glimpses of the reality of her relationship with the Joker many times, but each time she tries to convince herself that reality cannot be true. In another *Gotham City Sirens* story, Quinn recognizes that she is only a pathetic, fanatical admirer of the Joker, but quickly adds, "if the real Mr. J. shows up again, who's to say he won't have changed for the better?" ("The Last Gag"). In *Date Nite* she even considers the fact that the Joker tried

to kill her to be proof of his love. "I made him so jealous that he pulled out all the stops to get my attention (...) / My Puddin' loves me. Really." ("Date Nite").

"Eyes on the sassy sidekick in spandex"[10]

Brown and Leedom examine one more important thing: whether a woman's personality influences her desire to be bonded with a psychopath (22–25). Only women with certain personality traits are prone to this type of relationship.

According to Brown and Leedom, the key trait is extroversion, or their attitude to the outside world (25). Extroverts are very sociable, friendly, open, energetic, and active. It might be surprising because many believe that those involved in a relationship with a psychopath can only be weak, insecure, dependent women, but it is exactly the opposite. As Sandra L. Brown emphasizes: "Those with whom I have worked are gregarious powerful women! Most of them are highly educated or have done well in their own line of work and are successful by anyone's standards" (22–23). She also notes that most of these women are attorneys, doctors, therapists, social workers, nurses, teachers, CEOs of companies, or NGO directors (22–23).

As a psychotherapist, Harleen Quinzel fits perfectly into this pattern. There is no doubt that she has an extroverted personality. Before she met the Joker, she was very confident, resolute, and resourceful. In addition, later she is characterized by her high energy and zeal for excitement. Although *Mad Love* suggests that Quinzel graduated through the seduction of professors, other comics show that she has quite a lot of psychological knowledge as well. For example, in *Hell Hath No Fury* (Calloway), she uses psychological knowledge to defeat guards at Arkham Asylum, and in *Girls Talk* she practically guesses the reason why Batman runs his crusade against crime (Dini 10).

A trait that is closely associated with extroversion is disorderliness. "This free spirit part of her that accepts life as it is, also has the capacity for accepting the lack of order and routine that is in a psychopath's life" (Brown and Leedom 25). That explains why Harley Quinn does not bother trying to create order out of the chaos that the Joker creates. Instead, she causes even greater chaos.

Another common trait of extroversion is competitiveness (Brown and Leedom 25). In *Mad Love*, despite her great respect for the Joker, Quinn tries to show that she matches his creativity, humor, and cleverness. Moreover, she surpasses him by trapping Batman and fixing the Joker's plan to kill him with piranhas, with her "death of a hundred smiles" scheme.

The combination of high extroversion and excitement-seeking traits results in low harm-avoidance and lack of fear. These are very dangerous traits because they make such women engage in riskier behavior and riskier relationships (Brown and Leedom 30). In the case of Harley Quinn, low levels of anxiety often result in lack of prudence and self-preservation.

Another important trait of extroverts is relationship investment, or great interest in social contacts. Extroverts derive pleasure from these contacts and in being sensitive to others' needs. A psychopath can use this relationship investment as an effective tool of control and manipulation, exploiting a woman's sensitivity and empathy. In *Mad Love*, the Joker pulls Quinzel along in his game of pretending to be the boy wronged by his tyrant father, showing a similarity between the father-stalker and the Batman-stalker. He also pushes her away, manipulating her by letting her know that he does not have a good opinion of her, thus causing her to prove she can be just as witty and as effective as he is.

Female extroverts typically show a high propensity to cooperate. Such women are characterized by openness, empathy, and altruism. Because of this, they succeed in jobs that require a lot of interactions and cooperation with others. It also makes them a very easy target for manipulation. They are often ready to listen, support, and protect psychopathic men despite the suffering they inflict. Women in love with psychopaths are characterized by high levels of loyalty and trust. They readily ignore even the most obvious facts and convince themselves that the men they are with are not so bad. They try to remain faithful even if they are constantly betrayed.

The last important factor is self-direction that is manifested by responsibility, goals achievement, and keeping promises. Psychopaths use this trait to their advantage since they are often characterized by immaturity and lack of responsibility, so relationships with self-directed women can perfectly mask their social maladjustment. Brown and Leedom even write about "parenting" the psychopath (Brown and Leedom 41). A woman in love with a psychopath often acts like the mother of a rebellious teenager: concealing his sins, explaining his behavior to other people, lying to defend his good name; and when he does get into trouble, she is ready to save him at any cost. Again, Harley Quinn shows this behavior in *Mad Love*. When she sees the Joker battered by Batman, she considers it her duty to rescue him. This is why she dresses up in costume and allows him to escape from Arkham Asylum, beginning her career as a criminal. In the first issue of her solo series, she goes even further. Not only does she break into Arkham Asylum and release the Joker, she also prepares her beloved a special hiding place with an "expandable boxing glove," "acid-spraying lapel flower," and Cuban cigars (all just to make the Joker feel more comfortable) (Kesel 1–12).

"Your baby girl's home at last"[11]

In *Women Who Love Psychopaths*, Liane J. Leedom develops a very interesting theory explaining how the women who love psychopaths have an abundance of extroversion, responsibility, and empathy. In her opinion, the key factor is having pathological (especially psychopathic) parents (Brown and Leedom 36). "The typical dysfunctional family has an elder daughter who is an *empath* and a son who is psychopath" (36). Although boys may also develop empathy, often this applies more to girls because empathy is more consistent with stereotypically feminine traits. The crucial factor between developing empathy or psychopathy is impulse control. Good impulse control allows one to take control over her emotions and ignore her needs. In this case, she quickly learns that it is safer to satisfy the expectations of a psychopathic parent (and even anticipate it), as it prevents wrath and punishment. This specific training helps develop cooperativeness, empathy, and focus on the needs of others.

This interesting concept has confirmation in the case of Harley Quinn. The history of her family is almost completely unknown, but the seventh issue of *Gotham City Sirens* series, called *Holiday Story*, gives some details. This is the Christmas issue showing how each of the three protagonists of the series spends her holiday. After a long time away, Harley Quinn decides to visit her family home in Brooklyn. First, we meet her mother who closes the door in her face. From the beginning, Quinn's mother interacts with her daughter with obvious hostility. A conversation in the kitchen turns into an argument, and when Quinn asks for a second chance, her mother screams: "That's all I do, give chance after chance to people who refuse to behave— you, your brother, your father!" After that, she quickly calms down and apologizes.

This scene shows Quinn's mother hiding a lot of rage and anger toward other family members as well as significant emotional instability. Both these traits suggest a high probability that Quinn's mother is also a victim of domestic violence, and her experiences have left her feeling a mixture of anger and helplessness.

Later, Quinn interacts with her brother, Barry. He sits on the couch, watching TV, and playing a toy guitar. His children are running around the house, but he is not interested in them. From the conversation that follows, he talks of having no work or any idea what to do with his life and has several children with different women. He has also wasted the $300,000 Quinn gifted him earlier. He acts harshly toward Quinn but in a completely different way than their mother. He simply does not care about her feelings and argues with her for pleasure.

Barry is a parasite that feeds on others; it is his way of life. He is com-

pletely irresponsible, does not care about others' feelings or even for his own children. His behavior and characteristics are quite similar to those examined by Brown and Leedom. Barry is a classic non-aggressive psychopath.

Finally, her father is introduced when Quinn meets with him in prison. From the conversation she has with him, the reader knows that he is serving a sentence for seducing and swindling rich women. He promises that this is the last time, that he understands his mistakes, wants to settle down and to compensate his family for all they have suffered. He even provokes Quinn to promise that she will give him some money if he is serious. Quinn only later realizes that he is manipulating her, trying to find out where her money is so he can steal it.

This meeting clearly indicates that Quinn's father is a classic psychopath. He is a charming and manipulative narcissist who lives by the deception of women. He can lie without blinking an eye, promise anything, and say what the other person wants to hear. He is ready to do anything, even deceive his own daughter, to achieve his goal. Her father's first appearance also hints at Quinn's attraction to the Joker, as her father's face twists into a wide smile that is an amazing likeness of the Joker.

Shown in *Gotham City Sirens*, Quinn's family picture fits perfectly into the model presented by Leedom: her father is a psychopathic manipulator; her mother is a broken victim of a psychopath, a daughter who is empathetic and extroverted, and a son who is a psychopathic parasite. On this basis, Quinn's childhood could be fertile ground for her future fascination with the Joker. In a hostile environment, she perhaps had to learn how to read and meet the needs of her father and because of this had become extroverted, sensitive, and empathic. She could not count on support from her mother so she developed resourcefulness, vigor, independence, and responsibility. She even decided to become a psychotherapist in order to understand fully her painful childhood experiences. All these traits pushed her into arms of the Joker, an even greater psychopath and manipulator than those in her family.

Over the last several years, Harley Quinn as a character has gone through a significant metamorphosis. Progressively she ceased to be hybristophiliac, blindly fixated on and subordinate to the Joker. She has instead become a more independent, free-spirited, and sexual figure. DC Comics even decided to change Quinn's origin to show more internal causes of Harleen Quinzel's change into Harley Quinn and marginalized the role of the Joker in this process (Kindt 19–24). Earlier incarnations of Quinn had perhaps less psychological wealth and were maybe less interesting as a character. Still, this version of Harley is an interesting example of the hybristophilia phenomenon and allows the reader to examine why someone would want to love a monster like the Joker.

Notes

1. See for example "Victoria's" story in: Robinson, Julian. "Swedish Woman Reveals She is in Love with 'Dearest' Anders Breivik and has Written More than 150 Letters to the Mass Murderer who She 'Wouldn't Want to be Without.'" MailOnline: n. pag. Web. 20 August 2015.

2. All internal titles are quotations from Harley Quinn's speeches. Dini, Paul and Bruce Timm (w). Timm, Bruce (p) (i). "Mad Love." *The Batman Adventures: Mad Love*. #1 (February 1994), DC Comics.

3. Quote from Dini, Paul (w). Guichet, Yvel (p). Sowd, Aaron (i). *Batman: Harley Quinn*. DC Comics, 1999. p. 44.

4. More about the relationship of Joker and Harley Quinn as gendered power struggle in: Taylor, Tosha. "Kiss with a Fist. The Gendered Power Struggle of the Joker and Harley Quinn." *The Joker: A Serious Study of the Clown Prince of Crime*. Peaslee, Robert Moses and Weiner Robert G. (ed.). University Press of Mississippi, 2015. pp. 82–93. Print.

5. See the Joker's internal monologue in: DeMatteis John Marc (w). Staton, Joe (p). Mitchell, Steve (i). "Going Sane, Part One: In to the Rushing River." *Batman: Legends of the Dark Knight*. #65 (November 1994). DC Comics. p. 24.

6. Quote is from Dini, Timm. "Mad Love" page 34.

7. It's worth to add that shortly later comics was adapted into one of the series episode.

8. Quote is from "Mad Love" page 64.

9. All quotations from authentic testimonies of women. Brown and Leedom. *Women Who Love Psychopaths*. p. 59

10. Quote from Kelly, Joseph (w). Lopez, Jose Angel Cano (p). Alquiza, Marlo (i). "A Clown Comes to Metropolis." *Action Comics*. #765 (May 2000). DC Comics. p. 5.

11. Quote from Dini, Paul (w). Lopez, David (p). Lopez, Alvaro (i). "Holiday Story." *Gotham City Sirens* #7 (December 2009). DC Comics. p. 12.

Works Cited

"Anders Behring Breivik: The Indictment." *The Guardian*. Web. 16 April 2012.

Boucher, Ian (ed.). *Human and Paragons: Essays on Super-Hero Justice*. Sequart Organization, 2016. pp. 114–132. Print.

Brown, Sandra L., and Liane J. Leedom. *Women Who Love Psychopaths. Inside the Relationships of Inevitable Harm*. Health and Well-Being Publications, 2008. PDF.

Brubaker, Ed (w). Mahnke, Doug (p) (i). *Batman: The Man Who Laughs*. Warner Brothers. DC Comics, 2005.

Calloway, Peter (w). Guinaldo, Andres, and Ramon Bachs (p). Bachs, Ramon, and Lorenzo Ruggiero (i). "Hell Hath No Fury." *Gotham City Sirens*. vl. #20–21 (February-March 2011), Warner Brothers. DC Comics.

Crime Feed Staff. "Serial Killer Groupies: When Murderers Have Fans." *CrimeFeed*. Web. 5 June 2015.

Czerwiński, Arkadiusz, and Gradoń, Kacper. *Seryjni Mordercy*. Muza, 2001. p. 371. Print.

Dini, Paul (w). *Batman: Harley Quinn*. Warner Brothers. DC Comics, 1999.

_____. "Date Nite." *Gotham City Sirens*. vl. #4 (September 2009), Warner Brothers. DC Comics.

_____. "Girls Talk." *Gotham City Sirens*. vl. #2 (September 2009), Warner Brothers. DC Comics.

_____. "Holiday Story." *Gotham City Sirens*. vl. #7. (Feb. 2010), Warner Brothers. DC Comics.

_____. "The Last Gag." *Gotham City Sirens*. vl. #6 (November 2009). Warner Brothers. DC Comics.

_____. Bruce Timm (w). Timm, Bruce, and Glen Murakami (p). Timm, Bruce (i). "Mad Love." *The Batman Adventures*. (Feb. 1994), Warner Brothers. DC Comics.

Dutton, Kevin. *The Wisdom of Psychopaths: What Saints, Spies, and Serial Killers Can Teach Us About Success*. Farrar, Straus and Giroux, 2013. Print.

Englehart, Steve (w). Rogers, Marshall (p). Austin, Terry (i). "The Laughing Fish!" *Detective Comics* #475 (February 1978), Warner Brothers. DC Comics.

Kelly, Joseph (w). Lopez, Jose Angel Cano (p). Alquiza, Marlo (i). "A Clown Comes to Metropolis." *Action Comics* #765 (May 2000). DC Comics. p. 5.

Kesel, Karl (w). Dodson, Terry (p). Dodson, Rachel (i). "A Harley Quinn Romance." *Harley Quinn.* vl. #1. (Dec. 2000), Warner Brothers. DC Comics. Print.

Kindt, Matt (w). Googe, Neil (a). "Harley Lives." *Detective Comics* #23.2. (2013) Ed. Wil Moss, Warner Brothers: DC Comics.

Morrison, Grant (w). Van Fleet, John (a). "The Clown at Midnight." *Batman.* #663 (April 2007), Warner Brothers. DC Comics.

Morrison, James. *DSM-5 Made Easy: The Clinician's Guide to Diagnosis.* Guilford Press, 2014. p. 648. Print.

Parker, RJ. *Serial Killer Groupies.* RJ Parker Publishing Inc., 2014. Kindle Edition.

Pospiszyl, Kazimierz. *Psychopatia.* ZAK Wydawnictwo Akademickie, 2000. pp. 19–32. Print.

Ramsland, Katherine. "Women Who Love Serial Killers." *Psychology Today*: n. pag. Web. 20 April 2012.

Seltzer, Leon F. "Why Do Women Fall for Serial Killers?" *Psychology Today*: n. pag. Web. 24 April 2012.

A New Kind of Leading Lady

The Complexity of Surviving Abuse and Becoming a Hero

WILLMARIA C. MIRANDA

"Ya know what? I've just come out of a pretty abusive rela-
tionship. I've had a little bit of time. I'm starting to come to
terms with life without my puddin'. And, you know what
I've decided? No one gets to lay a hand on me ever again."
—"The Hunt for Harley"

Domestic abuse is statistically very common, and according to the
National Coalition Against Domestic Violence, "1 in 5 women and 1 in 7 men
have been victims of severe physical violence by an intimate partner in their
lifetime" ("National Statistics") in the United States. Abuse, be it physical,
psychological, emotional, or sexual, is a global issue affecting millions of
individuals daily, and many studies have suggested that the media's portrayal
of violence and abuse perpetuates an ongoing acceptance of these terrible
acts. This then makes it even more difficult for victims to speak out and
escape the abusive environment without fear of suffering additional negative
experiences in relation to the abuse.

According to an article published in the *Journal of Psychiatric and Behav-
ioral Science* written by S. Kohlman and colleagues, the way the media handles
domestic violence has a direct impact on the way it is viewed in society.
Repeated media coverage of domestic abuse cases normalizes its occurrence
and subsequently leads to peoples' desensitization. Chronic and repeated
exposure to domestic violence is believed to cause changes in affective, cog-
nitive, and behavioral processes (Kohlman). The idea of domestic violence

84

becomes normalized and the public's reaction becomes one of acceptance and even justification of the violence. Therefore, it is important for the media to challenge this trend instead of supporting a worldview in which domestic violence is accepted. While there are portrayals of violent abusers that are villainized, the predominant culture surrounding domestic abuse is still one that chooses to ignore the abuse instead of condemning it.

In the revamped DC comics, Harley acknowledges that her relationship with the Joker was physically and mentally abusive and is determined to treat herself better as well as demanding that of others. This is in stark difference to her first comic book appearances in which she did as the Joker bid her and did not question their relationship despite being physically and emotionally abused.

The Joker was Harley's reason for doing almost every atrocious act she committed in the comics. She wanted to make him proud, and in order to do so, she had to behave like him and cause pain and chaos around her. This essay explores Harley's journey to regain her autonomy and recover from an abusive relationship which leads her to value her life more and demand respect for herself and others who are victimized. In this journey, she changes from being a villain to being a complicated hero. A hero not only for furry animals and the elderly, but for women in society who can identify with a character that chooses to fight to recover from abuse and, while she struggles with it a lot, also attempts to make amends for her bad deeds by doing good for those who are forgotten or ignored.

In the foreword to *Mad Love*, writer Paul Dini states that after creating Harley for *Batman: The Animated Series* he saw that he had the opportunity to tell the story of someone who fell in love with the wrong person and the tumultuous relationship that ensued. Dini points out that since the *Mad Love* comic, Harley has moved on and understood that her relationship with the Joker was abusive. Dini states that he does not "think of *Mad Love* as a victim's tale, but a cautionary one about what happens when someone loves recklessly, obsessively, and for too long" ("Mad Love" 6–74). This cautionary tale has now turned into one of endurance and growth. I will examine Harley and the Joker's relationship in the beginning stages, Harley's journey away from her abusive relationship with the Joker, and her struggle to move forward without him and become the person she wants to be.

The Early Stages

In the comic, *Mad Love*, it is established that Harley is delusional and lets her love for the Joker guide her behavior despite her better judgment. When the Joker is formulating a plan to capture Batman but Harley wants

his attention, the Joker gets frustrated with her, knocks her down, pulls her by the nose, and proceeds to literally kick her out in the mud. Upon recovering and standing up, she laments her situation, "You're a certified nutzo wanted by the law in two dozen states ... and hopelessly in love with a murderous, psychopathic clown. At what point did my life go so looney? How did it Happen? Who's to blame?" ("Mad Love" 6–74)

The questions Harley asks herself could lead to a breakthrough, but she easily finds someone else to blame. She chooses to blame Batman and begins to formulate a plan to capture him herself in order to prove her worth to the Joker.

This attempt to appease the Joker is Harley's way of dealing with the abuse in hopes that if she proves herself capable of capturing Batman the Joker would be proud and would stop abusing her. This is often seen in abusive victims and according to Sarah Buel, "[s]ome victims are in denial about the danger, instead believing that if they could be better partners, the abuse would stop" (Buel). However, the Joker is less than pleased that Harley was able to capture Batman so easily, and when he confronts her, he defenestrates her. This leaves Harley severely injured, subsequently captured by police, and placed in Arkham Asylum.

When being admitted to Arkham Asylum, Harley reflects on her experience and decides that she has had enough of the Joker and his abuse. "Never Again. No more obsession. No more craziness. No more Joker. I finally see that slime for what he really is." ("Mad Love" 6–74). This resolve lasts just a few seconds and ends the moment she sees that the Joker has left her a rose with a note saying "Feel Better Soon" ("Mad Love" 6–74). This simple gesture is all it takes for her to snap right back into the Joker's control because she believes he cares about her wellbeing.

Harley's low self-esteem leads her to believe that she is a fool and the Joker is the intelligent one who knows what is best for her. The Joker makes a calculated move by giving Harley a flower; he knows that she would go back to him if he shows that he cares because she would believe it came from a place of love. As she had done before, Harley blames herself for making him angry. This is a common reaction victims have when an abuser becomes aggressive because they always blame the victim for causing their behavior. When it is framed that the victim angered the abuser, the fault for negative repercussions is never on the abuser but on the victim. This leads the abused to change their behavior in order to satisfy their partner and reduce the likelihood of upsetting them ("Emotional Abuse").

At the beginning of *Mad Love*, the Joker blames Harley for his foiled plan to kill Commissioner Gordon. Harley does not argue with him about it and does not defend herself against his verbal and physical abuse. Instead, she continues to try and engage him hoping to pry him away from his Batman

obsession and onto some fun with her. His negative behavior toward her does not thwart her attempts to get closer. She manages to redirect the blame for the physical abuse she suffers at his hand and redirects her energy to try and make the Joker happy by capturing Batman.

At this point in the relationship, Harley does not see a way out because she does not want it. "Being in an emotionally abusive relationship is often difficult to recognize, because you begin to believe you are the problem. And once you recognize it, it is difficult to admit and even embarrassing" ("Emotional Abuse"). She does not recognize the abuse for what it is and only desires that she could have a life full of love with the Joker.

Staying Versus Leaving

Once Harley accepts that the Joker had wanted to hurt her, she is able to leave him. However, she stays because, as many victims of domestic abuse believe, she thinks he loves her. The violence and aggression is ignored or explained away because his behavior had not always been negative. An abuse victim wants the violence to stop, and they believe that pleasing the abuser will put an end to the violence. Victims do not stop loving their abuser immediately, if ever, but they do recognize the abuse. They seek to change it by putting all of their effort into the relationship and satisfying their partner. Additionally, many abusers are enchanting and know how to emotionally manipulate their victims in order to remain in the relationship (Buel).

When the Joker sends her a flower and card, Harley takes it as a sign that he would be there for her, and she immediately forgives him for pushing her out of a window to her would-be death. The Joker does indeed break Harley out of Arkham Asylum to continue their criminal ways until one of them, or both of them, are captured again.

In *Preludes and Knock Knock Jokes*, Harley breaks the Joker out of prison and proceeds to gather his henchmen to work on a Joker themed amusement park. During this time, the Joker pretends to be sick while Harley orders the goons around to fix the amusement park to her specifications, which she believes would make the Joker happy. However, the Joker is a self-obsessed sociopath who becomes jealous at Harley's popularity and decides it is time to kill her. This attempt on her life drives her to leave the Joker and try to make it on her own.

Victims of domestic violence often suffer from post-traumatic stress disorder (PTSD), which the United States Department of Veterans Affairs states "can occur after someone goes through, sees, or learns about a traumatic event" ("PTSD: National Center for PTSD"). Harley struggles with the trauma but cannot stop herself from believing that the Joker can change and their

love will make her happy. It is only after several attempts on her life and years of abuse that Harley is able to leave the Joker and give herself some space. This is partly due to her cultivating a rather strong relationship with fellow female villain Poison Ivy.

In *Preludes and Knock Knock Jokes*, Ivy confronts Harley about helping the Joker escape, and after he tries to kill them both, Harley realizes that she is delusional about her relationship with the Joker. Following the incident, Harley admits to Ivy that she cannot believe the Joker has tried to kill her. This act truly jars her and leads her to seek time away from the psychotic clown.

Starting a New Life

At the beginning of DC's New 52 *Harley Quinn* comic, the Joker tries to kill Harley again, but this time, she resolves to truly break free of his grasp and never go back. According to an article published in the *Journal of Interpersonal Violence*, victims of domestic abuse begin recovery by defining who they are and finding their identity again. "This included (a) regaining self-esteem and self-worth that was damaged by the abuser, (b) finding the way back to one's 'old self,' and (c) creating a new identity, post-abuse" (Flasch). This is exactly what Harley sets out to do when we see her again in her stand-alone comic. With the inheritance of an apartment building on Coney Island, Harley decides to get a job as a psychiatrist for the elderly and joins a roller derby team in order to make money legally instead of continuing to live a life of crime. Although, that does not last very long.

An interesting aspect of this story line is that Harley chooses to become a better person by helping those in need, and unlike other female heroines, she is not put on trial to prove herself fit for the task. Julie O'Reilly writes that female heroines are typically asked to prove themselves worthy before they are allowed to be heroes, stripping them of their autonomy and their power.

O'Reilly presents Wonder Woman as an example of the female hero having to prove herself worthy before she is allowed to be a hero. In Wonder Woman's first issue, Diana must compete and win in a series of challenges. The final challenge consists of a deadly game of "bullets and bracelets" in which the Amazon Princess must deflect gunshots using her wrist bands. The Amazon Queen, Diana's mother, is the one who determines whether she is truly deserving of the title "Wonder Woman" and is able to leave the mother land and join the world of man (O'Reilly).

Harley does not answer to anyone and therefore, is given complete autonomy for her actions. In this new comic series, Harley has the opportu-

nity to choose for herself instead of acting within the realm of what the Joker wants.

Furthermore, O'Reilly states that the real problem is what the narrative presents a female heroine to be. The heroine is someone who always needs validation of her heroic status from someone else. The trials take the active female subject and turn her into an object to be judged and valued by others who claim authority over her identity (O'Reilly).

Because Harley is not put on trial to grant her the ability to be hero, she has an agency a lot of female heroines are denied. She has authority over her own life, and her actions are not put into question. Following a tumultuous relationship in which she was psychologically and physically abused, it is a different Harley that we see in the New 52 *Harley Quinn* comics.

In the February 2016 issue of *Harley Quinn*, she breaks into prison in order to help her current boyfriend, Mason, whose cell is coincidently right next to the Joker's cell. Naturally, the Joker taunts Harley until she opens his cell door and enters to talk to him. However, the Joker continues to push her buttons until they are fist fighting each other. This fight is different from the ones before. Harley wants to hurt the Joker. She no longer loves him and recognizes his abusive and manipulative ways. She defeats the Joker, and as she parts she wants to make a few things clear to him, "If I ever hear you or see you again…. If ya ever mess with my family or my friends…. I'm not gonna be as nice as I was today, an' I'll finish yer alabaster ass fer good!" ("Twenny-Five Big One$").

Harley stands up for herself against her abuser and establishes control over herself. The Joker cannot let this go, so he continues to challenge her until she pulls a gun on him. However, instead of exacting further acts of violence, Harley walks away. She recognizes that what the Joker wants is chaos, and if she kills him, she would be giving him what he wants. So instead, she walks away.

A Complex Heroine for the Modern Day Audience

Harley Quinn is a character with depth and the capacity to resonate with many audiences because she is not an archetypal hero. She is an abuse survivor, a reformed criminal, and a mentally ill woman trying to make amends for bad deeds committed in the past. Her character growth and rise from the shadows of the Joker represent a move to create more realistic characters to which women can relate and connect. Elfriede Fursich writes that "Contemporary mass media operate as a normalizing forum for the social construction of reality." Therefore, what is continuously depicted in the media

is what society will consider normal. This is a dangerous situation in which harmful behaviors become accepted and then go ignored, leaving victims suffering and holding on to the blame.

Furthermore, Fursich states that media outlets "are important agents in the public process of constructing, contesting or maintaining the civic discourse on social cohesion, integration, tolerance and international understanding." This representation validates the existence of abuse survivors who have escaped their abusive environments and have resolved to heal themselves and do good in the world. Representation in media has the power to influence societal views on different topics, issues, and people.

> [R]epresentations are constitutive of culture, meaning and knowledge about ourselves and the world around us. Beyond just mirroring reality, representations in the media such as in film, television, photography and print journalism create reality and normalize specific world-views or ideologies [Fursich].

It is these world views or ideologies perpetuated by the media that guide societal action, and because of its impact, a character like Harley Quinn challenges current norms and forces the audience to deal with the brutal truth about domestic abuse and its repercussions. Audiences will face it in the comics, then take that world view and apply it to reality.

George Gerbner, a communications expert who coined the Cultivation Theory of Television, stated that television is an integral part of a complex process that does more than just perpetuate commonly held ideologies. "Institutional needs and objectives influence the creation and distribution of mass-produced messages which create, fit into, exploit, and sustain the needs, values, and ideologies of mass publics" (Gerbner). The public then accepts these ideas because of the constant exposure to them.

While Gerbner's theory is based on his study of television, it can also be applied to different types of media. Harley Quinn began as a character on a cartoon show and then joined the comic books. Since the days of *Mad Love,* she has been in numerous DC productions, including a lead in DC's *Suicide Squad* film. Her character crosses media boundaries and is accessible to a wide audience that can reflect on her experience as the Joker's girlfriend and then as Harley Quinn, an independent woman who refuses to continue being someone's punching bag and instead gains control over her life.

This version of Harley, however, has not fully been explored nor presented in film. Her character arc in the *Suicide Squad* film focuses mostly on her relationship with the Joker without condemning his abuse of her or showing their love story as toxic. However, the actress playing the role of Harley, Margot Robbie, has stated in press interviews that the Joker is abusive and Harley should learn and move on from that relationship (Chitwood). Robbie will be producing and starring in the Harley Quinn solo film. Because she

seems to understand the abusive nature of the relationship and the potential of the Harley character, there is a good chance it may be a film that captures the complexities of Harley Quinn as an independent, fully fleshed out character (Kit).

Domestic violence is a serious issue, and victims of domestic abuse should not be in the shadows painted as simply victims. When Harley stands up to the Joker in that jail cell, it holds meaning beyond those comic book panels. Harley is representative of anyone who has suffered abuse and tried to recover. When she faces the Joker and tells him she no longer wants to be his puppet, she shows her audience that she is a true survivor. If, as Gerbner believes, representation in the media means social validation then this move in *Harley Quinn* provides a glimpse of social validation for survivors who stand up to their abusers and walk away. According to an article by Lori Heise on gender-based abuse:

> Violence is an extremely complex phenomenon with deep roots in power imbalances between men and women, gender-role expectations, self-esteem and social institutions. As such, it cannot be addressed without confronting the underlying cultural beliefs and social structures that perpetuate violence against women [Heise].

By presenting a leading character who has suffered psychological and physical abuse, escape her abuser, and worked on her recovery, Harley Quinn offers audiences a different way to look at abusers and their victims. Harley confronts the Joker and states very clearly that she wants nothing to do with him, recognizing the toxicity of their relationship. Perhaps this final step will lead to the media finally ceasing to market the Joker and Harley as a psychotic couple in love. As stated in the article by Kohlman for the *Journal of Psychiatry and Behavioral Science*, "misrepresentation of [domestic violence] as romantic and attractive translates that violence against women is acceptable" (Kohlman). Harley Quinn has a sordid background, but her journey shows that victims of abuse can still prosper against adversity. It provides a new kind of heroine for an audience that is increasingly aware of social issues and demands that media portray them accurately.

WORKS CITED

Buel, Sarah M. "Domestic Violence and the Law: An Impassioned Exploration for Family Peace." *Family Law Quarterly* 33.3 (1999): 719–44. Web.

Chitwood, Adam. "'Suicide Squad': Margot Robbie on Understanding Harley Quinn, Cracking the Joker, and Fighting in Heels." *Collider.* Collider, 11 July 2016. Web. 18 July 2016.

Conner, Amanda, and Jimmy Palmiotti (w). Hardin, Chad (p) (i). "Twenny-Five Big One$." *Harley Quinn.* v2. #25. (Apr. 2016), Warner Brothers. DC Comics.

Dini, Paul, and Bruce Timm (w). DeCarlo, Dan, and Bruce Timm. (p) (i). "Mad Love." *Batman: Mad Love and Other Stories.* (June, 2009), Warner Brothers. DC Comics. Print.

"Emotional Abuse." *Sister Namibia* 26.1 (2014): 22–23. Literary Reference Center. Web. 12 Feb. 2016.

Flasch, Paulina, Christine E. Murray, and Allison Crowe. "Overcoming Abuse a Phenome-

nological Investigation of the Journey to Recovery from Past Intimate Partner Violence." *Journal of Interpersonal Violence* (2015): 0886260515599161.

Fursich, Elfriede. "Media and the Representation of Others." *International Social Science Journal* 61.199 (2010): 113–130. ERIC. Web. 12 Jan. 2016.

Gerbner, George, et al. "Living with Television: The Dynamics of the Cultivation Process." *Perspectives on Media Effects* (1986): 17–40.

Heise, Lori. "Gender-Based Abuse: The Global Epidemic." *Cadernos De Saúde Pública* 10 (1994): S135-S145.

Kit, Borys. "Harley Quinn Movie in the Works at Warner Bros. with Margot Robbie (Exclusive)." *The Hollywood Reporter*. The Hollywood Reporter, 16 May 2016. Web. 18 July 2016.

Kohlman S, Baig A, Balice G, DiRubbo C, Placencia L, et al. "Contribution of Media to the Normalization and Perpetuation of Domestic Violence." *Austin Journal of Psychiatry Behavioral Science*. 2014;1(4): 1018. ISSN: 2381–9006.

"National Statistics." *Statistics*. National Coalition Against Domestic Violence, n.d. Web. 20 Feb. 2016.

O'Reilly, Julie D. "The Wonder Woman Precedent: Female (Super)Heroism on Trial." *Journal of American Culture* 28.3 (2005): 273–83. Web. 08 Dec. 2015.

"PTSD: National Center for PTSD." *What Is PTSD?*. U.S. Department of Veterans Affairs, n.d. Web. 18 Dec. 2015.

Taylor, Tom (w) Redondo, Bruno, and Mike Miller (i). "The Hunt for Harley." *Injustice: Gods Among Us Annual*. #1. (Jan. 2014), Warner Brothers. DC Comics.

Duality and Double Entendres
Bi-Coding the Queen Clown of Crime from Subtext to Canon

ALEX LIDDELL

In June 2015, comic writers Jimmy Palmiotti and Amanda Conner finally gave voice to "something that fermented in fans' heads for years," by formally announcing that Poison Ivy and Harley Quinn are "girlfriends without the jealously of monogamy" (Narcisse). The statement, via the official DC Comics twitter account, officially established Harley Quinn as a canon multisexual[1] in the DC universe. To those unfamiliar with Harley Quinn, this "coming out" might seem arbitrary and out of the blue, but this revelation was preceded by layers of subtext spanning more than two decades, which picked up a substantial fan following to the point where many considered it canon in every respect but name.

This essay will act as an introduction to the many forms this subtext took and how it evolved into canon, as well as how fans shaped this evolution and the context that necessitated using this subtext in the first place. The various "bisexual tropes" and stereotypes that Harley Quinn falls into will also be outlined, as well as a how both positive and negative aspects of this media representation affect and reflect real life multisexuals. From this, using the analysis of bisexual theorists, this essay will examine why Harley Quinn has developed into a bi-coded icon and how she has the potential to subvert these tropes as a multisexual A-list antihero in the DC canon.

The Comics Code Authority

First, to understand why representing Harley Quinn's sexuality predominantly as subtext was necessary, instead of overtly from the start, the influence

of the Comics Code Authority must be acknowledged. The Code's influence on DC Comics is especially worth noting because they were one of the last comics publishers to drop the Comics Code Authority Seal of Approval (in 2011), in favor of their own guidelines and ratings system "consistent with that of the rest of the industry" (Phegley). The Code's guidelines, when it was founded in 1954, originally defined all depictions of sexual and romantic same-gender attraction as "sex perversion" that couldn't even be portrayed "in inference" let alone overtly (Senate Committee on the Judiciary).

While these rules were relaxed over time, the stigma against LGBTQ representation in comics still persisted. A huge part of maintaining this is the industry being hesitant to risk potential sales and feeling obligated to keep to an almost sacred original continuity. As DC Comics writer Gail Simone observed, "We have a problem most media don't have, which is that almost all the tent poles we build our industry upon were created over half a century ago ... at a time where the characters were almost without exception white, cis-gendered, straight, on and on" (Simone).

In addition to this, mainstream comics' superheroes are often the protagonists that viewers insert themselves into as part of wish fulfillment and to channel their perspective in a fantastical world (Brooker). So when there is a wider perception that the viewer is usually a heterosexual man (Pantozzi), characters who deviate from such norms are more likely to be secondary to or unaligned with the main male hetero hero. Multisexual subtext can slip by without issue by applying it to supporting characters and villains, as it is less likely to be scrutinized, since main heroic characters are held to a higher standard.

Harley Quinn made her first appearance in *Batman: The Animated Series*, a time when the Comics Code Authority's power was dwindling but had established more than four decades of DC Comics continuity shaped by its restrictions. There simply wasn't any significant or allowable non-heteronormative plot points to build on for the new series, nor was it the norm or acceptable to directly introduce "mature content" (which any form of overt LGBTQ representation was widely considered to be at the time) in a DC property with a young audience, even if it did have a darker edge.

Pushing some of those deep-set boundaries via subtext was one of the only tools available to writers and artists at the time; therefore, it's no surprise that Harley Quinn's apparent intimacy with Poison Ivy is subtler than her affection towards her male love interests, given the context. Nevertheless, the subtext present between Harley and Ivy starts surprisingly early on in their continuity and, some would argue, is remarkably apparent compared to queer subtext in similar DC narratives. This subtext starts in *Batman: The Animated Series* in the episode "Harley and Ivy." This episode forms the foundation of the suggestiveness every time they appear together from then on, not least

because there is an immediate (in Paul Dini's words) "physical chemistry" between them.

Harley and Ivy

Dini's tale of "the clownish girl" (Harley) and "the vamp" (Poison Ivy) begins with Harley being unceremoniously dumped by her boss and lover, the Joker; pledging to "go solo" Harley has a chance meeting with Ivy when they both try to rob the same building, under fire from the police they instantly form an alliance and make their getaway together.

They go back to Ivy's place, now on a first name basis they exchange banter, and then they resolve to give Harley "lessons in good old fashioned female self-esteem" by robbing and terrorizing male misogynists in Gotham City.

The plot has many parallels to the female empowerment caper *Thelma and Louise*, a film notorious for its own queer iconography (Hart). In the DVD commentary of the episode, Paul Dini says he was unconsciously channeling the film when creating the story of "two crazed women on the loose," a reference which was not lost on fans arguing for the pairing being more than platonic (Ortberg). In the same way that Thelma and Louise generates queer subtext by focusing on the intense dynamic between two women on the run from the law, the bulk of the episode is Harley and Ivy detailing their successful crime partnership and domestic life, where both are comfortable enough to live together without their costumes, in just their shirts and underwear.

At this point Ivy has already been established as a man-hating femme fatale, who some would argue is purposefully written as a "straw feminist"[2] to undermine her anti-misogynist message. A typical part of constructing a straw feminist is "lesbian baiting," i.e., media portraying lesbianism as interchangeable with feminism in order to insult and discredit women, which provides tactical opportunities to marginalize lesbians and women in general (Anderson). This erroneous connection is often used against specific opposition to violence against women, where accusations of "turning women into lesbians" are used to derail campaigners protesting injustices against women (Grant).

Despite this connection not being made directly, given how pervasive the lesbian-baiting trope is, and how much the episode focuses on Ivy's brand of villainous female empowerment, it's easy to make that association. Harley Quinn in this case can be considered guilty by association, since she's complicit in Ivy's crime spree of misandry, thereby risking accusations of "being turned into a lesbian," too. However, what distinguishes Harley as

being bi-coded rather than lesbian-coded is her devotion to the Joker through-out all of this, displayed by her still pining for him despite his violent rejection of her and the comfortable life she has with Ivy.

Unlike Thelma and Louise, Harley and Ivy don't end their union with a kiss and a suicide pact, neither are they defeated by bickering or intention-ally double crossing each other or even by being outwitted by Batman; it's ultimately Harley Quinn's pining for the Joker that accidentally reveals their hideout and sets events in motion for their capture. They are incarcerated but not apart; both are alive and allowed to keep having future adventures; and while Ivy is clearly annoyed by Harley continuing to fawn over the Joker, their partnership continues.

The episode proved so popular that Harley and Ivy became one of the most enduring pairings in the TV series, which continued into comics and video games. Further subtext was laid out whenever they appeared together, becoming ever more apparent when set in contrast with Harley's strained relationship with the Joker. As comic book commentator Steve Morris (2015) observes, "It's reached a point where, if the pair aren't happily intimating a sexual relationship whenever they meet, they just aren't being written in char-acter."

Dual Relationships

Appropriately for the queen clown of crime, much of Harley Quinn's subtext manifests itself in the form of jokes, particularly innuendo. Through-out her continuity, she often engages Ivy in the same playfulness and double entendres that are prevalent in her exchanges with the Joker. In *Batman: The Animated Series*, she can be seen enticing the Joker to "rev up" his Harley in their lair ("Mad Love") and try her "pie" on their anniversary ("Beware The Creeper"), and in her recent run in the New 52 comics universe she's asking Ivy if she wants "to see her beaver" when entering her new apartment ("Helter Shelter") and asks Ivy to "feel her chicken skin" when enjoying a moment cuddling each other on a rooftop.

Then there are the physical moments that are often more reciprocal than Harley's advances on the Joker, such as in the animated series when Ivy gently touches Harley's face as she looks lovingly into her eyes, even when repri-manding her ("Girl's Night Out"). This intimacy becomes more explicit as time goes on, for example in *Batman: Arkham Asylum* (released almost two decades after the original animated series aired), Ivy blows a seductive kiss to Harley after being released from her prison cell (Batman: Arkham Asylum). In the comic "Harley Quinn Road Trip Special," Harley revels in daring Ivy to strip naked in a game of truth or dare ("Road Trip Special #1"). Further-

more, in the standalone Harley Quinn comics run, they are both seen sharing the same bed, with Ivy planting a kiss on a sleeping Harley and calling her "my cute little psycho" ("Helter Shelter").

In a later issue of the Harley Quinn comics series, under the influence of alcohol, Harley kisses Ivy on the cheek thinking Ivy is offering to be her assistant/sidekick, then she playfully pins Ivy to the ground and flirts with her ("Demental Overload"). During this infamous sequence, two panels in particular stand out as exemplifying Harley and Ivy's sexually charged banter, which is half seduction and half comedy routine. We see them both close-up and face to face, seemingly poised to kiss on the lips, when Ivy asks, "Is that your hand?" Harley replies, "Is that yours?" Both of them have mischievous grins on their faces, as Ivy then asks Harley, "Are you going to get off?" Harley replies: *"Are you?"*

This could be labeled as baiting fans with girl-on-girl titillation with no actual point or resolution; however, as Morris explains, the women's relationship proved thematically useful in developing Harley from a supporting character into an antihero capable of leading her own franchise. By drawing her away from her all-consuming obsession with the Joker, her relationship with Ivy gives Harley the support and alternative focus to avoid being restricted to being a "victim of diminishing returns," where she could go on her own adventures encouraged by Ivy and not merely as a glorified henchwoman.

Ivy represents one half of Harley's conscience, acting as the positive influence opposing the Joker's negative, (or at least as positive an influence as a villain can be in this fictional world), thus driving Harley's narrative in new directions. The dual nature of Harley's relationship with both Ivy and the Joker is a theme that follows her characterization throughout various continuities, and this duality is the defining feature of Harley that distinguishes her from her comic book peers.

The romantic nature of Harley's relationship with the Joker is undeniable, as well as unavoidable since her origin story in the majority of her continuities is inexorably linked to him. Most of her character motivation revolves around seducing and being seduced by the Joker, or from trying to break free from the relationship. Yet Ivy is just as strong a presence in Harley's story as he is, albeit in a softer focus; the relationship is foreshadowed in TV episode "Mad Love," where an incarcerated Ivy shares prolonged eye contact with psychiatrist Harleen Quinzel when she firsts enters Arkham Asylum. Harleen states her reasons for coming to Arkham involve having an "attraction to extreme personalities," during which the camera lingers so long on their curious stare that you're left to wonder, what would have developed between them if the Joker was out of the picture?

They're also linked by the fact that Ivy is responsible for Harley's poison

immunity by giving her an antitoxin that was first introduced in the animated series episode "Harley and Ivy," which makes her immune to the poisons surrounding Ivy's hideout, and immune to Ivy's poison kiss and mind-controlling pheromones. The reason why Harley would want to be able to be intimate with Ivy and live with her was the subject of much fan speculation, so much so that it was referenced in the comic book spin-off series "Batgirl Adventures." In a comical exchange between Batgirl and Harley, Batgirl awkwardly asks Harley what she means by "play" with Ivy, implying that they are more than just "friends" ("Oy to the World").

This conceit was revisited in subsequent comics, where Ivy's antitoxin not only revives Harley after a violent rejection from the Joker but also gives Harley super-powered strength, agility and endurance (Batman: Harley Quinn 1999). If the Joker is responsible for creating Harley Quinn, Ivy has credit for sustaining her, if not for supplying Harley with powers to withstand assaults from the Joker and other assailants, then for providing support when nobody else would.

While the Joker on one side indulges her dark desires yet attempts to (often literally) destroy Harley on a whim, Ivy on the other side patches her up then attempts to nurture her.

This theme is highlighted in the comic "24 Hours," wherein Harley is released from Arkham, seemingly rehabilitated. Ivy is still incarcerated, and they both sadly touch the glass of the cell separating them as Harley leaves, just as parting lovers do. However, as soon as Harley is released, she is picked up by the Joker who only has to smile to get her to go on a crime spree with him. His inevitable betrayal leads her straight back into Arkham, where she waves to Ivy as she is escorted to her cell, with a look that says both are happy to see each other again but unhappy it's under such circumstances. This day-in-the-life of Harley implies that this cycle repeats, over and over again, the Joker is there to tempt her and Ivy is there to help her recover.

Support for Harley is no small gesture for Ivy either, because a core gimmick of Ivy's villainy is her misanthropy towards all humans and an obsession with plants (that sometimes verges on sexual) ("Jungle Fever"). Other than occasional unconsummated romantic tension with Batman ("Year 1: Poison Ivy"), the only constant and genuine affection she shows towards another human being is Harley. The help she continuously provides, unlike most villain alliances in Batman's universe, doesn't seem to have an ulterior motive either, contrary to when the Joker aids Harley. Even if they have harsh disagreements, they eventually re-join forces because of their kinship. Based on this alone, it would not be unreasonable to believe that the reason Harley is Ivy's exception is because she feels a much deeper love for Harley than for anybody else.

However, Harley does not simply settle down with Ivy once the Joker is

no longer available (either after they've broken up or when he's presumed dead). She often continues the dual relationship dynamic with other male sexual/romantic partners as stand-ins for her relationship with the Joker, such as Deadshot in her New 52 Suicide Squad continuity. By doing this she keeps her bi-coding (as she is in relationships with more than one gender) and reveals her polyamory (which is also often associated with bisexual tropes).

Double Identity

The duality Harley represents doesn't begin and end in her romantic life, either. Fragmentation and doubles are echoed throughout her characterization, even in her costume choice. Whether it is her double life as Harleen Quinzel (accomplished scholar and romantic) and her criminal jester alter ego Harley Quinn, or her role as a mentally unstable ditz and master strategist, she embodies duplicity and contrariness. Why wouldn't her sexuality follow suit?

With comics and television being visual mediums, naturally some of this multiplicity seeps into how she looks. For example, her first costume, the iconic "jester jumpsuit," follows an asymmetrical playing card-like pattern. Her redesigns for the Arkham video game series, comics series *Suicide Squad*, and her own solo comics run were radically different as a combination of corsets, short shorts, nurse outfits and fetish leather apparel. While altered from her iconic jumpsuit, they still carry the same asymmetry, with one half of her costume being one color (either black or pink) and the other side contrasting it (with either red or blue), either in patches (Batman: Arkham City) or completely dividing her body from her hair parting to between her legs ("Kicked in the Teeth"). Either way, it physically represents Harley as being made of multiple parts pulled together to make a singular person.

This is not just in keeping with her duality theme, it is portrayed in some of her continuities as a manifestation of her insanity, which is stated explicitly by *Suicide Squad*'s Harley Quinn when she constructs her costume by violently ripping the clothes off pedestrians she comes across during her mental breakdown ("Harley Lives"). She remarks in her internal monologue, "I am more like a collage now. A mosaic."

Her choice of dress holds extra significance to her bi-coding, as it nods at the asymmetry of her relationships with the Joker and Ivy, as well as the increased sexualization. Reflecting the more "mature" tone of the media she is portrayed in, sexualizing Harley's costume coincided with her relationship with Ivy becoming more explicitly implied to be sexual in nature.

Bi-theorist Shiri Eisner explains, "Bisexual women are presented in

hypersexualized contexts, as sexual objects for the hegemonic cis straight male gaze, while directly or covertly appealing to a quasi-pornographic fantasy" (Eisner). By presenting Harley in this outfit alongside her suggestiveness with Ivy and submissive relationship with the Joker, her sexuality connects to titillation, which can be interpreted as a deliberate attempt to emphasize her multisexuality via tropes associated with bisexual women without clearly stating it, or it could be for the "satisfaction of the presumed male spectator" thus sanitizing her attraction to Ivy.

Attempting to make their subtext more palatable to the status quo could also be the reason behind not explicitly labeling their own sexualities and relationships[3] and why there is rarely any strong focus on either of them having any attraction to other female characters besides each other.

Writing romantic plots in this way, with characters being the "sole exception" to a character's otherwise unambiguously homo- or heterosexuality, is often used as a tactic to avoid drawing attention to the existence of and naming of multisexual identities, where it's portrayed as an "experiment" or "stepping stone" between legitimized sexualities, or as a phase until the "right" man or woman shows up ("If It's You, It's Okay").

This scenario is based far more in fantasy than reality, yet it sustains itself in fiction, particularly when concerning non-straight women, partly because of the pervasiveness of stereotypes and pandering to male fantasy. In this way, a heterosexist culture does allow characters to be bisexual and bi-coded, "but not too bi" (TV Tropes), i.e., a form of bisexuality that's undefined and easier to ignore.

Furthermore, her non-monogamy might be due to referencing tropes (namely the stereotype that multisexuals have loose morals and/or are incapable of monogamy because of their sexuality), which also appeals to male fantasy.

Bisexual Villainy

Harley's sexualization and polyamory is compounded with the so-called "depraved bisexual" trope she represents; that is, a presumed multisexual character who commits depraved acts, such as murder and sexual assault, and has relationships with multiple genders and/or multiple partners because they do not have any kind of sexual etiquette or ethics ("Depraved Bisexual"). The idea behind this trope is the misconception that bisexuals present a danger to themselves and the public because they won't "commit" to one gender; viewed to have an inherently "unstable" and "unnatural" sexual orientation, they are theorized to have a broken mental state (or are "confused"), and that manifests into manipulative, violent, promiscuous and predatory behavior.

Harley Quinn as a character doesn't exactly correct this misconception; whether as a villain or antihero, she frequently commits depraved acts including murder and violent assault, either as a means to an end or simply for the fun of it. This cannot be simply dismissed as her being manipulated by the Joker either; in the comic "Mad Love," Harley seduces her college professor to get better grades; in *Batman: The Animated Series*, she uses her sex appeal to distract ("Harlequinade") and entrap men ("Beware the Creeper"), all on her own initiative. In an expansion on her original origin story ("Larger Than Life"), it's implied that it was Harley that pursued the Joker. She craved the madness and intentionally broke the law and her ethics to gain access to the Joker's depravity so she could have a taste of it.

If the media isn't portraying bisexuals as crazed killers, they cast them as victims, and as Wayne M. Bryant notes, this is in tandem with a more recent trend of representing bisexual masochists, which he suggests gives "the hidden message [...] that bisexuals are not only victims, but enjoy it" (M Bryant). He further explains that "it is significant that no bisexual women are portrayed as overcoming victimization," suggesting that the "additional handicap" of being a woman forms a barrier to any redemption or recovery. Harley embodies an odd combination of these seemingly contradictory tropes; she is a depraved character, but she is just as much a victim of abuse as she is an abuser.

Paul Dini specifically wrote Harley as suffering violence from the Joker as a "cautionary tale" about falling in love with an abuser so passionately "that nothing else in the world matters" (Dini, Foreword 6–7). For much of her narrative, the lesson of this tale is lost on Harley, who never seems to break free of the abusive cycle, getting herself pulled back in frequently and disturbingly willingly.

Combined with her role as a villain and her bizarrely gleeful acceptance of the Joker's abusiveness, it's possible to conclude that she somehow enjoys her abuse and seeks it out as part of her role as Harley Quinn. What indicates this the most is what Harley says at the end of the comic "Mad Love" after she is hospitalized by the Joker's attempts to murder her. When asked what being abused felt like she replies, swooning, "It felt like a kiss."

This was further reinforced by her fetishistic costume redesign, when coupled with her unwavering devotion to the Joker, because he describes beating on Harley as his "hobby" (Batman: Arkham Asylum). It is possible to interpret the relationship as a sadomasochistic one, where Harley is deriving pleasure from being abused as part of her costumed fantasy (Roddy). Playing the dual role of baby-talking sexual submissive and second in command degenerate to a master criminal, we're never given a straight answer as to what is a performance and what is genuine with Harley. Kate Roddy writes that "whether Harley is a victim or manipulator depends entirely on

what you want to see"; because writers do not make it consistently clear which side of the dichotomy Harley falls on, readers must supply her "definite intentions."

A core characteristic of a bisexual femme fatale is that they present a danger in the narrative because we do not know where their loyalties lie. This ambiguity is often solved by the plot's end by them "picking a side" morally, and consequently picking just one gender to be attracted to (in this case it would most likely be the Joker or Ivy) (Farrimond). However, we never get a revelation like this with Harley. Thanks to her expanded continuity and ambiguity, she does not give the reader an easy answer as to whose "side" she is on. Given her mental instability, she might not know either. Harley is definitely a puzzle, but unlike other bisexual femme fatales she cannot be "solved," not by love or aligning sexually with either men or women at any rate.

By leaving it open to interpretation, the bisexual tropes that require a moralistic conclusion (for example, having her killed, commit suicide or have her join a committed monogamous relationship) are subverted, because her story is ongoing and has become increasingly independent and unpredictable as time has passed. Jimmy Palmiotti in particular stated that Harley's contrariness and randomized nature was by design, "If for some reason we think a story should go some way, we always flip it around, because it's Harley" (Jusino).

Instead of using her wayward nature to condemn her and pity her as part of a morality play, it is currently being used to open up new story arcs for her. These are cues for her to be interpreted as a multifaceted character rather than broken, her theme of duality being a representation of her complexity instead of duplicity and depravity.

Conclusion

The freedom that Harley is given as a character is what resonates so much with her fans. Her shortcomings are what humanize her, as Amanda Conner puts it: "Wonder Woman sort of represents perfection, whereas Harley represents everyone else" (Riesman).

It's also unlikely that she would have been given this unique opportunity or developed such a loyal fan base if she wasn't a villain or antihero. While this did lead to her having some negative tropes attached to her and others denied because she didn't fit the idealized standards of a traditional superheroine, it also gave writers and artists an excuse to take her to places where no superheroes dare to venture. This ironically made her more likeable in the process and presented opportunities to be written without using the usual tropes.

Harley's fans were also the driving force behind continuing her rela-

tionship with both Ivy and the Joker, consequently giving her more independence generally and leading to the transition from subtext to canon. They continue to steer her narrative in non-typical directions so she does not fall into clichéd tropes. The backlash against her sexualized costume redesign (Hornack) and the outcry against her proposed "sexy suicide" storyline (Pantozzi) is a sign that a growing number of fans are no longer accepting the status quo and care enough about Harley to mount protests if they believe she is being mistreated. This level of support is virtually unprecedented for an explicitly multisexual woman in popular culture and gives some hope for future development.

The current existence of Harley Quinn shatters the notion that superpowered protagonists need to be heterosexual and male with idealized morals, as she is none of these things and currently is one of DC Comics' best-selling characters who sometimes outsells big name DC properties such as Superman (Schedeen). Given how popular Harley is and how much sympathy she has generated from her fans, she also has the potential to raise positive awareness for bisexual women and other multisexuals who share her experiences to a large mainstream audience. Arguably, her status as an A-list DC villain and antihero has been the catalyst to create this rare platform for multisexual representation; one that brings attention to pressing issues rather than erasing them for the sake of "myth-busting," which Eisner points out only serves to represent "bisexuality more like an agent of normativity than an agent of social change."

According to studies that account for sexual orientation, bisexual women as a group are statistically more likely to have experienced domestic violence in their lifetimes, most often perpetrated by men (Walters). Another study suggest that bisexuals are an at risk group for mental health issues and that they suffer more discrimination in mental health services and statistically more mental health stressors than gays, lesbians and heterosexuals (Page). From this research it was also discovered that a great number of bisexual people have a preference for polyamory, yet many feel shame and pressure to closet themselves because of the guilt they feel believing that they are reinforcing the myth that "all bisexuals are polyamorous." Presenting a character that embodies all of these experiences yet is not presented as shameful or to be pitied, can potentially break down these stigmas.

In this sense, Harley Quinn can be seen not as a mouthpiece to portray stereotypes, but instead as a reflection and deconstruction of real multisexual experiences. After all, there is nothing inherently wrong with bisexuals being polyamorous or sexually expressive, and being in an abusive relationship doesn't negate or reinforce anybody's sexual orientation; it is only the stigma and generalizations society attaches to these experiences that results in marginalization.

Harley Quinn is a rare example of a multisexual character who is a bisexual icon not by appealing to hegemony, but is instead beloved because of her psychological depth and how she opposes convention. To paraphrase Jo Eadie, we can read Harley Quinn "not as misrepresenting us but as accurately locating tensions which we, along with all those other subjects constructed through them, must live with" (Eadie).

In this way, it is possible to challenge the systems used to oppress multisexuals by actively inserting multisexuals into the forefront of these issues instead of sanitizing or condemning them. Instead of positing so called "problematic" behavior as something to be debunked and shunned in multisexual women by "good bisexuals," Harley Quinn can embody all of these stigmatized traits as a compelling protagonist.

Notes

1. Multisexual is an umbrella term for all sexual orientations that encompass more than one gender, for example bisexuality, pansexuality, polysexuality and queer.

2. A character typically portrayed as a butch lesbian, femme fatale or spinster, created to espouse a man-hating ideology for the purpose of mocking or discrediting feminism/women's rights.

3. Despite their being confirmed as girlfriends, neither the writers nor DC have labeled them bisexual, polysexual, pansexual, queer in text or as an external announcement.

Works Cited

Anderson, Kristin J. "Manufacturing Man-Hating Feminism." *Modern Misogyny: Anti-Feminism in a Post-Feminist Era*. Oxford University Press. 2015. 50–73. Print.

Batman: Arkham Asylum. Rocksteady Studios. Eidos Interactive, Warner Bros. Interactive Entertainment, Square Enix, Time Warner, 2009. PlayStation 3, Xbox 360.

Batman: Arkham City. Rocksteady Studios. Warner Bros. Interactive Entertainment, 2011. PlayStation 3, Xbox 360.

"Beware the Creeper." *Batman: The Animated Series Volume Four*. Dir. Dan Riba. Writ. Steve Gerber. Warner Brothers, 2005. DVD.

Brooker, Will. "We Could Be Heroes." *What Is a Superhero?* ed. Robin S. Rosenberg and Peter Coogan. Oxford University Press. 2013. 11–17. Print.

Bryant, Wayne M. *Bisexual Characters in Film: From Anaïs to Zee*. Harrington Park Press. 70–72. 1997. Print.

"But Not Too Bi." *TV Tropes*. TV Tropes, n.p. Web. 5 February, 2016. http://tvtropes.org/pmwiki/pmwiki.php/Main/ButNotTooBi

Conner, Amanda, and Jimmy Palmiotti (w). Blevins, Bret. (p) (i). "Road Trip Special #1" *Harley Quinn*. v2. (Sept. 2015), Warner Brothers. DC Comics.

_____. Hardin, Chad (p) (i). "Demental Overload." *Harley Quinn*. v2. #15. (March 2015), Warner Brothers. DC Comics.

_____. Hardin, Chad, and Stéphane Roux (p) (i). "Helter Shelter." *Harley Quinn*. v2. #2. (Mar. 2014), Warner Brothers. DC Comics.

"Depraved Bisexual." *TV Tropes*. TV Tropes, n.p. Web. 5 February 2016. http://tvtropes.org/pmwiki/pmwiki.php/Main/DepravedBisexual.

Dini, Paul (w). Burchett, Rick (p) (i). "Oy to the World." *Batgirl Adventures* #1. (Feb. 1998), Warner Brothers. DC Comics.

_____. Guichet, Yvel (p). Sowd, Aaron (i). *Batman: Harley Quinn*. (Oct. 1999), Warner Brothers. DC Comics.

_____. Timm, Bruce (p). Glines, Shane (i). "Jungle Fever." *Batman: Harley and Ivy* #2 (July 2004), Warner Brothers. DC Comics.

Dini, Paul, and Bruce Timm (w). DeCarlo, Dan, and Bruce Timm. (p) (i). "Foreword." *Batman: Mad Love and Other Stories.* (June, 2009), Warner Brothers. DC Comics. Print.
_____. DeCarlo, Dan, and Bruce Timm. (p) (i). "24 Hours." *Batman: Mad Love and Other Stories.* (June, 2009), Warner Brothers. DC Comics.
_____. Timm, Bruce, and Glen Murakami (p). Timm, Bruce (i). "Mad Love." *The Batman Adventures.* (Feb. 1994), Warner Brothers. DC Comics.
Eadie, Jo. "'That's why she is bisexual': Contexts for Bisexual Visibility." *The Bisexual Imaginary: Representation, Identity and Desire.* ed. Phoebe Davidson. Jo Eadie, Clare Hemmings, Ann Kaloski and Merl Storr. Cassell. 1997. 142–160. Print.
Eisner, Shiri. Bi: *Notes for a Bisexual Revolution.* Seal Press. 158–174. 2013. Print.
Farrimond, Katherine. "'Stay still so we can see who you are': Anxiety and Bisexual Activity in the Contemporary Femme Fatale Film." *Journal of Bisexuality,* Vol. 12, Issue 1. Taylor & Francis. 2012. 138–154. Print.
"Girl's Night Out." *Batman: The Animated Series Volume Four.* Dir. Curt Geda. Writ. Hilary Bader and Robert Goodman. Warner Brothers, 2005. DVD.
Glass, Adam (w). Getty, Ransom and Frederico Dallocchio (p). Hanna, Scott and Frederico Dallocchio (i). "Kicked in the Teeth." *Suicide Squad.* v2. #1. (Sept. 2011), Warner Brothers. DC Comics.
Grant, Alan (w). Apthorp, Brain (p). Woch, Stan (i). "Year 1: Poison Ivy." *Batman: Shadow of the Bat Annual.* vol. #3. (1995), Warner Brothers. DC Comics.
Grant, Ali. "And Still, the Lesbian Threat: Or, How to Keep a Good Woman a Woman." *Journal of Lesbian Studies* Vol. 4, No.1. Taylor & Francis. 2000. 61–80. Print.
"Harlequinade." *Batman: The Animated Series Volume Three.* Dir. Kevin Altieri. Writ. Paul Dini and Eric Randomski. Warner Brothers, 2005. DVD.
"Harley & Ivy." *Batman: The Animated Series Volume Two.* Dir. Boyd Kirkland. Writ. Paul Dini. Warner Brothers, 2005. DVD.
Hart, Lynda. "'Til Death Do Us Part: Impossible Spaces in 'Thelma and Louise.'" *Journal of the History of Sexuality* Vol. 4, No. 3, Special Issue, Part 2: Lesbian and Gay Histories. University of Texas Press. 1994. 430–446. Print.
Hornack, Laura. "Interview with the Organizer of the DC Relaunch Protest." Comicbookmovie.com. Comicbookmovie.com. 29 June 2011. Web. 2 January 2016.
"If It's You, It's Okay." *TV Tropes.* TV Tropes, n.p. Web. 10 March, 2016. http://tvtropes.org/pmwiki/pmwiki.php/Main/IfItsYouItsOkay
Jusino, Teresa. "Interview: Jimmy Palmiotti Talks Harley Quinn's Contrary Nature and Starfire's Sexuality." *The Mary Sue.* 23 October 2015. Web. 20 December 2015.
Kesel, Karl (w). Dodson, Terry (p). Dodson, Rachel (i). "Larger Than Life." *Harley Quinn.* vol. #5. (April 2001), Warner Brothers. DC Comics.
Kindt, Matt (w). Googe, Neil (a). "Harley Lives." *Detective Comics* #23.2. (2013) Ed. Wil Moss, Warner Brothers: DC Comics.
"Mad Love." *Batman: The Animated Series Volume Four.* Dir. Butch Lukic. Writ. Paul Dini and Bruce W. Timm. Warner Brothers, 2005. DVD.
Morris, Steve. "Thumbnail: Harley and Ivy Sitting in a Tree." *Comics Alliance.* 16 June 2015. Web. 20 January 2016.
Narcisse, Evan. "DC Comics: Harley Quinn and Poison Ivy Are Girlfriends 'Without Monogamy.'" *Kotaku.*12 June 2015. Web. 14 January 2016.
Ortberg, Mallory. "Femslash Friday: Poison Ivy and Harley Quinn." *The Toast.* 20 December 2013. Web. 2 February 2016.
Page, Emily H. "Mental Health Services Experiences of Bisexual Women and Bisexual Men: An Empirical Study." *Journal of Bisexuality,* Vol. 4, Issue 1–2. Taylor & Francis. 2004. 137–160. Print.
Pantozzi, Jill. "DC Comics Apologizes for Content in Their Harley Quinn Art Contest." *The Mary Sue.* 13 September 2013. Web. 10 January 2016.
_____. "DC Comics Neilson Results Are In, They Are Interesting." *The Mary Sue.* 10 February 2012. Web. 9 January 2016.
Phegley, Kiel. "DC Drops the Comics Code" *Comic Book Resources.* 20 January 2011. Web. 3 March 2016.

Riesman, Abraham. "The Hidden Story of Harley Quinn and How She Became the Superhero World's Most Successful Woman." *Vulture*.17 February 2015. Web. 20 December 2015.

Roddy, Kate. "Masochist or Machiavel? Reading Harley Quinn in Canon and Fanon." Textual Echoes Special Issue, No. 8. ed. Cyber Echoes. *Transformative Works and Cultures*. 2001. Web. 27 December 2015.

Schedeen, Jesse. "Harley Quinn Beats Superman in June's Comic Book Sales." *IGN*. 14 July 2014. Web. 1 March 2016.

Senate Committee on the Judiciary. "Comic Books and Juvenile Delinquency." *Interim Report*. Washington, D.C. United States Government Printing Office. 1955. Web. 10 February 2016.

Simone, Gail. "DC Introduces First Transgender Character in Mainstream Comics." *Wired*. 10 April 2013. Web. 6 December 2015.

Walters, Mikel. Chen, Jieru. Breiding, Matthew J. "The National Intimate Partner and Sexual Violence Survey (NIPSVS): 2010 Findings on Victimization by Sexual Orientation." Atlanta, Georgia. National Center for Injury Prevention and Control Centers for Disease Control and Prevention. January 2013. Print.

Victim, Villain or Antihero
Relationships and Personal Identity

AMANDA HOYER

With her first appearance in *Batman: The Animated Series* (*BTAS*), Harley Quinn moved to featuring in Batman graphic novels, to feature-length animations, to video games, and to her own graphic novel series. Each medium reflects her journey from successful psychiatrist to willing villain, to hapless victim, back to villain, and then to an antihero. Each of these different iterations represent her diverse relationships, both working and romantic. Understanding these relationships is key to understanding Harley Quinn's ability to determine her self-identity.

Victim or Villain: Harley Quinn's Agency, or Lack Thereof

Determining Harley Quinn's identity depends on where she appears, who wrote her story, and when she appears. Her first appearances in *Batman: The Animated Series* depict her as ditzy, unintelligent, and a willing lackey. Her devotion to the Joker comes from a twisted sense of love and drives her to extreme displays of affection. Harley captures Batman in "Mad Love" and spiels about why she initially fell in love with the Joker. She recalls her sessions as Dr. Harleen Quinzel, where the Joker frames Batman as the aggressor of his symptoms ("Mad Love") and victimizes himself to gain Harley's sympathy. She maintains this belief when she also blames Batman for the Joker's plight and resolves to kill Batman and end her boyfriend's supposed victimization. Batman then questions Harley about proving his capture to the Joker, prompting her to invite him to witness her act of "mad love" ("Mad Love"). The Joker arrives in a hurry, furious with Harley for accomplishing what he

repeatedly fails to do, demonstrating her capability *without* the Joker. Additionally, his rage arises from her displaying a level of awareness to rise above a subordinate role and correct the "superior" Joker's flawed plan. Her ability to supersede the Joker's plans shows a reclamation of her agency but only to satisfy her need for making him happy. In this instance, she sublimates her desire for control by aiming to appease her abuser.

When Harley attempts to explain the joke (i.e., her correction of his mistake), the Joker uses this explanation as a reason for its unworthiness of Batman. He justifies the explained joke's inadequacy by throwing her out a window. At the episode's end, Harley lands in a wheel chair, covered in bandages where she fumes about the Joker. As soon as she enters her Arkham cell and sees a "Get well soon. J" card on a rose, she forgives him immediately. These actions function as survival mechanisms for a victim pleasing an abuser. Her immediate forgiveness shows a willingness to revoke her agency and consequently, her responsibility. Her choice to return to an abusive relationship shows identity issues left unexplained in Harley's first iterations, but as her character develops complexity, so does the rationale for her choices.

Batman questions Harley Quinn's motivations for being with the Joker in an early stage of their relationship, during which she often sacrifices her agency and self-identity to satisfy her boyfriend and her need to be with him.

"Dr. Quinn's Diagnosis"

Harley appears newly in her role as the Joker's bimbo girlfriend, ever willing to carry out any task to make him happy; she has yet to consider taking matters into her own hands for his own happiness. She stalls Batman for the Joker by posing as Dr. Harleen Quinzel and psychoanalyzing him, but Batman intends to determine her agency as a coerced victim or willing accomplice and interrogates her instead asking, "What about *you*, Dr. Quinn? What led you to *criminal behavior*? How did you become *obsessed* with the Joker?" (Zubkavich 8). Batman addresses Harley as "Dr. Quinn," a combination of her past and present identities, establishing his uncertainty about her agency. This amalgam represents her duality for the reader, showing the actual split in Harley's past and present identities, bridging the transition before she claims the Joker's alteration of her name and identity. The interrogation continues with Harley's defense,

> HARLEY: The Joker opened my eyes to what *true love* was! ... It's *not* obsession. It's *clarity*!
> BATMAN: But clearly *he's* pulling the *strings*...
> HARLEY: I'm no *puppet*! [10].

Batman psychoanalyzes Harley in return to pressure her honesty. What she calls *"true love"* and *"clarity"* translate to delusion and rationalization. Harley's insistence on these labels represents her need to convince Batman, as much as herself that she is "no puppet." The emphatic nature of her statements reinforce the level of her delusion as well; if she wholly believed her rationalizations, extra emphasis would be unnecessary. Batman continues to undermine Harley's reasoning while also aiming for the truth of her relationship with the Joker. "Dr. Quinn's Diagnosis" provides the reader with a direct look into Harley's understanding of herself in a relationship with the Joker. Batman's interrogation reveals,

> "Do you think the victims of your crimes find it 'funny'?"
> "It's not my fault if people can't handle some comedy."
> "Do you *believe* that? Are you *that* deluded?" [14].

Harley dodges Batman's questions and attempts to continue her own psychoanalysis, deflecting the question because she wants to avoid responsibility. Batman continues to confront her about her motivations, finally sousing out the truth, "Are you a *victim* of the Joker's madness or did you become this by *choice*?" (15). He inquires for his own purposes (i.e., to lock her away in Arkham) in determining Harley's agency; his questions serve to reestablish the individual's conscience, particularly hers. He understands the importance of this psychoanalytic interrogation: to establish her agency, Harley must examine her motivations.

Unfortunately, instead of taking responsibility for her various crimes with the Joker, she covers her "fear of *failure* by giving up *responsibility*" (14) and claims, "I'm not a *stooge* or *victim*! Harley Quinn is *who I am!*" (16). She emphatically accepts the Joker's fabricated identity as Harley Quinn, again over-emphasizing her role as "*stooge* or *victim*" (16) to convince herself as much as Batman that she still possesses control over her actions. She establishes a sense of agency in her abusive relationship by embracing her new identity. Batman reaches this conclusion, too, "As I suspected, she's a *willing* partner. She wasn't coerced or forced into it" (21). Later, Harley (and Batman) begin to recognize that this reclamation of choice functions as a coping and survival mechanism against the Joker's abuse. Until Harley reaches this realization, other iterations of her characterize her violence as purely her choice, without the Joker's mental machinations. This characterization appears in different story arcs, even after Harley moves on from her ex in her own comic series. Harley Quinn's internal conflict manifests far less often when in the initial phases of her relationship with the Joker. Well before he drops her in acid, Harley applies clown makeup as an extension and representation of her feelings for the Joker but does not fully commit to him until he removes her agency via dropping her in acid and bleaching her skin (Kindt).

Eventually, she recognizes the toxicity of her relationship with the Joker, reaching new levels of introspection and realizing why she chose to stay with him. In the comic book "Harley Lives," she acknowledges, "There is a me that craves a purpose. There was a me that craved something..."(Kindt 2). She only begins answering the question of her motivation after leaving the Joker, *after* he drops her in an acid vat. Harley recognizes how lost she was (i.e., in regards to her autonomy and self-identity) to choose romantic entanglement with the Joker. "Dr. Quinn's Diagnosis" asks the motivations of an unbleached Harley new to villainy. Only until "Harley Lives" does she answer these questions. She admits her use of dating the Joker, who she knew "honestly didn't care" as an escape from her "regimented way of life" (6). She "... loved flushing away the control. The goals.... To play for fun. To play crazy" (6) and in so doing, admits to consciously relinquishing her self-control. The irony lies in Harley directly choosing to remove her agency so she "was finally free. Free to forget" (6). The comic's title "Harley Lives" ironically portrays her claims of freedom and fun when with the Joker because she only truly "lives" after leaving him and her subordinate role behind. Additionally, she talks about "playing crazy" as if she still possessed sanity when choosing to pursue her interest in the Joker, lending more credibility to her actual choice in being with him.

In this specific issue, Kindt gives the character more authority by allowing Harley to introspect. The reader learns of her choice to engage with the Joker not romantically, but as a curiosity. He attracted her because she missed the insanity of home: "I was ... pushed to love order. As an escape.... To avoid the insanity around me. What I didn't realize at the time was that insanity is all about perspective" (3). This statement shows a polarization in Dr. Quinzel and Harley. Growing up used to "insanity" changed entirely when she met lunacy personified in the Joker. Not until she meets him does she "realize ... that insanity is all about perspective" (3). The dichotomy of her mental schema shows here: From a young age, she did not cope with "insanity" as much as ignore it by diving into structure. This avoidance behavior explains her rationale, but her supposed freedom comes at a price.

Using the self-psychoanalysis (i.e., introspection) of Dr. Harleen Quinzel, the clinically-trained, sane identity, reveals, "I've started to feel numb. In school they had a name for it: DISASSOCIATION. My rational mind can recognize pain when I see it. But my rational mind is in a pretty small box" (17). When the inner-dialogue splits between two distinct characters, disassociation seems all the more plausible. It leads the reader to believe that Harley Quinn began as an extension of Dr. Quinzel but evolved into another personality to shield her original self from consequence and responsibility. As soon as Dr. Quinzel recognizes the possible psychosis, Harley speaks up, "And the rest of me...? None of your damn business,

HARLEEN. Stop trying to psychoanalyze me and get back in your box" (17). Harley's direct, third-person address of Harleen epitomizes the dissociation from her past self. In "Dr. Quinn's Diagnosis," she deflects Batman's interrogation with her own questions as well as in "Mad Love." When she begins introspecting, Harley outright demands Harleen self-preserve by avoiding the truth of self-examination—as if Harley has no control over her other identity. Instead, Harley compartmentalizes Harleen, stowing her original identity's inconvenient truths away until she knows how to reconcile her two selves.

The conflicting portrayals of Harley Quinn in film and comic books represent the difficulty in determining her role as victim or villain. As indicated by Batman's repeated questioning, outside individuals do not understand Harley's fascination with the Joker. Batman's interrogation also reveals her personal confusion, too. After unknowingly entering an abusive relationship and repeatedly falling victim to the Joker's mood swings, she eventually reaches a breaking point. Although she admits, "It's liberating to not have to think" (Kindt 17), she also recognizes the cost. Not only does she suffer from a psychotic break leading to dissociation, but also sacrifices her power. In Dr. Harleen Quinzel's last moments of agency, she chooses to engage with the Joker. In Harley Quinn's first fleeting moment of agency, she chooses to relinquish her past identity with its "regimented way of life" (6). In so doing, she gives the power to her abuser. The other high price for her freedom involved being the Joker's subordinate: his lover, his punching bag, his lackey, his plaything. When he literally pushes her over the edge (into an acid vat), he strips the color from her flesh and her chances of ever returning to life as Dr. Harleen Quinzel. She then leaves him and begins the long journey to become her own version of Harley Quinn.

Villain to Antihero: A Bumpy Road to Self-Discovery

Throughout the comic books and animated series, Dr. Harleen Quinzel lost herself and became Harley Quinn by entering a relationship with the Joker. In order to make this new identity her own, she develops new working relationships and attempts to branch out romantically. These new relationships grow with her, shaping her into a better version of herself, pruning off the old parts of herself. Her first steps to reclaiming autonomy as Harley Quinn involve her first wanting to leave Arkham Asylum. She works with Batman while considering moving on from the Joker and her criminal career. She also befriends Poison Ivy in her various times in and out of Arkham, encouraging her own independence. These two partnerships provide her with

a chance to explore Harley Quinn in a positive arena sans–Joker's influence. In the New 52 storyline, Harley eventually ends up in the acid vat and decides to move on for good. All of this helps her embrace her new identity as more than the Joker's ex-girlfriend, especially when she starts a new life altogether, in a new city with new friends.

"Harlequinade"

Her first partner "in crime" is Batman, who ultimately seeks her mental rehabilitation and return to sanity as he provides their pair-ups for her redemption. Even in *Batman: The Animated Series*, Harley begins seeing how little the Joker cares for her and how leaving him might be her best option. In the TV episode "Harlequinade," Batman requests her help in ending another of her boyfriend's deadly schemes: "You help me find the Joker, and they'll [Arkham] write your ticket out of here." Batman wants to help Harley, as evidenced by his offer. If she helps him, it represents her willingness to reform and her regard for others' lives over her puddin's happiness. While investigating the Joker's whereabouts, Batman tries to understand her motivation:

> BATMAN: What's the attraction, Quinn? This sick infatuation with the Joker.
> HARLEY: Look, Bats, when I was a doctor I was always listening to other people's problems. Then I met Mr. J, who listened to me for a change and made everything fun.
> BATMAN: You think it's funny when he hurts people?
> HARLEY: It's just a joke.
> BATMAN: Hope you're still laughing when it's your turn ["Harlequinade"].

With this episode of *BTAS*, as with the comic book issue "Dr. Quinn's Diagnosis," Batman questions Harley, forcing her to grapple with her conscience—which she utterly disregards when appeasing the Joker. She wants to avoid the truth and consequences of her villainous acts in order to feel free. This interaction shows that she is not fully ready to reclaim responsibility or move on from the Joker. After this exchange, Batman and Harley find the Joker about to fly away from the soon-to-be blown up Gotham,

> BATMAN: It's lucky you were here, Harley. The countdown sequence didn't leave Joker enough time to swing by Arkham and pick you up.
> HARLEY: You were gonna come back for me, weren't you, puddin'?
> JOKER: Of course, pumpkin pie. It's just that.... Well, here you are so I can save myself a trip.
> HARLEY: But what about all our friends?
> JOKER: What about them? ["Harlequinade"].

Batman recognizes immediately that the Joker had no intention of grabbing Harley before blowing up Gotham. Batman highlights this fact to alert Harley

to the truth of the Joker's real feelings, even as she remains blinded by devotion. Clearly, the Joker does not really care about her, which she begins to recognize in the episode's end, "You know, Bats, I got a crazy idea Mr. J may not be the guy for me after all" ("Harlequinade"). She responds to this realization with equal viciousness—a trait enhanced by her relationship with the Joker—and attempts to kill him. Batman intervenes, and Harley's murder attempt fails. Not only does he want to preserve her boyfriend's life, but he also wants to preserve Harley's morality and prevent her from succumbing to the Joker's ultimate wish—falling to his level. Harley returns to Arkham having saved Gotham. Although not fully reformed, she has started a new path to redemption.

Considering her underlying social deviance and need for a strong female role model, Harley's friendship with Poison Ivy seems inevitable, especially as Batman's lawful nature contradicts her new identity. In "Harley and Ivy," these two villainesses meet for the first time and proceed to perform a myriad of bank heists, shopping (crime) sprees, and terrorist activism. The entire *BTAS* episode centers on female empowerment when only Detective Montoya succeeds in capturing the dastardly duo ("Harley and Ivy"), securing the importance of Ivy in Harley's life as a role model for independence.

"Role Models"

Their friendship continues through her skin bleaching and well into Harley's new life, illustrated in *The New 52* graphic novels and other comic book issues. In the comic "Role Models," a child on the run from her abductor runs into Harley and Ivy in the middle of a heist (Dini). This little girl views all costumed people the same, looking up to strong, superhuman women (e.g., superheroes like Batgirl, Black Canary) as role models and protectors. She recognizes Harley and Ivy as super heroic defenders. They step in to defend the little girl from her abductor at Harley's behest, "Well, Batgirl ain't here at present," and Ivy agrees, "But I *know* she won't mind if we fill in" (Dini). In this instance, Harley prompts Ivy, who prefers plants to people, to step in for the child's defense, even at the expense of their profit. This request shows a vast improvement in Harley's moral code; she chooses saving a kid over making money.

"Harley's Holiday"

These two instances represent Harley's desire to improve personally. Not only does she associate with someone who encourages her independence,

but she even finds opportunities to maintain a fraction of her morality. Her good behavior culminates in a few releases from Arkham Asylum in both *BTAS* and comics, even before she finally leaves the Joker for good. In the episode "Harley's Holiday," Harley obtains release from Arkham. On her way out the door, she runs into Batman and says,

> HARLEY: I've got my head back together, and I'm gonna live my life right.
> BATMAN: For your sake, I hope so.
> HARLEY: I'll show you. Starting tomorrow, you'll see I'm just as sane as anybody.

She seems genuine in her intent to rehabilitate herself; Batman stands as a reminder of her fate if she falls into her old ways. Unfortunately, Arkham failed her reintegration into society, so Harley remains ignorant of social norms when she introduces herself with, "Hey, remember me? That big charity bash a few years back? … I was the clown girl holding the gun on you!" which leads people to unease ("Harley's Holiday"). Unfortunately, a large misunderstanding occurs where she assumes no one wants to give her a fair chance, "All I'm looking for is a fair chance to start over. That's not asking too much, is it? Why, no. I tried to play by the rules, but no. They wouldn't let me go straight. Society is to blame" ("Harley's Holiday"). Harley tries to move on, but after the misunderstanding, she defaults to the Joker's Harley Quinn, using this alternate persona as a way to cope with stress and as a return to the familiar.

When she misunderstands, she blames society for once because she does try and follow its rules, but no one seems willing to forgive her past transgressions. Batman understands the entire situation as a confused mess, "If we can find her first, maybe we can stop her from ruining her chance" ("Harley's Holiday"). When he catches Harley, who has committed crimes in response to the misunderstanding (e.g., car theft, property damage), he addresses her, "We wanna help you sort this out before it gets worse. All the work you've done, your freedom…. If you run away, you'll lose them, Harley. You're so close to winning back your real life" ("Harley's Holiday"). Batman clearly wants to help her. He pities her situation and sympathizes with her desire to reform because she seems lost on her path to redemption and independence. As much as he fights for justice, he champions for the lost, too. Batman eventually captures her and returns her to Arkham but does so on a hopeful note,

> BATMAN: With a little more hard work, you should be ready to reenter society for good.
> HARLEY: There's one thing I gotta know. Why did you stay with me all day … someone who's never given you anything but trouble?
> BATMAN: I know what it's like to try and rebuild a life. I had a bad day too, once ["Harley's Holiday"].

Batman does nothing but encourage her rehabilitation, even if it means returning her to Arkham. He supports her efforts by showing hope in her case, which society failed to do this time. Furthermore, his previous work with her indicates nothing but a strong, guiding hand who will put her in her place (e.g., Arkham) when necessary. Harley's question about his tolerance of her crimes reveals why he chooses to hope for her betterment because his "bad day" meant the death of his parents, and he tries every day to rebuild his life, just like her. Even though Harley returns to Arkham, she does not resent Batman, instead kissing him in thanks for his goodwill for her cause.

"Kind of Like Family" and Selected Suicide Squad

Further evidence of Batman's guiding hand and Harley's desire to reform occur in the comic book "Kind of Like Family." Again, she seeks release from Arkham, this time in front of a review board including Bruce Wayne, who denies her request (Dini 4). Shortly after, Scarface kidnaps her and tries to murder her, so she considers running away (8, 15), but stops herself because she desires a real freedom where she is not considered criminal. To gain social goodwill, she calls Commissioner Gordon, informing him of the crime for which Scarface originally kidnapped her; she works alongside Batman to apprehend Scarface, emphasizing her role as coerced abductee (14, 17–20). In the end, she returns before Arkham's review board and Bruce Wayne agrees to release her (23). Again, Batman (as Bruce Wayne) guides Harley's fate, testing her intent and determining its merit. Only until she proves her integrity does she convince Batman/Bruce of her rehabilitation. She achieves her goal and continues to make further positive progress in society eventually on her own, until the Joker returns into her life.

She was already on the path to reclaiming her agency before he bleached her skin. Even relapsing into her past criminal behavior as a reaction to the acid vat incident, Amanda Waller sees potential in her and recruits her for the Suicide Squad, shortening her criminal sentence. From the start of the comic book "Bad Company," Harley appears still in love with the Joker and has yet to realize why he dropped her in acid. She learns of the Joker's assumed death from Capt. Boomerang,

> HARLEY: If Mr. J could only see me now.
> BOOMERANG: *The Joker*...? Yeah, he'd be real impressed if he wasn't *dead*.
> HARLEY: What're you talking about?
> BOOMERANG: ...You haven't heard. Joker's *dead*. Skinned alive [Glass 9].

Initially, she appears excited to cause mayhem and impress the Joker but then uses violence as vengeance against the world which took her "puddin'," as

well as an opportunity to work through her loss. His absence leaves room for Harley to reflect on what the Joker did to her and how he *permanently* changed her to be like him. She still resorts to violence as an escape for the trauma of her loss and permanent change, as seen in comic book "The Hunt for Harley Quinn Part 1," which portrays Dr. Quinzel as more aware. In this comic book iteration, she was more like the Joker's equal. She reflects on their first meeting while searching for the impostor wearing the Joker's face, "It's about control.... You create mayhem so you can be the eye of the storm. Because everything in that storm gets turned upside down *but* you. Hiding behind your madness is control.... You're just a *control freak* with a sense of humor" (9). In this memory, the Joker tests and pushes to see if she is his equal and to entertain himself.

He then psychoanalyzes her, beginning his long period of manipulation of Dr. Harley Quinzel into Harley Quinn. He admits as much in another therapy session with her, "If you have a piece of them, you have power over them. Then you can bend them to your will. Make some bozo *laugh* as easy as you can make him cry. [Get] their attention. Suddenly, you *matter*" (17). Harley's reflection on this statement shows her motivation for seeking him out. Not only does she desire to make peace with his death, but to make peace with her past and to move onto her new identity. Her recollection of this memory represents the moment he bent her to his will. She remembers the rest of the Joker's manipulative spiel, "I used to be ... *powerless* against those who wanted to keep me down.... [My accident] set me free, because once I didn't *care* about the rules any more, I had all the *power*. We all have it inside of us, we just got to let it out" (18). This recollection reveals when Dr. Harleen Quinzel started to crack; her recollection continues in the comic book "The Hunt for Harley Quinn Conclusion," where she releases the Joker and changes her life forever. This issue shows Harley pushed into the acid vat by the Joker, even after she admits she "wants to go home"(13). He then names this day as Harley Quinn's birthday (13), but not Dr. Harleen Quinzel's birthday, expressing his role as controller and removing her agency. He strips away her old identity, placing "Harley Quinn" onto Dr. Harleen Quinzel to best suit his needs. He sells his accident as positive because he "had all the power" (18), which serves as ironic for what he does to Harley. She becomes powerless against the Joker, who persistently keeps her down; her accident trapped her in a relationship with him and gave him all the power. As mentioned in "Harley Lives" she realizes this, thus her desire to leave him.

She finds the impostor Joker and uses him as an emotional stand-in for the "dead" Joker. In the comic "Running with the Devil, Part 2" she says, "... I never felt right doing the things we did. But I loved you. And for that, I did it. Then you left and I was alone. And someone offered me a chance to be something different.... I liked it. It felt right. But I still loved you. [That] ...

doesn't mean I belong with you" (14). In her mind, she breaks up with the Joker. Although she recognizes him as a prop for the real thing, she settles because she needs closure. This is a metamorphic moment, where she asserts herself and establishes Harley Quinn as *her* identity. In this moment, she admits her motivation and decision to move on. She leaves the faux-Joker behind, also leaving behind her old self and stepping towards her reclaimed identity.

The New 52

Harley eventually finishes her time with the Suicide Squad, becoming a much-reformed version of herself. After erasing her Arkham files, she physically distances herself by first moving to Brooklyn, where Ivy helps with the move in a *New 52* comic (Conner and Palmiotti, *Hot in the City*). Ivy, at least, keeps the criminal activity to a minimum around Harley while also encouraging this new direction of personal growth. With old social support, Harley can establish herself until she makes new social support. She becomes the landlord of an apartment; she makes new friends with the tenants; and eventually saves an entire shelter's worth of cats and dogs from their abusive owners (Conner and Palmiotti, *Hot in the City*). The physical relocation alone shows a large improvement in her desire to leave the past behind her, coupled with these other acts, she progresses in a positive direction. In establishing new social support, Harley also establishes preventive measures from returning to her old ways. Her antics persist when she finds a job as a therapist in a nursing home; teams up with an amnesiac Power Girl; and develops a new love interest in Mason Macabre, a man convicted of manslaughter, but willing to serve his time in prison (Conner and Palmiotti, *Power Outage*). She continues to help others, and her previously established relationships begin to blossom.

Her choices to help others waver between self-serving and full-blown altruism. In *Harley Quinn: Kiss Kiss Bang Stab*, she earns Batman's approval after stealing money from a corrupt Wall Street banker and donating it to a charity fundraiser date with Bruce Wayne. Batman speaks with her after, "Wayne did mention who you ... *procured* ... the million from. I'm pleased that *Runoff* finally tasted a bit of *justice* [but]...I'm still keeping an eye on you.... Don't consider it a *warning*, Harley. Consider it *friendly advice*" (Conner and Palmiotti, 38–39). Again, Batman has only ever wanted to help. Now that Harley's moved on with life (metaphorically and physically to Brooklyn), he has hope for her full mental rehabilitation. To help with her ever-growing amount of responsibility, she hires paid help whom she lodges and feeds, almost acting as their mentor. After recruiting her followers, she represents

her autonomy by setting out to save the underdogs of the city, including correcting the charges on her new boyfriend's behalf. Instead, she discovers corruption in the mayor's office which results in Mason's relocation to Arkham ("Sy Borgman and Harley Quinn Must Die!!!."). She breaks into Arkham to free Mason and discovers that his cellmate is the real Joker, whom she physically confronts about staying out of her life ("Twenty-five Big One$"). She successfully breaks out her new man with Ivy and her new friends' help. Batman catches them since Ivy stole his boat to get to Arkham, but offers his support for Harley's endeavors, placing Mason into a witness protection program. This signifies that Harley has become her own person, healthily on her way to a full recovery and reintegration into society.

Works Cited

Batman: Arkham Asylum. Rocksteady Studios. Eidos Interactive, Warner Bros. Interactive Entertainment, Square Enix, Time Warner, 2009. PlayStation 3, Xbox 360.

Batman: Arkham City. Rocksteady Studios. Warner Bros. Interactive Entertainment, 2011. PlayStation 3, Xbox 360.

Batman: Arkham Knight. Rocksteady Studios. Warner Bros. Interactive Entertainment, 2015. PlayStation 4, Xbox One.

Conner, Amanda, and Jimmy Palmiotti (w). Hardin, Chad (p) (i). "Hot in the City." *Harley Quinn*. v2. #1. (Feb. 2014), Warner Brothers. DC Comics. Print.

_____. Hardin, Chad (p) (i). "Twenny-Five Big One$." *Harley Quinn*. v2. #25. (Apr. 2016), Warner Brothers. DC Comics.

_____. Hardin, Chad, et al. (a). "Sy Borgman and Harley Quinn Must Die!!!" *Harley Quinn*. v2. #22. (2015) Ed. Chris Conroy, Warner Brothers: DC Comics.

_____. Hardin, Chad, John Timms, Marco Failla, et al. (a). *Harley Quinn: Power Outage*. v2. (2015) Eds. Katie Kubert and Chris Conroy, Warner Brothers: DC Comics.

_____. Hardin, Chad, John Timms, Stjepan Sjeic, et al. (a). *Harley Quinn: Kiss Kiss Bang Stab*. v3. (2015) Ed. Chris Conroy, Warner Brothers: DC Comics.

_____. Roux, Stéphane (a). "Secret Origins." *Harley Quinn: Power Outage*. v2. (2015) Eds. Katie Kubert and Chris Conroy, Warner Brothers: DC Comics.

_____. Timms, John, et al. (a). "Just Batty Over You." *Harley Quinn: Kiss Kiss Bang Stab*. v3. (2015) Ed. Chris Conroy, Warner Brothers: DC Comics.

Dini, Paul (w). Kramer, Don (p). Faucher, Wayne (i). "Honor Among Thieves." *Batman Detective Comics #837*. (2007) Ed. Mike Marts, Warner Brothers: DC Comics.

_____. "Kind of Like Family." *Batman Detective Comic #831*. (2007) Ed. Peter Tomasi, Warner Brothers: DC Comics.

_____. Roux, Stéphane (a). "Role Models." *Batman Black and White #3*. (2014), Warner Brothers: DC Comics.

Glass, Adam (w). Dallocchio, Federico, et al. (a). "Bad Company." *Suicide Squad*. v2. #4. (2011) Ed. Pat McCallum, Warner Brothers: DC Comics.

_____. Dagnino, Fernando, et al. (a). "Running with the Devil, Part 2." *Suicide Squad*. v2. #15. (2013) Ed. Rachel Gluckstern, Warner Brothers: DC Comics.

_____. Henry, Clayton (p). Barros, Ig Guarra (i). "The Hunt for Harley Quinn," *Suicide Squad*. v2. #7 (May 2012), Warner Brothers: DC Comics.

_____. Henry, Clayton (p), and Scott Hanna, et al. (i). "The Hunt for Harley Quinn Part 1." *Suicide Squad*. v2. #6. (2012) Ed. Pat McCallum, Warner Brothers: DC Comics.

_____. Jonsson, Henrik (p), Florea, Sandu, et al. (i). "Death Blooms." *Suicide Squad*. v2. #18. (2013) Ed. Rachel Gluckstern, Warner Brothers: DC Comics.

"Harlequinade." *Batman: The Animated Series Volume Three*. Dir. Kevin Altieri. Writ. Paul Dini and Eric Randomski. Warner Brothers, 2005. DVD.

"Harley & Ivy." *Batman: The Animated Series Volume Two.* Dir. Boyd Kirkland. Writ. Paul Dini. Warner Brothers, 2005. DVD.

"Harley's Holiday." *Batman: The Animated Series Volume Three.* Dir. Kevin Altieri. Writ. Paul Dini and Eric Randomski. Warner Brothers, 2005. DVD.

Kindt, Matt (w). Googe, Neil (a). "Harley Lives." *Detective Comics* #23.2. (2013) Ed. Wil Moss, Warner Brothers: DC Comics.

Lieberman, A.J. (w). Huddleston, Mike (p). Nixey, Troy (i). *Harley Quinn: Vengeance Unlimited.* (2014) Ed. Matt Idelson, Warner Brothers: DC Comics.

"Mad Love." *Batman: The Animated Series Volume Four.* Dir. Butch Lukic. Writ. Paul Dini and Bruce W. Timm. Warner Brothers, 2005. DVD.

Zubkavich, Jim (w). Googe, Neil (a). "Dr. Quinn's Diagnosis." *Batman: Legends of the Dark Knight* #50. (2012) Ed. Hank Kanalz and Kristy Quinn, Warner Brothers: DC Comics.

"Stronger than their madhouse walls"

Disrupting Gotham's Freak Discourse in "Mad Love" and "Harley Quinn"

AIDAN DIAMOND

This is how Batman is born:

A gun fires twice, and Bruce Wayne is left orphaned and kneeling in the bloodstained street. For the next fifteen years, he tries desperately to develop the ability to stop this violence from happening again. By adulthood, he is lost, purposeless, and grievously injured in an isolation of his own making, desperate enough to call out to his long-dead father for guidance. In the darkness, the windows of Wayne Manor shatter, or appear to; a beast swoops through the black air and settles, silent and watchful, on the bust of Thomas Wayne. A smile tugs at Bruce's split lip. "Yes, Father," he says, or thinks he says: "I shall become a bat."[1]

This refrain has reverberated through every iteration of Batman's origin story, but it is an inherently erroneous declaration. Bruce cannot any more become a bat than the bat can become him; without superpowers or dubiously plausible scientific intervention,[2] all he can do is fashion a Bat-suit, complete with a winged cape and pointy-eared cowl, and don it at dusk. In the night, disguised as the Bat, he fights crime and saves lives by rounding up Gotham's deviant denizens. At dawn, he returns to his cave and removes the cowl and cape, revealed as only—always—a man. He dresses in the finest suits, as befits the CEO of Wayne Enterprises, and turns heads all over the city as Gotham's most eligible bachelor. Every night, he puts on the Bat-suit for a few hours, until he is ready to take it off again.

Robert Bogdan, writing on freak show hierarchies, identifies four types of freak: the "born" freak, the "made" freak, the "novelty act," and the "gaffed"

freak (24). In freak show culture, the born freak, corporeally different from birth, was the most privileged, as one cannot choose to become as physically different as a dwarf or hermaphrodite. The made freak and the novelty act were next in line. They respectively imposed difference upon themselves through modifications like full-body tattoos or by performing skills such as sword-swallowing. The gaffed freak, however, was despised as a fraud, a normative body aping the born freak's difference through removable costume by binding one's arms to appear armless, for example, or hiding another person beneath a costume to appear superfluously limbed. Applying this hierarchy to Gotham's cast of villains, born freaks are in short supply, though those whose difference is inflicted upon them or learned are not. Batman is not a freak by birth, making, or training. He merely dresses up as one.

This essay aims to articulate and interrogate Gotham's freak discourse through the figure of Harley Quinn. The first section will clarify what is meant by "freak," summarize the existing body of scholarship on the subject, and expand it to include psychological, rather than entirely physical, deviance. The second section delineates the stark divide between "normality" and "freakish" deviance in Batman comics, a phenomenon equating psychological and physical difference with criminality and moral corruption. The final sections focus on the character of Harley Quinn, who destabilizes the otherwise absolutist construct of normative/freak in Gotham City through three key aspects of her character: her motivations, which stem from empathetic love rather than greed or malice; her relationship to the regulatory apparatus of psychiatry; and her ambiguous identity as someone who is both freaked by others and herself.

Freaks, Madness and the Institution of Normality

The word "freak" conjures up a variety of impressions, most of them unpleasant and distasteful for their accusing, ostracizing bluntness. The freak is alien, something other than human: an abject spectacle which can neither be ignored nor faced, its difference disturbing in that it suggests how fragile our own normality is. At once, "freak" encompasses the grotesque, the monstrous, the politically incorrect, and the outcast. In every case, "freak" signifies the undisputed *other*.

Otherness has always been the key defining trait of those called (by themselves or others) freaks. They are primarily distinguishable from the normative by the difference manifested in their corporeal selves. The normative body is average and unexceptional; it is evenly proportioned, with four, five-fingered or -toed limbs. Its variations in size or coloring fall within

an acceptable range. Freaks, however, are too tall (giants) or too short (dwarves), too much (conjoined twins) or not enough (limbless), and always too different (Grosz 56). The divide between a freakish body and the normative one is insurmountable. One either is normal or not; any deviation, no matter how insignificant, sets one apart.

The freak's otherness is constructed in three key historical periods. Throughout the Middle Ages, the freak was not ostracized or isolated but rather deified, made sacred as a symbol of divine power (as in the case of epilepsy) (Porter 13) or of divine wrath (in the case of physical grotesqueness) (Grosz 57). The nineteenth century reinvented the freak as a spectacle to be gazed upon with horror and fascination by the public, a scientific marvel and myth packed into a single strange body. The twentieth-century medicalized difference by hospitalizing the deviant body. The framing of the "anomalous body," argues disabilities scholar Rosemarie Garland Thomson "can be characterized simply as a movement from a narrative of the marvelous to a narrative of the deviant. [...] In brief, wonder becomes error" (3). This transformation is absolutely crucial to any understanding of freaks, as both Garland Thomson and social historian Roy Porter acknowledge.[3] In the body or mind, sites of difference transformed from divine evidence to public spectacle to private patients in need of correction (Garland Thomson 2). Freaks were—and to a large degree are—viewed as evolutionary errors to be diagnosed and corrected at best, or cloistered out of sight and mind at worst. In brief, the freaked body is a *wrong* body and must be corrected, not for the benefit of the freak, but for the benefit of normative society.

However, there is something more than the corporeal to the freak, as Bogdan suggests: "being a 'freak' [...] is not a personal matter, a physical condition that some people have," he writes. "'Freak' is a way of thinking about and presenting people—a frame of mind and a set of practices" (24). Porter suggests a similar phenomenon may be observed in the asylum as in the freak show or hospital theater. Madness is another form of difference, and often a more troubling one, as it is devoid of corporeal signifiers and only manifests externally in action. Great effort was made to illustrate the "normal" accomplishments of those exhibited in the nineteenth-century freak show—showmen lauded Siamese twins' respective wives and families or bearded ladies' Victorian femininity (Bogdan 30). The same cannot be said for the mad. "Abnormality," Porter writes, "provoke[s] anxiety" (15), but abnormality—difference, deviance, psychological freakishness—may be the *only* thing that provokes it. Insanity, he argues, may "be better regarded essentially as a badge we pin on people displaying a rather subjectively defined bundle of symptoms and traits, but who at bottom are just mildly or severely 'different' or 'odd'" (8–9). Much like the freak, the mad are mad because they are indisputably abnormal—"mentally 'confused' because we find them 'con-

fusing,' 'disturbed' essentially because we find them 'disturbing'" (9). The mad are not normal because they are different from the normative *us*, and so, like the freak, must be medicalized and confined and corrected.[4]

What is significant about the freak and the mad is that both are different, and it is this shared difference that crucially links the two. Both challenge "the nature and limits of the rationality, humanity and 'understanding' of the normal" because both are perceived as alien (3). Accordingly, each present a threat to normal society to be contained (for the good of everyone involved) (17) and corrected to better emulate the normative "ideal" (for the good of normative society) (Grosz 57). It is this discourse that this essay aims to identify in Batman comics and interrogate through the character of Harley Quinn.

What It Means to Be a Freak in Gotham

When considering the Gotham rogues' gallery, it is difficult to call to mind a villain who is not articulated in terms of physical difference or insanity, or both. In most cases, this freaking is something that was done *to* them, and, in most cases, Batman is solely responsible for their confinement and punishment.

The Joker is the most prolific example, having fallen (possibly at Batman's hand) into a vat of acid that bleached his skin and made his hair a nauseating green. In Alan Moore and Brian Bolland's *The Killing Joke* (1988), he loses his mind after "one bad day"—in his case, the murder of his wife and child and his fall into acid. Harvey Dent only adopts the Two-Face persona after an attack by a witness disfigures the left side of his face so badly that he appears literally split in two, half man and half monster, each with a voice and mind of his own (Loeb and Sale). Mr. Freeze, former cryogenic researcher, loses his sanity and his interest in obeying the law after his employers terminate an experiment meant to save his wife and expose Mr. Freeze to a cryogenic reaction that leaves him entirely dependent on a cybernetic suit ("Heart of Ice"). Clayface, able to assume the guise of anyone he chooses, becomes a monstrous golem after suffering from a poisonous cosmetic cream designed to make him the greatest actor alive ("Feat of Clay: Part 1 and Part 2"). Poison Ivy, implicitly dehumanized by her unwilling participation in scientific experiments, is more plant than woman, growing leaves from her own green body and preferring to communicate with Mother Nature than with humans (Lieberman et al). Each is incarcerated not in Blackgate Penitentiary but in Arkham Asylum for the Criminally Insane, following the twentieth-century model of medicalized difference. In each case, their difference is inflicted upon them, and, in each case, Batman swoops in to confine and correct them the moment their difference manifests.

Batman is neither insane nor physically deformed; his defining traits are his absolute rationality and exceptional physique. Out of costume, he passes not only as "normal" but as extraordinarily pleasing to the eye; his is an extraordinary body, but not one different enough to provoke anxiety. His costume is just a costume, to be adjusted and worn at will, easily removed and hidden away. While Gothamites may casually refer to Batman as the first of the city's costumed "freaks," he is—costume aside—the epitome of super heroic normality, without any powers to other him. Because he is only a freak when in costume and so can un-freak at any moment, interactions between Batman and the rogues' gallery reinforce the dichotomy of "good" as "normative" and "evil" as "freaked." Batman, like the twentieth-century medical model, regulates normality and deviance in Gotham, taking upon himself the task of protecting normative society by confining and correcting those he perceives as dangerously different.

Disturbingly, Batman's perception of difference determines policy in Gotham's institutions of confinement and punishment. Bogdan argues that, "Whenever we study deviance we have to look at those in charge—whether self-appointed or officially—of telling us who deviants are and what they look like" (35). As a self-appointed regulator of deviance who literally tells Gotham through its police department who the deviants are and what they look like, Batman identifies deviance purely on the basis of what *he* finds strange and disturbing: essentially, what he finds different from himself. Broadly, this encompasses identity markers such as race, disability, sexual orientation, class, and gender identity,[5] but more immediately, what Batman finds different from himself is the different body. Since physical deviance is so frequently equated with madness in Batman comics, Batman can comfortably admit the freak of the day to Arkham Asylum for rehabilitation—or, rather, coercive normalization.

Porter outlines the general discourse of the asylum by identifying two principle schools of treatment: that of teaching normalcy, and that of restoring the mind through the body (17). Following the theories of John Locke, the madman "was not utterly bereft of reasoning power (such was the idiot); nor had his reason been totally destroyed by the anarchy of the passions." Instead, the madman was "essentially delu[ded]" due to "intellectual error," requiring a stable, regulatory environment that could impose "a stiff dose of rigorous mental discipline, rectification and retraining in thinking and feeling" (19). The madman, then, was grimly trained to act and think in a normative fashion. As Grant Morrison's and Dave McKean's *Arkham Asylum* (1989) attests, the eponymous madhouse adopts these tactics in its mission of rehabilitation.[6] Outside Arkham is little better; Batman's modus operandi is violence, reasoning that to correct the mind, one must first correct the body, often to devastating effect.

Batman, then, acts in the interests of normative society as he interprets these interests and thus replicates a centuries-old discourse of normality and deviance. Without exception, Batman answers difference with violence, confinement, and correction. He coerces deviance into resembling normality, and failing that, cloisters it away from normative society. He absolutely reinforces the belief that the normative body is good while the different body is evil and wrong and must be forcibly corrected.

Into this freak discourse enters Harley Quinn. Harley disrupts and critiques Batman's absolutist binary of good or normal and evil or freaked in three crucial ways: first, through her empathetic motivations; second, through her complex relationship to the regulatory psychiatric institution; and third, through her ambiguous identity as someone whose freaking was inflicted upon her and/or someone who deliberately freaks herself.

Madly in Love

Batman comics largely cleave to the logic of institutionalized normalcy: that "good" people adhere to the norm and "bad" people do not, either physically, mentally, or morally.[7] In many cases, the transformation into a deviant figure distorts the mind and/or morality from the normative baseline; the freaking itself is expressed through acts of evil motivated by greed, hate, ambition, jealousy, and anger. However, Harley Quinn stands firmly outside this mode of deviance, as her criminal or morally-dubious enterprises are motivated by her empathy and her love for others. In doing so, she blends the motives of the "good" guys with the actions of the "bad" ones—and, in some cases, actually achieves greater success than either.

This motivation is transparently clear throughout her narratives. Her incredible capacity for empathy drives her to rescue dogs slated to be euthanized (Conner, Palmiotti, and Roux "Helter Skelter") and threaten her lonely psychiatric patients' families until they visit their loved one to her satisfaction ("Very Old Spice"). She even interrupts a bank heist with Poison Ivy to help a little girl escape a would-be kidnapper (Dini and Guichet 152), whom the two defeat handily before taking Batman to task for leaving the saving of innocents to them, once he finally shows up (153). "Seriously," Harley says, "What's Gordon payin' ya for, anyway?" In this moment, Harley and Ivy are heroes, recognized as such by the girl's grateful exclamation (154) and by Batman's own silent admission: there is nothing villainous about what Harley and Ivy did (155).

Harley's empathetic love manifests in the aptly-titled "Mad Love" story, which reveals Batman's knowledge of her origin story and tracks Harley's efforts to earn the Joker's undivided affection. In this, possibly Harley's most

successful criminal venture, her empathetic motivation is beautifully explicated, as Dini and Timm trace her metaphorical fall for the Joker to a literal fall at the comics' end. Though, Batman notes, "Harley Quinn was *no angel*" (18), using unethical means to ace med school and secure a position as a psychiatrist at Arkham Asylum, her empathy undermines her otherwise uncompromising ambition. Recalling her preparation for her first therapy session with the Joker, Harley says, "I was determined not to be taken unaware, and studied up on all his jokes, tricks and gimmicks. Then I went in, ready for anything." This hubris leaves her susceptible to the Joker's machinations. Having already realized her emotional vulnerability, the Joker devises a backstory to provoke her empathy: one in which he suffered parental abuse, often to the point of hospitalization, and continues to suffer violence at the hands of a misunderstanding Batman. As Harley says, she had been ready for anything—"Anything *except that*" (33–37). The Joker, a mass murderer and archvillain, becomes in her eyes "nothing more than a tortured soul crying out for love and acceptance. A lost, injured child looking to make the world laugh at his antics" (37), and thus her fate is sealed. Because Harley empathizes, she loves; because she loves, she commits—to the Joker, to a transformation of self, to crime.

Because crime in Gotham, and Joker-related crime in particular, inexorably involves Batman, a confrontation between Batman and Harley is inevitable. When she decides to take on Batman, it is not due to personal enmity or moral opposition, but because she holds him responsible for the Joker's violent distress. "[F]or what it's worth, this really ain't a personal grudge," Harley tells him, lovesick and earnest. "Y'see, I actually *enjoyed* some of our romps. But the time comes when a gal wants *more* from life. And now all this gal wants is to settle down with her lovin' sweetheart" (52). Having a more objective perspective on the Joker, Batman reacts first with shock, and then with disbelieving laughter—something the Joker has never managed to coax from him outside of *The Killing Joke*'s final scene.[8] "I've never seen you laugh before," Harley remarks uneasily. "Cut it out. You're givin' me the creeps." Here, Batman drops the proverbial bomb in revealing the Joker's duplicitous manipulations, the sequence culminating in an explosive panel as Harley screams at him to "*STOP IT!!*" (53). The revelation that the Joker used her devastates Harley more than any of his abuse could, because she realizes that the love between them is nothing more than a farce, unwanted and unreciprocated. Thus, her actions, committed for a love in which she believed, are criminal and wrong.

To prove Batman mistaken and herself good and loved, Harley invites the Joker to the Aquacade to witness the death of his nemesis. However, instead of showing gratitude or appreciation for her accomplishment, the Joker attacks Harley with such violence that she crashes through the Aqua-

cade windows, falling five stories into a dank alleyway and police custody. The police recommit a grievously injured Harley to Arkham Asylum, where her former supervisor, Dr. Leland, waits to rehabilitate her for normative society. Harley herself, dismayed by her unreciprocated love, vows to reform herself in her cell, the sooner to get out—until she spots a rose in her cell, the attached note reading, "Feel better soon.—J." At this, her face lights up, her entire attitude shifting from despondent to exuberant. With the slightest hint that her love may be reciprocated, she re-commits herself to an empathetic relationship with the Joker, because doing so redeems her past actions as good—even if she must remain a freak to remain good. For Harley, then, freaking is not equated with moral corruption or criminality; it is equated with love.

Two key aspects of Harley Quinn as a character emerge from these narratives. First, on either side of the freak discourse, she ably achieves success where those less ambiguously positioned do not; she and Poison Ivy rescue a young girl while Batman is inexcusably late, and where Joker fails to contrive and execute a fitting end for Batman, Harley adapts a plot with dazzling simplicity, getting closer than the Joker—and perhaps any of Gotham's other rogues—ever has to killing Batman. Second, her success in both cases is driven by her empathy and her love—a love that, primarily aimed at the Joker, is "stronger than their madhouse walls" (Dini and Guichet 11). In short, her capacity for love allows her to transcend the regulatory apparatus of the normative/freaked binary.

A Session with Dr. Quinn

Throughout her narratives, Harley operates on either side of Gotham's psychiatric apparatus in both her Harley Quinn and Dr. Harleen Quinzel personas, repeatedly crossing the line between the regulators and the regulated freaks. Harley performs four different roles in relation to the psychiatric apparatus embodied in Arkham Asylum: first, as Dr. Harleen Quinzel, psychiatrist to the Joker; second, as Dr. Harleen Quinzel, patient/subject to the Joker's therapy; third, as Harley Quinn, performing psychiatry upon Batman; and fourth, as Harley Quinn, a psychiatric patient at the Asylum. As such, Harley significantly problematizes both the authority and the success of the institutions built to regulate deviance in Gotham City.

"Mad Love" provides the most succinct presentation of three of these identities. As previously discussed, Harley ends the comic as a psychiatric patient, and it is as Dr. Harleen Quinzel, Arkham psychiatrist, that Harley first meets the Joker, intent on cashing in on his villainy to secure her own fame in a tell-all book. As we know, Harley is too empathetic to succeed, and

too quick to relate to the Joker's insanity to escape his manipulations. It is thus tragically easy for the Joker to turn the tables on her—to act as a psychiatrist, with Dr. Quinzel on the couch. In this role, he is able to further manipulate her by normalizing her unprofessional and dangerous attachment to him. "...I had fallen in love with my patient," Harley confesses (37). "Pretty crazy, huh?" In this panel, Harley looks down, her attitude ashamed and discouraged, until the Joker responds sympathetically. "Not at all," he says: "As a dedicated, career-oriented young woman, you felt the need to abstain from amusement and fun. It's only natural you'd be attracted to a man who could make you laugh again" (38). Her attachment is "natural," normal, *good*; the Joker arrests any qualms by assuring Harley that she—and by extension, he—is perfectly normal and perfectly good. The Joker thus sets the foundation for Harley's eventual self-freaking, which becomes a means of maintaining Harley's goodness and of acting, like Batman, to defend her interpretation of normality.

The last manner in which Harley subverts Gotham's regulatory psychiatric apparatus is when she acts in a psychiatric capacity as Harley Quinn. In "Dr. Quinn's Diagnosis" (Dini and Guichet 156–176), Harley persuades Batman to submit to a session of psychotherapy. In response to Batman pointing out that her "doctor's license was *revoked*," Harley retorts that he has no authority for his activities, either: "You're not a *cop*, but you *arrest* all kinds o' *crooks*..." she beams, delighted to have outwitted him. "Think of me as your very own *vigilante therapist!*" (166).

Despite her lack of professional accreditation, Harley quickly discerns the cause of Batman's "vigilante overtures." "Were [your parents] the *victim* of some kinda *crime?*" she asks, and though Batman does not respond, the black of his cowl dissolves into the grief-stricken face of his younger self as his parents are murdered. Reading the accuracy of her insight in his grim expression, Harley's eyes fill with tears: "Whoa, they *were!* That's *terrible,* Batski. Sorry to hear it." She continues in her psychological interrogation— did Batman talk about his trauma? (Yes.) Was he medicated because of it? (No.)—scribbling their exchanges down furiously (168) until she has enough information to finally diagnose. "Subject shows signs of *obsessive narcissism* and clearly has *anger management* issues pertaining to childhood *trauma...* " she reads from her notes (169), concluding that Batman "has *compulsive* nature reflected in an *endless* need for *conflict*" (171). Despite her lackadaisical methodology and Batman's repeated efforts to turn the psychoanalysis back on her, it is difficult to find fault with Harley's conclusions. After all, Batman does fight crime with a cold, relentless anger inspired by his childhood trauma; he is obsessive and narcissistically believes that Gotham's fate lies in his hands and his hands alone; he turns compulsively to vigilantism rather than legal alternatives; and he does engage in endless conflict of his own design. In spite of his rationality, he commits strange and criminal acts

according to a moral code, and so must, by his own edicts, be normalized for the benefit of normative society.

Harley, costumed and criminal, thus inverts the typical regulatory relation between normalcy and deviance in Gotham, by not only performing psychiatry as one of the city's freaks but doing so upon Batman, the epitome of superheroic normality and the self-appointed guardian of Gotham's normative society. In doing so, she suggests that Batman himself is a freak in his own application of the word, in need of the same regulatory apparatus he imposes upon others. The boundaries between freak and normative are thus far more fluid than he would like to admit.

Making a Freak

The final way in which Harley Quinn problematizes Gotham's freak discourse is through the act of freaking. As previously discussed, Gotham's villains are freaks because something was done to them, and the process of transformation similarly transforms their psychology. However, Harley Quinn's freakishness is considerably more complex and complicates the absolutist logic of Batman's regulation of deviance. The question of Harley's freak identity—was she made a freak or did she make herself into one?—has no clear answer and an abundance of contradictory evidence. Both "Mad Love" and "Harley Quinn" present a different take on Harley's freaking. In each comic, a character is positioned to inflict deviance upon her—the Joker and Poison Ivy, respectively—and in each comic, Harley freaks herself as well. Where my previous analyses have been organized by narrative, this analysis is organized by external/internal freaking.

As we have seen in "Mad Love," the Joker manipulates Harley's empathy in order to repeatedly escape Arkham (Dini and Guichet 11) and acquire an ally inside its walls (Dini and Timm 50). In doing so, he lays the groundwork for her unexpected self-freaking. His psychological corruption thus constitutes an act of preliminary freaking; Harley's physical freaking would be unnecessary or even impossible without the Joker's influence. A more obvious form of external, physical freaking occurs in Harley's first encounter with Poison Ivy, during which Ivy force-feeds Harley a draught to enhance her speed, strength, and agility, and to grant her immunity from Ivy's various toxins. In short, Ivy gives Harley superpowers, and in doing so, sets her immutably apart (Dini and Guichet 31–33). Few Gotham villains have superpowers; most are othered only by their madness or their freaked physique, with the exception of figures like Poison Ivy or Clayface. Accordingly, Harley is further othered from her criminal peers and from the unpowered Batman—and freaked entirely without her consent.

Though Harley bears Ivy no ill will, the fact that this particular freaking was neither her idea nor something she was able to refuse seems to plant Harley firmly in Gotham's rogues' gallery, yet another criminal whose deviance was inflicted upon her. However, in both "Harley Quinn" and "Mad Love," Harley freaks herself without Ivy's influence, preparing to cartwheel to the Joker's side. "I wanted to make a statement," she recalls, "one that would let the world know I was [the Joker's] [...] alone" (14). She tries on a variety of outfits, burgled from a costume shop—a purple suit is "too derivative," a mismatched clown ensemble receives an "Ick!" but a red-and-back harlequin jumpsuit fits the bill to a tee. "Hello, *gorgeous!*" Harley crows.

In "Mad Love," the transformation happens a little differently, but the elements are the same. Rather than springing joyfully to the Joker's side, Harley bursts from Arkham in stunned outrage as Batman returns a bloodied Joker to its care. She ransacks a costume shop, throwing the proprietor through a window when he protests, and slips silently past the asylum's security to blow the Joker's cell wide open (41). "Knock, knock, puddin'!" she cries, striking a pose. "Say hello to your new and improved—*HARLEY QUINN!*" (42). Again, she freaks herself in preparation to join the Joker, but it is a decision based in her empathetic response to a wounded and delirious loved one; she freaks herself in order to join him, and she joins him because, however unwisely, she loves him.

This is far from the only instance of freaking Harley performs, which suggests that Harley has a far more nuanced understanding of what freaking means than most of Gotham's villains. Essentially, Harley's freaking is performance—and, like every great performance, it is absolutely true. Luring Batman to her piranha-infested trap, Harley doffs the donkey-eared jester cap and wipes white makeup from her face, appearing to restore the pale, blonde, *normative* Quinzel to the scene (47). Batman only responds to her call because she normalizes herself; un-freaked, she is a normative body to be protected from deviance. However, left to her own devices, the harlequin suit and clownish cosmetics return and remain, marking Harley as an indisputable freak opposing Batman—no matter how their characters overlap. Despite the confusion of costuming, the freaking inflicted upon her and the freaking she chooses herself, Harley Quinn is Harley Quinn; no matter how she dresses or moves, she will still save helpless animals, fall for the Joker, and make Batman laugh as few others can.

Conclusion: "Harley Quinn is who I am!"

In "Intolerable Ambiguity: Freaks as/at the Limit," Grosz argues that

> The freak is an object of simultaneous horror and fascination because, in addition to whatever infirmities or abilities [they exhibit], the freak is an *ambiguous* being whose existence imperils categories and oppositions in social life. Freaks are those human beings who exist outside and in defiance of the structure of binary oppositions that govern our basic concepts and modes of self-definition [57].

If Harley Quinn is anything, she is ambiguous. This essay argues that Batman enforces a strict binary of good/normative and evil/freaked bodies in Gotham City and that Harley problematizes this otherwise absolutist binary in three ways: by committing crime for love; by operating in the psychiatric institution of regulation in four distinct roles; and by occupying an ambiguous position as someone who is freaked by others and who freaks herself. In the end, ambiguity is her calling card. At the close of her psychiatric session with Batman, Batman cuttingly asks, "Are you a naive *victim* of the Joker's madness or did you become this by *choice?*" (Dini and Guichet 173). He essentially demands to know if she is a victim or an accomplice. A brainwashed, normative citizen under his protection, or a freak through and through? For a single silent panel, Harley stares dubiously at Batman, hands on her hips, as if incredulous that he, of all Gotham's doubled identities, would miss the joke. "I'm not a *stooge* or a *victim*, Bats!" she says, pointing at him sternly: "Harley Quinn is *who I am!*" (173). Whatever motive, psychiatric role, or costume she wears, she is indisputably herself: ambiguous, defiant, a cheerful red-and-black outlier to both sides of Gotham's freak discourse throwing Batman's entire methodology into question. She is, in short, the freakiest of them all.

NOTES

1. For comparison, please refer to: Finger, Fox, and Kane 2; Miller and Mazzucchelli 22; Snyder and Capullo n.p.

2. This dubiously plausible intervention manifests in Kirk Langstrom's Man-Bat serum, which transforms the subject into a monstrous bat-like figure.

3. Michel Foucault prolifically explicates upon this topic in *Madness and Civilization*.

4. I parallel psychological and corporeal difference here not because I believe the two to be interchangeable, but because I believe that Batman comics equate madness with freakishness. I establish a link between the two in my theoretical framework to identify and analyze this pattern.

5. Shannon Austin argues that "Batman's female villains serve as examples of the correlation drawn between female power and monstrosity," and that "any deviation from [the gendered, passive] norm is viewed as a threat" (286), compounding the "threat" of those, like Harley, with intersecting identities.

6. In *Arkham Asylum*, a number of inmates attest to enduring electroshock therapy throughout their rehabilitative treatment.

7. Though this logic became widely accepted as deviance was medicalized, it was not always so. Robert Bogdan notes that doctors responsible for "authenticating" the freaks exhibited in the nineteenth century "emphasized that the abnormality was a discrete condition, not an indictment of the integrity or morality of the exhibit" (30).

8. For further reading on the transgressive nature of laughter, especially in Batman comics, see: Grayson, Ellen Hickey. "Social Order and Psychological Disorder: Laughing Gas Demonstrations, 1800–1850." *Freakery: Cultural Spectacles of the Extraordinary Body*. Ed.

Rosemarie Garland Thomson. New York: New York University Press, 1996. 108–120. Print; Spanjers, Rik. "The Killing Joke: The Joker's Laughter and Resistance." MA Thesis. University of Amsterdam, 2010. Print.

WORKS CITED

Austin, Shannon. "Batman's Female Foes: The Gender War in Gotham City." *The Journal of Popular Culture* 48.2 (2015): 285–295.

Bogdan, Robert. "The Social Construction of Freaks." *Freakery: Cultural Spectacles of the Extraordinary Body.* Ed. Rosemarie Garland Thomson. New York: New York University Press, 1996. 23–37. Print.

Conner, Amanda, and Jimmy Palmiotti (w). Hardin, Chad (p) (i). "Hot in the City." *Harley Quinn.* v2. #1. (Feb. 2014), Warner Brothers. DC Comics. Print.

Dini, Paul (w). Guichet, Yvel, et al. (p). *Batman: Harley Quinn.* Ed. Robin Wildman, et al. Burbank: DC Comics, 2015. Print.

Dini, Paul, and Bruce Timm (w). Timm, Bruce, and Glen Murakami (p). Timm, Bruce (i). "Batman: Mad Love." *Batman: Mad Love and Other Stories.* vol. 1. Ed. Scott Peterson. NY: DC Comics, 2005. Print.

"Feet of Clay Part 1 and 2." *Batman: The Animated Series Volume One.* Dir. Dick Sebast and Kevin Altieri. Writ. Marv Wolfman and Michael Reaves. Warner Brothers, 2005. DVD.

Finger, Bill, and Gardner Fox (w). Kane, Bob (a). "The Batman and How He Came to Be." *Detective Comics* #32–33 (Nov. 1939). New York: DC Comics. Comixology.

Garland Thomson, Rosemarie. "From Wonder to Error—A Genealogy of Freak Discourse in Modernity." *Freakery: Cultural Spectacles of the Extraordinary Body.* Ed. Rosemarie Garland Thomson. New York: New York University Press, 1996. 1–19. Print.

Grosz, Elizabeth. "Intolerable Ambiguity: Freaks as/at the Limit." *Freakery: Cultural Spectacles of the Extraordinary Body.* Ed. Rosemarie Garland Thomson. New York: New York University Press, 1996. 55–66. Print.

"Heart of Ice." *Batman: The Animated Series Volume One.* Dir. Bruce Timm. Writ. Paul Dini. Warner Brothers, 2005. DVD.

Lieberman, A.J. (w). Barrionuevo, Al, et al. (p). "Human Nature, Part 2." *Batman: Gotham Knights* #62 (Apr. 2005). Ed. Matt Idelson. New York: DC Comics. CBR file.

Loeb, Jeph (w). Sale, Tim (a), Wright, Gregory (c). Starkings, Richard, and Comicraft (l). *Batman: The Long Halloween.* Ed. Archie Goodwin and Chuck Kim. New York: DC Comics, 2011. Print.

Miller, Frank (w). Mazzucchelli, David (a). Lewis, Richmond (c). *Batman: Year One.* Ed. Dennis O'Neil. New York: DC Comics, 1987, 2005. Print.

Moore, Alan (w). Bolland, Brian (a) (c). *Batman: The Killing Joke.* Ed. Dennis O'Neil and Mark Chiarello (2008), Warner Brothers. DC Comics. Print.

Porter, Roy. *A Social History of Madness: The World Through the Eyes of the Insane.* New York: Weidenfeld and Nicolson, 1987. Print.

Snyder, Scott (w). Capullo, Greg (a). Miki, Danny, et al. (a). "Secret City" *Batman: Zero Year.* Ed. Mike Marts, Katie Kubert, and Peter Hamboussi. New York: DC Comics, 2013, 2014. Print.

Arkham Origins
Looking at Grown-Up Themes
Through the Lens of a Kid's TV Show

DEREK MORELAND

From her first appearance onscreen, it was clear Harley Quinn was going to be special. Harleen Quinzel, one of the first original villains created for *Batman: The Animated Series*, had a distinctive look (40s bombshell, evocative of Veronica Lake), a unique voice (the unmistakable Arleen Sorkin, whose contribution to the character is inestimable), and a killer hook (she's a woman henching for the Joker, not a common occurrence even in the world of comics). As the show continued, however, Harley Quinn became a sum greater than her parts. Watching episodes featuring Harley in their original production order reveals a heartbreaking, breathtaking, and expansive narrative arc. Harley is a character used to explore gender- and queer-positive ideas, as well as co-dependence and the cycle of abusive relationships. These themes, conveyed through the medium of a children's television program, catapulted Harley to unprecedented heights of popularity and created a lasting fanbase that follows the character to this day. This is not an exhaustive chronology of Harley's *B: TAS* appearances—there are a few episodes where her presence is largely cosmetic ("Almost Got 'Em," "Lock-Up," "Over the Edge," "Joker's Millions"), and she had cameos in other properties that are outside this essay's purview ("Superman: The Animated Series," "Batman Beyond: Return of the Joker"). This is a review of Harley's growth, progress, and development over the course of *Batman: The Animated Series*.

"*Joker's Favor*"

Harley debuted relatively late in *B: TAS*, in the episode "Joker's Favor." A well-known bit of trivia is that Paul Dini decided the Joker needed a

henchwoman in order to have someone jump out of a cake at an event; however, it was ultimately decided that the Joker himself popping out was funnier, so Harley's role was changed (Cronin). Dini cast his friend Arleen Sorkin in the role, whom he'd seen dressed as a clown on *Days of Our Lives,* which Dini found inspiring (Reisman). Sorkin served as a model for Dini as well, who claims to have based a number of Harley's mannerisms on her (Dini). Sorkin's personality and talent brought a fresh, vibrant life to Harley, giving her an immediate appeal.

Harley's character is firmly established by her actions and antics in this episode, even if she is a little more subdued than she would eventually become. Harley never stands still, prancing and pantomiming while the Joker threatens Charlie Collins, acrobatically egging the Joker on as he outlines the details of his plan to kill Commissioner Gordon. Later, at the Peregrinator's Club, her natural charisma and spunkiness are on full display. When Harvey Bullock gets lascivious, she cracks his shin with a baton—after which Sorkin puts the cherry on top, her voice dripping disgust as she walks by and calls him a "jerk." She shares the Joker's flair for the theatrical, whooping and cheering when the Joker makes his debut at the party, kissing Gordon's cheeks as she sets a bomb in his lapel, and blowing kisses to the crowd as she and her nefarious beau take their leave. She even makes a half-hearted attempt at stabbing Batman, after trying to garner his sympathies, claiming to have been "led astray by bad companions." Harley embraces both her sexuality and her femininity in these scenes—she is empowered, playing on men's expectations of her and showing strength and will without sacrificing her womanliness.

The meat of Harley's first appearance is, of course, her interaction with the Joker. She is immediately sycophantic, coddling his ego with whistles and applause as he first announces his plans. The moment is played for laughs, but it is a show of devotion much stronger than the ones put on by his other two henchmen. Instead of paying strict attention to the boss, one is reading a *Tiny Toons* comic (a hilarious in-joke nod to Paul Dini, who wrote for both shows), the other playing a pinball game. They get with the program, sure, but only after Harley's continued cajoling. In the very next scene, she's giving "Mistah J" a haircut, an incredibly intimate and trusting gesture for someone like him. However comedic the scene is played—"Leave the sideburns!" he snarls—there is still an implication of intimacy that we have not seen in the Joker's life before now. Harley is no mere hired goon: as they leave the party at the Peregrinator's Club, Harley is right behind the Joker, trading quips as the bomb he planted explodes behind them. She's not his equal—someone like the Joker does not believe he has an equal—but she is the next best thing, an audience. It is astonishing how quickly Dini seeds their relationship and its nature in these two scenes. The roots of abuse and codependence are plain;

Harley is the devoted subservient, and the Joker enjoys having her around because it gives him a crowd to play to, even if it is a crowd of one. This chemistry with the Joker, alongside Harley's distinct, feminine visuals and buoyantly effervescent personality, provide an immediate hook onto which young viewers could latch.

"The Laughing Fish"

The audience gets their first real taste of Harley as victim in "The Laughing Fish." Her power and charm are no longer hers—she flirts a bit with G. Carl Francis, but as part of the Joker's scheme, not of her own volition. The Joker also physically abuses her for the first time in canon: he forcefully feeds her his tainted fish, over her objections (and a hinted allergy), and stuffs her into a fish costume later in the episode.

Harley is much less manic this time around, as well. When Batman is struggling with the shark, she stands around, watching but not engaging with the action. At the end of the episode, when Detective Bullock later mocks her "demented, abusive, psychotic maniac" of a boyfriend, she can only bawl, "I'm really gonna miss him." Her independence, her investment in herself as a person, has been compromised by this relationship. Harley's identity is now defined by her association with the Joker, giving Harley an added layer of pathos—as well as giving those in the audience who might find themselves enthralled by the Joker's antics a point of identification. Not everyone wants to be the bad guy; but sometimes, it's nice to root for them.

"The Man Who Killed Batman"

"The Man Who Killed Batman," Harley's next major appearance, is important for two reasons. One, this is the first time the name Harleen Quinzel is used in continuity, though she claims to be legal counsel, not a psychiatrist. Two, the audience is treated to a short reappearance of the old Harley—once again, with Harvey Bullock as the instigator. When Bullock tries to remember where he has seen her before, she mentioned she once served him a subpoena—"a *small* subpoena." Note that both of these character moments occur when the Joker has not yet made an appearance. Once back in his presence, she becomes the simpering love-struck submissive once again, playfully intoning "Amazing Grace" on the kazoo while Sid the Squid, the titular Man Who Killed Batman, is lowered to his death. She also cracks wise when another subordinate is fed to the hyenas Harley keeps as beloved pets.

Additionally, this is the first episode where the audience is told defini-

tively that the Joker cares more about Batman than Harley. He throws her around in grief and rage when he realizes that Batman is, as far as he knows, dead, and makes her put the loot she is toting back. After all, "Without Batman, crime has no punch line." Harley's desire for the spoils of larceny is forever superseded by the Joker's whims and disappointments. In addition to once again showing Harley's subjugation to the Joker's all too mutable will, this also appears to be the first time Harley is treated more as a child than an adult. In later episodes, this feels more emblematic of Harley's crippled emotional growth. Here, however, it is used more for audience identification: after all, what child watching couldn't identify with the feeling of being told they can't leave the store with whatever they wanted, without being told why?

"Harley and Ivy"

It makes sense, then, that her next appearance is "Harley and Ivy," the episode that first hints at Harley's bisexuality. After multiple episodes of being the Joker's doormat—something Ivy calls her out on here—Harley reclaims her womanhood with the help of another woman. She does still pine for the Joker, despite the fact that he is at his most verbally and physically abusive here. Harley cowers and wilts under his anger, and seems genuinely afraid that he will hurt her because he has before. "You'd think, living with Mistah J, I'd be used to a little pain," she confesses to Ivy. For Harley, pain is a way of life now. She cannot imagine existence without it.

Getting together with Ivy is not just about being out from under the Joker's thumb. Harley also shows just what a capable thief she can be. Mere hours after she has been kicked to the curb, Harley's quick thinking and incredible skill-set save her and Ivy from the police in a situation that was Ivy's fault in the first place. Harley was already surreptitiously burgling the museum with ease and aplomb. It was Ivy's carelessness, while on a completely different caper, that brought the two together and necessitated Harley's save. The point is undeniable; Harley is a better, more effective criminal when she gets to call the plays. The character that bloomed so brightly in "Joker's Favor" has started to bud once again. Later, when the pair are catcalled from a car by a trio of lewdly flirtatious jocks, Harley blows up their vehicle in response. The boys survive, but the message is clear. Harley is done with men treating her like dirt. At least for now.

However, the heart of the episode is in Harley's budding relationship with Ivy. Whether it was intended by the episode's creators or not—talk of bisexuality or queer positivity are absent in the commentary track, for example—it is clear that the titular couple is just that. The audience is given little clues throughout the episode, touches that hint at more than mere friendship.

Ivy drapes a casual arm over Harley's shoulder at the Peregrinator's Club and puts up newspaper clippings of the pair's exploits on the refrigerator, all of which have a photo of them committing some new crime together. The fridge is a hodgepodge of memories, like a twisted criminal scrapbook of a couple's honeymoon vacation.[1]

Of course, the most obvious subtext is seeing Harley and Ivy having breakfast together in long, oversized men's shirts and nothing else. The lack of bottoms is a particularly compelling sign that the two women are together; lounging around in tops alone speaks of a level of comfort between two people that mere friendship cannot provide. This is a subtle, often used trick by television writers to imply to the audience that sex has happened off camera, but one that still gets around Broadcast Standards & Practices.

Lamentably, even in this setting of domestic bliss, Harley misses her ex. The morning after another successful heist, all Harley can think of is how long she has been away from her old flame. She backslides, saying she just does not "feel like her old, perky self," even though moments ago she was singing and dancing around the kitchen in BS&P-approved lingerie with her gal pal. She even calls the Joker while Ivy is out, "checking on him" and evasively stating that she is "staying with a friend" when asked about her location.

Harley's reaction to the Joker tracing her call, hunting her down, and threatening to kill her new girlfriend is genuinely heartbreaking: she expresses unbridled relief that the Joker still cares for her. Still, she manages to hold onto some of her rediscovered self, attempting to make a getaway with Ivy only to be brought to justice by another woman, Renee Montoya. The clear conclusion here is that, at least in Harley's case, a (criminal) relationship with a woman is healthier and more fulfilling than a relationship with a man, especially a man as abusive as the Joker. It's the most important conclusion the show's audience would catch; one that would give queer viewers a relationship anchor they could both identify with and champion. This episode builds the depth and complexity of Poison Ivy, one of Batman's most legendary female rogues, as well, showing that even in her own mania, Ivy is capable of caring about a human being.

"Trial"

The audience next encounters Harley in "Trial"; presumably, she's been locked up in Arkham since Montoya busted her at the end of her last appearance. The episode itself is a brilliant ensemble piece. Unfortunately, Harley has less to do here, and her role for the most part is reduced to comic relief. She does shine in a couple of moments: she and Ivy get some screen time

together, first when Harley welcomes "Red" back to Arkham (one assumes she escaped or somehow got released between "Harley and Ivy" and now), and later when the pair work in tandem once again to deceive and capture Batman. Harley's former career as a doctor is first referenced here as well, meaning another facet of her backstory is slotted into place. Otherwise, the episode is mostly a series of (admittedly very well done) humorous gags. Harley wears Batman's utility belt, rubbing his helplessness in his face, and shows Judge Joker some animation-appropriate affection while on the witness stand. She threatens the Joker later when she learns he "finked" on her to try to get a suspended sentence, but it is played entirely for laughs, and no one— not even Harley—seems to be buying this as a legitimate moment of reprisal since she literally just thanked Batman for creating the Joker. Without him, they never would have met. Regardless of her team-up with Ivy earlier, in which both of them surprised, outfought, and rendered Batman unconscious *for the second time*, she is happily back in the Joker's pocket.

"Harliquinade"

"Harliquinade" is famous for being the episode Paul Dini wrote specifically so Arleen Sorkin could sing "Say That We're Sweethearts Again," a silly MGM ballad from a 1940s musical she was practicing in his car ("Harliquinade").[2] More importantly for Harley, however, Dini also begins to slip more overt references to Harley's past in this episode. Harley wasn't just a doctor, she was a clinical psychiatrist, and the first allusion is made to the idea (later canonized in "Mad Love") that she once attempted to treat the Joker. The inference can also be made that a young Harleen was either a narcissist or suffered some form of trauma. This is evident when pressed by Batman as to what she finds so appealing about him, Harley replies, "Look Bats. When I was a doctor, I was always listening to other people's problems. Then I met Mistah J, who listened to me for a change, and made everything fun." She then (in classic abused lover fashion) defends his sadistic behavior, dismissing it as "just a joke" to Batman, and insisting the clown is only "a little temperamental" when gangster Boxy Bennett starts getting handsy with her arm later in the episode. Noticeably, she shrugs off Boxy's advances with what looks like mild revulsion, much as she did with Detective Bullock earlier in the series. Only two men seem able to touch her with any degree of comfort: the Joker, when he's being kind, and Batman, for reasons that will become clearer in "Harley's Holiday."

In addition, this episode is notable for the first appearance of Harley's empathy. Up to this point, Harley has been pretty single-minded in her devotion to the Joker. With the exception of a brief tryst (and true love, acceptance,

and freedom) with Poison Ivy, she only has eyes for the Clown Prince of Crime. However, when the Joker decides to nuke Gotham City, Harley refuses to leave behind their former cellmates in Arkham, nor can she abandon the pet hyenas she affectionately calls her "babies." She even shrugs off the Joker long enough to save the day. This is a moment of genuine growth for the character, though for the most part it is once again played for broad comedy.

The most telling line of the episode, however, comes when she first puts on her Harley Quinn outfit. She leaps and flips back on screen, declaring, "I feel like a human being again." This is an interesting choice of words. Harley, up until this point in the episode, has been acting bizarrely childish with her hair up in the now ubiquitous pigtails, she smacks gum and plays with a stuffed clown while lying upside down in her cot. Later, she starts playing with the Batmobile radio, showing a complete lack of impulse control. Once in her costume, the more familiar Harley comes out to play. Her movements become suppler and gymnastic; her body language becomes more open, flirting, and sexy. For the first time, the audience sees what being Harley Quinn means: Harley is the excuse for a little girl to be the woman she wants to be, the mask she can put on to pretend to be what she believes is her best self. This, more than any of the excuses she piles on, explains her infatuation with the Joker, and why she holds onto him so tightly even when real love, like Ivy, or a protective authority figure, like Batman, try to reason with her. The Joker gives her the freedom to become whom she believes she is, and it is this freedom, this casting off of society's mores and moralities, that makes Harley so appealing as a character. Even wrapped in the cloak of animated insanity, there is genuine bravery in choosing to cast aside your upbringing and choose to be the person that makes you happiest.

"Harley's Holiday"

With the last episode in mind, it is a bit of a surprise that Harley next appears in the aptly named "Harley's Holiday," her first episode where the Joker is not a key plot point. In fact, her ersatz beau is not even mentioned in this episode, which hinges on Harley being declared sane and being released from Arkham. Instead, the audience is treated to a very different relationship dynamic. If the Joker is Harley's personal Puck, this episode posits that Batman is her father figure, which is only made clear because Harley attempts to purchase a nice dress.

The dress in question is the antithesis of her Harley Quinn outfit, a rejection of that mask in favor of clothes befitting an adult. The fact that she attempts to pay for the dress is less important than her desire to wear something new and mature. She goes into an upscale department store wearing

an outfit befitting a teenaged girl: a tied-off sleeveless t-shirt, short shorts, and skates. Even though she is out of Harley Quinn's costume, she has still reverted to the young, presumably abused girl who seeks freedom behind Harley's make-up. She rejects this outfit, calling it "outta style," before trying to purchase a classy pink number. The audience knows it is classy, because it is being bought from the same store that high-society *fashionista* Veronica Vreeland is trying to find a new outfit for Bruce Wayne. Presumably, a dress like that is another step on the road to recovery, a rejection of both Harley Quinn's antics and the protective façade of suspended adolescence. It is no wonder that she falls back on the Harley Quinn persona when she feels persecuted by the store's security guard. If rational society is going to reject her attempt to rejoin it, then why shouldn't she reject rational society?

Batman pursues her throughout the ensuing chaos, which includes kidnapping Vreeland, smooching Boxy Bennett to get back into his good graces, and running poor Detective Bullock's car through the ringer. Despite her best efforts, Batman attempts to talk her down, to bring her back to some state of rationality. This is because the belief at the core of Batman is that rehabilitation *works*. Criminals can be helped, and with that help, become productive members of society. With Harley in particular, this belief manifests itself as almost paternal. He cares about Harley and her well-being. She has made a genuine effort, and he will not see that effort wasted. In the end, when he rescues her from an explosion caused by a multi-vehicle pile-up, Batman cradles her in his arms like a child. Afterwards, he visits her when she has returned to Arkham, leading to one of the greatest exchanges in the history of the series:

> HARLEY: "There's one thing I gotta know—why'd you stay with me all day, risking your butt for someone who's never given you anything but trouble?"
> BATMAN: "I know what it's like to try to rebuild a life. I had a bad day too, once."

He then hands her the dress she bought, reaffirming her desire to have a life that is her own, as a father would with an ostracized daughter. Harley's reaction is to kiss Batman twice. The first one is a tender, adult peck, but the second is a longer, zanier kiss, more befitting a cartoon character than a grown woman. Harley is still Harley, after all, and even honest affection can be played for laughs. Tellingly, the only other rogue to see this happen is Ivy, who merely shrugs at Robin and smiles, happy that Harley is happy.

This episode, more than any other, epitomizes what makes Harley so endearing and enduring. Yes, she is wacky, sexy, and free-spirited, all admirable traits that any number of viewers could see in themselves (or, alternately, could wish desperately that they had). Beneath that flamboyant exterior is a core of emotional anxiety, self-recrimination, and doubt. Watching a character like Harley cope with her flaws, even when she fails, helps the predom-

inantly young adult audience process their own feelings of awkwardness and even isolation.

"Holiday Knights"

When the show was retooled as *The New Batman Adventures* in 1997, Harley seemed to be little more than a bit player, albeit more vocally murderous. "Holiday Knights" sees her once again shacking up with Poison Ivy. They share a bed in a fleabag motel where Ivy happily pretends to smother Harley with a pillow while the other bemoans the lack of Christmas decorations. Originally, the scene was also going to be even more blatantly erotic, with Harley in a pair of panties instead of boxers (Smith). As it stands, the moment is still playful and teasing, a direct contrast to the times the Joker has attempted to silence Harley using much more violent means. Once again, the pair's closeness and affection is demonstrated, showing how caring these two women remain.

To make up for her lack of the Christmas spirit, Ivy uses her hypnotic lipstick to force Bruce Wayne to take them on a Christmas-time shopping spree. Harley still acts silly and a little childish, choosing intentionally goofier clothes and showing a preference for candy and toys over finer things. She does show a penchant for jewelry, but even then, she piles it on herself like a kid playing dress-up. This episode shows that, while not as healthy as the life she briefly flirted with in the last appearance—the life that Batman is trying desperately to steer her towards—her relationship with Ivy may be, in fact, the best of both worlds. Harley is with a partner who cares about her enough to risk arrest and imprisonment for her happiness; Ivy also shares and appreciates Harley's criminal tendencies, making their illegal escapades the felonious equivalent of dating. If Harley is doomed to a cycle of crime and violence, she can at least do so in a committed, adult relationship with someone who loves her.

"Girl's Night Out"

Or maybe not. "Girl's Night Out" throws a wrench into this blissful dynamic by introducing Livewire, a character from Superman's animated Rogue's Gallery, into the mix. In her own way, Livewire is a Harley analogue—a character who debuted in an animated series whose popularity led her into the comics. She also works as a foil for Harley and appears to share Harley's infatuation with Ivy. The two women flirt almost from the moment Livewire appears onscreen. Harley, in response, is livid; she has never had anyone

present a challenge for Ivy's affection before and this new girl is encroaching on her territory.

Livewire puts Harley down at every opportunity, which does not help. Harley, whose intelligence fluctuates from caper to caper depending on writer fiat, sees every potential target in their latest heist as a nail and, of course, she has her giant, carnival-sized hammer. Ivy is, as always, charmed. "She tries so hard," she explains to Livewire, but the new girl would rather take charge and relegate Harley back to henching status, over Ivy's defensive protests. No wonder, then, that Harley takes her revenge as soon as possible with a comically sized seltzer bottle. This later leads to the villain's undoing at the hands of a Batgirl/Supergirl team-up, which is a growing friendship that juxtaposes nicely against the Harley/Ivy relationship.

Batgirl and Supergirl meet and get to know each other over the course of the episode. By the end, they are sitting on a couch together in thick bathrobes, hair up in towels, high-fiving their victory over their foes. Contrast that with the usual depiction of Harley and Ivy, which more often than not involves much less clothing and much more intimate accommodations. Batgirl and Supergirl are friends, comfortable enough in each other's company to take a shower while the other is in the same apartment. Harley and Ivy, on the other hand, playfully roll around in bed together. By demonstrating what a close, caring, but chaste relationship between two characters can be, this episode erases any lingering doubt that Harley and Ivy are lovers.

"Mad Love"

If "Girl's Night Out" is the show's last word on Harley and Ivy, then it is only fitting that "Mad Love" (Harley's final major appearance) is the definitive statement on Harley and the Joker. After half a decade of hints and teases, the audience is finally given a conclusive origin for Harley. Before she donned the pancake make-up, she was Arkham's newest clinical psychiatrist, a bright young doctor with an eye on the fortune and fame that would come from rehabilitating a celebrity case. She calls super-criminals "glamorous" and later mentions on her first walk through the facility that she has "always had an attraction for extreme personalities." Not unnoticeably, her eyes happen to fall on an incarcerated Poison Ivy when she uses the word "attraction," showing that even as straight-laced Harleen, the woman knew what she wanted.

The Joker, however, is the one who catches her full attention, and he plays her from the very beginning. Even before they share a session, he breaks out of his cell to leave a rose in her office. When Harleen confronts him about it, he stays loose and languid on his cot, oozing confidence and charm. He

tells Harleen that if she were going to report him, she would have done so. He is right, of course, and they both know it.

The Joker presses his advantage, gaining first her sympathy and then her heart with a few cunning make-believe tales of childhood woe. When Batman returns the Joker to Arkham after one of his many escape attempts, however, she finally breaks from reality. The passion the Joker stirs in Harleen Quinzel inspires her to create her own "extreme personality" in Harley Quinn. Harleen has become the kind of person that she finds attractive. Quite literally, she has become a person she can love. She also describes the Joker as "a lost, injured child trying to make the world laugh at his antics." Harley must have missed studying Freud when she was earning that psychiatry degree because she is clearly projecting, describing herself, and attributing her supposed innocence to the Joker's murderous ambitions.

Of course, Harley projects in another way as well. She believes her domestic bliss is consistently and cruelly shattered by Batman, not her own beloved's homicidal tendencies. Harley abandons all progress made over the course of the series; for her, a fantasy life as the Joker's girl is more satisfying than a reality without him. She proves this by using cunning and guile to lead Batman into a trap, employing the one weapon she knows she has over him: his iron-clad belief in her attempts to reform, as shown in "Harley's Holiday." She sends him a video claiming to have insight into the Joker's latest scheme, but only when she takes off the mask and rubs away the make-up does Batman decide to take her at her word. She further sells her deception by wearing her hair in a loose, adult ponytail to their meeting, eschewing her traditional pigtails, and tasing Batman in the back while he is distracted by a feigned attack. This is not the silly Harley who attacked ATMs with a giant hammer; nor is this the overtly sexy Harley attempting to seduce another man for personal gain. This Harley is prepared to murder her surrogate father to secure her future with the man he rejects.

Harley also makes Batman laugh, something the Joker could never actually do which, naturally, creeps her out to no end. Worse, the source of his mirth is how thoroughly Harley has been played, and he tells her the Joker had her "pegged for hired help from the moment you walked into Arkham." Unfortunately, even when the only other man she has a modicum of respect for breaks down in laughter at the idea that Harley will ever make the Joker happy, she holds onto her fantasy. That is, until the Joker backhands her so hard the camera has to cut away for BS&P reasons. He then throws her out of a window several stories up. Still, as she has so many times before, she manages to blame herself for his actions. "My fault. I didn't get the joke," she moans.

Harley appears to wise up while in traction, promising herself that she's through; that his manipulations will no longer sway her ... right up until she

finds a rose in her cell at Arkham, and the cycle begins anew. This beautiful, tragic ouroboros serves Harley as a continual motivation, pulling sympathy from her audience as she seems incapable of avoiding her own destruction.

"Beware the Creeper"

If only "Mad Love" had been Harley's final appearance; alas, "Beware the Creeper" finds her henching for the Joker once more. She does get one seminal moment: she pops out of a banana cream pie, doing a sexy dance and declaring in song that it has been seven years since she and the Clown Prince of Crime got together. This is a sweet moment that brings Harley full circle—she was created to jump out of the cake all the way back in her first appearance. Now, five years later, she finally gets to be the one in the pastry.

Conclusion

In his commentary for "Harliquinade," Paul Dini attempts to rationalize Harley's popularity by saying, "Yeah, she's a villain, but she gets out of situations by using her wits or her charm, or saying something funny" ("Harliquinade"). While this statement is true, it feels dismissive of the other traits that made Harley so identifiable. Over her five years on screen, audiences got to watch a character grow and change, as many members of the audience themselves were growing and changing. They saw a tough, strong woman who could hold her own against the Joker's stardom, someone who was cool enough and savvy enough to stand alongside the most popular villain in the world. They saw a woman who loved someone so much and so deeply that she was blind to his faults and willfully ignorant of his manipulations. The Joker is a physically and psychologically abusive maniac, a man Harley at first believes she can "fix," but eventually just falls under his spell—like so many young women who have found themselves the prey of charming, indecent men. They saw someone find comfort and solace with another outsider, a friendship that became love and acceptance. Pamela Isley is Harley's soul mate, and gender is not (nor should it be) a boundary, which is an inspiring lesson to young viewers struggling with their own identities and sexualities. They saw a little girl who played dress-up to pretend she was the person she thought she was supposed to be, and the caring authority figure who tried to help, no matter how many times that hand was slapped away. This mirrors the trials brought on by puberty and the desire to experience the world on one's own terms from under the guiding hands of parents. As viewers of *Batman: The Animated Series* watched Harley Quinn evolve, they saw

themselves discovering new facets of their own personalities, new hopes and opinions and ideas. In Harley's madcap journey through the underworld of Gotham, they saw their own strange, weird journey into adulthood and beyond. Harley Quinn is popular because we were given the chance to know her—and, in knowing her, learn about ourselves.

NOTES

1. It's worth noting that in the Ivy-centric "House and Garden," Pamela cracks open a photo album of her and Harley together that is reminiscent of those on display here.

2. The story is told in the commentary track for the episode "Harlequinade."

WORKS CITED

"Beware the Creeper." *Batman: The Animated Series Volume Four*. Dir. Dan Riba. Writ. Steve Gerber. Warner Brothers, 2005. DVD.

Cronin, Brian. "The Strange History of Harley Quinn." *CBR News*. Comic Book Resources, 10 Feb 2015. Web. 6 Feb 2016.

Dini, Paul, and Chip Kidd. *Batman: Animated*. China: HarperCollins, 1998. Print.

"Girl's Night Out." *Batman: The Animated Series Volume Four*. Dir. Curt Geda. Writ. Hilary Bader and Robert Goodman. Warner Brothers, 2005. DVD.

"Harlequinade." *Batman: The Animated Series Volume Three*. Dir. Kevin Altieri. Writ. Paul Dini and Eric Randomski. Warner Brothers, 2005. DVD.

"Harley & Ivy." *Batman: The Animated Series Volume Two*. Dir. Boyd Kirkland. Writ. Paul Dini. Warner Brothers, 2005. DVD.

"Harley's Holiday." *Batman: The Animated Series Volume Three*. Dir. Kevin Altieri. Writ. Paul Dini and Eric Randomski. Warner Brothers, 2005. DVD.

"Holiday Knights." *Batman: The Animated Series Volume Four*. Dir. Dan Riba. Writ. Paul Dini. Warner Brothers, 2005. DVD.

"Joker's Favor." *Batman: The Animated Series Volume Three*. Dir. Boyd Kirkland. Writ. Paul Dini and Eric Randomski. Warner Brothers, 2005. DVD.

"The Laughing Fish." *Batman: The Animated Series Volume Two*. Dir. Bruce W. Timm. Writ. Paul Dini. Warner Brothers, 2005. DVD.

"Mad Love." *Batman: The Animated Series Volume Four*. Dir. Butch Lukic. Writ. Paul Dini and Bruce W. Timm. Warner Brothers, 2005. DVD.

"The Man Who Killed Batman." *Batman: The Animated Series Volume Two*. Dir. Bruce W. Timm. Writ. Paul Dini. Warner Brothers, 2005. DVD.

Reisman, Abraham. "The Hidden Story of Harley Quinn and How She Became the Superhero World's Most Successful Woman." *Vulture*. 17 Feb 2015. Web. 6 Feb 2016.

Smith, Kevin, and Paul Dini. "#21: Paul Dini: The Dini Dossiers Pt. 4." Audio blog post. *Fatman on Batman*. Smodcast, 21 Dec 2012. Web. 6 Feb 2016.

"Trial." *Batman: The Animated Series Volume Three*. Dir. Dan Riba. Writ. Paul Dini and Bruce W. Timm. Warner Brothers, 2005. DVD.

Harlequin, Nurse, Street Tough

From Non-Traditional Harlequin
to Sexualized Villain to Subversive Antihero

JUSTIN WIGARD

When first introduced in *Batman: The Animated Series* (*B: TAS*) in 1992, Harley Quinn featured the primarily buxom female form of many women in *B: TAS* (long legs, hour-glass figure) but was fully clothed in black, red, and white bodysuit ("Joker's Favor"). Creator Bruce Timm later depicted Harley in this same costume in her second appearance in DC Comics ("Mad Love"). Problematically, however, later appearances transformed Harley from a sly and sexual, if visually demure, henchwoman to a hyper-sexualized villain shown in a variety of objectifying outfits in the recent *Batman: Arkham* video game series.[1] While in her original outfit, Harley fills more of a sidekick or henchwoman role to the Joker's spotlight as a villain, whereas the *Batman: Arkham* video games find Harley operating as a villain on her own. Harley's appearances in her self-titled comic book series, part of DC's The New 52 initiative, feature Harley in a (slightly) more modest outfit, but one that is characterized by the black-and-red style of her original outfit ("Hot in the City"). Most recently, Harley wears a torn, punk-infused costume in the *Suicide Squad* movie, one that, at first glance, holds few influences from any of her preceding outfits (Ayer).

This essay, then, will analyze the visual evolution of Harley Quinn's costumes, in order to reveal how her outfits not only reflect shifts from villain to antihero, but directly embody the specific role she plays in each narrative. I argue that her initial outfit, that of a harlequin costume, reflects her position as a villainous, if comedic, sidekick role, one that Batman doesn't take seriously. In the *Batman: Arkham* video game series, and more specifically in *Batman: Arkham Asylum*, Harley's role as one of Batman's villains is reflected in her demeaning and sexually-objectified costume. However, her position

146

in DC's the New 52 comics features a modified harlequin costume, reflecting her identity as a sexually confident woman and as an antihero liberated from the Joker, one that exercises agency without masculine influences. In this fashion, Harley Quinn's visual evolution is one that reflects her shift from comic relief sidekick to misogynistic sex object, ending with her current incarnation as an antihero with feminist undertones, an evolution that can only be charted by examining the visual semiotics at work in each of her supercostumes.

Tights, Diamonds and Visual Semiotics

To frame this analysis of Harley's visual evolution, the significance of the supercostume to this study must first be explored. For the sake of clarity, the term "supercostume" will be utilized to refer to both costumed heroes and villains alike, as supervillains are noted to operate under the same visual cues as superheroes, in addition to fitting in to the same nomenclature that existing terms like "superpower" and "superhuman" occupy. Peter Coogan identifies the presence of the costume as being integral to the nature of the superhero genre, writing that the superhero's primary ideology is distilled in "a simplified idea that is represented in the colors and design of the costume" (Coogan 33) which makes the superhero costume a "direct statement of the identity of the character" (Coogan 35). Therefore, superhero identities can be derived by studying the superhero's costume. This notion is reinforced through Barbara Brownie and Danny Graydon's assertion that superheroes consciously construct their identities, due to the specific consideration each superhero gives to their design and overall aesthetic of the costume (Brownie). Because superheroes presumably create their own costumes, it stands to reason that they also construct their own identities. Fashion theorist Raymond Barnard supports this concept by noting that clothing, and by proxy costumes, act as a form of communication, sending messages through a combination of color, form, and style (1996). Moreover, Barnard argues, changing one's attire conveys messages, using the example of wearing clothes that are brighter or have bolder lines to convey moods of joy or happiness (Barnard 57). In essence, then, supercostumes define and shape the reader's first perception of a character in a superhero narrative.

This becomes most apparent when viewed through the theoretical lens of visual semiotics, a subset of semiotics primarily concerned with how meaning is constructed and represented in visual images. As texts comprised of the interplay between images, many scholars have applied semiotics to various facets of comics. Comic scholar Scott McCloud doesn't utilize the term "visual semiotics" proper, yet discusses the capacity of icons, visual representations

of real-world objects, to convey meaning. He writes that "icons demand our participation to make them work," as in, icons that comprise the visuals of comics only act as signifiers, relying on the reader to draw out the signified, or the meaning (1993). This notion is supported by Mikael Kindborg and Kevin McGee, who note that, because they occupy the vast majority of comics, characters and objects (i.e., costumes) are the most obvious semiotic signs in comics ("Visual Programming..."). Similarly, Barnard corroborates this intersection of semiotics and clothing by noting that the interplay of visual cues in clothing act as signs to be interpreted by the viewers (Barnard 79). Though little work has been conducted on the visual semiotics of the super-hero genre, McCloud again offers commentary by noting that many popular superheroes are identified by the colors of their costumes. Not only does he argue that characters like The Incredible Hulk (green, purple, and white), Batman (blue, yellow, and grey), and Superman (blue, red, yellow) are able to be recognized by the colors of their costume, but that supercostumes featuring those specific colors convey the visual identity of said superheroes (McCloud 188). In essence, then, supercostumes operate as signs to convey the visual identity of their given character.

"It is to laugh, huh Mistah J?"

Given this intersection of visual costumed identity, problematic female superhero costumes, and of the male gaze, the visual evolution of Harley warrants exploration, beginning with her first costumed iteration in the *Batman: The Animated Series'* episode "The Joker's Favor." Harley Quinn quickly became a fan-favorite character after just a few short appearances in the series, but her most notable scene is her first. Though this is the original appearance of Harley Quinn, the viewer is not treated to any sort of origin story; instead, the viewer's initial perception of the character is reliant upon the construction of Harley's identity through her costume's color, details, and overall aesthetic. Perhaps the most readily identifiable visual marker of Harley Quinn, in her initial appearance, is her form-fitting, alternating red and black costume. Her bright coloring stands out amidst the dark aesthetic of Gotham City, red and black clashing with not only with Batman's blue, grey, and black ensemble but the Joker's green, purple, and white suit, while Harley's outfit itself is dominated by diamonds. Further, Harley wears what amounts to a jester's hat, complete with bells and a white neck ruffle that matches the same alternating red and black coloring of her costume. Returning to the idea that super-costumes reflect the identity and role of the wearer, at first glance, Harley's costume seems to put her in the position of the *harlequin* to the Joker.

Yet, a breakdown of the harlequin's visual markers causes one to question the nature of Harley's initial role in *Batman: The Animated Series*. Traditionally, the harlequin looks similar to, but very different from Harley Quinn. What's interesting here is that, according to Meredith Chilton, Harlequin (the character) and the other individual characters of the *commedia dell'arte*, a form of Italian theatre in the 16th century based on masked archetypes, wore standardized costumes that "enabled the audience not only to recognize the characters but to anticipate their behavior, thereby prompting an instantaneous silent communication between the actors and the spectators" (Chilton 33). To wit, harlequins by and large were rarely seen without obnoxious masks, ones that typically had at least one wart, a brazen mustache, and an exaggerated chin (Chilton 37). Because the masks and costumes defined the actors, the audience then were able to readily identify and connect with the harlequin, whose multicolored costume reveals a "chameleon-like, multifaceted character, at once stupid, brilliant, cunning, shrewd, and nimble in mind and body" (Chilton 38). Here, Harley wears a small black mask around her eyes, baring much of her pale white skin, much like the Joker himself does. Her red and black suit also doesn't align with the traditional harlequin jacket (which typically features a minimum of four colors). Likewise, her cap with bells attached is rarely, if ever, seen or depicted with any images of traditional harlequins, as "hats of this shape, particularly those with little bells, are not usually associated with Harlequin … the medieval costume for Fools always included a hat embellished with bells" (Chilton 41–42). What emerges from this comparative analysis is that Harley's supercostume is closer to a court jester's, or for a more popular incarnation, closer to the Joker card found in most playing card decks.

This explanation of Harley's supercostume to be akin to that of a court jester reveals how her costume reflects this role in *Batman: The Animated Series*. In her first appearance, and in subsequent appearances with the Joker, Harley acts as a sounding board for the Joker's humor, rousing the audience (in the case of "The Joker's Favor," two unnamed henchmen in the room) into applauding uproariously for the Joker's humor. Based on the visual cues of her supercostume, Harley's entire role is to serve as a lackey to the Joker and be laughed at. This correlates to Brownie and Graydon's assertion that supercostumes dictate and define the role the superhero will play in the narrative" (Brownie loc 820). Enid Welsford notes that the jester typically wore a "conventional jester's costume of motley, cap and bells" (Welsford 121). Though the colors may vary from court to court, the word motley refers to a multicolored bodysuit typically decorated in a checkered pattern of diamonds ("Motley, n. and adj."). The attire of the fool, in other words, was designed to, much like the harlequin (which stems from the fool), make the fool stand out, be noticed, and be identified immediately as someone meant to poke

fun and provide humor. This same attire is what Harley wears a modified version of, and it is the role of the fool or jester that Harley embodies within *Batman: The Animated Series*: her very nature, at its outset, is to be the fool for the main audience.

Oh, I Got Something to Show You... One Second, B-Man!

Harley Quinn's visual identity of the jester, or fool, is lost in the translation from *Batman: The Animated Series* to the recent *Batman: Arkham Asylum* video game. Rather than seeing Harley in her traditional jester-like supercostume, the viewer is instead treated to something new. Even more so than her original supercostume, Harley's outfits in these video games are subject to and dominated by the male gaze, primarily depicting Harley in sexually objectifying clothing. The first costume, seen in *Batman: Arkham Asylum (B: AA)* (2009), finds Harley in an outfit that barely retains any of the defining elements of her original costume. Gone are the playing card-esque diamonds, the alternating red and black coloring (replaced with a red, white, and purple color scheme), and the jester's cap; what remains of Harley's original outfit are the slight altering of red with an off-color, purple, and her white, pale face. Rather than wearing a nurse's standard workplace attire of scrubs of some kind, what Harley wears is a short, skimpy nurse's costume. The nurse's costume itself is not out of place, as Harley is frequently shown wearing disguises to help with the Joker's capers in *B: TAS*. The key difference here, however, is that Harley is not wearing a disguise, is not trying to hide her identity from Batman at all, but instead has changed her supercostume altogether, pointedly taunting Batman: "Harley Quinn here! How d'you like my new uniform? Pretty hot, huh?" Because *Batman: Arkham Asylum's* depiction of Harley clashes with her original visual identity, it alters the perception of Harley and similarly reflects a new role.

Each of the major changes from the original outfit featured in *Batman: The Animated Series* to Harley's new supercostume in *Batman: Arkham Asylum* represent new meanings that, when viewed through the lens of visual semiotics, offer new insight into the dramatic transition in supercostume. The loss of the jester's hat is one of the most telling signs, as it signals an abdication or shedding of the fool's role. Likewise, the presence of Harley's natural hair can be seen as embracing a more serious side of her personality, rather than being identified as a fool. Another prominent change, the palette shifts from the red and black embodiment of playing card elements to one of purple and red, is again a shift away from the nature of the fool, and by proxy, the jester's modern association with the black and red stylings of most

playing cards. In truth, the nurse's outfit is most noticeable wardrobe feature of Harley's *Batman: Arkham Asylum* supercostume, which also communicates perhaps the most significant message: sex appeal.

As Katherine E. Whaley and I note, superhero narratives have a long and sordid history of depicting women in sexist, objectifying manners. Quite often, these costumes have little to do, visually, with women's identities as superheroes, instead seeming to be primarily designed to reveal as much skin as possible (Whaley 203–204). Richard Reynolds finds that these outfits and their compromising, unnatural positions seem designed almost specifically for male readers, noting the extreme commonality of the "male gaze" (Reynolds 37). The male gaze is Laura Mulvey's notion that female figures are intentionally "coded for strong visual and erotic impact," revealing that the figures of women, especially in comics, are to be viewed by the male reader (Mulvey 9). In this regard, Harley's nurse outfit acts as a spectacle specifically for the male gaze, especially in her first scene. She reaches out to Batman from a remote location in Arkham Asylum via live television stream. The player watches as Harley speaks to Batman from the television screen, before becoming the direct spectator as the scene shifts directly to the camera facing Harley. This places Harley into a precarious and problematic position, one in which she is subject to the male gaze. Yet, at the same time that she is showing off her new supercostume, Harley is revealing her new role, in which she is both actively antagonizing Batman and the player. In essence, she is proving that she has become a villain, and is to be taken seriously.

Her role has changed: rather than simply being the Joker's sidekick, lackey, and pseudo-love interest,[2] Harley is a direct antagonist to Batman, and, while carrying out an overall crucial part in the Joker's plans to kill Batman, she undertakes her own agenda to defeat Batman by freeing various additional inmates. As Harley's role shifts, or rather, as Harley is promoted to the role of a supervillain, so too does her costume change to reflect this shift. When Harley played the part of slapstick lackey, her supercostume was similar to a jester's (*B: TAS*); in the role of a supervillain, Harley wears an objectifying nurse's costume (*B: AA*). This outfit creates an air of sexual desire, especially in regards to Harley's previous costume and role, but in conveying the message of sexual desire, the costume also conveys a desire for Harley to be seen as something more than her occupation: a psychologist. Before Harley worked with the Joker as a henchwoman, she worked as a psychologist, a doctor bent on helping people. By changing into this overtly sexualized nurse costume, Harley signals a desire to leave her past behind in more ways than one. Instead of wearing traditional nurse scrubs, Harley's short and showy nurse costume, more resembling one found in a Halloween costume shop, signals an inversion of her previous occupation and a mockery of the pro-

fession of helping others. In other words, her sexualized nurse costume conveys the message that Harley is neither in the profession of being the fool, nor of helping people, but that she has transitioned to becoming a villain.

How Cool Would It Be to Have My Own Comic Book?

Upon first glance, the supercostume that Harley wears in her ongoing self-titled comic is one that may seem familiar. While Harley is shown to change the design almost once an issue, her primary supercostume consists of the now-familiar and iconic (in the McCloudian sense) color scheme of red and black, eschewing the red and purple of *Batman: Arkham Asylum* and embracing the color scheme of her original outfit from *Batman: The Animated Series*. As mentioned earlier, the leather bustier style from both *Arkham City* reappears, yet is primarily seen in bold, bright contrasts of red and black, rather than the more realistically toned-down elements of her *Arkham Knight* style. Perhaps one of the most prominent visual changes revolves around her hair: Harley's hair is now split evenly in half, with one side colored entirely red and the other entirely black.

Beginning with her hairstyle choices, Harley's outfit demonstrates remarkable agency in comparison to any of her previous supercostumes (Connor and Palmiatti loc. 2). The black-and-red color scheme of her pigtails bring direct comparison to her supercostume in *B: TAS*, yet the incorporation of the coloring into her hair itself and the lack of adorning bells indicates that Harley has embraced this new identity. By again leaving behind the jester's cap, the full identity of the fool seems to be missing while the inclusion of the coloring indicates that Harley still retains elements of the fool on her terms, namely the jester's signature penchant for humor. The booty shorts that Harley wears seem, at first glance, out of place and strange in relation to her previous outfits of either leather pants (*Batman: Arkham Asylum*) or full bodysuit, replete with leggings (*Batman: The Animated Series*), but given her hobbies in the series, the shorts convey a lighthearted and practical purpose: Harley's primary mode of transportation is a motorcycle, while she takes part in the sport of roller derby as a hobby, both activities that she chooses of her own accord (Connor and Palmiatti loc. 43). Beyond this, though, Harley's conscious effort to frequently change costumes ranges from a black-and-red striped cocktail dress to a tank top with stars on it. She further distances herself from traditional superheroes as she says she'll "never understand why Superman wears the same outfit every day," as well as revealing that though her costume changes, her identity as a hero doesn't (Connor and Palmiatti loc. 79).

Given these unique facets, then, Harley's supercostume in the New 52 DC comics reflects a shift in identity: no longer is Harley the Joker's henchwoman, nor a full villain, but a multi-faceted hero-type with agency. In previous iterations, Harley's role was dictated by her relationship to the male characters around her, but in her comic series, Harley makes her own decisions. She decides to free animals from a euthanasia shelter (Connor and Palmiatti loc. 63), tries to help old women who suffer from Alzheimer's disease (Connor and Palmiatti loc. 110), and chooses to help stop a gang of mobsters in her local neighborhood (Connor and Palmiatti loc. 113), all while holding onto a professional job as her current alter ego, Dr. Harleen Quinzel (Connor and Palmiatti loc. 128). This utilization of an alter ego helps establish Harley as a superhero, meeting one of the classic criteria as noted by Coogan (32). Though most of her guiding ideology is self-serving, she happens to make a positive difference in helping others, marking her more as an antihero, somebody who Randy Duncan and Matthew J. Smith note as lacking "one or more of the qualities associated with the heroic ideal" (Duncan 226). In this instance, she readily utilizes excessive, violent, and often lethal force in dealing with problems, distancing herself from classic superheroes who uphold nonlethal methods.

The most significant trend in the evolution of Harley's costumes, up to this point, is her ever-growing independence and rejection of patriarchal norms. While not every supercostume transition has been ultimately feminist or liberating, each has elements that signify growth towards agency and towards feminist ideals, in that Harley's wardrobe reflects a shift towards independence. The argument can, and should, be made that Harley has not yet fully escaped the male gaze. Harley is frequently shown in compromising positions aimed quite literally at the reader, yet in terms of the visual interplay between what the elements of her supercostume in *Harley Quinn, Vol. 1* signifies, Harley's visual evolution indicates that her most recent comic book incarnation has feminist undertones signaling agency. In her comic narrative, Harley doesn't pander to any hard lines of moral right and wrong, as in her previous incarnations, and instead seems more inclined to pursue the activities that interest her (like helping out the few friends she has and hurting people that annoy her, pursuing legitimate jobs when possible or engaging in illicit activities that pay better, and playing roller hockey, whether in a sanctioned league or one without rules).

We're Bad Guys: It's What We Do.

Harley Quinn's most recent incarnation, as played by Margot Robbie in Warner Bros.' blockbuster DC Comics' film *Suicide Squad*, offers something

new. Rather than dressing in the traditional red and black, tight-fitting suit shown in *Batman: The Animated Series,* or in the overly sexualized nurse costume from *Batman: Arkham Asylum,* Harley wears something completely unique, for her, in this instance: normal clothing or, at least, what constitutes normal clothing for Harley.

In *Suicide Squad,* Harley primarily wears a grungy, punk-infused outfit (Warner Bros. Pictures YouTube). Her white tank top reads "Daddy's Lil' Monster" in a stylized, retro, playful font, yet is ripped and torn in multiple spots. Instead of wearing black-and-red pants, or in the case of her New 52 incarnation, red and black thigh-high stockings, the film version of Harley wears fishnet tights, eschewing her normal playing card-inspired attire seemingly in favor of something more common. Yet, the playing card elements have not left Harley. Instead, these elements manifest in the form of tattoos on Harley's wrist and thighs, roughly in the same location that the familiar diamond shapes appear in other depictions. One element stands out that is not featured in any previous incarnation: a gold choker reading "Puddin" in large letters, referring directly to the Joker and indicating that Harley is his property. Similar to her New 52 supercostume, Harley has blonde hair rather than red and black, this time tinged with blue and pink, rather than the standard red and black coloring associated with Harley. This stems, in part, from her origin story: like previous iterations, Dr. Harleen Quinzel falls in love with the Joker during psychiatric treatment. Unlike previous iterations, the Joker asks, "Will you live for me?" Her response is to dive into a vat of chemicals, becoming more like the Joker himself. As her clothes are burned off her body, their red and blue dye seeps into her now bleached hair, coloring the tips pink and blue.

Herein lies the demarcation in Harley's *Suicide Squad* costumes: those she wears in flashbacks to her time with the Joker, and costumes while she is part of the Suicide Squad. Brief and chaotic scenes of Harley's time with the Joker reveal her wearing three different outfits: professional attire while conducting therapy sessions with the Joker as Dr. Harleen Quinzel, a harlequin costume reminiscent of that which she wore in *Batman: The Animated Series,* and a gold-and-black diamond dancing outfit worn when Batman finally caught her. Each of these costumes define Harley by her relationship to the Joker, in that, each costume is primarily worn for the Joker himself. Professional and demure work attire signifies that the Joker is to respect Dr. Harleen Quinzel's role as a psychotherapist. As mentioned previously, the harlequin costume acts as a signifier of her role in amusing the Joker, of obtaining his gaze and keeping it. This is further exemplified and embodied as she wears her harlequin-inspired black-and-gold dancing outfit, as one of the Joker's associates remarks, "She's yours," without ever having to speak to her. Acting as a stand-in for the audience, this unnamed associate responds

in this manner due to the outfit's inherent visual signifiers: the combination of harlequin-styled diamonds with a more provocative outfit reveals that the costume is for "Mistah J" and Mistah J alone. Her role is defined by what the Joker wants, by what she can provide to the Joker, and by his existence: she is at times either a villain or a villain's sidekick, both sexualized and mocked.

Returning to Harley's punk-infused costume, elements of the Joker still remain, but so much more of the costume is evocative of her New 52 costume, signifying her role within the *Suicide Squad* film as that of an antihero. Her red-and-blue booty shorts are worn with a seeming ignorance, yet this panders to the audience, signaling that she has not escaped the male gaze (in this case, may have even taken a step backwards in terms of progressive clothing). Moreover, Harley is shown sifting through various costumes, including her harlequin costume and the gold-and-black diamond dancing outfit, before finally choosing her punk-infused costume, symbolizing that those costumes belong in the past. Likewise, she hefts the hammer popularized in *Harley Quinn, Vol. 1: Hot in the City*, but chooses a baseball bat and revolver instead, again showing that she is leaving behind some of the blatant comedic elements of a past incarnation and moving forward into a more serious role. Something changes for Harley within *Suicide Squad*: the Joker is shown to die in a helicopter crash, and rather than wallow in depression or grief, she chooses to stick with the Suicide Squad. In this instance, Harley is free from the control of Amanda Waller and free from the masculinity of the Joker; instead of returning to a life of looting, mayhem, and criminal activity, Harley embraces her identity as an antihero.

At the climax of the film, the villain, Enchantress, reveals what each member of the Suicide Squad truly wants. Harley's dream is of a nuclear family life with twin infants and the Joker, both of whom are sans make-up and look decidedly "normal." This vision of Harley's inner desire problematizes her development and historical trajectory, as it reveals that Harley's definitive wish is to be domesticated, stable, and subservient to the Joker. Leading up to *Suicide Squad* and even during the film, Harley seems to be gaining agency, growing from a pseudo-harlequin/sidekick to her self-referential and antiheroic New 52 version. Her role in Ayer's *Suicide Squad* finds Harley in a precarious place, exercising agency as an antihero but falling back into the role of sex object. Ultimately, Harley's visual cues signify that the Joker may always hold some sway over her in the DC Cinematic Universe: no matter the costume change, the Joker's tattoos and masculine influence remain, like a cattle-brand of vulgarity and playing card symbolism.

NOTES

1. The *Batman: Arkham* series of video games consists of *Batman: Arkham Asylum* (2009), *Batman: Arkham City* (2011), and *Batman: Arkham Knight* (2015). *Batman: Arkham City* and *Batman: Arkham Knight* were deliberately not covered in this exposition for sake

of brevity, but an extended treatment could be conducted of the visual semiotics at work within Harley's supercostumes in video games alone.

2. Many of Harley's sub-narratives revolve around her one-sided love towards the Joker, which is not often reciprocated and has been firmly established since Bruce Timm and Paul Dini's *Mad Love*.

WORKS CITED

Ayer, David, director. *Suicide Squad*. Perf. Margot Robbie, Will Smith, and Viola Davis. 2016. Warner Bros., 2016.

Barnard, Malcolm. *Fashion as Communication*. New York: Routledge, 1996. Print.

Batman: Arkham Asylum. Rocksteady Studios. Eidos Interactive, Warner Bros. Interactive Entertainment, Square Enix, Time Warner, 2009. PlayStation 3, Xbox 360.

Billington, Sandra. *A Social History of the Fool*. New York: St. Martin's Press, 1984. Print.

Brownie, Barbara, and Danny Graydon. *The Superhero Costume: Identity and Disguise in Fact and Fiction*. New York: Bloomsbury, 2016. Kindle.

Chilton, Meredith. *Harlequin Unmasked: The Commedia Dell'arte and Porcelain Sculpture*. New Haven, CT: Yale University Press, 2001. Print.

Coogan, Peter. *Superhero: The Secret Origin of a Genre*. Austin: MonkeyBrain Books. 2006. Print.

Conner, Amanda, and Jimmy Palmiotti (w). Hardin, Chad (p) (i). "Hot in the City." *Harley Quinn*. v2. #1. (Feb. 2014), Warner Brothers. DC Comics. Print. Kindle.

Dini, Paul, and Bruce Timm (w). DeCarlo, Dan, and Bruce Timm. (p) (i). "Mad Love." *Batman: Mad Love and Other Stories*. (June, 2009), Warner Brothers. DC Comics. Print.

Duncan, Randy, and Matthew J. Smith. *The Power of Comics: History, Form, and Culture*. New York: Continuum, 2009. Print.

"Joker's Favor." *Batman: The Animated Series Volume Three*. Dir. Boyd Kirkland. Writ. Paul Dini and Eric Randomski. Warner Brothers, 2005. DVD.

Kindborg, Mikael, and Kevin McGee. "Visual Programming with Analogical Representations: Inspirations from a Semiotic Analysis of Comics." *Journal of Visual Languages & Computing*, 18.2 (2007): 99–125. Print.

McCloud, Scott. *Understanding Comics*. New York: HarperCollins Publishers. 1993. Print.

"Motley, n. and adj." *OED Online*. Oxford University Press, June 2016. Web. 15 August 2016.

Mulvey, Laura. "Visual Pleasure and Narrative Cinema." *Film Theory and Criticism: Introductory Readings*. Eds. Leo Baurdy and Marshall Cohen. New York: Oxford University Press, 1999: 833–44.

Reynolds, Richard. *Super Heroes: A Modern Mythology*. Jackson: University Press of Mississippi, 1992. Print.

Warner Bros. Pictures. "Suicide Squad—'Harley' [HD]." *YouTube*. Jul. 20, 2016. https://youtu.be/ASg8ab9vluQ Accessed Aug. 15, 2016.

Welsford, Enid. *The Fool: His Social and Literary History*. New York: Farrar & Rinehart, 1935. Print.

Whaley, Katherine E., and Justin Wigard. "Waiting for Wonder Woman: The Problematic History of Comic Book Women and Their Cinematic Doubles." *Critical Insights: The American Comic Book*. Ed. Joseph Michael Sommers. Ipswich: Salem Press. 2014. Print.

Problematic Fave
Gendered Stereotypes in the Arkham Video Game Series

Ian Barba

Background

Superhero comic stories are particularly suited to the video game medium. Their narratives are filled with action, adventure, and excitement, which are all elements that make for good game play. Video games allow the player to take the story one step further and inhabit the role of these characters. It is therefore no surprise that there have been numerous *Batman* titles throughout the history of video games. Batman, the Joker, and most other major characters in the Batman universe were created, and their definitive stories told, decades before video games existed. That is not the case with Harley Quinn.

Quinn was created in "Joker's Favor," the 1992 episode of *Batman: The Animated Series* and appeared in her first video game only two years later, *The Adventures of Batman & Robin.* As technology advanced, and her appearances in video games grew in both graphical and narrative complexity, Quinn came to be defined as much by video games as comics and television. On one hand, this likely helped cement her place as a fan-favorite and a necessary character in the *Batman* universe. On the other, her characterization in video games suffers many of the same stereotypical pitfalls that have for years bedeviled female video game characters. Particularly in the case of the *Arkham* video games, her characterization is problematic and a somewhat negative departure from the Harley Quinn of *Batman: The Animated Series* and *Mad Love.* This departure is especially troubling as the games initially featured many of the same voice actors and writers from the original animated series. Further, as evidence mounts that negative, stereotypical portrayals

have significant and measurable impact upon the players (both male and female), it is worth considering how and why Quinn's portrayal might be improved in future games (Kondrat 177; Fox, Bailenson, and Tricacase 935).

The *Arkham* series of games consists of four titles: *Batman: Arkham Asylum*, *Batman: Arkham City*, *Batman: Arkham Origins*, and *Batman: Arkham Knight*. Among all Batman video games across various consoles, personal computer (PC), and mobile devices, the *Arkham* series is notable for its critical acclaim and commercial success. Over various consoles and PC, the titles sold 8.04, 11.15, 5.42, and 5.13 million copies respectively (see VGChartz.com). The titles received Metacritic scores of 92, 96, 76, and 87, which reflect aggregated reception of the games from a wide range of reviews. Metacritic considers video games rating from 75 to 89 as "generally favorable reviews" and 90 to 100 as receiving "universal acclaim." This is to say that *Asylum* and *City* are considered outstanding video games, and *Origins* and *Knight* not quite so, but still good. These scores and sales figures speak not only to the series' excellent gameplay and graphics, but to the complex and connected narrative, or story, of the games. It is thus highly disappointing that the games fall into some of the most common gendered stereotypes of the medium.

Sexualization

In *Batman: The Animated Series*, Quinn is portrayed in a form-fitting yet unrevealing costume. As a children's show, it makes sense for the writers and animators to keep sexuality at a tasteful minimum. Bruce Timm, in a commentary for *Mad Love*, even mentions the nervousness in drawing Harley in some of the "sexier" scenes, going so far as to tone down some of her poses (74). However, for video games, women are often "depicted as having large breasts, tiny waists, and full, pouting lips" (Dickerman, Christensen, and Kerl-McClain 23). This is exactly how we are introduced to Harley Quinn in *Batman: Arkham Asylum*, the camera initially lingers just on her exposed cleavage, a preview of her thoroughly sexualized character. In *Mad Love*, Harleen Quinzel is shown using her sexuality as a weapon, seducing her professor in exchange for a higher grade on her thesis. The act itself is only suggested, occurring off-panel. The reader can only infer what happened based on the results. Her use of her sexuality is subtle and used with a purpose. In *Asylum*, it is overt and directionless. This is not, as Shannon Austin describes, an example of Gotham's women using sexuality to fight against male control (286). It is another example of females in video games sexualized as an "object of male gaze" (Kondrat 172). Indeed, Harley Quinn makes it a point to ask Batman how he "likes her new uniform" in *Asylum*. Austin describes how female characters are able to use displays of sexuality as a way to "fight back"

(287). Quinn's old costume is replaced by a short skirt and skimpy top, both of which reveal much more skin than usual. Her sexuality is not used as a weapon; it makes little impression on Batman. It exists only for the, assumedly, male gamer. Much like her hypersexualized body, her costume is another stereotypically gendered portrayal (Jansz and Martis 147). Harley Quinn is not alone in this treatment. Poison Ivy and Catwoman are sexually objectified in costume, lingering camera shots, and their sexualized body language (Lavigne 137). In *Asylum,* when Quinn releases Poison Ivy from her prison cell, the Joker crudely quips that he could "watch those two all day," the implication quite obvious. Harley's objectification continues in subsequent games, as she asks Batman essentially the same question about her new skimpy outfit in *Batman: Arkham City.*

Harley, Ivy, and Catwoman were also featured prominently in print and online advertising, their sexuality a selling point for the games. This is consistent with the video game industry where female characters are more likely than not to be sexualized in advertisements (Fox et al. 931). Objectification is so pervasive in the industry that even games completely lacking in sexual content will at times still use sex as a selling point (Dickerman et al. 23). Her objectification harms not only Quinn but the player as well. In Quinn's first appearance in "Joker's Favor," she is leered at and propositioned by Detective Bullock. This is played for laughs. Bullock is a crude, gross character and his advances are summarily rebuffed. In the *Arkham* games, the player is invited to become Bullock and to ogle Quinn's exaggerated form.

Stereotypical Gender Roles

Aside from her obvious sexualization, Quinn initially appears to be the same goofy yet endearing character she was in the cartoons and early comics. *Asylum* follows the Joker's plan to trap Batman in the titular Arkham Asylum, an institution for the criminally insane. Though women in the series are portrayed as "damsels in distress," one of the most common stereotypes in games (Kondrat 172), Harley is decidedly not in any distress. Quinn is the Joker's paramour/sidekick, a roll she is shown to excel in. Not only does she adopt many of the Joker's comedic mannerisms, she is clearly also his most competent henchman—or in her case, henchwoman. Her role is subordinate, at times submissive to the Joker, a position that Quinn also fills in the comics and cartoons. Kate Roddy, in her examination of the character through fanfiction, argues there is subversive power in Quinn's choice (3.11). While Roddy examines submission through a sexual lens, her argument is instructive to Quinn and the Joker's overall relationship. It then becomes possible, she argues, to read this subordinate role as a fulfilled fantasy, a choice from a

"position of privilege" (Roddy 2.15, 5.3). It is an intriguing argument. Whatever choices Quinn made to arrive at her position in *Asylum*, it is difficult to argue the character is unhappy where she is.

As *Asylum* is the peak of her "happiness" in the series, the first game would unfortunately also prove to be the peak of Harley Quinn's agency and her capacity or ability to act as an individual. Whether or not that was a deliberate choice on the part of the writers, it is instructive to her character. Though *Asylum* and *City* would hint at Quinn's origin story through found audio and text, it was not portrayed cinematically until *Batman: Arkham Origins*. The story is similar to Dini's *Mad* Love. Harley was originally Dr. Harleen Quinzel, a psychiatrist who meets the Joker through the patient-doctor relationship. In *Mad Love*, Batman notes that even before meeting the Joker, Quinzel was "no angel" (Dini 18). It was Quinzel who sought to work with the criminally insane, believing shrewdly it would advance her career and notoriety. While there is some argument among fans regarding the degree to which Harleen Quinzel's transformation was manipulation or liberation (Roddy 3.3), her choice to become Harley Quinn was, at the very least, complicated. *Origins*, however, portrays no such complexity—her back story is one of obsessive and complete infatuation.

Throughout *Asylum*, Quinn is unquestionably advancing the Joker's ends. However, far from following orders, she appears to have wide latitude in her decisions in achieving those goals. Her decision to free Poison Ivy had significant consequences on the narrative of the game, a decision she made without any input from the Joker. In *City*, the Joker is gravely ill, suffering from a toxin that is slowly killing him. One might expect to see Quinn assume more of a leading role in their relationship, being of able body. Yet she does very little at all other than order around nameless goons and fret over the Joker's declining health (Lavigne 139). The autonomy she had in *Asylum* is gone, replaced with dutiful and immediate responses to the Joker's requests. Though he is ill throughout the game, it is still somewhat shocking that the game climaxes with his death. For *Batman: Arkham Knight* and DLC (downloadable content) expansions, the Joker's death means that Harley Quinn is no longer anchored to his schemes. The series had an interesting opportunity to develop Quinn as a leading villainess. Arguably, the opportunity was squandered. Perhaps Quinn could have developed as a character outside of the Joker or been paired with her sometimes partner Poison Ivy. After all, their relationship was hinted at in *Asylum*, and the duo is a subversive fan favorite. Shannon Austin argues this is because their teamwork makes them more of a threat, deadlier, and they "are women helping each other gain power" (288). She argues that these female villains are able to use their sexuality to subvert their gendered roles (292), but in this series, their sexuality is not used to further their ends, it is only meant to be observed.

Alas, Quinn remains tethered to the Joker in *Knight*, in a convoluted and regrettable story line about Joker "clones" who were infected with his blood and begin exhibiting his mannerism and psychosis. Again, she is seen ordering clown-themed goons around, but her story is tangential to the main. At the core of her character, Quinn is a woman in an obsessive and abusive relationship with a dangerous man (Roddy 1.7). *Knight* suggests that without the Joker, Quinn is nothing at all. Her obsessive behavior in the wake of the Joker's death fits a common feminine stereotype which is overly emotional, hysterical, and mad with grief (Lavigne 140). This stereotype is furthered in her playable DLC. She proves to be a capable fighter, but whereas Batman has a "detective" mode he can switch in and out of, Quinn has a "crazy" mode, that can build up and be released in a fit of rage. Quinn is the lead character for this DLC, and yet again she is still overtly sexualized though it has no particular bearing on her goals, fitting yet another video game stereotype (Jansz and Martis 147). Interestingly, though she is seen to be more than a match for the many random men she fights, she is shown to be comically weak in comparison to Batman. For example in *Knight*, as Batman is moving Quinn to a temporary jail cell, he carries her over his shoulder caveman-style while she beats her tiny fists against his back to no effect. Behm-Morawitz and Mastro found that players discounted the physical abilities of sexualized female characters (820). Perhaps the game's writers had internalized their experiences playing other such stereotypical games.

To understand Harley Quinn's characterization in the series, it may prove helpful to have additional context about how the other women in the games are treated. *City* is considered the best game in the series (and it further was the bestselling of the *Arkham* games), and yet it may be the most problematic in terms of gendered stereotypes. Carlen Lavigne argues the game allows only "restrictive, heteronormative gender performances" (135). Outside of Quinn, Catwoman, and Poison Ivy, there are only six named women in the game, all playing the role of damsel-in-distress (136). Batman's stoic male violence is needed to protect these vulnerable women (136). These stereotypes are all too common in games with Batman as the brooding hero, paper-thin women existing only to be rescued, and the remaining women of substance are overtly sexualized. Oracle (aka Batgirl) avoids the fate of helpless damsel in *City*, only to suffer it later during the events of *Knight*. Though the story is played somewhat as a joke, Catwoman also falls into this trope during *Knight*, requiring Batman to rescue her. Even though Catwoman and Oracle are capable and strong women, the game cannot resist using them as plot points, mere justification for Batman's actions. This kind of objectification is different than the sexualizing of female characters discussed earlier, but potentially just as insidious.

Rape Culture

Even worse, though, are examples of rape culture influence within the *Arkham* series. As mentioned previously, the majority of characters in the game are men (usually violent men), and the few women present are either helpless victims or sexpot villains. Some of the men in the video game seem to take the sexualized dress of the games' women at face value. Catwoman is repeatedly threatened and slurred with sexist innuendo (Lavigne 137). She laughs it off, though it hardly seems funny or necessary. While patrolling the streets of Arkham City, random goons will occasionally discuss the possible kidnapping and rape of the faceless women in the city (Lavigne 138). Harley Quinn, though she should arguably be working on her own after the Joker's death, ends up working for the Penguin (in this series, a Cockney gangster). Throughout the mission, he repeatedly calls her a "harlot." After following his orders to the letter, he crudely and insistently propositions her, "How much luv?" She rebuffs him, and after repeated attempts to purchase her services, the Penguin returns to insulting her with gendered slurs. This perpetuates the stereotype that women who look or dress a certain way are asking for it. Batman himself, unfortunately, is a participant as well. After subduing Quinn during the events of *City*, Batman (meaning the player) has the option of removing and replacing the duct tape over Quinn's mouth, as often as they wish (Lavigne 139). As she is also bound at the time, this player-interaction is a disturbing choice on the part of the game designers, particularly considering that Batman is the game's hero.

Identifying the Problem

It is worth asking why these stereotypes occur with such reliability in video games. It may have much to do with stereotypes about gamers as much as anything. Recent surveys and studies have found that women are growing increasingly likely to play video games. In 2009, 40 percent of all game players in the United States were female, and 80 percent of girls from grades 4 through 12 were gamers (Behm-Morawitz and Mastro 808). Findings later that year indicated women over the age of 18 represented a larger portion of the gamer population than boys 17 and younger (Wohn 199). In fact, the median age of video game players is 35 (Behm-Morawitz and Mastro). By 2013, females comprised 45 percent of the gaming population (Kondrat 173). By most recent measures, women either have or nearly have reached parity with men regarding overall gaming population. Regarding gendered stereotypes, both men and women agree there is a problem. Kondrat notes that 78.4 percent of women and 76.4 percent of men, nearly identical number,

acknowledged female stereotyping in games (183). Similarly, surveys tend to show that sexualizing female characters, particularly in terms of their figures and outfits is the most common way of stereotyping them (188). Arguably, it is possible that gamers are ready to see substantially more female characters in non-stereotypical roles. Yet, the perception is still that gamers are over-whelmingly young and male. As such, representation of the female gender by video game companies is distorted, and society continues to view them through this young male lens (Kondrat 178).

This certainly appears to be the case in the *Arkham* series. Female char-acters, including Quinn, may have been thusly stereotyped by a decision to appeal to a young and male audience. Perhaps Rocksteady, the company designing the game, wanted to make full use of their eventual Mature rating. Whatever the case, by angling for more mature and gritty content, the char-acter of Harley Quinn is stereotypically diminished through the series com-pared with her earlier appearances in *Batman: The Animated Series* and *Mad Love*.

Psychological Effects

These gendered and stereotypical choices by video game companies have measureable effects on gamers, both male and female. The literature regard-ing the psychological effects of stereotypically gendered video games is not as vast as that for other forms of media such as film and television, but the findings are similar. However, compared with the above passive forms of entertainment, video games are active (or interactive), often requiring the player to step into the role of the main character or characters. Yao, Mahood, and Linz describe this interaction as gamers "virtually practicing" the actions of the characters (82, 86). Jansz and Martis dub this interaction with the game as "presence" and describe it as the key difference between a player "being in charge" of a video games action, compared with passively watching characters in film or television (142). In their study, they noted gendered stereotypes; male characters were typically masculine and muscu-lar, women were dressed in a hypersexualized manner with an emphasis on their breasts and buttocks (147). Again, this is exactly how Harley Quinn is depicted in the games. If evidence suggests these depictions have conse-quences for viewers of stereotyped film and television, it stands to reason that the effect of presence in video games will have similar or greater conse-quences. Indeed, Jansz and Martis suggest that "presence conceivably may intensify the gamer's reception of game content" (142). As gamers assume the roles of these stereotypical characters, they inevitably tend to identify with them.

Kondrat describes how gamers view these depictions for both masculinity and femininity. Boys view the muscularity, power, and abilities of male characters as traits they would like for themselves (177). Female characters, who tend to have fewer roles that are more often than not subordinate, tend to be appreciated for their attractive and sexy appearance. Girls, says Kondrat wish to be thin, large-breasted, with small waists and hips, and boys view this ideal as normal and attractive (177). Simply put, gamers are more likely to adopt these body standards than non-gamers (173). As this standard is often unrealistic, exposure to these kinds of stereotypical depictions is problematic. Similar findings abound in psychological studies of video games. Fox et al. find that study participants exposed to sexualized female characters reacted with more body-related thoughts (935). Behm-Morawitz and Mastro describe problems for girls' self-efficacy in a study that found a negative correlation between game play with sexualized characters (808, 817). Similarly, additional studies have found that as video game–playing increased, female gamers' self-esteem decreased (810). How then, might female gamers react to assuming the role of Harley Quinn, only to see the Penguin proposition her and insult her? Fox et al. believe that these sexually stereotypical characters lead to overall negative feelings for the female players (935).

Moreover, there is evidence that in addition to these negative feelings for the individual, gamers also form negative opinions about women in general (Fox et al. 935). Thus, not only should the community be concerned for female gamers, but, as Behm-Morawitz and Mastro argue, for male gamers as well (811). Though more studies on these issues are needed, the findings thus far range from negative to troubling. In a study on attitudes towards sexualized female characters, Behm-Morawitz and Mastro find that "participants who played the sexualized character reported less favorable attitudes toward women's cognitive capabilities than non-players" (817). This finding is similar to findings of film and television, and has been further confirmed in subsequent studies (Fox et al. 931). In addition to causing gamers to question women's intelligence, there is a correlation between sexualized female characters and less favorable attitudes regarding women's physical abilities (Behm-Morawitz and Mastro 817). This was particularly ironic, as their study included the character Lara Croft, definitely a sexualized character but inarguably physically strong and capable. If these same findings hold true for the *Arkham* series, it is likely that the appearance, posture, and otherwise sexualized depictions of Harley Quinn, Catwoman, and Poison Ivy (like Lara Croft, all three physically strong and capable) will cause gamers to view women as weak and less intelligent in the real world. These attitudes tend to fall under the related umbrella of benevolent sexism. This also relates to the trope of the damsel in distress or the notion that women (in this case female video game characters) are weaker, less intelligent, less capable than men,

and either need rescuing by or the support of a male character. These sexist themes have been shown to increase male players' acceptance of benevolent sexist beliefs and in perceiving women in stereotypically sexist ways (Stermer and Burkley 51, 52). Although Quinn is not a true damsel in distress, she is depicted as repeatedly and increasingly reliant on male characters for support. The series could have chosen to explore how she might act outside of the Joker's influence. It did not.

Violence and Aggression

Even worse than the link to issues of self-esteem, self-efficacy, and forms of benevolent sexism, is the link, found in various studies, between playing sexualized stereotypical content and attitudes regarding rape culture, aggression, and violence against women (Fox et al. 931; Stermer and Burkley 49; Yao et al. 85). In their study of sexualized avatars, Fox et al. found that women who played sexualized avatars were more likely to accept rape myth attitudes than women who played non-sexualized avatars (935). In other words, they were more likely to agree that women who look and dress a certain way bear some responsibility for rape. In a similar study, it was found these attitudes extend to male players as well. Men who frequently played violent and sexualized video game content showed higher acceptance of rape myth than men who did not (Stermer and Burkley 49). In a study of sexually-explicit video games, Yao et al. found that male players "reacted significantly faster to sexual words, sexually-objectifying descriptions of women, and reported a greater tendency to sexually harass" (85). The men in their study showed what they describe as a "negative gender schema" that is, in essence, the sexual objectification of women (85). Moreover, Yao et al. found that men were more likely to engage in inappropriate sexual advances after as little as twenty-five minutes of playing sexualized video games (85). The games in their study would be rated "Adults-Only," one step above the "Mature" ratings of the *Arkham* series as a result of their explicit rather than implicit content. Their findings seem to suggest that as sexually stereotypical content increases in severity, so do the negative psychological consequences for the players. Interestingly, their study measured effects of short-term exposure to sexualized content when the question of long term exposure to this kind of content might be more important in addressing. Playing through all four *Arkham* games would take hours, not minutes, likely spread over weeks if not months. It is possible, if not likely, that Quinn's portrayal in the series not only harmed fan opinion of her but women as well along the stereotypical lines found in these and similar studies.

Quinn, Video Games and Their Possible Future

The rise of female gamers has coincided with an increase in casual and mobile games. These games are typically much cheaper or free when compared with titles like the *Arkham* series and interestingly do not appear to suffer from the same gendered stereotypes. Women, not men, are over-represented as the main characters in these games, and both women and men tend to be shown in an asexualized manner and dress (Wohn 203). Moreover, gender representation in these games is overwhelmingly non-stereotypical (204). This may be due to the nature of the games having simple premises and low budgets. It also may be due to the fact that women make up a larger share of the casual game market than typical games. Whatever the case, the trend is welcome for games overall.

Future portrayals of Harley Quinn will likely remain problematic for fans, regardless of her appearances in television, film, comics, video games, or any other medium. At her core, she is defined by her obsessive love of a man who is psychotic and often verbally and physically abusive. Though she is not exactly a role model, neither is she a victim. As Paul Dini describes her, Quinn is a cautionary tale (7). Her adventures on her own, or with Poison Ivy, give nuance and depth to her character. Though she inevitably returns to the Joker, Dini argues her growth makes her "his equal partner in crime, and not the eager-to-please hench-wench of old" (7). It is in this spirit that Harley Quinn's depiction in the *Arkham* series is lacking. In *Batman: The Animated Series* and comics like *Mad Love*, Harley was attractive without being sexualized, feminine without being shrill, supportive without being submissive, and ultimately a character in charge of her own actions. To increasing degrees through the games, that cannot be said of Harley Quinn's character. Make no mistake, the games themselves are fantastic and immensely fun to play. The first two, *Asylum* and *City*, in particular are among the best games ever made. The stories drew from existing material and created something new and familiar at the same time. Yet, regarding how the game depicts women and Harley Quinn in particular, the games suffer from common gendered stereotyping more often than not. With Quinn's recent portrayal in *Suicide Squad*, it appears likely the *Arkham* series has negatively contributed to her depiction in film, which is possibly psychotic and definitely much more sexualized than the character was originally. In a way, her poor treatment in recent years somewhat mirrors her relationship with the Joker. One can only hope Harley the character will bounce back, as she has in the past. She deserves better.

WORKS CITED

Austin, Shannon. "Batman's Female Foes: The Gender War in Gotham City." *Journal of Popular Culture* 48.2 (2015): 285–295. *Academic Search Complete*. Web. 1 June 2016.

Batman: Arkham Asylum. Rocksteady Studios. Eidos Interactive, Warner Bros. Interactive Entertainment, Square Enix, Time Warner, 2009. PlayStation 3, Xbox 360.

Batman: Arkham City. Rocksteady Studios. Warner Bros. Interactive Entertainment, 2011. PlayStation 3, Xbox 360.

Batman: Arkham Knight. Rocksteady Studios. Warner Bros. Interactive Entertainment, 2015. PlayStation 4, Xbox One.

Behm-Morawitz, Elizabeth, and Dana Mastro. "The Effects of Sexualization of Female Video Game Characters on Gender Stereotyping and Female Self-Concept." *Sex Roles* 61.11 (2009): 808–823. *SocINDEX with Full Text*. Web. 1 June 2016.

Dickerman, Charles, Jeff Christensen, and Stella Beatríz Kerl-McClain. "Big Breasts and Bad Guys: Depictions of Gender and Race in Video Games." *Journal of Creativity in Mental Health* 3.1 (2008): 20–29. *Academic Search Complete*. Web. 1 June 2016.

Dini, Paul, and Bruce Timm (w). DeCarlo, Dan, and Bruce Timm. (p) (i). "Mad Love." *Batman: Mad Love and Other Stories*. (June, 2009), Warner Brothers. DC Comics. Print.

Fox, Jesse, Jeremy N. Bailenson, and Liz Tricase. "The Embodiment of Sexualized Virtual Selves: The Proteus Effect and Experiences of Self-Objectification Via Avatars." *Computers in Human Behavior*. 29.3 (2013): 930–938. *Elsevier SD Freedom Collection*. Web. 1 June 2016.

"Game Database, Best Selling Video Games, Game Sales, Million Sellers, Top Selling—VGChartz." *VGChartz*. Brett Walton, 2005. Web. Accessed 1 June 2016, www.vgchartz.com/gamedb/?name=batman%3A+arkham

Jansz, Jeroen, and Raynel G. Martis. "The Lara Phenomenon: Powerful Female Characters in Video Games." *Sex Roles* 56.3 (2007): 141–148. *SpringerLink*. Web. 1 June 2016.

"Joker's Favor." *Batman: The Animated Series Volume Three*. Dir. Boyd Kirkland. Writ. Paul Dini and Eric Randomski. Warner Brothers, 2005. DVD.

Konami. *The Adventures of Batman & Robin*. Konami, 1994. SNES.

Kondrat, Xeniya. "Gender and Video Games: How Is Female Gender Generally Represented in Various Genres of Video Games?" *Journal of Comparative Research in Anthropology & Sociology* 6.1 (2015): 171–193. *SocINDEX with Full Text*. Web. 1 June 2016.

Lavigne, Carlen. "'I'm Batman' (And You Can Be Too): Gender and Constrictive Play in the Arkham Game Series." *Cinema Journal* 55.1 (2015): 133–141. *Project Muse*. Web. 1 June 2016.

"Metacritic—Movie Reviews, TV Reviews, Game Reviews, and Music Reviews" *Metacritic*. CBS Interactive, 1999. Web. Accessed 1 June 2016.

Roddy, Kate. "Masochist or Machiavel? Reading Harley Quinn in Canon and Fanon." *Transformative Works and Cultures*. 8.2 (2011): Online-only Journal. Web. 1 June 2016.

Stermer, S. Paul, and Melissa Burkley. "Sex-Box: Exposure to Sexist Video Games Predicts Benevolent Sexism." *Psychology of Popular Media Culture* 4.1 (2015): 47–55. *PsycARTICLES*. Web. 1 June 2016.

WB Games Montreal. *Batman: Arkham Origins*. Warner Bros. Interactive Entertainment, 2013.

Wohn, Donghee Y. "Gender and Race Representation in Casual Games." *Sex Roles* 65.3 (2011): 198–207. *Springer Standard Collection*. Web. 1 June 2016.

Yao, Mike Z., Chad Mahood, and Daniel Linz. "Sexual Priming, Gender Stereotyping, and Likelihood to Sexually Harass: Examining the Cognitive Effects of Playing a Sexually-Explicit Video Game." *Sex Roles*. 62.1 (2009): 77–88. *SpringerLink*. Web. 1 June 2016.

The Motley Queen
A *"Spicy Package" of Misrule*

Erica McCrystal

Harley's autonomy emerges in full force in the New 52's *Harley Quinn* series, where her super villainy reigns independent of the Joker. The argument that she lacks independent agency because her identity is intrinsically tied to the Joker (Taylor 82) may hold true for *Mad Love*, and certainly Harley exists as a supervillain because of the Joker—the love story has become an identifying part of her character. However, her break away from the Joker and independence in *Harley Quinn* marks a Harley who is completely autonomous. Harley's role thus shifts from a lovesick man-pleaser to a woman driven by her own agenda who disregards codes of conduct, rules, and laws, and instead operates through impulsive drives to protect those in harm's way or to fuel a playful hunger for violence. A crucial part of Harley's supervillain identity is her ability to play different roles to suit a variety of agendas. In "Secret Origins," Harley muses on how she realized that she could be multiple selves, saying that the Joker "made me understand that in order ta be free, I hadda push aside what I knew an' become a whole new person. Someone who could be anything they wanted. The sex kitten, the seductress, the innocent, the aggressor, the antagonist, the victim, the ditz.... He really loved the ditz, so I played along." Here, Harley claims that her lovesick ditzy self is actually an adopted persona that she deliberately chose to best please her lover. Once they break up, she realizes, "now I could choose fer myself who I wanted ta be ... and I chose ta be all 'a those things in one spicy package" ("Secret Origins #4: Harley Quinn"). Harley asserts her agency in her ability to be whomever she desires; she can pick a persona, or she can be the accumulation of multiple roles. Each persona Harley performs throughout *Harley Quinn* fulfills a different purpose in her daily escapades to survive on her own in New York City and to protect those she cares about. Harley's crimes

and murders are often rooted in either the concern for another or pure play. She is simultaneously compassionate and heartless, as she murders for noble causes but without any feeling for those she kills, making her harder to define through concrete characteristics.

This essay analyzes the instability of Harley's character as one whose compassionate behavior coexists with a "murder as play" approach, where she kills without concern for her victims for her own pleasure fulfillment. Through consideration of Carl Jung's definitions of "persona" and George Herbert Mead's philosophies of gameplay, this essay rationalizes the ways in which Harley's roles are not determined socially, as she instead flourishes as a comic supervillain through her volatile agency. Comic writers, in their variations of her character, make a unique supervillain rooted in both loyalty and play. In this way, Harley's variegated self can be the "spicy package" she claims to be. Harley, then, is the embodiment of motley, both in costume and in identity, a playful and compassionate psychopath who has achieved self-efficacy. As Harley's place in the comic book multiverse continues to expand, the various representations put pressure on her initial submissive sidekick role, and she emerges as an agentive motley queen.

Performative Agency

Harley's multiple selves are personas that she is self-aware of and embodies as she finds necessary. In analyzing an individual's relationship and place in the world, Carl Jung defines the "persona" as having social aspect. Jung posits that the persona is "the individual's system of adaptation to, or the manner he assumes in dealing with, the world" (122). Thus, one's agenda and physical surroundings greatly impact the persona he/she takes on. Jung also claims, "the persona is that which in reality one is not, but which oneself as well as others think one is" (123). The role one assumes and the way others perceive oneself constitute the prescribed persona. Such a definition would fit Harley's understanding of herself from "Secret Origins." Harley assumes particular roles when needed or desired; thus, she can be a psychiatrist by day and a roller derby player by night and then assume other roles as situations arise. While Jung argues, "fundamentally the persona is nothing real: it is a compromise between individual and society as to what a man should appear to be" (158), Harley negates society's demands and instead follows her own personal agenda. Since she does not obey rules, she denies having a self that society would actually prescribe to her. She may play the role of psychiatrist but makes her own rules, eventually being kicked out of Arkham in both *Mad Love* and "Secret Origins." Harley does not let society assign her roles; instead, she is an agent of shifting personas, picking who she wants to

be given the circumstances of any particular moment. While Harley's role-playing fits Jung's personas to an extent, since they are not socially constructed, she embodies a purely autonomous self. Harley's independent agency and ability to shift roles effectively marks her supervillain identity as both modifiable and unpredictable.

With this perspective, I argue that Harley's character embodies pleasure-based role-playing performativity, even if these roles arise from her own agenda and do not fulfill particular expectations of society. Twentieth-century sociologist Erving Goffman finds that "sincere" performers believe they are the person they perform to the social world, whereas "cynical" performers do not present their real selves (17–18). Harley acknowledges that she performs roles but claims that they collectively composite her complete self. Thus, she is a sincere performer who knowingly adopts cynical performances, if needed. Judith Butler's theories of gender performativity find that "norms are acting on us before we have a chance to act at all, and that when we do act, we recapitulate the norms that act upon us, perhaps in new or unexpected ways, but still in relation to norms that recede us and exceed us" (xi). For Butler, gender is an identity we perform according to prescribed social norms. We do not have autonomy in our performance, as it has already been determined. Yet, since Harley does not perform according to social norms, and instead, disregards all rules, she does have agentive power in the adoption of her various personas. Her actions may appear to illustrate the "new or unexpected ways" that Butler mentions, but since Harley does not perform her female gender according to any sort of pre-coding, she defies performativity based on social norms. Harley is neither consistently feminine nor masculine, heterosexual nor homosexual. She cannot be concretely defined because she is multiple and adjusts her performances of her personas according to situations to best suit her needs or to fulfill personal desires for violence.

Harley's autonomy allows her to separate herself from normative society and behave according to her own agenda. She may still be recognized for her history with the Joker but is disengaged from the dependence made visible in *Mad Love*. However, since Harley's origins as a supervillain are tied to the Joker, she is often compared to his character. For Tosha Taylor, "her violence … is itself another mirror of the Joker, for it has an origin in the Joker's own actions. Harley's reflection of the Joker often seems a willing performance rather than an intrinsic identity; it is an aspect of the 'Harley Quinn' persona but not its whole" (89). If Harley's violence is simply due to aping, then it constitutes a persona she adopts to fulfill a particular need. In "Secret Origins," when Harley admits she "played along" with the "ditz" role, she confesses to knowingly behaving in a way simply to please another. Taylor's observation about Harley mirroring the Joker is part of the role she plays

simply to satisfy her lover. She thinks that to be loved by him, she needs to engage in particular behaviors. However, in *Harley Quinn*, Harley's violence occurs frequently and often as a result of impulse, suggesting that it is an innate characteristic rather than a deliberately adopted trait. Turning to the origins of her super villainy, in *Mad Love*, Batman observes, "in her own way, Alfred, Harley Quinn's as crazy as the Joker. Her playful exterior hides an obsessive and dangerous mind" (Dini and Timm 18). Batman sees the layers of Harley's character, noting that her playfulness is a mere appearance. She is all the more dangerous because she is not who she pretends to be and does not allow access to a true, observable self. Batman sees through the act, but in calling her "as crazy as the Joker," he raises awareness to her indefinable and unpredictable nature.

Violence and Play

In the New 52's *Harley Quinn* series, following Batman's observation in *Mad Love*, Harley is both playful and dangerous, acting on whims to achieve self-satisfaction through violence. She enjoys the roller derby league because it is a space where she can let her violent nature loose in a game-playing setting, but she is also often incredibly impulsive with her violent behavior in various settings. In "The Hunt for Red Octogenarianz," while watching a performance where a woman is attacked, Harley jumps onstage attacking the actor. Afterwards, she says, "I really thought … the knife … it was so real!" The actress responds, "Real? I was in a monkey suit and it all was on a stage. What part of that was real?" Harley questions the performances of others because she cannot successfully read their roles—whether deliberately or socially performative. The actress understands performance versus reality, but Harley does not follow normative society even in its everyday, commonplace activities. Her rejection of social cues and violent impulses cause her to act rather than think which illustrates one observable aspect of Harley's character as a lack of control when stimulated.

Harley's affinity for violence may also be viewed as pleasure-fulfillment akin to playing a game. She enjoys committing violent, destructive behavior and takes on roles that seemingly encourage her to do so, or she makes violence into her own game. Early twentieth-century American philosopher and social theorist George Herbert Mead looks at a child's role-playing as a "play period," during which stimuli "call out" for responses, and "the child utilizes his own responses to these stimuli which he makes use of in building a self" (150). Mead notes an early stage, where the child "passes from one role to another just as a whim takes him" (151). Harley's taking on personas and role-playing occurs very much like Mead's description of childhood play. She

typically acts as the child in the early stage since she is so impulsive and does not think about the responses of others. In "Need Some Rage with Your Birdcage?," she gets a part in a show, and, during the performance, she forgets she is supposed to be acting and attacks one of the other actresses. When she realizes, she says, "Uh-oh. I think I went full Strasberg with my method acting and forgot where I was." Harley is not always aware of her surroundings, and since she so often acts upon impulse, her behavior may hurt innocent people. She is like a child in this way, acting on whims to fulfill particular needs. Even though she has claimed that she knowingly performs roles, she still struggles when the roles are socially prescribed and have particular requirements. Instead, she acts according to her own agenda. Even when Harley joins the roller derby league, playing on a team in an environment that allows violent behavior, she completely disregards the rules of the game, which ultimately results in her dismissal from the league. Harley's lack of standardization and refusal to perform according to social codes often causes those who do abide to criticize or reject her from the social setting.

Mead's analysis of children and their personality development suggests that role-playing gameplay helps the child develop an identity: "the child is one thing at one time and another at another, and what he is at one moment does not determine what he is at another.... He is not organized into a whole. The child has no definite character, no definite personality" (159). The lack of social normative coding on the child and his unpredictable, shifting behavior certainly fits Harley's character. The nature of the comic book form also invites her to play a new role in each issue, whether a goddess on a deserted island ("Crappily Ever After") or a superhero sidekick on another planet ("Not Kansas"). Because she is so impulsive and erratic with her behavior, it becomes harder to identify her. Mead argues that identification becomes possible through gameplay, where "an organized personality arises" that allows the child to "becom[e] an organic member of society" (159). Further, Mead finds the social aspect of gameplay requires an understanding of the roles of others followed by an appropriate response (151). Harley is, in a sense, stuck in early childhood. When she plays games, she does not become a member of society but emerges as an autonomous self who plays according to her own agenda, not in response to "players" in a social setting. While Harley does not fit the norms of society since she does not follow rules, her character has found a place in the DC multiverse, where shifting personas of characters are more commonplace due to the variegated nature of comic books and their media adaptations. Harley fulfills the role of supervillain in such a context, where individual depictions demonstrate that she is capricious and volatile.

Her identity, then, is simultaneously recognizable and indefinable. However, Harley claims that she does have definite character, as she asserts that

she is the "spicy package," the accumulation of all the various selves she has effectively portrayed. In this way, her variety becomes a defining characteristic, though it makes her all the more difficult to identify since her personas are, at times, contradictory. While Harley is compassionate for animals and fights against their mistreatment, she has no qualms about hurting or killing humans. In "Hot in the City," she sees a dog being dragged by its owner and cuts the leash, letting the dog free, and then ties the owner's neck and drags him by her motorcycle. Later, in "Helter Shelter," she tries to adopt animals from the pet adoption center that euthanizes animals if no one adopts them, saying, "I'm a real nurturer." Yet Harley's compassion is not consistent with her treatment of humans. While she actively protects animals, she readily and, at times, eagerly hurts or kills humans, especially if part of a game or situation that she turns into a game.

Because Harley does not follow rules, her version of gameplay contradicts with those within the game setting. Harley gets dismissed from the roller derby league, which encourages violence and attacking players, after the team manager tells her, "the game has rules and it's clear breaking rules is what you're all about" ("Pies in the Skies"). Even in a space that would seem to allow Harley to release her violent urges, she goes too far. The manager recommends she join Skate Club, which does not have any rules. This would seem to be an ideal playground for Harley, but even here, she is disqualified for blowing up another skater after their bout is over ("There Are No Rules!"). Skate Club, despite claiming not to have rules, does still have some parameters that Harley cannot follow because she completely rejects order and organization. Harley, preferring chaos, finds rules do not inhibit her actions. She does not develop according to Mead's analysis because she does not know how to respond to others. Rather, she sees an objective—attack the opponent—and disregards any appropriate codes of conduct. She assumes "no rules" literally means no rules and therefore kills the opponent skater without a care, thinking it is part of the game. Social settings maintain particular standards, while Harley plays roles that are not socially coded or determined.

As seen, a recognizable staple of Harley's character is that she enjoys chaos and violence, especially in harming others. When Sy Borgman recruits Harley to help him kill a gang of underbosses from his past, she is eager to help, saying, "I got energy to burn ... or mutilate, or whatever" ("The Hunt for Red Octogenarianz"). Taking pleasure in violence, Harley signs on as if these murders are part of a game. She follows Sy to find the targets, but even when playing with a teammate, Harley makes her own decisions regarding the attacks. After they successfully kill all the underbosses, Harley tells Sy, "you sure know how to show a lady a good time, Sy. Call me anytime you need a date" ("Better Nuthead Than Red"). Harley takes on the role of assassin

to play the game of murder with Sy. She never acknowledges that she is breaking the law, as laws and rules do not discipline or control her behavior. Instead, Harley enjoys her and Sy's success and is eager to play again in the future. She likes such a game because of the adventure and excitement it brings. The other "players" are unpredictable, like Harley, so she embraces the opportunity to engage in chaos.

Harley's perception of chaos is also inconsistent with social definitions. In "Harley Quinn Invades Comic-Con International: San Diego," Harley joins a group of women dressed as her who say they are out for a night of "chaos and pandemonium … breakin' the law … murder and mayhem!" Harley immediately interprets "chaos and pandemonium" in her own way, covering the eyes of the limo driver and stopping the limo on train tracks to get ripped in half by an oncoming train. She then holds up some police officers and accidentally shoots one. In the police lineup, the officer cannot identify who shot him, since all the women are dressed in the Harley Quinn costume. Harley takes the chaos game to a level beyond the idea of chaos these other women had in mind because they maintain a particular code, trying to dissuade her from holding up the officers and crying about being almost thrown in jail. Harley, who abides by no rules, enjoys the excitement of her adventure. While these women begin the night trying to play the role of Harley, the real Harley demonstrates that she actually cannot be understood or interpreted. Her definition of chaos is inconsistent with that of the others since, like her identity, her actions are autonomously erratic. Harley's motley identity is comprised of the personas she takes on to suit her needs or desires at any given time. She still plays the role of psychiatrist because it helps her pay bills (which is oddly the only rule of society that she seems to follow), but she does not obey standard procedure with her patient care. She attacks and threatens a family of a patient who says they have not come to visit; learning after the attack that the family visits often, but the elderly woman has Alzheimer's and forgets ("Very Old Spice"). Harley does not follow proper protocol and, instead, acts based on emotion. Her capricious nature causes her to react violently rather than discussing the circumstances with the family. She destroys their house and almost kills them due to her lack of social etiquette and couth. This is another example of Harley's contradictory self, as she feels extreme levels of compassion for the old woman but readily harms the family and destroys their property without care. Through Harley's various role-playing escapades, her impulsivity and disregard of social cues, norms, and codes of conduct are defining characteristics that paradoxically make Harley even harder to define. Since Harley's identity is not shaped by her social environment, she further becomes more difficult to identify. Instead, she exists as the epitome of motley.

An Autonomous Construct

Harley's identity is also complicated through a meta-level where she is aware of her shifting place within the DC multiverse. When Harley is kidnapped by an obsessive fan, she tells him, "You only know me from what you've read, and trust me; I'm completely different than that" ("Need Some Rage With Your Birdcage?"). The self-reflexivity of the *Harley Quinn* series acknowledges that Harley is a comic book character, while the character is a "real" person aware of her notoriety. Here, Harley denies the persona that has been written for her, claiming that is not truly who she is. In "Harley Quinn Invades Comic-Con International: San Diego," Harley meets Bruce Timm, whom she calls, "My hero!" and tells, "I've been following your career since the beginning!" Such a statement ironically suggests that she would be aware of the creation of her own self. If she is aware that she is a construct, then she may more easily adapt into different character types and personas, and her volatility may be more expectable. The self-reflexivity of Conner and Palmiotti's comics make for a character who knows she is a character and therefore more readily plays any role. In "Picky Sicky," each page is drawn by a different artist; thus, Harley's appearance changes. However, even here, she is aware of being created by artists. In one such meta-moment, she says, "Interesting! Becky [Cloonan] made me into a rock star." Paradoxically, even though she has claimed agency, Harley is also aware that she is a construct. She is dependent upon the artists and writers that imagine the different roles for her while still asserting that she has self-control and a sense of self. She invites the opportunity to be imagined in alternative roles because any of these typically lead to the violence and chaos that give her pleasure. In another meta-moment, in "Secret Origins," Harley sits on stage and tells her origin story to an audience, saying, "How did I become the wonderful person you see before you? A couple'a ways, actually, but the funny thing is, each time I tell this story, it's a bit different. That happens, y'know. As time goes on, the details change but the players ... the players stay the same." In this example, she claims that she tells the story rather than the comic book writers. She acknowledges the variety that is inherent to the comic book medium but asserts some control over the various depictions of her character. It seems, then, that Harley simultaneously exists as an independent agent and accepts being under the direction of others because she knows that each constructed version of herself allows her to be autonomous in a new way. Because writers embrace the impulsivity of her character, they can offer her so many different roles that she may readily assume. Harley's character does not need to be consistent beyond that since her impulsive nature and affinity for violence make it all the more believable that she would take on any role and kill any person.

While Harley may be identified by her capriciousness and violent tendencies, her character is most clearly motley. She is the accumulation of multiple selves that are at times contradictory, thus demonstrating a childlike nature. Harley's character is simultaneously recognizable and impossible to pin down. Her ties to the Joker gave birth to her character in the DC multiverse, but as she has broken away and become an autonomous self, she exhibits that her nature is to be multiple. When she acts on impulse, her identifiable characteristics become more transparent, and when she takes on personas, her character is unstable and resists delineation. Harley, the motley queen, is a composited character who is self-aware of herself as both an individual and a comic book character. She is the "spicy package" and will continue to infiltrate a variety of contexts and fulfill violent urges within DC's multiverse, accumulating a diverse, motley catalog of representations, which all continue to make her both recognizable and indefinable.

Works Cited

Butler, Judith. "Performativity, Precarity and Sexual Politics." *AIBR* 4.3 (Sept–Dec 2009): i–xiii. *AIBR.Org.* Web. 4 Jan. 2016.

Conner, Amanda, and Jimmy Palmiotti (w). Hardin, Chad (i) "Better Nuthead Than Red." *Harley Quinn.* v2. #6 (July 2014), Warner Brothers: DC Comics. Print.

_____. "Crappily Ever After." *Harley Quinn: Futures End.* #1. (2014), Warner Brothers: DC Comics. Print.

_____. *Harley Quinn Invades Comic-Con International: San Diego.* #1. (2014), Warner Brothers. DC Comics. Print.

_____. "Helter Shelter." *Harley Quinn.* v2. #2. (Mar. 2014), Warner Brothers. DC Comics.

_____. "Hot in the City." *Harley Quinn.* v2. #1. (Feb. 2014), Warner Brothers. DC Comics. Print.

_____. "The Hunt for Red Octogenarianz." *Harley Quinn.* v2. #5 (June 2014), Warner Brothers. DC Comics. Print.

_____. "Not Kansas." *Harley Quinn.* v2. #12 (Jan. 2105), Warner Brothers. DC Comics. Print.

_____. "Picky Sicky." *Harley Quinn.* v2. #0. (Jan. 2014), Warner Brothers. DC Comics.

_____. "Pies in the Skies." *Harley Quinn.* v2. #8 (Sept. 2014), Warner Brothers: DC Comics. Print.

_____. "Secret Origins Harley Quinn; Secret Origins Green Arrow; a Boy's Life Damian Wayne Robin." *Secret Origins.* #4 (Sept 2014), Warner Brothers. DC Comics. Print.

_____. "Some Nerd Rage with Your Birdcage?." *Harley Quinn.* v2. #9. (Oct. 2014), Warner Brothers. DC Comics. Print.

_____. "There Are No Rules!" *Harley Quinn.* v2. #10 (Oct 2014), Warner Brothers. DC Comics. Print.

_____. "Very Old Spice." *Harley Quinn.* v2. #4 (May 2104), Warner Brothers. DC Comics. Print.

Dini, Paul, and Bruce Timm (w). DeCarlo, Dan and Bruce Timm. (p) (i). "Mad Love." *Batman: Mad Love and Other Stories.* (June, 2009), Warner Brothers. DC Comics.8–72. Print.

Goffman, Erving. *The Presentation of Self in Everyday Life.* New York: Doubleday, 1959. Print.

Jung, C.G. *The Collected Worlds of C.G. Jung: Complete Digital Edition.* Ed. and Trans. by Gerhard Adler and R.F.C. Hull. Princeton: Princeton University Press, 2014.

Mead, George Herbert. *Mind, Self, and Society.* The Definitive Edition. 1934. Chicago: University of Chicago Press, 2015. Print

Taylor, Tosha. "Kiss with a Fist: The Gendered Power Struggle of the Joker and Harley Quinn." *The Joker: A Serious Study of the Clown Prince of Crime.* Ed. Robert Moses Peaslee and Robert G. Weiner. Jackson: University Press of Mississippi, 2015. 82–93. Print.

There Shall Be Order from Chaos

*Hope and Agency Through
the Harlequine's Subalternity*

MICHELLE VYOLETA ROMERO GALLARDO
and NELSON ARTEAGA BOTELLO

Introduction

During the 2015 Halloween season, international media networks reported that the most searched costume on the Internet was not one of the classic specters, such as ghosts or witches, but Harley Quinn (Hawkes). The preference for this character extends beyond the Halloween context: Morrison (6) has noted the increased popularity of this figure among cosplayers at U.S. comic book conventions, and the same phenomenon has been observed at similar events in Latin American and European countries. This is not the first time that a figure designed to be an antihero or antiheroine has been favored by audiences, as evidenced by the popularity of Darth Vader, Hannibal Lecter, and Maleficent. Nevertheless, Harley Quinn embodies a set of characteristics that make her distinct from these powerful antagonists. She is a young, attractive woman in whose personality childish and naive traits are juxtaposed against the sexual charge of each of her actions, phrases and poses. In addition, she is a villainess who is not afraid to resort to violence. She beats security guards with rubber chickens, shoots at point-blank range, and puts dead bodies into refrigerators or luggage. What is perhaps most surprising, however, is that this figure is extremely popular among women despite the fact that, although strong and independent, she continues to love a man who abuses her both physically and psychologically.

The hypothesis that comic book characters are popular because they

177

provide an escape from reality does not easily explain this phenomenon, nor is it explained by the opposing hypothesis that comic book characters are appreciated because they provide guidance that helps readers confront real life situations (Leng 196). Harley Quinn's popularity is also not explained by Habermas's suggestion that fictional narratives are substitutes for relationships with reality that allow readers to enter the literary action as if it were a training backdrop for critical public reflection or a literary precursor of the public sphere. A more probable explanation of this popular culture phenomenon is that readers use the narratives to which they are exposed to develop models of liberty and autonomy (Alexander, *The Civil Sphere*) that allow them to question moral principles and the essence of what it means to be human (Rorty). These models can be applied to problematic experiences that cannot be rationalized within other available frameworks. Therefore, Harley Quinn may be popular because she projects a model of liberty and autonomy different from what is defined by traditional models. Nevertheless, this theory contrasts with the ideas that typically inform contemporary academic debates regarding the villainess figure. In these debates, Harley is analyzed to comment on the reduction of female comic book characters to objects of sexual attraction and on the unproblematized treatment of partner violence in the products disseminated by the mass media (Austin; Sawyer; Schmidt).

A first point of entry into these discussions is to distinguish *which* Harley Quinn is being analyzed. After all, almost a quarter-century of interaction with innumerable characters from the Batman universe has resulted in a multi-faceted Harley. However, despite the different versions of her character, Harley Quinn remains recognizable through her persona's allusion to the harlequin, her sexualization and her relation to Gotham City's clown prince of crime, the Joker, as his former sidekick and love interest (Peaslee and Weiner). Interweaving and questioning these characteristics, this essay analyzes Harley Quinn's persona as the product of traits already present in Harleen Quinzel's personality long before she experiences an identity transition. It argues that the character of Harley Quinn is that of a self-sufficient woman who is undeniably linked to the Joker but who does not necessarily depend on him to come into existence. By discussing this increasingly popular comic book figure, this essay aims to demonstrate that characters who are often typified as submissive victims of controlling men can nevertheless exercise power, even from their subordinate position. The argument also explores agency-related elements in Harley Quinn's behavior and shows that these are already present during her life as Harleen Quinzel. Therefore, meeting the Joker does not *create* Harley Quinn, but it allows Harleen Quinzel to maximize her ability to weaken order in society.

To illustrate the trajectory of Harleen Quinzel/Harley Quinn's life, this essay draws on the 1994 comic book story *Mad Love*. The first step in this

analysis is to reconstruct the events that indicate that, even before she became a villainess, this character already lived her life in a way that did not conform to social conventions and gender expectations. In the section that follows, it is argued that a discussion of Harley Quinn that centers on her passiveness and banality is only partially justifiable since such an analysis risks reducing her personality to only one of its facets. The following section performs a deeper character analysis, adopting subalternity and liminality theories as these are applied to the study of rites of passage. This is followed by a section that uses the figures of the ritual clown and the persona of the Harlequine to provide content for a liminal model of Harley Quinn that explains her social function. Finally, the way in which similarities between the ritual clown and Harley Quinn might explain the latter's paradoxical global popularity is hypothesized from the perspective of the iconic turn in cultural sociology.

Two Names, One (Made-Up) Face

A fundamental source of information about the pre–Joker life of Harleen Quinzel is the "Mad Love" chapter of the comic strip-novel *Mad Love and Other Stories* (Dini and Timm). In "Mad Love," Batman and his butler Alfred share their impressions of the Joker. Batman states that the Joker's criminal abilities appear to be enhanced when Harley Quinn is by his side. Batman [talking about the Joker]: "He's become more slippery than *ever* … now that he has a *playmate*"[1] (17–18). Subsequently, while studying an image of the sidekick on a large screen, the superhero remarks, "[b]ut even from the beginning…. Harley Quinn was *no angel*"[2] (18). Following this commentary, Batman shares select aspects of the life of Harleen Quinzel with Alfred. First, he mentions that she was a gymnast as a teenager. Among sepia images, which contrast with the range of colors associated with Batman's "narration in the present tense," the reader sees Harleen Quinzel at what appears to be a sporting event in a stadium or gymnasium filled with enthusiastic spectators. Harleen is suspended in the air on a ring apparatus, though in "real life" sporting events, only men perform the still rings routine. Women eventually began to participate in the flying rings routine, but this was more commonly seen in circuses and not at sports competitions (Adams and Keene 175). Harley wears a gymnastics uniform that exposes her arms, thighs and calves. Her tailored leotard emphasizes her waist, which is extremely narrow in proportion to her wide hips and large bust, even if these characteristics contrast with the flat-chested features traditionally associated with gymnasts (Marland 191). Harley displays a wide smile in this atmosphere of admiration and outstanding physical performance.[3] Batman continues, describing to Alfred the period during which Harleen studied at Gotham State University on an

athletic scholarship. He then implies that the future psychologist might have resorted to providing sexual favors in exchange for the modification of the lower-than-average grade that she received on her thesis (Dini and Timm 19).

The following insight from Harleen Quinzel's past comes from Harley Quinn's own recollection of her first encounter with the Joker. Before Harleen agrees to provide the villain with therapy in the Elizabeth Arkham Asylum for the Criminally Insane, he comments on her name: "[r]ework it a bit and you get *Harley Quinn*, like the classic clown character, Harlequin…. The very *spirit* of fun and frivolity"[4] (32). For a moment it looks as if Harleen could turn away with indifference were it not because the Joker insinuates that he might reveal his secrets to her if she takes him on as her patient.[5] She then begins treating him, still as Harleen Quinzel, until the Joker, having briefly escaped from Arkham, is pursued and caught by Batman and returned to the asylum. Harleen is present when the superhero brings the Joker in, holding him by the collar of his famous purple suit jacket. The criminal is in bad condition. His body bears the marks of his confrontation with Batman. Harleen cries, screams, and becomes increasingly agitated, kneeling down in the hallway with outstretched arms while the other employees resettle the villain in his cell. Harleen then leaves the asylum and robs a costume store before returning to Arkham. After she blows up the single glass wall of the Joker's cell, the reader is confronted, for the first time, with the woman's new appearance. She is clothed in red and black attire similar to that of a harlequin. It is so close-fitting that each curve of her body is exposed, though the clothing covers her from head to foot. Stretched out on the floor at her feet, the Joker turns his back to the readers. Then, the following declaration is made, "Harley [to the Joker]: *Knock, knock*, Puddin'! Say hello to your new, improved … *HARLEY QUINN!*"[6] (42).

The transition is complete. The name of "Harleen Quinzel" is not mentioned again in the story. Some would think that, having begun a criminal life with a name originally suggested by the Joker, Harley was actually created by him. From that perspective, he has manipulated her to the point of insanity, and the villainess's personality has been reduced to a subaltern position in the purest Spivakian definition of an inferior subject—an oppressed and underrepresented woman who does not even have her own narrative (Spivak 283). This interpretation is illustrated by statements such as "Harley Quinn is a superheroine whose entire identity is based on and defined by her romantic relationship" (Schmidt 101). Her creators' description that her character was conceived as a "sideline character" for the Joker (Dini and Timm 6) further supports Harley's subaltern position. Likewise, the *DC Comics Encyclopedia* (Jimenez) delimits Harley Quinn's profile by defining her as a victim, introducing her with the statement, "[e]ncountering the Joker, the inveterately

evil Clown Prince of Crime, was the very worst thing that could have hap-
pened to young and impressionable Arkham Asylum psychiatrist Dr. Harleen
Quinzel" (140). In this way, Harley Quinn's personality would appear to be
predetermined: she would never be more than a poor silly girl.

The Dangers of Being Only a Poor Silly Girl

Thus far the evidence might indicate that the Harley-Joker duo is a part-
nership characterized not by equality but by subjugation, occasionally diluted
by comic or confrontational interactions with other characters. Sawyer (101)
suggests that it is precisely because of this intertwining of violence with other
types of situations that the message transmitted by the Harley Quinn figure
completely downplays the problem of partner violence. Likewise, Sawyer
emphasizes that having a protagonist role does not mean that a female comic
book character is empowered. To the contrary, these characters are presented
as if they were sexual objects on display (104), which robs them of all agency
(106).

Morrison subscribes to the idea of the Joker as the origin of the problems
in Harley Quinn's narrative, as can be inferred when the author states that
the criminal "always has a way of coming back into [her] life, often causing
chaos, violence, and inevitable heartbreak" (73). Austin's discussion of Harley
Quinn also revolves around her loss of agency as a result of having been
"forced to use her sexuality in order to obtain what she wants" (286). These
comments create a discourse in which the transition from Harleen to Harley
depended upon the Joker, who "manipulates [this woman] and transforms
her into his sidekick" (286–287). Therefore, it can be said that analyses of
Harley Quinn consistently reinforce the subalternity of a poor silly girl who
is incapable of losing enthusiasm for a relationship that will eventually destroy
her. Harley appears to be nothing more than clay in the hands of a man who
molds her and a piece of meat in the claws of a society that has placed her
sexuality in her hand as if it were a gun, forcing her to point it at her own
head.

Is this the only way in which this character can be analyzed? What could
be revealed if instead we were to inquire whether Harley Quinn's transfor-
mation was foreshadowed by qualities present in her before she became a
villainess, that is, when she was simply Harleen Quinzel? This seems like a
reasonable exercise considering that in real-life circumstances, defining a
woman only in terms of the situations of abuse that she has experienced
would be deemed a reductionist stance that only prolongs victimization. Of
course, omitting these violent episodes from a consideration of her life

trajectory would practically constitute complicity with the aggressors. There is a delicate balance between these two extremes. Without "exonerating" the villain's use of violence or that of his writers, cartoonists, and the society from which they sprang, this essay analyzes whether Harley Quinn really has been constructed as a character who has no agency and no narrative of her own.

The Liminal Woman

The first point that sheds light on Harley Quinn's origins and suggests alternative interpretations of them is that, sociologically, the Joker *does not create Harley Quinn's character to be substantially different from her former characterization.* In order to see this, it is useful to approach her transformation as a rite of passage. From this perspective, the Joker would at first appear to be an authority figure who observes and certifies the transition to villainy. However, recalling the earlier description of the Joker lying at the feet of the voluptuous woman who just blew up the glass wall of his prison, we see that the villain is being confronted by the surprise of a consummated act, during the critical phase of which he was not even present.

In effect, an authority and a group *create* the new life of a person through ritual. However, some characteristics of this process do not entirely fit with the experience of Harley as it is portrayed in "Mad Love." In *The Ritual Process*, Turner echoes Van Gennep's definition of *rites de passages* as "rites which accompany every change of place, state, social position and age" (94). These rites are processes characterized by the following phases: (a) separation from a person or group associated with the subject's original state or position, (b) margin, or *limen*, during which the subject who undertakes the rite of passage displays ambiguous characteristics that fall between the state he/she is leaving and the state into which he/she is passing, and (c) reincorporation, during which other persons or groups acknowledge that the crossing over has taken place. In comparison to this schema, if we thought of the transformation of Harley Quinn as a trajectory from (a) normality, through (b) indoctrination during therapy, to (c) criminal life, we would lose sight of what Batman says to Alfred in the Batcave while drinking a hot cup of what is probably coffee: Harley Quinn was *never* an angel.

There have been many descriptions throughout history of sword-wielding angels dressed in red (Classen). Even when, in some religious traditions, angels lack free will, in Christian thought they do possess it and can exercise it to the point of becoming fallen angels. Therefore, Batman's judgment of Harley can only be understood in relation to contemporary popular culture's representations of angels as spirits of pureness. Within this framework, to say that a woman does not have the characteristics of an angel is to

negate her purity, a purity that manifests itself in attributes such as goodness and morality. Moreover, the stereotype of feminine morality often involves the negation of the body and the evasion of sexuality (Zimbalist-Rosaldo 31). However, Harleen Quinzel—suspended in the air clad only in a tight-fitting gymnast's leotard, engaging in sexual relations in exchange for better grades, disguised as a nurse in her role as the Joker's sidekick, or lying on his desk in a red baby doll nightgown—is designed to play out, from the first until the last scene of her life in the comic books, a narrative of sexuality.

Because Harleen Quinzel was not constructed in accordance with the "norms of gender-related conduct" (women as angels), it cannot be asserted that she deviated from these norms when she adopted her identity as a villainess. Therefore, it is not that the Joker disturbed her normal state of being; rather, what begins to reveal itself is a *continuum* in the characteristics of Harleen and Harley. Interestingly, this set of "permanent traits" is more consistent with what Turner describes as individual traits in the liminal stage, for example, monstrosity and nakedness (95). Is it possible that Harley Quinn's normal state is *limen*?

It is also relevant to keep in mind J.L. Austin's speech act theory. Just as the words "I now pronounce you husband and wife" have the power to create matrimony, calling Harleen Quinzel "Harley Quinn" should represent a crucial moment in her transformation. Nonetheless, when the Joker himself suggests the name "Harley Quinn" to the psychologist, she does not undergo any transformations at all. It is not until Harleen declares herself to be "Harley Quinn" that she enters upon a new phase of her life. Looked at this way, though the Joker's influence over the villainess cannot be denied, the assertion that her traits are no more than brief footnotes to the actions of a man who is not in his right mind is questionable.

Because, strictly speaking, no concrete steps are evident in Harleen's transition to Harley, the conclusion could be drawn that the villainess is not the final product of a rite of passage carefully officiated by the Joker. Rather, she is a product of herself and her worldview. This theory strengthens the character's agency (with respect to her ability to self-create, even if this creative act tends towards madness) and in some way links her disengagement from "normal life" with the disengagement that Nietzsche is said to have experienced on January 3rd, 1889. On this day, the German philosopher observed a horse being severely whipped in public and leaped forward to embrace it, submerging himself in a state of madness from which he would never recover (Dorré 159). This incident has traditionally been interpreted as an act of embracing otherness, of fusion with animalism, and of the most profound identification with the vile and the abject (160). Perhaps in the same way that a horse in distress served as the catalyst for Nietzsche's dementia, seeing the badly beaten Joker is part of the agentic narrative of Harley Quinn,

but only as little less than a trigger that unleashes something Harley already was.

This conclusion is inadvertently suggested by the "Harley Quinn" entry in the *DC Comics Encyclopedia*, which states, "[d]angerous curves accentuate Harley's costume" (Jimenez 140). A more "natural" way of expressing this would appeal to the opposite phrasing—that a costume accentuates a woman's curves. It is a powerful idea if Harleen accentuates a costume rather than having a costume which creates her. In this way, she has power in her story as would a protagonist, even if it only leads her to embrace the path of criminality, sexualization, and questionable post-feminist models to relate with men, other women, and consumerism.

Contrary to what Schmidt argues (iv), looking beyond the victim status does not necessarily lead to the negation of violence and the blaming of abused women for the situations in which they find themselves. Instead, doing so may promote reflection about the ways in which characters are *much more* than victims. Schmidt (72–73) also proposes that there is no specific label that confers meaning to Harley Quinn's actions and behaviors. However, what if there were a protagonist role that signified precisely Quinn's position of subalternity, ambiguity, *limen*, and madness?

The Cry Which Started the Whole World Laughing

Evidence indicates that Harley Quinn's character construction could easily be associated with the social functions performed by the "ritual clown," "sacred clown," or "ceremonial jester," a figure studied by George Balandier. The author defines this character as transgressive (53) and states that it performs three functions traditionally present in the "dramas of social rupture": the ritual clown (a) does what is usually considered taboo, (b) makes sexuality and bestiality visible instead of hiding them, and (c) represents misery in a way that is ridiculous and absurd. Balandier also remarks that the supernatural abilities attributed to the ritual jester make him a quasi-hero (54). Could this apply to an antiheroine?

The ceremonial clown's transgressive features may have the function of strengthening the social order (55) because the latter is not always explicit, and crossing a threshold in a scandalous fashion reminds observers of what the contours of normality look like. On the other hand, because the ritual jester is allowed to commit transgressions for which he receives no punishment, his function is to denounce the abuses of dominant figures (55). Balandier links this characteristic with the tradition of literary figures whose madness allows them to speak inconvenient truths (58). Therefore, scan-

dalously sexualized and demented behavior that is transgressive of social norms may revitalize the social order through a cathartic process in which all of the rules that are broken and transgressed become a map of what other members of society should avoid doing. Thus, the ritual jester personifies a warning regarding "what would become of a society in which all norms were to dissolve" (58).

In addition, Balandier traces an arc that directly associates the ritual jester of pre-modern and non–Western societies with the jack-of-all-trades of the European deck of playing cards (a card that is ambiguous because it does not have a specific position) and with the court jester (57). The latter version of the jester is also interesting because, as the French anthropologist notes, it was a *co-protagonist of power* (not a slave or a servant lacking control). The power held by the court jester was significant enough that, in the four-teenth century, the profession was institutionalized and only those who were trained by a master jester could become one. Notably, the master trained jesters to be physically skilled and clever and often resorted to violent pun-ishments to achieve this (60).

The characteristics of this historic profession imply that there is a marked difference between the character of the court jester and that of the popular jester. Originally a figure from town celebrations, the popular jester was assimilated into the theater where, according to Balandier, he gradually lost his roughness and gained a certain refinement. This is illustrated by the figures of Harlequin and his feminine version, Harlequine, in the *commedia dell'arte* of the Italian Renaissance. Unlike the court jester who shares royal power, the Harlequin(e) character is always a servant. Additionally, Harle-quin(e) is never the main character of a story, nor does he/she spark the action of any of the scenes in which he/she appears (Chaffee and Crick 57). He/she was practically reduced to a victim of events. The harlequin of nine-teenth century France no longer made fun of the powerful but became a pop-ular character due to the way in which audiences identified with his/her role as the subaltern in relation to the powerful and socioeconomically privileged sectors of society. The court jester usually dressed in rags, and the more they tore to pieces, the more they were patched with pieces of colored fabric and in random patterns. In opposition to this, the costume of the popular jester or Harlequin(e) gradually became stylized until in the seventeenth century it took the form of a suit of perfect rhomboids interlaced with ribbons.

Which of the two clowns is Harley Quinn? Is she the popular jester who has no agency and does not figure as the main character of any story? Or is she the court jester, powerful sovereign of everything she laughs at, who dis-plays to society phenomena that it would rather not see (such as partner vio-lence) and who reveals the ideal social order (feminine empowerment) by behaving in a way that is contrary to this order? To answer these questions,

it is worth remembering that while Harlequine's figure becomes more refined over time, Harley Quinn becomes increasingly "wild." Today, she is presented wearing typical roller derby attire (DC Comics), which emphasizes her strength, cleverness, and violent and competitive nature, independent of the fact that this sport (when practiced by women) is a signifier of post-feminist agency (Pavlidis and Fullagar) rather than a real-life instance in which physical ability is used to transgress gender stereotypes.

The Icon Between Order and Chaos

Just as the figure of the court jester breaks taboos and social norms but is also integral to the normal functioning of power in the kingdom, Harley Quinn is capable of disrupting social order but finds herself embedded in a relationship marked by the outrageous irrationality of being in love with her abuser. She has considerable power to break the chains of the social order. However, it would appear that she is incapable of breaking the chains of emotional dependence. This contradiction has fueled most of the debates surrounding the figure of Harley Quinn. Nonetheless, unlike the popular jester, Harley Quinn is not condemned to be outside of the power that the Joker represents. Rather, she is his *co-protagonist*: her trajectory, beginning with her life as Harleen, provides a model of liberty and subaltern autonomy that subverts established norms. Based upon this, it can be hypothesized that one of the reasons that she is so popular is because she is an icon within whom this morality and group of values are aesthetically condensed.

Icons are "symbolic condensations that root social meanings in material form" (Alexander, "Iconic Consciousness" 10). They have the attribute of becoming more than mere objects when they form part of a narrative, transmitting an experience to those who contemplate them (12). This, however, is an aesthetic experience "different from any *Knowledge of Principles, Proportions, Causes, or the Usefulness of the Object*"[7] (Hutchenson cited in Alexander 17). An object acquires the characteristics of an icon because it is capable of arousing a feeling consciousness: the feeling of understanding something "by the 'evidence of the senses' rather than the mind" (11).

What does this surrendering of the senses that the villainess provokes in some people involve? What is Harley Quinn an icon of? The admiration for this woman who is known to the public through comics, movies, cartoons and video games and the popularity that causes her costumes to sell out might be rooted in the fact that she is an icon of the liminal who constantly subverts the social order and her own identity. What she offers for mass consumption is a figure who expresses problematic experiences that are difficult to rationalize and who exposes tensions and conflicts present in society. Her perma-

nent status of *limen* allows her to laugh at normality and at those who occupy positions of violent domination. Harley exhibits the crooked timber of humanity and maybe even has the last laugh about it.

These points of contact and identification may be the powerful reasons behind the growing wave of Harley Quinn's popularity. After all, knowing or not knowing that one knows (Alexander, Iconic Consciousness), might not the public be seeking the same renovation and acknowledgment as she does? Furthermore, literary drama not only *originates from* social drama but also *provides meaning and strength to* the social drama (Turner, The Anthropology of Performance). In other words, the violence that this villainess experiences is part of the merchandise of her franchise because such violence exists in society. However, in addition to being a final product, she can function as a starting point for discussing the problematic interactions that she has caricaturized. This interpretation resonates with the ideas of Harley Quinn's creators concerning what she first signified and what she has become:

> Through Harley's tragicomic experiences, we catch a glimpse of ourselves in a funhouse mirror, distorted and all too willing to play the fool for someone we'd be much better off without[....] And even Harley has changed a little in the interim[....] Harley's [the Joker's] equal partner in crime, and not the eager-to-please henchwench of old. That's not a reformation by a long shot, but it's a tentatively hopeful step in a debatably right direction. And if there's hope for Harley Quinn, then there's hope for the mad lovers in us all [Dini and Timm 7].

If the continuity between Harleen Quinzel and Harley Quinn is mediated by the concept of subalternity while the character's transgressive agency also remains constant, the attractiveness of the villainess, who is linked to the several-centuries-old figures of Harlequine and the ritual jester, is not exclusively the result of her short shorts and tailored t-shirts. She possesses the same attraction as the figure of Pandora opening her infamous box for the second time: the ability to create order from chaos. Hope.

Conclusions

Harley Quinn's actions indicate that her narrative seeks to make evident the absurdity within the social order, which is then subverted by the blurring of categories such as sexual normality, violence, reason, and convention. Harley Quinn's grotesque deeds and insane outbursts ultimately exhibit the "other face" of power apparatuses such as law, hetero-patriarchal normativity, and even the order of masculine criminal milieus. The villainess's performative acts constitute her as a woman loaded with anti-social drives and inconvenient truths. Nevertheless, through the study of the characteristics that she shares with the ritual jester, it becomes apparent that her propensity for

subversion contributes to the social order because summoning chaos is part of the ritual dramatization of normality; unleashing lawlessness allows social renovation. The character's violence also embodies a warning: it portrays all the chaos that would materialize if society were to lose its norms, its prohibitions, and the strength of its codes. This is exemplified several times during Harley Quinn's life, especially in her desire for personal proximity (as the Joker's lover) and for professional validation (as a leading figure in the criminal world). Such traits could also account for Harley Quinn's increasing popularity because she becomes an icon which symbolizes the (never achieved) goal of social recognition and the hope of renewing the social order.

NOTES

1. Emphasis in original.
2. Emphasis in original.
3. Though gestures such as these are common during floor routines in women's gymnastics, they are not customary during performances on apparatuses such as the uneven bars or the balance beam because of the strength and concentration required to perform these routines.
4. Emphasis in original.
5. Previously, while recounting Harleen Quinzel's first day of work at Arkham, it was insinuated that she might have been interested in benefitting from publishing the experiences of prominent inmates in the asylum.
6. Emphasis in original.
7. Emphasis and capitals in original. It refers to the name of a book.

WORKS CITED

Adams, Katherine H., and Michael L. Keene. *Women of the American Circus, 1880–1940*. Jefferson: McFarland, 2012. Print.

Alexander, Jeffrey C. *The Civil Sphere*. Oxford: Oxford University Press, 2006. Print.

_____. "Iconic Consciousness: The Material Feeling of Meaning." *Thesis Eleven* 103.I (2010): 10–25. Print.

Austin, Shannon. "Batman's Female Foes: The Gender War in Gotham City." *The Journal of Popular Culture* 48.2 (2015): 285–295. Print.

Balandier, Georges. *El Poder En Escenas. De La Representación Del Poder Al Poder De La Representación*. Barcelona: Paidós, 1994. Print.

Chaffee, Judith, and Olly Crick. *The Routledge Companion to Commedia Dell'Arte*. London: Routledge, 2015. Print.

Classen, Constance. *The Colour of Angels: Cosmology, Gender and the Aesthetic Imagination*. London: Routledge, 1998. Print.

Conner, Amanda, and Jimmy Palmiotti (w). Hardin, Chad (p) (i). "Hot in the City." *Harley Quinn*. v2. #1. (Feb. 2014), Warner Brothers. DC Comics. http://www.dccomics.com/comics/harley-quinn-2013/harley-quinn-1.

Dini, Paul, and Bruce Timm (w). DeCarlo, Dan and Bruce Timm. (p) (i). "Mad Love." *Batman: Mad Love and Other Stories*. (June, 2009), Warner Brothers. DC Comics. 8–72. Print.

Dorré, Gina M. *Victorian Fiction and the Cult of the Horse*. Cornwall: Ashgate, 2006. Print.

Duncan, Randy, and Matthew J. Smith, *Icons of the American Comic Book: From Captain America to Wonder Woman*. Vol. 1. Santa Barbara: Greenwood, 2013. Print.

Habermas, Jürgen. *The Structural Transformation of the Public Sphere: An Inquiry into a Category of Bourgeois Society*. Cambridge: MIT Press, 1989. Print.

Hawkes, Rebecca. "Harley Quinn: A Guide to This Year's Most Popular Halloween Costume." *The Telegraph*. 28 Oct. 2015. Accessed 22 Jan. 2016. http://www.telegraph.co.uk/film/suicide-squad/harley-quinn-costume-halloween/.

Jimenez, Phill. "Harley Quinn." *The DC Comics Encyclopedia. the Definitive Guide to the Characters of the DC Universe.* Ed. Alastair Dougall. London: DK, 2004. Print.

Leng, H.K. "Of Bats and Spiders: The Appeal of Comics to Adult Readers." *GSTF International Journal of Law and Social Sciences* 2.1 (2012): 196–200. Print.

Marland, Hilary. *Health and Girlhood in Britain, 1874–1920.* New York: Palgrave, 2013. Print.

Morrison, Amber. *Understanding Gender Identity Among Women Cosplayers of the Gotham City Sirens.* Orlando: University of Central Florida (Thesis), 2015. Print.

Pavlidis, Adele and Simone Fullagar. *Sport, Gender and Power: The Rise of Roller Derby.* London: Ashgate, 2014. Print.

Peaslee, Robert Moses and Robert G. Weiner, *The Joker: A Serious Study of the Clown Prince of Crime.* Jackson: University Press of Mississippi, 2015. Print.

Rorty, Richard. *Contingency, Irony, and Solidarity.* Cambridge: Cambridge University Press, 1989. Print.

Sawyer, Elliott Alexander. *Postfeminism in Female Team Superhero Comic Books.* Utah: The University of Utah (Thesis), 2014. Print.

Schmidt, Katlin. *Siren Song: A Rhetorical Analysis of Gender and Intimate Partner Violence in Gotham City Sirens.* Las Vegas: University of Nevada (Thesis), 2015. Print.

Spade, Joan Z., and Catherine G. Valentine. *The Kaleidoscope of Gender: Prisms, Patterns, and Possibilities.* Los Angeles: Sage, 2008. Print.

Spivak, Gayatri Chakravorty. "Can the Subaltern Speak?" *Marxism and the Interpretation of Culture.* Eds. Nelson, Cary, and Lawrence Grossberge. London: Macmillan, 1988. 271–313. Print.

Turner, Victor. *The Anthropology of Performance.* New York: PAJ Publications, 1988. Print.

_____. *The Ritual Process. Structure and Anti-Structure.* New York: Cornell University Press, 1977. Print.

Zimbalist-Rosaldo, Michelle. "Woman, Culture, and Society: A Theoretical Overview." *Woman, Culture, and Society.* Eds. Michelle Zimbalist-Rosaldo and Louise Lamphere. Stanford, CA: Stanford University Press, 1974. 17–42. Print.

The "Mistress of Mayhem" as a Proxy for the Reader
A Metafictional Link
Between Fiction and Reality

MEGAN SINCLAIR

At just over two decades old, Harley Quinn is still a relatively young character in the comics world, but despite her huge fan following, she has an ambiguous place in comics and popular culture, partly due to her rather unconventional origin. Unlike many characters who began in comics and expanded into new media, Harley instead made the transition from animation to comics due to her popularity on *Batman: The Animated Series* (1992–95), becoming one of the best loved and cosplayed characters. In fact, according to *Frightgeist*, she "[was] the top-trending Halloween costume in the country [in 2014]," suggesting that her widespread appeal as a modern cultural icon stretches far beyond comics (Melrose). Similarly, her online fan base continually adds to her popularity. On *fanfiction.net*, a website where fans post their own interpretations of popular characters, Harley Quinn has over 1,100 stories and a further 874 within *Batman: The Animated Series* continuity.[1] Part of her success comes from the fact that she inhabits the role of the superfan, standing in for a certain construction of the reader, and in so doing, bridges the realms of fantasy and reality. Her madness is often presented as a parody of the obsessive fan, and as such she offers a commentary on the nature of comics fandom, the rise of metafictional tropes in superhero comics, and the absurdities of some genre conventions. Harley Quinn's unhinged, delusional state of mind allows her a self-awareness that most other comics' characters do not possess. Her (almost) unique ability to act as a proxy for the reader (there are some similarities to Marvel's character Deadpool) is established through various metafictional strategies. As a proxy, the readers give

Harley the power and authority to act in place of themselves, offering a self-reflexive critique of fan culture. This technique is predominantly used in the New 52 *Harley Quinn* series by Amanda Conner and Jimmy Palmiotti (2013–). Through their use of metafiction, Harley Quinn springs to life in a world where she simultaneously exists alongside superheroes and villains and amongst the comics' creators and readers. This essay primarily examines *Harley Quinn #0*, *Harley Quinn #22*, *Harley's Little Black Book #1*, and *The San Diego Comic Con Special* to explore the ways in which the character and her creators use metafiction to play in the liminal space between the real world and fantasy. To borrow Patricia Waugh's formulation, Harley Quinn is a character who "self-consciously and systematically draws attention to [her] status as an artefact in order to pose questions about the relationship between fiction and reality" (Waugh). Through this position, she represents the tension between insanity and sanity, reality and fiction, and parody and satire in order to comment on the complex relationship between comics' characters, creators, and readers in contemporary comics.

Conner and Palmiotti's Harley Quinn

Harley Quinn #0 opens with a panel of her sitting in a storage garage surrounded by comics. As she rifles through them, she fantasizes over what it would be like to be in a comic book, saying how great it would be to have "social misfits lined up waiting for the newest issue of me to come out each and every month," ("Picky Sicky") a joke both aimed at the readers and herself, who both collect and enjoy comics. Importantly, despite the existence of comic characters within the story, Harley no longer lives in the fictional city of Gotham; instead, she moves out of the realm of fantasy to Coney Island in New York, thus moving closer to reality. By using Harley as a metafictional tool, the creators "call into question the difference between fiction and reality, and thus the nature of what we call real or true" (Charlie). Placing Harley in this hybrid world playfully manipulates, subverts, and critiques our construction of fantasy worlds and allows her to engage with readers who are encouraged to relate and associate with her through humor and other techniques.

The series is vibrant, bright, playful, and deliriously surreal; therefore, juxtaposition and contrast are key techniques. It is heartfelt yet horrifically gory: a meeting point between the bizarre storytelling of American superhero comics of the 1960s and the later trend for violent vigilante antiheroes. This rewards a keen sense of comics history and continuity, but it also represents a radical meeting of these opposed influences, revealing the problems with both points of reference and their apparent incommensurability. Yet despite the many comical elements to the series, at its core it is a revision of Harley

herself. Harley Quinn is no longer depicted as a hench-wench, a supervillainess, or a criminally insane inmate of Arkham Asylum. Instead, she is a psychiatrist who works nine-to-five shifts, a landlady managing an apartment full of equally eccentric neighbors, a roller derby player, a newly single woman on the search for romance, an animal lover, and the head of a superhero gang. As blogger nkay96 states, "She is a woman obsessed with life and freedom [...] She's trying to figure out the world just like you and me, but just has a very extreme way of doing so" (Nav K). Harley Quinn is such a mentally unstable character that despite her greatest efforts she cannot live a normal life (or what passes for one in comics). Unlike the Joker, who for the most part is associated with insanity and chaos, Harley is a sane character with a capacity for madness and, as such, must balance the two in order to assimilate into society. The stories within the series, unlike most superhero titles, do not need to be action-packed nor supernaturally driven; rather, the greatest achievements within the series are the moments that feel somehow real. Conner and Palmiotti display their skill through these simple, heartfelt emotional moments, but they also use this as a commentary on the genre as a whole. This can often be seen in their representation of Harley and Ivy, who throughout the series have a playfully romantic relationship and a strong emotional bond. For example, in *Harley Quinn* #25, when Madame Macabre asks Ivy if she is jealous watching Harley kiss Mason, Ivy responds saying, "Never. I'm happy when she's happy" ("Twenny-Five Big One$"). Their genuine love and concern for one another throughout the series, mixed with the suggestive comical elements of their friendship, is a wonderful example of Connor and Palmiotti's skill in making Harley an emotional and relatable character. Harley Quinn's deluded sense of justice and morality is made rational in the way she responds to her friends or those in need. It is these aspects of her character, mixed with the lovable madness readers have come to expect, that makes Harley an emotive and likeable figure for many readers.

Fangirl Harley

Ironically, despite her past as a villain, Harley idolizes superheroes, which explains many of her actions throughout the series. From issues #14 through #17, she stars as the sidekick to Power Girl, who loses her memory and is convinced by Harley that they are a dynamic duo. The team-up proved so popular that the two then went on to star in their own mini-series, which ran for six issues (*Harley Quinn/Power Girl* #1–6). In addition, another spin-off series titled *Harley's Little Black Book* features Harley teaming up with a multitude of characters. The first issue again deals with Harley desperately trying to achieve superhero status and unabashedly fangirling over these

heroes in the process. In #1, Harley is a closeted, obsessive fan of Wonder Woman and has been since her youth. After showing her collection of memorabilia, the comic offers an analepsis of Harley Quinn as a child at school. This Harley is in complete contrast to the vibrant figure readers have become accustomed to throughout the series. Instead, she is a shy, clever, and bullied little girl beaten and forced to do homework for the popular kids in class. While in her room doing said homework, she hears a news announcement describing actual footage of Wonder Woman. She stops what she is doing and rummages under her bed to find a Wonder Woman costume mask ("Little Black Book"). The scene emphasizes Harley's role as the superfan, "a person who has an extreme or obsessive admiration" (Oxford) for something that they are so emotionally attached to that they are characterized by it (Schumaker). When Harley puts on the mask, she becomes her own version of Wonder Woman, embodying the justice and morality of that character. The mask is a real consumer item that could be purchased in 1976. By using a photograph of the item, within the context of the comic world, the creators are emphasizing Harley's ability to bridge the realms of fantasy and reality. With the mask on, she has the confidence to take on her bullies to the point of nearly hanging one with the Lasso of Truth. This shows not only the empowerment that comes from her role as a superfan but that she was always prone to mental instability with or without the help of her psychotic ex-boyfriend. To illustrate this point, one need only adapt Fragopoulos's comment about the metafictional novel in order to discuss comics instead, noting that "metafiction is the twice-told lie. Much of the [comic's] aesthetic power rests in its paradoxical nature. The [comic] posits itself as a vibrant fiction driven by a convincing verisimilitude; it is in blurring the line between reality and fiction that the [comic] really takes form. Metafiction is simply logical extension of the [comic's] initial goal: a fiction that would be so convincing it would fool us into accepting it as reality" (Fragopoulos). Although Harley is still very much an eccentric fantastical character who never openly tries to either tell the truth or lie about her fictional status, by blending self-conscious (meta)fiction and gestures towards something more realistic seamlessly in their comic, Conner and Palmiotti question the readers' understanding of the relationship between the characters, the comic, and comics history.

The Joker and Harley

Despite the playful façade of the team- up issues, they do also show the obsessive nature of Harley Quinn. She is the ultimate embodiment of the superfan and in a way becomes an extension of the superheroes, imitating

their power and persona, immersing herself in worship and infatuation. This is mostly recognizable in her relationship with the Joker. Despite not regularly featuring within these comics, his hold on Harley remains powerful. Taylor argues that both Harley and the Joker enact a performance of gender and identity throughout their relationship, with both characters often subverting or resisting commonly accepted models of gender. She notes that, "despite his pretenses at ignoring his hench-wench and her affections, the Joker actively makes her a subject to his control, ties her to his identity through positioning himself as the model of his own criminal persona and grounds himself in her" (Taylor). Although Conner and Palmiotti often deal with this complex, controlling relationship comically, there are several instances when the reality of their so-called "mad love" is shown in its true, horrific nature.

The series is filled with clearly delusional representations of their relationship, with romanticized pictures of him on her phone and laptop desktops, recalling her naive and unrequited relationship with him as presented in the earliest version of the character in comics and animated cartoons. However, there are a few moments where Harley snaps out of these fantasies which offer a haunting glimpse into her reality. For instance, in issue #22, Harley calls an emergency meeting with her superhero gang, a group whose identities are variations of Harley herself. They arrive half-dressed in the middle of the night with Harlem Harley holding a Joker plush in her arms. Harley stops mid-sentence when she sees it, commenting how unusual it is seeing him used as a safety mechanism. Harvey Quinn (a male member of the team) interrupts jokingly saying, "Show us where he touched you," and in response Harley grabs the teddy and rips its head off, yelling, "He touched me here ... in my head! Ya happy now?" ("Sy Borgman and Harley Quinn Must Die!!!."). The gang, the readers, and even Harley herself seem taken aback by her sudden outburst. The scene shows the contrast between the "Mad Love" fangirl romance she wants and the harsh and haunting reality of the physical and mental torture and abuse she has suffered through her obsession. Jane Dini comments on why this representation of Harley is just as important as her other incarnation and how this vulnerability makes her more human to us saying, "I observed my brother's fans and how they identified with a deeper story behind this figure—one that speaks to people who, like Harley, cover up pain and loss with a façade of silliness" (2015). This is shown immediately after this scenario where Harley instantly snaps out of her rage, light-heartedly commenting, "Yikes. It's okay! I feel better now!" and continues her prior conversation. Harley Quinn constantly changes and adapts to suit her environment. She is a complex, emotional, fallible, and realistic character in whom many readers can find a sense of humanity underneath the mask of madness.

Harley Quinn #0

The fluidity of her character is revealed in the New 52 *Harley Quinn* series debut issue #0. As Harley imagines what creators she would want working on her comic, two narrating voices appear, Palmiotti and Conner, and guide her through an array of artists and writers, each with their own interpretation on her character, from a Godzilla-style robot, to a rock star, a samurai, and a soccer player. Harley molds to fit into every storyline, all the while she, Palmiotti, and Conner discuss each one, complimenting and critiquing their interpretations. As Harley is placed within these different narratives, she is simultaneously within the realms of a diegetic fantasy and a metafictional commentary on the technical process of comic's creation and the fluidity of the superhero genre. At one point she is rendered in a blue pencil rough outline and panics yelling, "I can't look like this!" Palmiotti then tells her to relax and that she just needs inked, while explaining that it is Adam Hughes behind this artwork. Harley, who is aware of the name of this popular artist, makes reference to another of his comics, *Before Watchmen*, saying "Hey! With the blue pencil and all, is he going to be drawing another big, blue pe…" (in reference to Dr. Manhattan's nudity) only to be cut off by Conner saying, "Whoa girl. Different book" ("Picky Sicky"). This points to Harley's role as a superfan, having conversations with the creators about the direction of her comic, while also revealing that she shares the same perspective and cultural reference points as the presumed readers.

Another section of the comic pays homage to her original creators, with Bruce Timm providing a short story in the style of *Batman: The Animated Series*. While Mr. Freeze hands out legal forms to be filled out courtesy of Mr. Timm, Harley sneaks off, only to appear on stage sitting on the Joker's desk in front of a live audience. This scene refers to the famous "Mad Love" episode of the cartoon, but in this comic, Harley freezes and forgets her lines. The Joker repeats his to get her attention while Poison Ivy line-prompts from the curtains off the stage. The story is set up as a theatrical performance, with comic characters turned into actors playing a role for entertainment, used repeatedly by different creators and adapted in order to maximize reader investment in the characters, and therefore profit.

The story concludes with one final metafictional trope that invites readers to continue questioning the boundaries between the comic page and reality. After the Joker leaves a surprise bomb in Harley's hideaway, her garage is destroyed, and she is left in a pile of scattered comics. Picking up an intact one, she looks at a page which shows her reading that very comic in her hand. The next panel shows a mysterious car pull up, and a man hands her a piece of paper before driving off. As she looks up from the comic, the car appears, and what we have just seen plays out in the comic in her hands. This suggests

that not only is Harley Quinn able to act as a proxy between reality and fantasy, or between two levels of fantasy, but that she exists in a world somewhere between these possibilities. Indeed, Waugh argues that neither reality nor fantasy can ever be truly represented in literature, noting that, "the metafictionist is highly conscious of a basic dilemma: if he or she sets out to 'represent' the world; he or she realizes fairly soon that the world, as such, cannot be 'represented.' In literary fiction it is, in fact, possible only to 'represent' the discourses of that world" (Waugh 3). In this scene, Harley breaks down the conventions that support the representation of reality. She holds the comic that we hold in our hands, so she is both actively the character and the reader, existing in the discourses between our reality and the comics world. Not only does Harley make reference to the fact she is reading her own comic, she comments on the creational process of the comic. After examining the beautiful artistic depiction of herself in the comic, she jokes that there is no way that artist Chad Hardin can keep to a monthly deadline. "Look how nice this guy's art is…. With my luck, he'll probably need a fill-in artist by issue two" ("Picky Sicky"). The joke references the commercial side of comics in keeping to a schedule to create a finalized product.

Harley Invades Comic-Con International San Diego

Although issue #0 shows that Harley is very aware of the creational process that goes into comics, her special issue, *Harley Quinn Invades the Comic-Con International San Diego*, is the most prominent example of her in the role of a superfan. Again, the story features a number of artists each contributing their own style to the character. The narrative takes the reader day-by-day through the event, playfully commenting on the stereotypes of comic conventions and the process of comics creation. On day one, Harley arrives at the event and checks into a hotel where she tells Queenie her intentions of getting a portfolio review on her comic. She shows Queenie her superhero comic "Hurl Girl." The readers view her comic within the comic as it becomes a first person perspective of Harley's creation. The plot is about a hero who projectile vomits on her foes. After receiving a semi-complimentary response from Queenie on her work, Harley departs for the convention.

On day two, Harley goes to pick up her press pass, but it takes a page for her to do so as she finds herself joining line after line of people, a nod to the not uncommon experience of convention-goers. Eventually, she gets the pass and makes her way to the convention floor to have her portfolio reviewed. Unfortunately, on arrival DC editor Katie Kubert dismisses Harley,

explaining that she has missed today's session and suggests she go to see Bob Harras instead. While waiting for Harras, the lines between the comic's world and reality begin to blur as Harley finds herself waiting behind a Batman cosplayer whom she assumes is the real character, saying, "Drats! Batman! And he's talking to Bob Harras. He's prob'ly telling Mr. Harras to look out for me, or something." Deciding she has to make Batman look bad in order to get Harras' attention, she pulls down the cosplayer's trousers only to reveal he is wearing Harley Quinn boxers. Two security guards then grab her and escort her out of the building while Harley, still unaware that it is not the real Batman smiles, saying, "Batman has a secret crush on me! Who knew?" (Harley Quinn Invades Comic-Con International: San Diego).

After being kicked out and her pass confiscated for the day, a young girl dressed as Cheetah arrives to tell her the Joker was looking for her. Filled with a newfound momentum, Harley squeezes the girl, yelling, "nothing is gonna keep me from my pudding!" as she plans how to sneak back into the building. When she eventually succeeds and reaches the room, it is filled with hundreds of cosplayers dressed as the Joker. Harley then breaks the fourth wall saying, "Sorry readers, yer just gonna have ta use your imagination here. See ya on the next page." The page cuts to three panels of the closed door with bangs and thumps coming from within. Harley then re-appears from the door, behind her the crowd of the Jokers lay slumped with smeared make-up, and huge smiles on their faces. One comments, "Best. Convention. Ever." Harley reveals that she knows none of them were the real Joker, showing that she can be aware of the differences between reality and fantasy, but humorously stating, "I hadda be sure" (Harley Quinn Invades Comic-Con International: San Diego).

At one point Harley encounters her own fan club and is mistaken for a cosplayer. She then leads the gang astray on a night centered on chaos. The real Harley's version of mayhem, however, differs greatly from the other cosplayers, and she ends up shooting a police officer who she thinks is a male stripper. The event results in a night in jail and a police line-up of the girls (and male gender-bender cosplayer), each dressed as their own personification of her character. This concept is pushed further in *Harley Quinn and her Gang of Harleys*, which Palmiotti noted was inspired by Harley Quinn cosplayers. He comments "that you can do anything with Harley," fans can adapt and restyle her but she remains instantly recognizable ("DC Suicide Squad: Most Wanted"). The idea that fans can inhabit and influence Harley is another way that the character is able to break the fourth wall. However, despite their physical similarities, when released, Harley is the only one of the group left smiling. The others after spending a night in jail have had enough chaos, and Harley goes back to the convention alone. However, her attempts are short- lived as she encounters another comic celebrity, DC editor

Dan Didio. The comic series playfully makes fun of Didio throughout and portrays him as a money-grabbing, self-centered figure. Propp discusses exaggeration in comics, saying that "parody is comic exaggeration [...] that exposes the comic" and that "[exaggeration] take us beyond the boundaries of the real world" (Propp). Thus, arguably by emphasizing Didio and parodying his characteristics, the comic has both referenced its links to the real world while simultaneously exposing itself as a comic through the caricature of a well-known, contemporary figure. Disagreeing with his interview, Harley sneaks up behind and photobombs him only to be caught and again quickly removed from the vicinity.

The comic continues to playfully reference comic creators in the industry, and on day five of the convention Harley eventually gets a portfolio review with Jim Lee, "a veritable legend in the industry" ("Jim Lee"). The page consists of the two sitting silently as Jim Lee reads through her comic, while she waits to hear his advice. Again, Lee is drawn in the same style as Didio, parodying his appearance, such as his wearing his iconic cap. Given his importance, it is no surprise that Harley nervously second guesses every expression he makes as he assesses her work. The pages soon fill with thought balloons as she overthinks the scenario. At first confident, then panicked by his silence, she wonders whether he notices her slight plagiarism of his older work and whether he will question her on it; then she becomes angry as she envisions him ruining her prospective career. Just as she is about to break into an argument with him over it, Jim Lee interrupts the silence saying, "Looks pretty good. Storytelling is solid. Keep it up and you'll be there in no time" (Harley Quinn Invades Comic-Con International: San Diego). At which point Harley excitedly skips out of the room announcing how much she loves Jim Lee. While comical, the scene also provides an insight to the world of an aspiring creator. It places Harley not just in the role of the superfan but as a fan and a creator; she not only inhabits a comic, she also creates her own within it.

The comic concludes on the final day of the con where "Harley meets her maker—literally" (Carrillo). While everyone crowds around Stephen Amell of *Arrow*, Harley pushes through the crowd towards Bruce Timm, saying, "My hero! I can't tell you how much of an honor it would be to get my book signed by you! I've been following your career ever since the beginning!" The phrase works on two levels, one being that Harley has followed Timm's career since he first started out in comics, the other meaning since her creation in 1991, her own beginning. In response, Timm replies, "How sweet, it would be my pleasure Harley," to which Harley replies in awe, "You know who I am? Really?" In this case, Harley is not aware that she is mistaken for a cosplayer. At this point, only the reader grasps the entirety of the situation. Currie comments that metafiction is a useful tool because the "basis of their comedy is in making the paradox visible," in this case it is only the readers

that find the scenario comical, through our background knowledge of Harley Quinn (Currie). Her excitement is heightened even more when Bruce Timm introduces her to Paul Dini, both of whom are, of course, her original creators, to which she exclaims, "Mr. Dini.... I feel like I know you!" The scene, and indeed the issue overall, constantly subverts Harley's character, both as a real figure within a comic and as a comic character within a real interpretation of our world. She is placed in a setting well-known to many comic readers where she co-exists and meets face-to-face with various celebrities in the comics industry, some of whom are directly involved in her creation. Harley, as such, acts as a proxy bridging the realms of fantasy and reality, offering us both an insight to the comic industry and to the comic world which she simultaneously inhabits.

Conclusion

To conclude, Conner and Palmiotti's run on Harley Quinn has both re-vitalized and paid homage to the already popular figure. Arguably, however, since her solo series began in 2013, Harley has become an instantly recognizable character both in and out of comics. Ratcliffe argues that Harley's popularity is due to her universal accessibility. Appearance-wise, she is very marketable, her trademark red-and-black coloring and diamante design make her instantly recognizable, noting "It's far easier to find Harley Quinn merchandise than it is to find representation for Black Widow or [...] Catwoman," even the likes of the Joker, a much older character with a similar marketable color scheme, fairs badly in comparison to the sale of Harley Quinn merchandise (Ratcliffe). As of 2015, *Hot Topic*'s online store had 105 Harley Quinn products in comparison to only 71 Joker ones. Similarly, in time for Valentine's Day 2015, the site also released an exclusive line dedicated to Harley titled *The Harleen Collection* (Granshaw). Arguably, Harley Quinn is particularly appealing to young female readers, a demographic that American comics have ignored for too long. This group has very much embraced Harley as a proxy figure who reflects and comments on their relationship to comics and to fandom. Although her appeal to male readers is also understandable, she is more than a typical superhero sex icon. Her humor and ability to ironically comment on the world of fandom is what makes her, like Deadpool, such an attractive character.

Harley Quinn can adapt to suit audiences; as such, she is a complex yet widely relatable figure. This relatability arguably stems from her position as a vehicle for her metafictionality, and as an element of her proxy nature. This concept is similar to Marvel's Deadpool. Woodrow comments on the relationship between Deadpool and the readers saying, "We [are] constantly kept

on our toes, always with an idea of who the man behind the mask is, but never sure how right we might be—or if we're even in the same ballpark as the truth" (Woodrow). Harley Quinn operates in a similar way, despite the many unreliable elements of her character, the readers place their trust in her and in doing so allow her a unique position in which she comments on both the realms of fantasy and reality. Both Harley and Deadpool have flexibility built into their characters, as they are both mentally unstable, but this serves as an opportunity to comment on the highly unstable world of comics where continuities are overturned and characters are ret-conned and franchises rebooted for creative and commercial reasons. If this is one of the defining characteristics of the media landscape that comics (and the films and other spin-offs) inhabit, then Harley and Deadpool are proxies for the readers' experience of this and have the same cynical knowingness, combined with passion and fun, which characterize the superfan. Harley's relatability is also evident in Conner and Palmiotti's recent nomination in the 27th Annual GLAAD Media Award (2016). Harley Quinn is a product of her fans; as Roddy notes, her character represents "a move from passive to active reading strategies—where creators refuse to inscribe the characters with definite intentions, the reader must supply them in order to generate meaning. By inviting the reader to participate in the text instead of merely consuming it, these works show fan media at its most challenging and creative. A given character may or may not be submissive, but the reader certainly is not" (Roddy). She has a widespread appeal that stretches far beyond the realms of the comic book. Of course, most contemporary readers are sophisticated enough in their knowledge of comics history, the weird tropes and conventions of the genre, and the nature of fandom, but Harley represents a meeting point between all these things and creates a space in which these can be critiqued, played with, and commented on.

In recent years, Harley has increased her popularity by branching out from comics into wider media such as the release of her first full-length film, *Suicide Squad* and possible other films to follow. In a recent survey, *Capewatch* revealed that "Margot Robbie's Harley Quinn [has been] named as the new superhero character audiences are most excited to see" (McMillan). Part of Harley's appeal is that she is a fun and vibrant character who, like many fans that cosplay, uses her costume, her mask, to be playful, colorful and bold. In a recent *BuzzFeed* video discussing cosplay, one of the interviewees responded saying, "Through cosplay, I can become these characters. I could live vicariously with how cool they are" (BuzzFeedYellow). Harley Quinn is a cool character made through her fans; thus, it seems fitting that she is such a popular cosplay character as through cosplay fans can continue to add to and modify her. Fan-art and fan-fiction are in many ways the same as comics, those working in the comics industry, especially in the case of superhero

comics, write for and draw an already formed character and develop them in their own interpretation. In the same way, fans similarly express their admiration of their favorite characters through art and fiction.

Comics overall are a largely subversive media that suits metafictional tropes, most are done for humor or to play around with comic conventions, as is often the case with Harley Quinn. However, more so than this, Harley fully engages the readers in her hybrid world, which as Waugh notes, refuses the readers a passive role, fully engaging them into "a 'total' interpretation of the text" (Waugh 13). She questions our own understanding of comics and comments and critiques the relationship between comics fandom and creation, acting as a valuable tool to offer an insight into both. As Ratcliffe summarizes, "Harley has managed to take her giant mallet and bust down the door to become eminently recognizable in not only comic book circles, but in the greater realms of modern pop culture." Harley Quinn has come a long way from hiding in the shadows of her psychotic beau; she is her own Mistress of Mayhem who incorporates the perfect combination of absurdity and accessibility. From the gritty gutters of Gotham to the colorful compositions of Coney Island, readers engage with and excite over Harley's transitional journey. Fans will continue to follow her in and out of the panels into the interconnecting realms of fantasy and reality, for in Waugh's words, "human beings can only ever achieve a metaphor for reality [however] … this need not be cause for despair, for indeed if we could not create these metaphorical images then we would all surely become insane" (Waugh 15–16). In which case, Harley Quinn has had it right all along.

NOTE

1. http://www.fanfiction.net. [Statistics correct at the time of publication.]

WORKS CITED

BuzzFeedYellow. "Why I Cosplay." *YouTube*. YouTube, 09 Sept. 2014. Web. 14 Nov. 2016. Web.

Carrillo, Elena. "Harley Quinn Invades Comic Con #1 Review." *Batman News*, July 2014, http://batman-news.com/2014/07/16/harley-quinn-invades-comic-con-1-review/. Web.

Charlie. "The Fourth Wall, Metafiction, and Defamiliarization." *Comics and Theory*, April 2014 https://web.archive.org/web/20141111064214/http://www.comicsandtheory.com/?p=412. Web.

Conner, Amanda, and Jimmy Palmiotti (w). *Harley Quinn Invades Comic-Con International: San Diego.* #1. (2014), Warner Brothers. DC Comics. Print.

_____. *Harley Quinn/Power Girl.* #1–6. (2015), Warner Brothers. DC Comics. Print.

_____. "Little Black Book." *Harley's Little Black Book.* #1. (Feb. 2016), Warner Brothers. DC Comics. Print.

_____. "Picky Sicky." *Harley Quinn.* v2. #0. (Jan. 2014), Warner Brothers. DC Comics.

_____. "Twenny-Five Big One$." *Harley Quinn.* v2. #25. (Apr. 2016), Warner Brothers. DC Comics.

_____. "Sy Borgman and Harley Quinn Must Die!!!." *Harley Quinn.* v2. #22. (2015) Ed. Chris Conroy, Warner Brothers: DC Comics. Print.

Currie, Mark. *Metafiction.* Longman, 1995: 5.

Dini, Jane A. "Harley Quinn: A Modern Harlequina." *The Metropolitan Museum of Modern Art*. October 2015, www.metmuseum.org. Web.

Fragopoulos, George. http://quarterlyconversation.com/salvador-plascencia-the-people-of-paper-metafictio. Web.

Granshaw, Lisa. "Harleen Fashion Line Takes Inspiration from the Villainous Style of Harley Quinn." *The Daily Dot*. N.p., 30 Jan. 2015. Web. 14 Nov. 2016.

"Jim Lee." *DC*. Warner Brothers. DC Comics, n.d. Web. 14 Nov. 2016. http://www.dccomics.com/talent/jim-lee. Web.

McMillan, Graeme. "Cape Watch: Harley Quinn Is Your New Favorite Superhero." *Wired*, January 2016 http://www.wired.com/2016/01/cape-watch-71/. Web.

Melrose, Kevin. "Everybody Wants to Be Harley Quinn for Halloween, Apparently." *Comic Book Resources*, October 26th, 2015, http://robot6.comicbookresources.com/2015/10/everybody-wants-to-be-harley-quinn-for-halloween-apparently/. Web.

Nav K. "The Psychology of Harley Quinn: A Character Analysis." *Girl-On-Comic-Book-World*. N.p., 30 Dec. 2014. Web. 28 Nov. 2016. https://girloncomicbookworld.com/2014/12/30/harley-quinn-psychology-character-analysis/. Web.

Palmiotti, Jimmy, San Diego Comic Con Panel. "DC Suicide Squad: Most Wanted," July 22nd 2016.

Propp, Vladimir Âkovlevič. *On the Comic and Laughter*. University of Toronto Press, 2009: 60–67. Print.

Ratcliffe, Amy. "What's Red and Black and Seen All Over? Exploring the Popularity of Harley Quinn" Jan 2015, http://www.comicbookresources.com/?page=article&id=58900. Web.

Roddy, Kate. "Masochist or Machiavel? Reading Harley Quinn in Canon and Fanon." Ireland: Trinity College, Dublin, 2011. http://journal.transformativeworks.org/index.php/twc/article/view/259/235. Web.

Schumaker, Erin. "Inside the Mind of a Superfan." *Huffington Post*. (May 2015). http://www.huffingtonpost.com/2015/04/08/super-fan-psychology_n_7012324.html. Web.

"Superfan—Definition of Superfan in English" *Oxford Living Dictionaries: English*. N.p., n.d. Web. 14 Nov. 2016. http://www.oxforddictionaries.com/definition/english/superfan. Web.

Taylor, Tosha. "Kiss with a Fist: The Gendered Power Struggle of the Joker and Harley Quinn" *The Joker: A Serious Study of the Clown Prince of Crime*, University Press of Mississippi, 2016: 83–84. Print.

"The 27th Annual GLAAD Media Award Nominees Were Announced Today and DC Comics Has Two Nominees in the Category of Outstanding Comic Book." *DC Blog*. Warner Brothers. DC Comics, 27 Jan. 2016. Web. 14 Nov. 2016. Official Press Release http://www.glaad.org/mediaawards/nominees. Web.

Waugh, Patricia. *Metafiction: The Theory and Practice of Self-Conscious Fiction*, London: Routledge, 1984: 2. Print.

Woodrow, Kari. "Deconstructing Comics: Why Deadpool Is Different." *Comic POW!* August 2013, http://www.comicpow.com/2013/08/30/deconstructing-comics-why-deadpool-is-different/. Web.

Super-Villain or Sociopath
Evilness at the Turn of the Century

FERNANDO GABRIEL PAGNONI BERNS
and LEONARDO ACOSTA LANDO

Introduction: Thinking About Evil

In the nineties, the comic-book industry saw the huge success of *Suicide Squad*, published by DC Comics, which obtained good reviews and high sales figures. The title, written by John Ostrander, tells about a group of super-villains who are gathered together and sent on suicide missions by the government. The series is still popular today with the recent release of a film based on the comic.

Suicide Squad is not alone anymore in the market. A new phenomenon of villains leading their own series has seen light in the last years. Both DC Comics and Marvel, the two major publishers of superhero comics, have had several titles headed by villains. DC Comics has *Sinestro, The Secret Six, Lobo, Harley Quinn,* and *Suicide Squad* while Marvel has published series for *Loki, Carnage,* and *Magneto,* along with the hit *Superior Foes of Spider-Man.* It could be argued that our present is one of villains.

This new phenomenon is framed by the current social and cultural climate. Since the terrorist attacks of September 11, 2001, and after years of relativism, the clear-cut dichotomy of "good versus evil" is reinstated as justification for war efforts. Still, as never before, America, native country of the most popular superheroes, has been tagged as evil by foreign countries. This last statement closely follows postmodernity: evil, rather than being a concrete force, is a social construct, a product of subjectivity defined solely through its contextualized manifestations. Good and evil lie in the eyes of the beholder. Yet, contradictorily, the Bush administration accentuated the idea of evil as something external to the individual, a concrete entity. Indeed,

203

some even witnessed the Devil's face materializing from the flames and smoke emanating from the Twin Towers. Because evil can be seen, it is not some subjective moral perspective but something material. However, "in the speeches of George W. Bush the nature of evil is variously conceived" (Jeffrey 136), thus adding further complexity to the matter of evildoers.

At the turn of the new millennium, one of the most fan-loved evildoers of DC comics got her own comic-book series: *Harley Quinn* ran for 38 issues in the first years of the new century, traversing the tragedy of September 11, 2001, the aftermath, and the time for thinking that came later.

The series had to face two challenges: first, it never actually found its footing. Both Karl Kesel and A.J. Lieberman had many difficulties handling Quinn. Clearly, a psychopathic villain has to be evil but, at the same time, bond with the readers in some way. If not, readers simply will not be that interested in buying the book. In partnership with the Joker, Quinn works as a balance to his evilness. She is his "human" half that allows some humanity to shine through the darkness of the Joker's world. However, without the Joker, she must be crazy and cruel. After all, she is a *villain*. Still, how evil is she?

The other problem that the series had to face was the September 11 attacks. The graphic depictions of death and suffering on a massive scale presented in a never-ending temporal loop on television, where trauma was repeated over and over again, together with displays of heroism on the part of so many citizens, made the dichotomy of good and evil particularly relevant to Americans. The media coverage seemed to be infinite, with innumerable attempts on the part of journalists, historians, political scientists, and others to discuss every imaginable side of evil. With the tragedy of September 11 so close in time, the explorations on evil that Harley Quinn could provide were limited and ran the risk of being read as slightly misplaced.

In this respect, Kesel and Lieberman, the only two writers of this particular run, undertook Harley in seemingly similar but, at close examination, different ways: while Kesel mostly embraces the Manichaean notion of a world ruled by forces of good and evil, Lieberman chooses to depict Quinn as a person situated within a gray area, with capacity for remorse and empathy. While Kesel mostly constructs Quinn on the basis of mental illness, Lieberman makes a slight movement towards societal issues. Still, both takes are filled with complexities about what kind of "evil" Harleen Frances Quinzel, M.D., the psychiatrist in love with the Joker, embraces. In her first solo series, Harley Quinn embodies the contradictions of morals in our world and denounces the futility of the simplistic dichotomy of good/evil. A close reading of Harley Quinn's first solo series is necessary to show the ways in which evil is represented in times indelibly associated with aggression.

Quinn by Kesel: The Good/Evil Dichotomy

An interesting aspect regarding Quinn as a character, in both Kesel and Liberman, is the fact that this particular villain is depicted as a woman suffering domestic abuse. Her relationship with the Joker is an unhealthy one, with Quinn carrying the role of a battered girlfriend. In this sense, the villain Poison Ivy, Quinn's only friend, acts as the voice of reason: she is the good female friend who wants Quinn to stand on her own and step out of the Joker's shadow.

For example, in the one-shot *Harley and Ivy: Love on the Lam* (Winick 2001) written by Judd Winick, the trigger of the action is Harley Quinn once again falling out of good graces with the Joker after she almost ruined a heist. Without money or a home, Harley teams up with her friend Poison Ivy to try and score big. However, what Quinn really wants is to get back with the Joker. The money that she so desperately wants is just a path to ensure the Joker's approbation of her as a criminal. Quinn is depicted as a woman living under terrible strain and emotional dependence the whole time, constantly afraid of her boyfriend's outbursts of violence. When the Joker reprimands her, Quinn is depicted as a frightened girl, a woman expecting what is coming next for her. Indeed, the Joker kicked her out of a speeding car (Winick 14), just another moment in a recurrent cycle of violence. Still, at the end, Harley goes back to her abusive boyfriend. The last page actually concludes the story on a sad note: Quinn is once again kicked out by the Joker (Winick 48), thus illustrating that the relationship that both share is one based in recurrent cycles of abuse.

It is not by chance that Kesel chooses to inaugurate Harley Quinn's first solo series by separating her from the Joker. This way, Quinn can shine and choose a side: a good one or a bad one. In fact, the first words spoken to Quinn in the first issue ("A Harley Quinn Romance"), are "Rise and shine, girlie!" (Kesel 1), thus inviting both the main character and readers alike to prepare for the villain's first solo series.

Quinn's depiction in Kesel's run will follow three main threads: she is (a) fully evil in her actions, killing and committing any kind of imaginable crime, (b) a deeply disturbed woman, and (c) a woman embodying dichotomy (both in her assumptions about goodness and evilness and in the way in which she sees the world). All three issues will be interconnected in the first issue.

"A Harley Quinn Romance" opens with Terry Dodson, the artist, drawing the first pages following an exaggerated cartoonish style reminiscent of *Batman: The Animated Series* (WB, 1992–1995), the TV show in which Quinn made her debut, rather than Dodson's characteristic realistic style. After a number of pages, Dodson recuperates his own technique. That same cartoonish

sketching is used recurrently, as for example in issues 6, 7, 8 or 16, the latter told entirely from two points of view, one "real" and the other from Quinn's disturbed point of view. The election points to Quinn's highly distorted vision of reality: she sees herself as a cartoon rather than a real being. This election serves a twofold purpose: on one hand, establishing Quinn's madness. On the other hand, all her crimes are the production of a sick mind. Thus, she is not fully responsible for her actions since she lacks free agency. Also, this distorted perspective is interesting since the perpetrator's point of view is likely to be overlooked or trivialized in studies about evil (Miller 9).

The issue with evil as mental illness in popular culture is the tendency to explain criminal behavior by reference to internal dispositional factors while minimizing the impact of social context. Traditional psychiatry as depicted in popular culture locates the source of an individual's violence and antisocial behavior within the psyches of disturbed people, often tracing it back to early roots in unresolved, mostly silly, infantile conflicts (Zimbardo 23–4). These links, especially in comic-books (filled with deranged serial killers as they are) sometimes link pathological behaviors to pathological origins or personality structures in a simplistic way; for example, if an evil character has a fetish with cold guns (as Mr. Freeze), he probably had an interest in freezing insects in his childhood. Locating evil within selected "crazy" individuals takes away any responsibility that society could have as blameworthy (Zimbardo 25). Societal structures are exonerated from being the sources and the circumstances that create evil.

This simplistic orientation to understanding evil implies as well a "simplistic, binary world of good people, like us, and bad people, like them. That clear-cut dichotomy is divided by a manufactured line that separates good and evil. We then take comfort in the illusion that such a line constrains crossovers in either direction" (Zimbardo 25). However, what is more important, "this extreme position also means we forfeit the motivation to understand how they came to engage in what we view as evil behavior" (Zimbardo 25).

In this respect, it is interesting to point to a little chat that Quinn shares with one of the Joker's goons, Martin, in issue #1. In it, the simplistic meditation of evil as the product of an unstable mind born in turn from some event of the past, is foregrounded. Quinn has been telling her story to Martin and asks about him. She tries to guess why he had chosen the evil path:

> QUINN: You wanted to be a clown, but you had to join the military to pay for clown school. During a routine invasion, you were exposed to an experimental nerve gas that left you allergic to grease paint. Embittered, you rejected all authority and turned to a life of crime. (....)
> MARTIN: Afraid my story ain't all that, Harley. I made some big mistakes when I was young ... things I can't fix, can't undone. But I got a girl, and we love each other, and we got a baby. I send what money I can... [25].

In this exchange, Quinn explicitly addresses evil as a production of mental disturbance created, in turn, from a silly childhood trauma. However, Martin's evilness is more a product of social variables and structures than just some form of craziness. In issue #3 "The Wilde Life," Harley is proving herself by choosing her own henchmen. To her comes a severely battered man asking for a job. He is depicted as an addict who can just barely stand on his feet. Quinn rejects him on the basis that she prefers "altered mental states of a psychological nature …not pharmaceutical" (8). After he retires, Martin makes a not-so-subtle reference to drug abuse that Quinn quickly interrupts to start to plan some senseless evil scheme. Evil as linked to societal problems has no place in Quinn's world of evilness. In fact, issue 5 is used to retell the origin of Harley Quinn without any major variant from what was widely known by readers. The issue serves to foreground her mental state. In that particular issue, "Larger than Life," it is clear that Quinn is truly an insane woman only capable of wacky plans and with no interest in money or any other practical gain.

That is not to say that Kesel depicts a simplistic version of Quinn. On one hand, it is clear that the aforementioned exchange has an ironic tone in which Quinn exaggeratedly focuses on identifying a set of personality factors, overlooking processes operating at political, economic, societal or cultural levels. However, the answer to this overlooking is Martin himself, who is there as a mirror to Quinn's craziness. His evil is born from some undisclosed societal issues.

Still, Harley Quinn is truly evil: she blackmails a woman while putting her in danger (*Harley Quinn* Vol. 1 #2, "A Heart Broken in Two"), tortures a pizza boy (issue #3, "Welcome to the Party"), kills her former teacher (#8, "Be Cruel 2 Your School"), goes rampage in a crime spree (#9 "Shop 'Til You're Drooped!") and even kills Martin, her only friend within her henchmen in issue 12 ("A Date Which Will Live in Infamy"). Still, her schemes involve mental illness. Mostly, they do not involve monetary gain. Actually, "A Date Which Will Live in Infamy" is all about kidnapping two private investigators to give them a time and a place so they will fall in love. Quinn certainly is a criminal and an evil person. However, she is also a woman looking for the best in others, such as the Joker, thus revealing a complex persona behind the harlequin costume and the criminal deeds.

Still, the Manichean approach makes an explicit entrance within the series when Quinn imaginarily talks with the Devil and the Angel literally sitting on each of her shoulders as can be seen, for example, in page four of *Harley Quinn* #2, "A Heart Broken in Two," in page 18 of "Shop 'Til You're Drooped!" (#9) or page one in "Brilliant Mistake" (#10). This situation would state that Quinn is capable of distinguishing "right" from "wrong" since that dichotomy is made flesh in her imagination. Still, a point must be addressed: her little Devil sitting upon her shoulder takes the figure of the Joker, while

the Angel is Quinn herself. So, it can be argued, she somehow imagines herself *as a good person*. This way, Kesel allows some shades of grayness within Harley Quinn. Locating the causes of evil just in *crazy people* lets out of the frame societal and cultural issues and all those people who deem themselves as not evil. As Baumeister (1997) has noted, "Evil usually enters the world unrecognized by the people who open the door and let it in. Most people who perpetrate evil do not see what they are doing as evil" (1).

Mostly, Kesel places Quinn in situations involving good and evil as a clear-cut dichotomy based in mental states and personality factors. In issue 2, Quinn tries to work as henchwoman for Two-Face, the villain who represents the dichotomy of good versus evil for antonomasia. In that issue, both Two-Face and Quinn kidnap Anya Cartwright, wife of a multimillionaire, mistaking her for the lover of the latter. The twist lies in Anya having split personality, thus being both the wife and the lover. In issue 17, Poison Ivy and Quinn kidnap Thorn, a female vigilante from Metropolis. While keeping her captive, Quinn discovers that Thorn suffers from split personality.

With these cases, Kesel reassures the equaling of the dichotomy goodness and badness as projections of split personality, i.e., an individual issue. Even if evil as a social problem is present (Martin's case), the main thread traversing through the whole of Kesel's run is that of a monstrous double that constructs and divides an evil Other clearly delineated against normalcy. This is explicitly addressed in the duality of the art style.

In brief, under Kesel's terms, Harley Quinn is a case of schizotypal pathology, "characterized by maladaptive perceptions of self and other people, problems in reality testing, and defense styles that impair interpersonal functioning and/or impulse control" (Bornstein 175) in which "both the concept of self and the concept of significant others are severely fragmented, similar to the case of the borderline personality disorders" (Kernberg 47). It is interesting to observe that the schizotypal personality is linked to the psychological issue of the split personality (Kernberg 47) so frequent in Kesel's run because it allows the author to mark a clear line between good and evil and reinstate the Manichean dichotomy. Lastly, schizotypal personality is mostly derived from past traumas and parental behavior (Silverstein 190), thus further taking away Quinn from any notion of evilness as born from societal issues.

Quinn by A.J. Lieberman: Blurring Good and Evil

Lieberman's run takes place in post–September 11 times, when evil as an abstract concept was under consideration and moral order, agency and choice were studied as a way to understand the traumatic events. After the

terrorists' attacks of September 11, George Bush, then President of the United States, argued that "Evil is evil, and it must be opposed" (Michaels 332). Bush, in this simple declaration, had swiped away one basic principle of postmodernity: everything is relative, there are not more truths (Dustin 17), but uncertainties since everything is a social construct. In one simple line, the president erased years of relativism: evil is evil, a concrete, material thing, easily discernible to everyone. On that day, surely, postmodernism died and the phrase "absolute evil" was readmitted to language (Hartley and Lumby 48). "The moral language of the Bush administration relies on a pure dichotomy between good and evil, and commands the world to see the situation in those Manichean terms" (Gehman 15).

However, the attacks "punctured a cherished collective self-image. Americans have persisted in imagining themselves as the most virtuous and generous nation on earth, and yet the atrocious morning of September 11 revealed them to be targets of an intense hatred. The attacks did not just strike the symbols of US power; they also struck the ground of American identity" (Ray 137). In other words, some people see the Good Ones (Americans) as the main villains. America, seen from other perspectives, is the evil entity in global issues. The fixed categories "We" (good people) and "They" (bad people) become blurred.

To further complicate matters, on other occasions, Bush has spoken of the "instruments" or "servants" of evil. To be exact, he describes the September 11 hijackers as "instruments of evil who died in vain," people without agency to choose to act otherwise. In other words, these killers who had caused the death of thousands were not entirely evil but, rather, *victims* themselves of Evil. "Agency is the capacity to act outside of social-structural pressures and psychological forces" (Hitlin 196). The hijackers were evildoers who cannot entirely escape from the ideological pressures of their sociocultural context.

Thus, a contradiction between the reinstatement of the dichotomy of good and evil overlaps with the less studied issue of the overlapping of victims as victimizers, a blurring of the categories of evilness and goodness. This is illustrated in A.J. Lieberman's run in Harley Quinn.

One of the most-loved villains within the catalogue of Batman's rogues, Harley Quinn is the perfect vehicle for discussions of domestic terrorism. The events of September 11, 2001, had directed some academics to speculate on some possible relationship between gender and terrorism to the point that acts of global violence can be read as "gender war" (Correia and Bannon 252). September 11 and, by extension, terrorist acts and the evil perpetrated were triggers to speak of brutality and terrorism, including the transnational situation of women and domestic violence, also labeled intimate terrorism, patriarchal terrorism, or private torture (Meyersfeld 101).

The issues of domestic violence are already present in issue 1, written by Kesel. The story of the first issue shows the problems taking place when Quinn displays some signs of female autonomy, which provokes the Joker's rage. Soon enough, he has beaten Harley and attempted to kill her. Scenes of conjugal violence abound in the short-lived series: in the first issue, the Joker hits her with the butt of a gun (Kesel 35) and kicks her when she is lying on the floor. This last image explicitly refers to images of real women experiencing domestic abuse.

Quinn's origin is retold again in Lieberman's first issue, but in this version the writer favors not only Quinn's mental instability but also her role as a battered girlfriend. She speaks about the Joker's "commitment issues" and how she has forgiven him "the first seventeen times" (Lieberman 11). This last statement points to the recurring cycle of violence within a couple in which Quinn fills the role of the recurrently battered girlfriend.

Harley Quinn is not a good person because she suffers, but unavoidably, her situation invites the reader's sympathy. Judith Shklar hints upon elements of this problem when she argues about the danger of identifying too strongly with the victims of cruelty, when, in doing so, we forget that the victims of cruelty are not necessarily better than their tormentors. "They are only waiting to change places with the latter" (18). However, Shklar resolves this problem by arguing that if we "put cruelty first," then it makes absolutely no difference whether "the victim of torture is a decent man or a villain." What matters is that "no one deserves to be subjected to the appalling instruments of cruelty" (19).

If true that Harley Quinn is a bad girl, she asks for sympathy because of her ties to victims of violence in real life. She is a perpetrator of violence but also a victim herself of "intimate terrorism." Of course, being a victim of violence does not make her good, *per se*, but opens the path to sympathy and understanding from readers.

Already from issue 26, the first one wrote by Lieberman, Quinn is a slightly different persona than the one illustrated by Kesel. The adventure starts *in media res*, with Quinn's life in danger at hands of an unknown criminal. While fighting for her life, she analyzes the behavior of her captor: "Use his name. Keep him calm. Regain his trust" (Lieberman 3). Arguably, Quinn here employs her skills as a psychiatrist. It can be argued that Quinn already did that in Kesel's run. Still, two things should be noted. First, that this essay does not argue here that both runs are entirely different but that there are subtle differences but also continuations. Second, Quinn acted as a psychiatrist before only in an ironic way, as already pointed out in the talk between her and Martin. Here, Quinn is making a real use of her profession as a doctor.

Actually, in Lieberman's run, Quinn resumes her job as a psychiatrist,

an issue which was entirely dropped in Kesel's run, where her civil life was left aside to favor her criminal persona. Here, Harley Quinn has work besides being a criminal. This is an important factor. As a working woman (under the name of Jessica Seaborn), Quinn reassumes some lost identity as a citizen. Lieberman's remarks with regard to Quinn's job reflect consciousness of the effects of citizenship status. "As professional citizens, we individually and collectively have responsibilities towards the betterment of communities" (Bryer 65). Citizenship is, along with class, ethnic affiliation, gender, and age, constructed by the capacity of having a job. As a doctor working within a prestigious mental health facility, Quinn reassumes her citizenship and loses some of her identity as a monstrous creature, an other. As a bad citizen, Quinn is most recognizable in her persona as a super-villain living in warehouses decorated with giant silly objects (as in Kesel's run). She can work properly within the structures of normal society while also behaving badly when she desires to do so.

Her rationale is further enhanced when Quinn only undertakes jobs with logical goals such as stealing discs with secret information ("Unlimited Vengeance") in exchange for money. The fact that Quinn acts mostly for money rather than for some silly reason like freeing hyenas from the zoo, downplays in part her craziness. She is not that different here from Catwoman, another character whose criminal career is motivated mostly by money. Together with Quinn's capacity to act within large amounts of time as a normal person (and even act like a very good professional), the character is increasingly taken further away from evil as related to mental issues or split personality (that helps enhance the idea of goodness and evil as mutually excluding spheres) to link her to socio and cultural factors. In "Vengeance Unlimited, Part Three" (*Harley Quinn* #28), she, in her professional persona, defines herself as "a feminist role model staking her claim in a male-dominated field" (Lieberman 10), as a woman acting badly because of patriarchal oppression (sadly, she does not further develop her idea). Her patient, a cop, dismisses this societal-driven theory in favor of evil as product of a deranged mind: "She's a homicidal psychopath" (10).

"Vengeance Unlimited," the first arc under Lieberman, revolves around Quinn trying to clean up her name from a crime that she had not perpetrated. In her second adventure, "Who Steals from a Thief?" (*Harley Quinn* #31), she has been set up when selling stolen goods. Also, thieves stole from her the drug concocted by Poison Ivy that Quinn needs to keep her abnormally high stamina. Like in the first arc, she acts against circumstances beyond her control. She seems to always be reacting aggressively against circumstances beyond her grasp. The attack on the United States on September 11, 2001, has obviously "affected citizens' feelings of security. It certainly has affected the need for a positive identity. The events of 9/11 also created a feeling of pow-

erlessness and helplessness" (Staub 77), which echoes in Quinn's need to regain some control upon her life.

"The Year of the Rat" (*Harley Quinn* #32) tells about Quinn's attempts to have a normal life by beginning a new romantic relationship. The Joker shows up to oppress her and tear apart any possibility of that normalcy. This creepy scenario echoes the reality of many women trying to heal from abusive pasts when their former partners do not want them to be free even though they are in new relationships (DeBare 30). Quinn simply cannot escape from an aggressive climate.

Lieberman chooses to depict Quinn as a citizen doing criminal things because that is the shortcut that she has found within the system. That is not to say that Quinn is not insane, but her personality here is more close to coldness than full insanity. Here, Quinn is a woman who can live without the afflictions of guilt. Quinn favors instrumental aggression, which uses aggression as a tool by which to gain benefits for oneself (Staub 67) rather than harm others because reality is recreated as a weird cartoon. Harley Quinn in Lieberman's hands shows proclivity toward moral disengagement. "People who are treated in certain ways, or find themselves in stigmatized social groups, will be more likely to develop in ways that contribute to moral disengagement. These processes did not start with the individual, but rather with the ways social structure and culture shaped their perceptions" (Hitlin 123). In this sense, Quinn is here related to a world of male violence (as she herself denounces) that had toughened her to the point that she lacks empathy towards others. As a woman consistently socially excluded, she shows less empathy and less helpful behavior toward others. Victimization tends to lead to aggression (Staub 73). The domestic abuse will be especially important to connect with readers through a complex play of victim/victimizer.

In this regard, Lieberman drops entirely the subject of the angel and the devil sitting on Quinn's shoulders. These Manichean depictions of evilness and goodness are not of interest for Lieberman's take on Quinn. Lieberman also drops the double illustration as a form that underlies madness and dichotomy. His Quinn lives within a world of gray. She is an ordinary citizen, rather than a super-villain, who can act in a good fashion or can choose to act badly, according the circumstances.

Conclusions

Harley, as an evil character leading a comic-book, is almost obliged to give some commentary about the nature of evil. This is especially true since the series run overlapped with the historical turning-point of the September 11 attacks.

The differences between both approaches to Quinn made by Karl Kesel and A.J. Lieberman are underlined in the ways in which each author ended his run. Kesel's last arc involves Harley Quinn escaping from the ultimate place representing pure Evil in Manichean beliefs: Hell. Indeed, this last arc (issues 20–22) works upon the premise of Quinn going to Hell and her attempts to escape from it. In one of the most outrageous chapters in Quinn's history, she comes back to life in Harley Quinn #24. Hell is, literally, Quinn's dark intimate place.

However, A.J. Lieberman, chooses to end his run placing Quinn into another kind of intimate dark place: Harley Quinn's own sense of guilt, the one which never made any appearance during Kesel's run.

In issue 32, Quinn uses a method to calm herself in the face of troubles and adversity. This means something new: the villainess has, at least, some form of self-control, which implies the conception of agency. She can choose to act otherwise, unlike Quinn in Kesel's run. Conceptualizations of moral agency include "the possession of consciousness, an 'inner life,' rationality, sentience, intentionality, and self-awareness; the capacity to transcend mere feelings and passions and act in accordance with moral law; the ability to act on the basis of altruism; and the capacity for remorse and empathy" (Jeffrey 88). Unlike in Kesel's hands, Quinn is here a woman who knows moral values, who chooses, who sees reality as it is.

Lieberman's run ends with Quinn facing remorse and guilt, furthering the idea of her as a moral being who lacks empathy at the suffering of others. At least, until the last issue, in which Quinn's actions had left a little girl blind for life. Our villainess does not leave the whole situation unscarred. All hell breaks loose when she falls into guilt and remorse, feelings that she cannot handle. Thus, Harley Quinn ends her own series as she began it: incarcerated within the walls of the Arkham Asylum.

The whole series does not address the tragedy of September 11, 2001, but the cultural climate slips in, nonetheless. Two versions of evilness permeated popular wisdom during those years: evil as a concrete thing differentiated from goodness, like a devil and an angel sitting on shoulders, (like in Kesel's case) or evilness as a subjective gray zone living within any person (like in Lieberman's case).

All these potential readings are what made Harley Quinn such a rich character to study. And that is why she is, currently, more than just the Joker's girlfriend.

WORKS CITED

Baumeister, R.F. *Evil: Inside Human Violence and Cruelty.* New York: Freeman, 1997.

Bornstein, Robert F. "Psychodynamic Theory and Personality Disorders." *Handbook of Personology and Psychopathology.* Ed. Stephen Strack. Hoboken, New Jersey: John Wiley & Sons, 2005. 164–180. Print.

Bryer, Thomas. *Higher Education Beyond Job Creation: Universities, Citizenship, and Community*. Lanham: Lexington Books, 2014. Print.

Correia, Maria, and Ian Bannon. "Gender and Its Discontents: Moving to Men-Streaming Development." *The Other Half of Gender: Men's Issues in Development*. Ed. Maria Correia and Ian Bannon. Washington, D.C.: The World Bank, 2006. Print.

DeBare, Deborah. "The Evolution of the Shelter Movement." *Violence Against Women in Families and Relationships*, Volume 1. Ed. Evan Stark and Eve Buzawa. California: ABC-CLIO, 2009. 15–32. Print.

Dustin, Donna. *The McDonaldization of Social Work*. Hampshire: Ashgate, 2007. Print.

Gehman, Heidi. "September 11: The Terrorist Attack on America." *September 11: Religious Perspectives on the Causes and Consequences*. Ed. Ian Markham and Ibrahim M. Abu-Rabi.' Oxford: Oneworld, 2002. 1–20. Print.

Hartley, John, and Catharine Lumby. "Working Girls or Drop-Dead Gorgeous? Young Girls in Fashion and News." *Youth Cultures: Texts, Images, and Identities*. Ed. Kerry Mallan, Sharyn Pearce. Praeger, 2003. 47–68. Print.

Hiltin, Steven. *Moral Selves, Evil Selves: The Social Psychology of Conscience*. Palgrave Macmillan, 2008.

Jeffrey, Renée. *Evil and International Relations: Human Suffering in an Age of Terror*. Palgrave Macmillan, 2008. Print.

Kernberg, Otto. "Identity Diffusion in Severe Personality Disorders." *Handbook of Personology and Psychopathology*. Ed. Stephen Strack. John Wiley & Sons, 2005. 39–49. Print.

Kesel, Karl (w). Dodson, Terry (p). Dodson, Rachel (i). "A Harley Quinn Romance." *Harley Quinn*. v1. #1. (Dec. 2000), Warner Brothers. DC Comics. Print.

_____. "A Heart Broken in Two." *Harley Quinn*. v1. #2. (Jan. 2001), Warner Brothers. DC Comics. Print.

Lieberman, A.J. (w). Huddleston, Mike (p). Nixey, Troy (i). "Vengeance Unlimited." *Harley Quinn*. v1. #26. (Jan. 2003). Warner Brothers. DC Comics. Print.

_____. "Vengeance Unlimited, Part Three." *Harley Quinn*. v1 #28 (March 2003). Warner Brothers. DC Comics. Print.

Meyersfeld, Bonita. *Domestic Violence and International Law*. Hart, 2010. Print.

Michaels, C. Williams. *No Greater Threat: America After September 11 and the Rise of a National Security State*. Algora Publishing, 2002. Print.

Miller, Arthur. "Introduction and Overview." *The Social Psychology of Good and Evil*. Ed. Arthur G. Miller. The Guilford Press, 2004. 1–20. Print.

Shklar, Judith. *Ordinary Vices*. The Belknap Press of Harvard University Press, 1984. Print.

Silverstein, Marshall. "Self Psychological Foundations of Personality Disorders." *Handbook of Personology and Psychopathology*. Ed. Stephen Strack. John Wiley & Sons, 2005. 181–197. Print.

Staub, Ervin. "Basic Human Needs, Altruism, and Aggression." *The Social Psychology of Good and Evil*. Ed. Arthur G. Miller. The Guilford Press, 2004. 51–84. Print.

Winick, Judd (w). Chiodo, Joe (p) (i). "Love on the Lam." *Harley and Ivy*. (2001), Warner Brothers. DC Comics. Print.

Zimbardo, Philip. "A Situationist Perspective on the Psychology of Evil: Understanding How Good People Are Transformed into Perpetrators." *The Social Psychology of Good and Evil*. Ed. Arthur G. Miller. The Guilford Press, 2004. 21–50. Print.

Appendix
A Mediography of Harley Quinn

Joy M. Perrin

This is not an exhaustive list but an attempt at highlighting the major representations of the character of Harley Quinn in the media. The citations and annotations are intended to guide readers to useful sources (including essays in this book). The entries themselves are presented here in chronological order. The essay "It is to laugh" provides a thorough review of the history of the character of Harley Quinn, so this mediography highlights the major contributions in addition to some of the ones not discussed in the essay. If there is an essay in the book that deals primarily with a particular text, it is included in the write up here.

Television

Batman: The Animated Series (1992–1995)

The series aired between September 5, 1992, and September 15, 1995, and ran under three different series names including *The Adventures of Batman and Robin* and *The New Batman Adventures*, but they are all collectively called *Batman: The Animated Series*, which was the show's original title. This animated series saw the creation of Harley Quinn in the episode "Joker's Favor" which aired on September 11, 1992. Highlight episodes of the series for Harley include "Harley and Ivy," "Harlequinade," "Harley's Holiday," and "Mad Love." The essay "Arkham Origins" deals with the animated series in depth, while "Duality and Double Entendres" talks about the animated series and the subtext of Harley's relationship with Poison Ivy.

Birds of Prey (2002)

This live action show was developed by Laeta Kalogridis around the idea of the *Birds of Prey* comic book, and ran for only 13 episodes. Harley

Quinn is the mastermind behind many of the group's problems. This depiction of Harley, played by actress Mia Sara, is psychopathic but less flashy than the animated Harley. It is an interesting live action depiction that is less cartoonish and less jovial.

"Hard as Nails." *Static Shock* (2004)

Static Shock was an animated television series that focused on the DC character Static and seems to be an attempt to make superheroes interesting to a new generation. The show was on from September 23, 2000, until May 22, 2004. Paul Dini writes a crossover episode "Hard as Nails" where Harley and Poison Ivy use an online discussion board to lure a young girl with superpowers to them in order to exploit her. The online predator message is heavyhanded. The two choose screen names that hint at their broader archetypes: Poison Ivy chooses Ceres (the goddess of the harvest) and Harley chooses Thalia (the muse of comedy).

"Two of a Kind." *The Batman* (2007)

Harley is introduced in season 4 in the episode "Two of a Kind" (February 24, 2007), which was directed by Anthony Chun and written by Paul Dini. The episode introduces Harley as a recipient of an online degree and the host of a daytime TV show which is canceled. She is then easily lead into crime by the Joker after a night out on the town causing mayhem. This depiction of Harley is adorable, absent-minded, but not completely insane. After "Two of a Kind," she has minor appearances in the episode "Rumors" and another episode "The Metal Face of Comedy." While the series is not a significant contribution to the concept of the character, this episode is another origin story written by Paul Dini that brings a fresh look at the character.

"Emperor Joker." *Batman: The Brave and the Bold* (2010)

The series ran from November 14, 2008, to November 11, 2011, and used more content from the early Batman comic books. Harley was featured in the episode "Emperor Joker," which aired on October 22, 2010. The episode's tone is a bit odd since the premise is that Bat-Mite gives Joker some magical power. The Joker creates the world he has always wanted, a world where he can kill Batman as many times as he wants. Harley is without her normal costume and is instead black and white with a 1920's flapper girl design. She develops a crush on Bat-Mite.

Comic Books

"Batgirl: Day One." *The Batman Adventures*. #12 (Sept. 1993)

This was Harley's first appearance in comic books. In it, Batgirl goes out dressed as herself on Halloween. Meanwhile, Harley Quinn and Poison Ivy

go out dressed as themselves to kidnap someone. The issue is interesting if only to see the intermediate step between the animated series and Harley's fully realized comic persona.

"Mad Love." *The Batman Adventures* (1994)

This one-off comic book is one of the seminal works for Harley Quinn as a character. It established many of the basic concepts of the character's history and motivations. It was finally adapted to be included in the animated series in 1994. Many of the essays in this book focus on this comic to help unpack its significance. It is an essential read for anyone interested in the character of Harley Quinn.

Elseworlds (1997): *"Batgirl and Robin: Thrillkiller"* (1997); *"Batgirl and Batman: Thrillkiller '62"* (1998)

The *Elseworlds* series was a catch-all title for stories that happened outside the general continuity. For example, Harley is represented, but her name is Hayley Fitzpatrick. She's a college student addicted to a drug-laden cigarette brand and who is obsessed with Batgirl, Batman, and the Joker's character (whose name is Bianca). Hayley is taken hostage only to realize she's being held hostage by her idol Bianca. Hayley puts on one of Bianca's outfits and becomes her henchwoman. Batman defeats Bianca and believes he has saved Hayley. However, the story ends with Hayley killing her family and setting her house on fire. This particular story is an interesting commentary on Harley's bisexual coding in the other comic books. It is interesting to note that in this continuity, Joker's gender being switched does not change Harley's (or Hayley's) feelings or the obsession that develops.

"Oy to the World." *Batgirl Adventures.* #1 (Feb. 1, 1998)

This issue is a one-off comic for Batgirl starring Harley and Ivy. Harley lures Batgirl into helping her save Poison Ivy. During the encounter, the topic of rumors that Harley and Ivy are more than just friends comes up. When Batgirl asks, Harley asks if it is like the rumors about Batgirl and Supergirl, and Batgirl, embarrassed, drops the question. It is one of the more obvious tongue-in-cheek references to the potential relationship between the two villainesses.

"Mightier Than the Sword." *Batman: Gotham Adventures.* #10 (March 1, 1999)

Batman: Gotham Adventures is a comic book that is more like *Batman: The Animated Series* than in the general comics and exists in its own continuity. Poison Ivy describes her feelings for Harley as sisterly in the "Turnabout" issue. The series sometimes represents a more abusive relationship

between the two, such as in the issue "6 Hours to Live" where Poison Ivy loses her patience with Harley.

In the issue "Mightier Than the Sword," Harley is declared sane and released from Arkham. She sets out to write a book. The Joker, sure that the book is about him, tries to get Poison Ivy to work with him to stop Harley from writing the book. Poison Ivy, however, is much more supportive of Harley's efforts and is not afraid of anything Harley would write about her. In the issue, it is revealed that Harley wrote books as Dr. Harleen Quinzel before becoming Harley Quinn. In the end, the Joker finds out that instead of writing a tell all book about him, she's actually writing a fanfic romance novel about herself falling in love with a Batman-like character called Owlman.

Batman: Harley Quinn (Oct. 1, 1999)

This book represents the original origin story for Harley in the comic books in continuity and takes place during the "No Man's Land" story arc. Poison Ivy finds Harley in a pile of rubble. She is badly hurt but still looking to get back at the Joker for trying to kill her. Poison Ivy recognizes Harley from Arkham, and Harley ends up telling the story of how she got to where she was. This comic fills the gap between the one-off comic "Mad Love," and the rest of the comic book universe. While in the animated series, Poison Ivy gives Harley an antitoxin to keep from being killed by Toxic Acers, in this issue, Harley gets a similar concoction that actually gives her super strength, agility, and immunity to poisons and toxins like the kind that Poison Ivy creates. She reveals her newfound abilities by catching one of the Batman's punches and fighting him head on. By the end of it, Harley is back in the Joker's arms.

Harley Quinn. v1. #1–38 (2000)

This was the first solo title for Harley Quinn, and it ran for 38 issues. Because there is a later Harley Quinn series, the first series is referred to as volume 1 throughout this book's citations. The original issues were republished in four trade volumes. Preludes and Knock-Knock Jokes (issues 1–7), Night and Day (Issues 8–13), Welcome to Metropolis (issues 14–25), and Vengeance Unlimited (#16–38).

The essay "Super-Villain or Sociopath" addresses the difference between the issues run by Karl Kesel and A. J. Lieberman and the different ways they approach her evilness.

Batman: Harley and Ivy (2001)

Published by DC Comics, the first printing in 2001. It contains the collected miniseries Batman: Harley and Ivy, and includes the special Harley and Ivy: Love on the Lam by Judd Winick and Joe Chiodo.

Gotham Girls (2003)

This is a five-issue miniseries written by Paul Storrie. It is connected to the *Gotham Girls* seb content. Each issue is dedicated to the perspective of one character, giving some insightful looks inside the minds of different characters. Harley's issue is issue #3 "Harlequinade." The title is clearly referring to the *Batman: The Animated Series* episode of the same name. Right off the bat, the issue references "Mad Love." The series is a short read and a very interesting look at the events of the comic and Harley's relationships through Harley's own perspective.

Batman Adventures. #1, #3, #16 (2003)

The *Batman Adventures* comic book is based loosely on the animated series. The story arc for Harley revolves around her, Poison Ivy, and the Joker. The story revolves around Harley dealing with both the Joker and Poison Ivy in Arkham and then dealing with both of them once they break out. The story arc ends in a failed wedding between the Joker and Harley, and a broken friendship between Poison Ivy and Harley. However, Poison Ivy's story arch goes on to reveal that the Poison Ivy Harley has been dealing with is a failed plant clone created by the original Poison Ivy to keep Harley company. The story seems to be a way of reconciling the more human Poison Ivy from the first animated series and the part-plant Poison Ivy with powers from the later episodes of the animated series after the character was revamped.

"Kind of Like Family." Detective Comics. #831 (June 1, 2007)

The story is a lot like the animated series episode "Harley's Holiday," in that Harley tries to get out of Arkham the right way. She claims she has Stockholm Syndrome. Bruce Wayne is on her committee and realizes she has put a lot of effort in, but he also knows that her seeing the Joker again would destroy her resolve and send her back. Harley is initially denied release but is broken out of Arkham by Scarface so that she can help break into another building. She double-crosses Scarface and calls the police. In the fight with Scarface, she is so fast, agile, and erratic that she is nearly impossible to shoot. In the issue, Harley talks about her first week at Arkham and how scary it was, and how the Ventriloquist made her feel better. She also admits to having suicidal thoughts. Her double-crossing Scarface was out of respect for the Ventriloquist. In the end, her good deed earns her freedom from Arkham.

Gotham City Sirens. #1–#26 (2009)

Along with "Mad Love" and Harley's original solo series, *Gotham City Sirens* is one of the central Harley Quinn texts. Harley's relationship with the Joker, and her addiction to him, is dealt with in depth. Harley's intelligence

and her cruelty are highlighted. Also highlighted is the romantic, although not explicitly sexual, relationship between Harley and Poison Ivy. In this volume, "That Just Proves He Wants Me Back" discusses how the series reflects the concept of victimhood, agency, and partner violence.

Issue #7, "Holiday Story," is a highlight as Harley goes back home and sees her family for the first time. The essay "Bride of the Monster" talks about this interaction in depth and how it sheds light on Harley's feelings for the Joker.

Suicide Squad. v2 (2011)

In 2011, DC relaunched a number of their titles to update their characters and format. This is collectively called the New 52, since there were 52 titles. The original *Suicide Squad* is referred to as volume 1 in the citations, and the New 52 *Suicide Squad* is referred to as volume 2 throughout the book. This was Harley's first appearance in the revamped New 52 continuity for DC. Harley's appearance in the series was criticized for being hyper-sexualized. A number of essays touch on this run of *Suicide Squad.*

Harley Quinn. v2. #1–Current (2014–)

After *Suicide Squad*, DC launched a new solo series for Harley. The series follows Harley as she tries to establish a new life without the Joker. It is during this series that DC officially announced the existence of a sexual relationship between Harley and Poison Ivy and clarified that the relationship is also an open one. The series is still ongoing as of the writing of this book. Overall, the series has been well-received and would be a good read for anyone who wants to see Harley sans the Joker. The essay "The 'Mistress of Mayhem' as a Proxy for the Reader" discusses the series in terms of how Harley is represented as a proxy for comic book fans.

Web Content

Gotham Girls (2000–2002). Web flash animation

The *Gotham Girls* web series had three seasons. It was released as part of the *Birds of Prey* TV series DVD set in 2008. Harley is voiced by Arleen Sorkin. The series is mostly lighthearted episodic stories that are a surprisingly domestic look at the day-to-day relationship between Harley and Poison Ivy. The series is full of little moments between Harley and Poison Ivy which any fan of the relationship between the two would enjoy. While the original flash animations are no longer available, some of the episodes have been uploaded to video-sharing sites and are relatively easy to find with a quick search for the series title.

DC Super Hero Girls. YouTube (2016)

This is a non-canon web series created to support a doll line. Harley and Poison Ivy are depicted as being high school age and less villainous. While the series is not significant for the character of Harley Quinn, it is an interesting result of the popularity of the character that she was included in a "Hero" line of toys for girls.

Video Games

Batman: Arkham Series (2009–2015)

While Harley has appeared in other video games such as *Lego Batman: The Videogame* (2008) or *Injustice: Gods Among Us* (2013), her most significant appearances are in the Arkham series. The series consists of *Batman: Arkham Asylum* (2009), *Batman: Arkham City* (2011) and *Batman: Arkham Knight* (2015). The essay "Problematic Fave" discusses these video games and the ways in which their depictions of Harley compromise the character.

Movies

Suicide Squad (2016)

One of the more exciting developments for Harley fans has been the possibility of Harley being represented on film. *Suicide Squad* stars Margot Robbie as Harley Quinn. While the movie did not do well with critics, it was a box-office success. While there has been criticism of Jared Leto's depiction of the Joker, Margot Robbie's depiction of Harley was well-received. As of the time of this writing, Warner Brothers is planning on further solo Harley Quinn movies starring Margot Robbie. The essay "She Laughs by Night" touches on some of the issues related to how Harley is represented in the movie.

About the Contributors

Leonardo **Acosta Lando** has a degree in psychology from the Universidad de Buenos Aires (UBA). He has essays in a number of collections, including *Mediamorphosis* (Wallflower, 2016) and *The Ages of the Justice League* (McFarland, 2017).

Nelson **Arteaga Botello** is a professor and researcher at the Latin American Faculty of Social Sciences Institute (FLACSO), Mexico. He specializes in issues of violence, security, and cultural sociology, and has published more than 60 articles.

Ian **Barba** is an associate librarian at Texas Tech University Libraries. His writing has appeared in *Cases on 3D Technology Application and Integration in Education*, as well as a number of journals. He serves as an editor for *Archivation Exploration*.

Shelley E. **Barba** is an associate librarian at Texas Tech University. She has published in a variety of journals including *College & Research Libraries, The Reference Librarian,* and *Texas Library Journal*. In addition to this collection, she coedited *In the Peanut Gallery with Mystery Science Theater 3000* (McFarland, 2011).

Brandon **Benge** is a graduate of Texas Tech University where he earned a B.A. in accounting. He works at Star Comics in Lubbock, Texas.

Gregory **Bray** is a filmmaker, writer and associate media professor at SUNY New Paltz. His writing has been published in *The Journal of Popular Culture, Shadowland Magazine,* and in a number of essay collections.

Aidan **Diamond** is a graduate student at Memorial University of Newfoundland, where she researches the narratological function of mixed media in comics and teaches superhero narratives. She presents at conferences internationally.

Jennifer A. **Guthrie** is an assistant professor in the Department of Communication Studies at the University of Nevada, Las Vegas. She obtained her Ph.D. at the University of Kansas and teaches courses and conducts research in the areas of interpersonal and small group communication.

K. Scarlett **Harrington** is an adjunct instructor at the College of Southern Nevada. She holds an M.A. from the University of Nevada, Las Vegas, and conducts research on rhetoric and popular culture with an emphasis on social justice.

Amanda **Hoyer** graduated from Texas Tech University with a dual degree in psychology and English. She is working on contributions to the *International Journal of Comic Art*.

Cia **Jackson** is a Ph.D. candidate at the University of Glasgow where she is writing her thesis on the portrayal of power and female superheroes in DC's The New 52: *Batgirl* and *Harley Quinn*.

Alex **Liddell** is a philosophy graduate from the University of East Anglia, with a fascination for political, literary, and queer theory. They have had articles and features published in *Time Out London* and *The Independent*.

Erica **McCrystal** earned a Ph.D. from St. John's University, New York. Her interests include Gothic crime and aesthetics, Victorian fiction, and new media. She has published articles on 19th-century Newgate Prison and detective fiction.

Willmaria C. **Miranda** is an adjunct professor of English at Kean University in Union, New Jersey. Her research interests include writing center studies, popular fiction, gender studies, and cultural studies.

Derek **Moreland** is the writer of the comic *Legends of Streaming*, and cohost of the podcasts *Blah Blah Comics, Blah Blah Curse Words*, and *Assembling the Avengers*. He has published in *Cease, Cows*, as well as on zeitgeeks.com and thesurlynerd.com.

Emilee **Owens** is a student at Penn State University, where she is pursuing a degree in psychology. She writes analyses on comics for a university course on the graphic novel.

Fernando Gabriel **Pagnoni Berns** is a Ph.D. candidate at Universidad de Buenos Aires (UBA), where he teaches seminars on horror film and is director of the research group on horror cinema "Grite." His work can be found in a number of essay collections.

Joy M. **Perrin** is an associate librarian at Texas Tech University. She has published many articles in journals on the topic of digital collections and is author of *Digitizing Flat Media* (Rowman & Littlefield, 2016).

Michelle Vyoleta **Romero Gallardo** is member of the tenth cohort of the doctorate in research in social sciences with a major in sociology at the Latin American Faculty of Social Sciences Institute (FLACSO), Mexico.

Megan **Sinclair** is a Ph.D. student at the University of Dundee, Scotland. She has an M.A. in comic studies and is the coordinator at The Scottish Centre for Comic Studies. She is working on a comic intended to raise awareness about heart disease and is collaborating on a comic about organ donation.

Michał **Siromski** is a psychologist and social project coordinator in Poland, as well as a comics researcher. He has written many articles for Polish comics magazines and has been on the editorial staff of the *Magazyn Miłośników Komiksu* (*Comics Lovers Magazine*) since 2004.

Justin **Wigard** is working toward a Ph.D. at Michigan State University, where he was awarded a University Distinguished Fellowship. His work focuses on chrono-topal representations of patriarchal villainy and the feminist antihero in Marvel's *Jessica Jones*.

Index